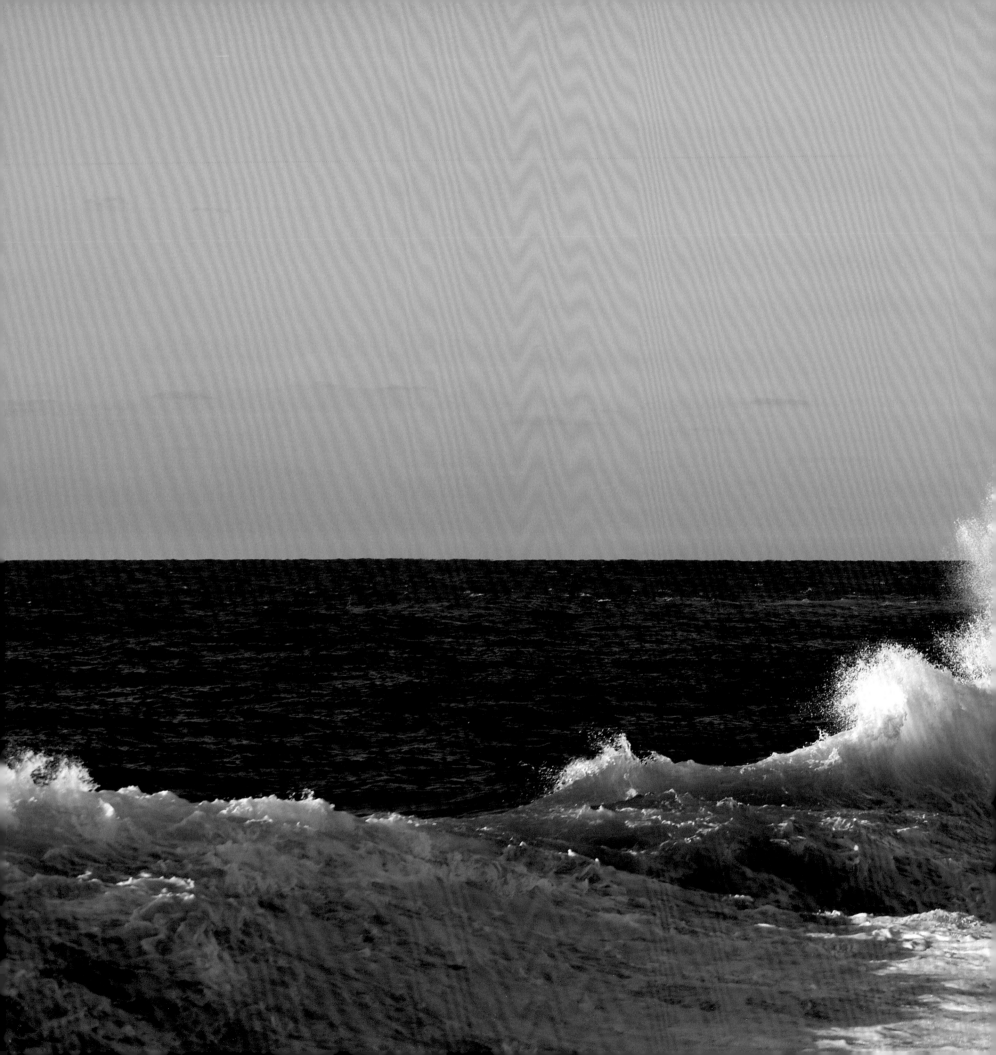

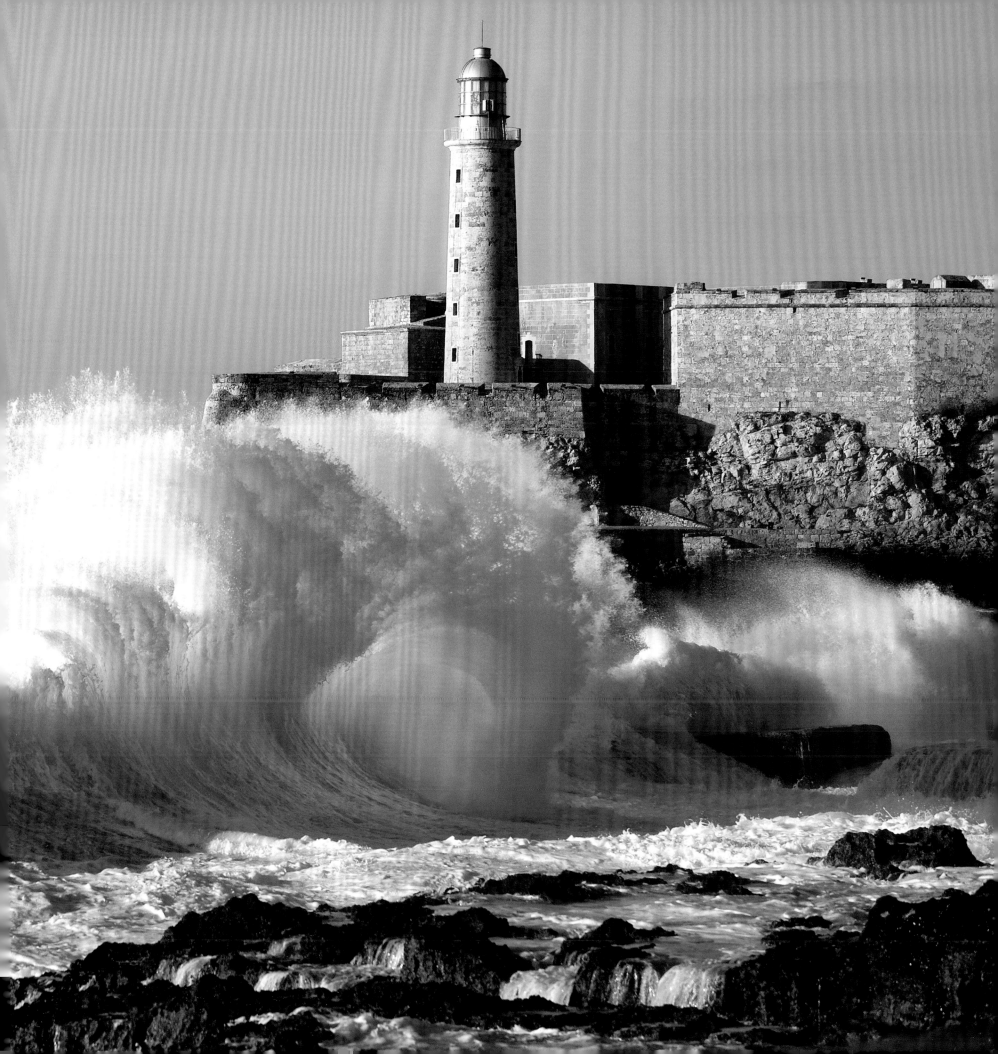

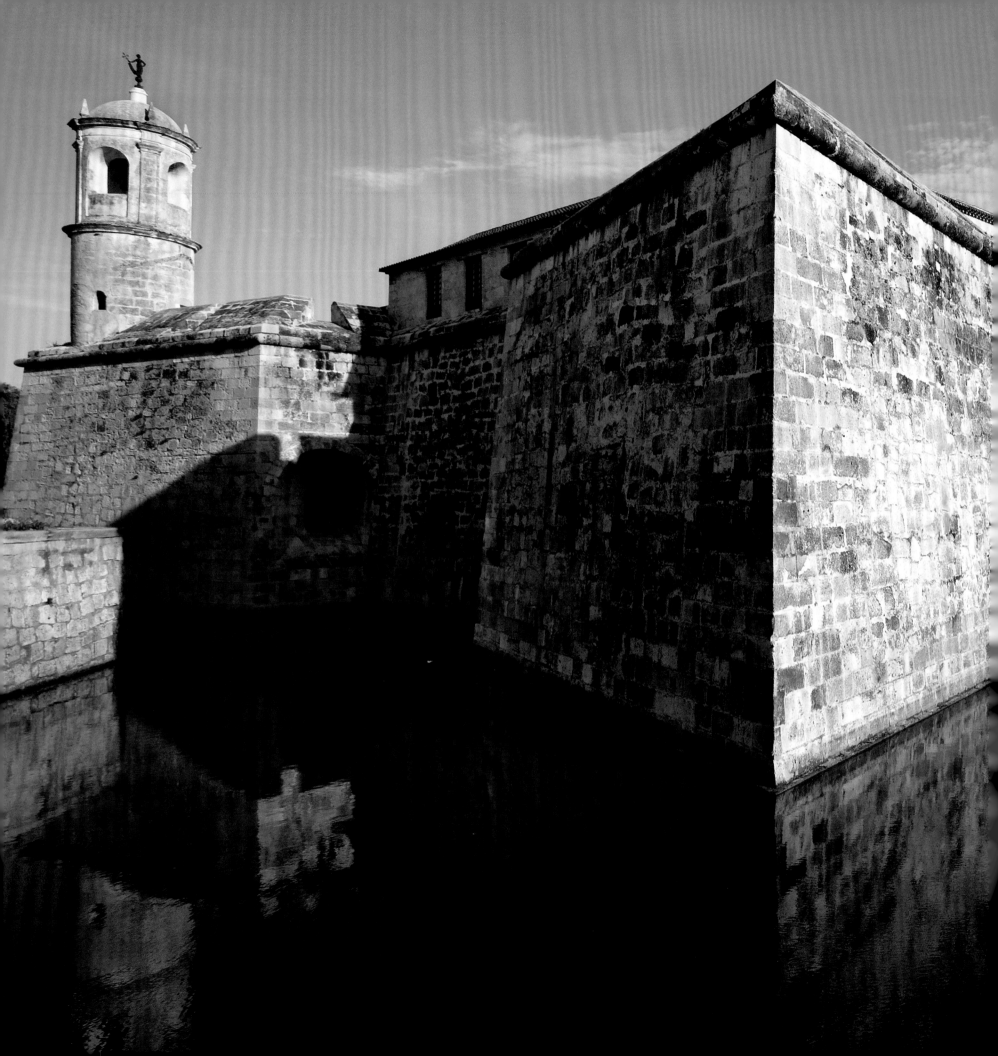

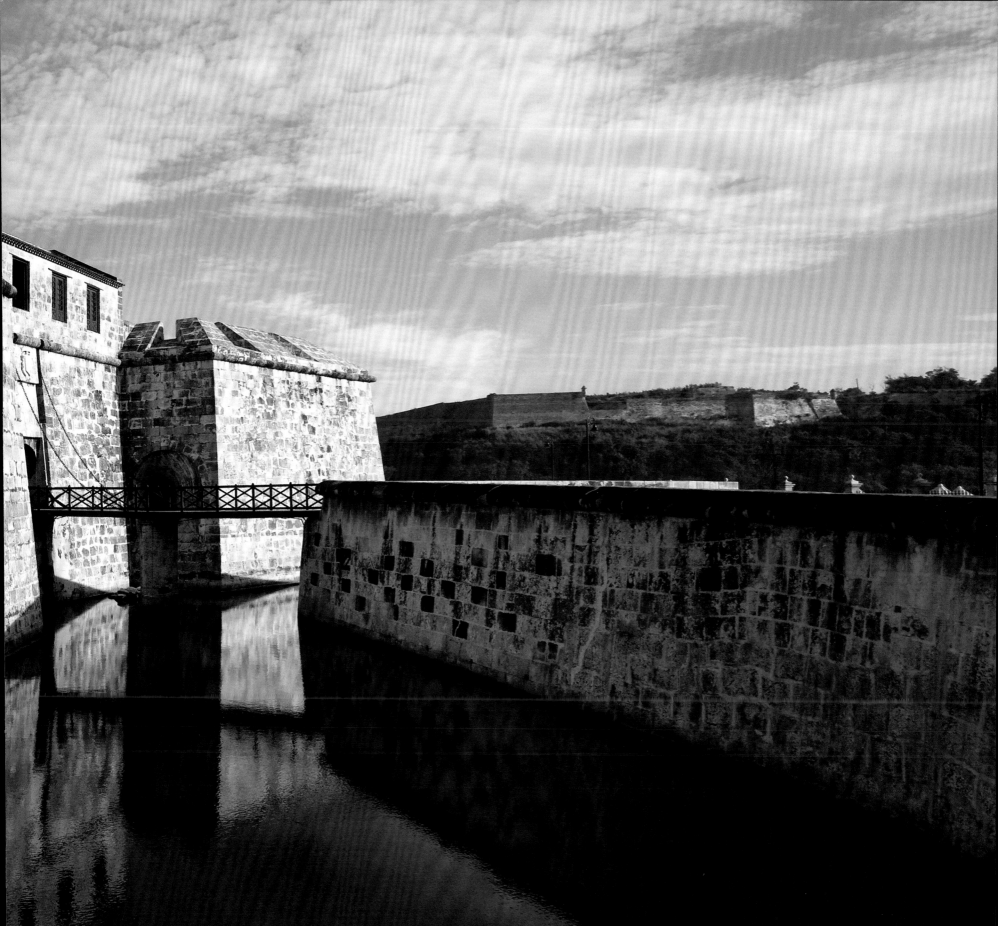

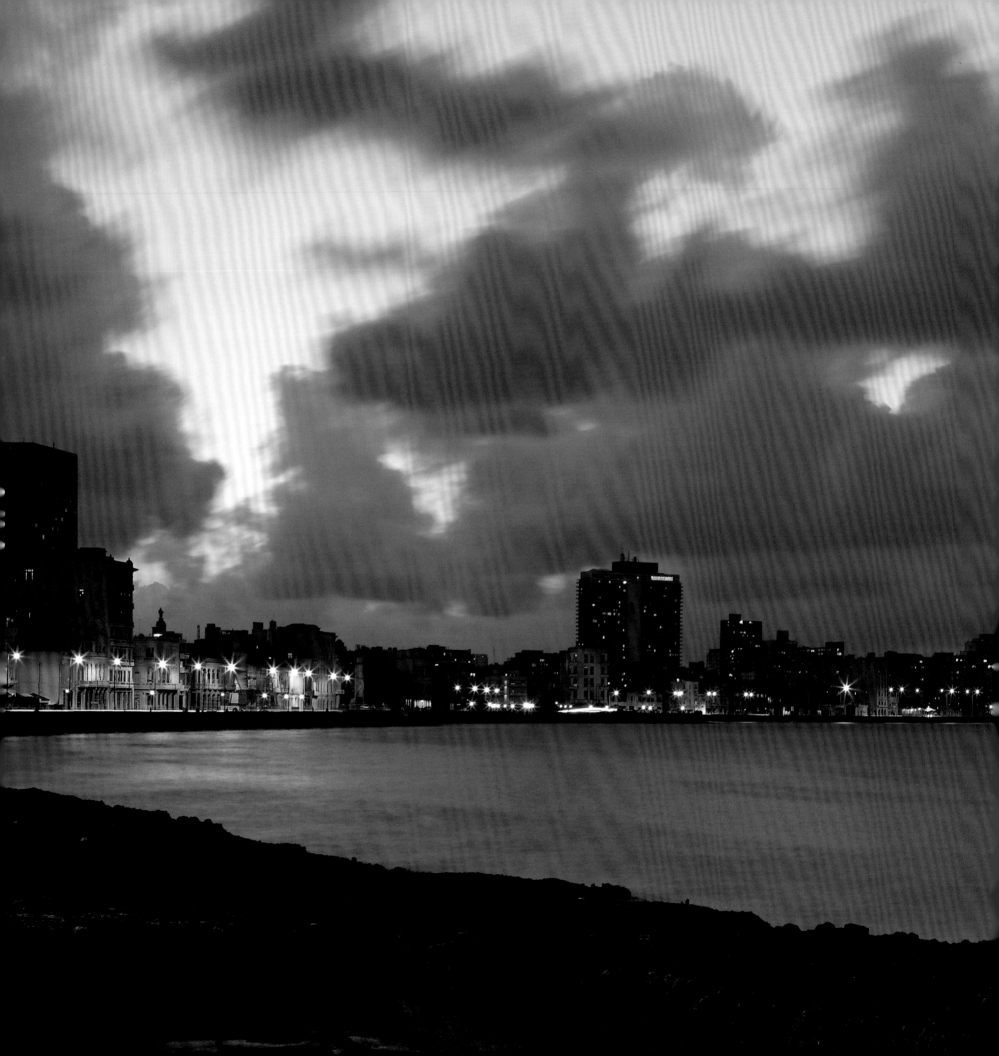

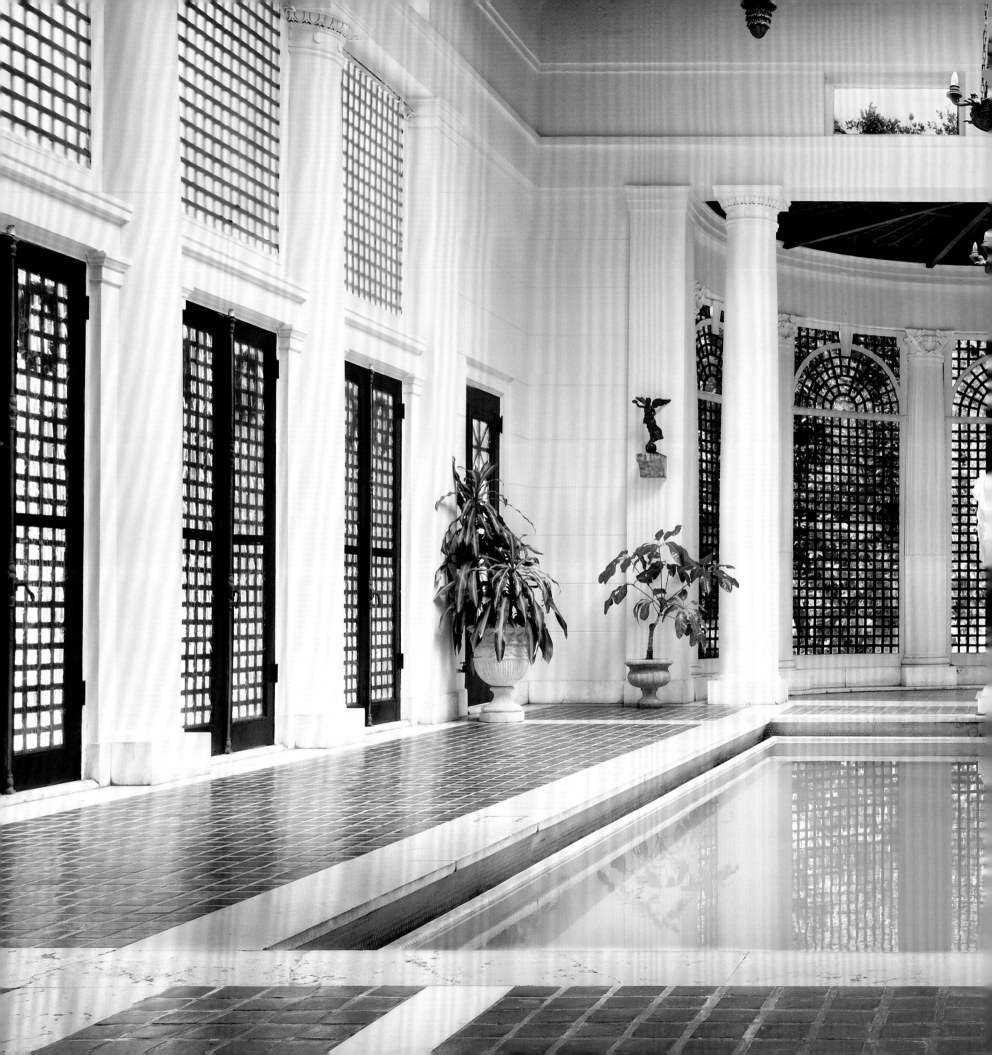

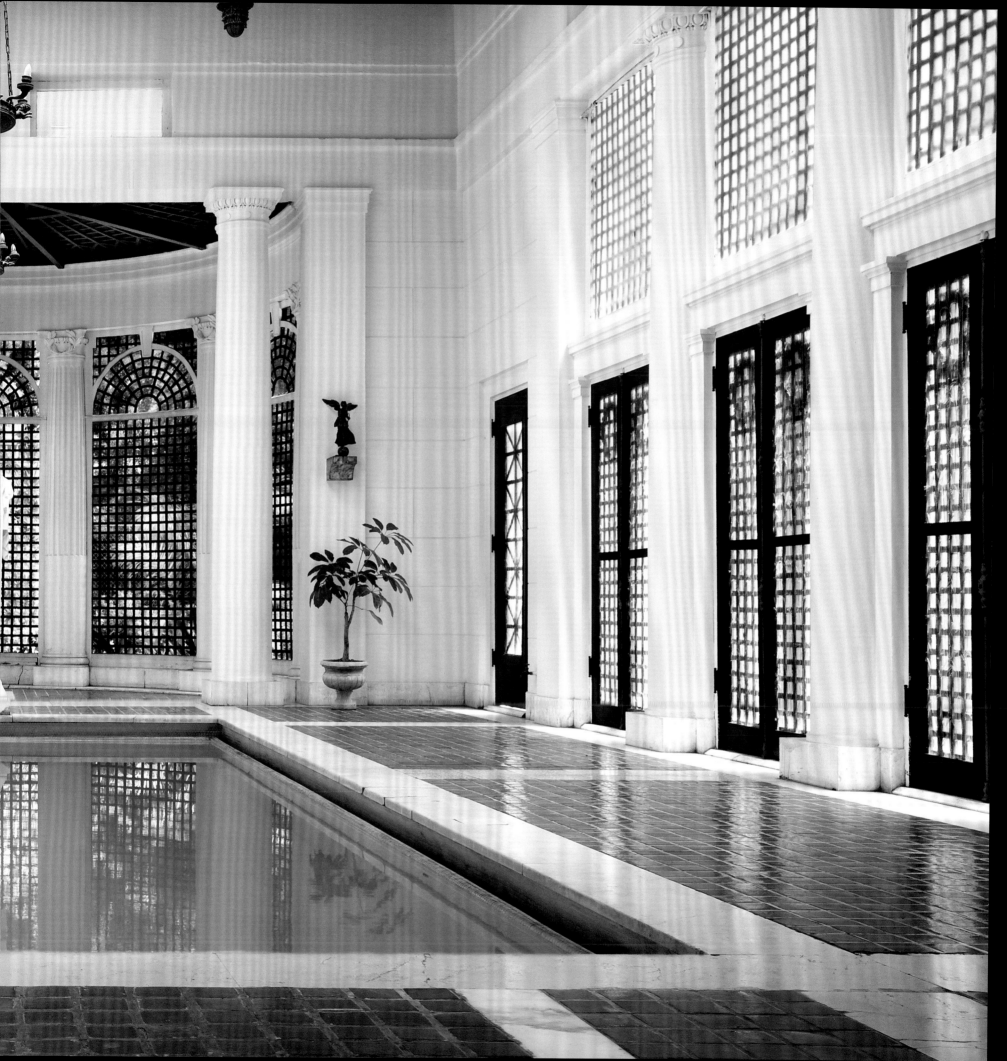

THE SPLEND

450 Years of Architecture and Interiors

Michael Connors

Principal photography by Brent Winebrenner
Design by Massimo Vignelli

OR OF CUBA

RIZZOLI
NEW YORK

New York · Paris · London · Milan

Previous spreads

Lighthouse at Castillo del Morro at the entrance to the bay of Havana. Construction of this fortress, which was designed by Italian military architect Giovanni Bautista Antonelli, began in 1589.

Castillo de la Real Fuerza, the first bastioned fortress built in the Americas, was constructed in 1558 to protect Havana from pirate attacks following a raid by the French buccaneer Jacques de Sores in 1555. Enslaved Africans and French prisoners were used for labor.

View of the Malecón and Havana skyline overlooking the Straits of Florida.

The fashion for an indoor private swimming pool was introduced by Pablo Gonzáles Mendoza who built this one in the Pompeian style (baño romano) in 1916.

Next spread
The turquoise sea at Guardalavaca adjacent to the Bay of Bariay where Columbus first landed in Cuba in 1492.

Table of Contents

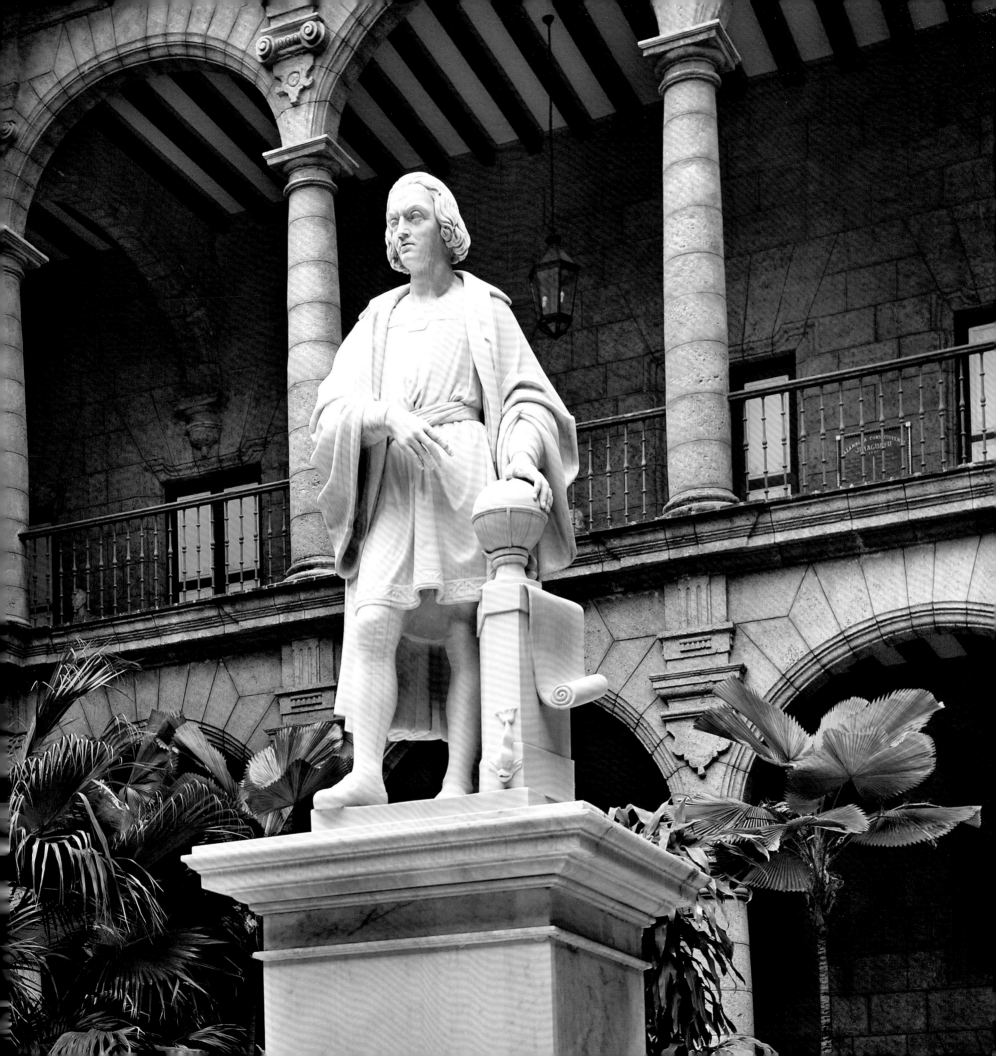

Introduction

In 1492 the first European, Cristoforo Colombo, a Genoese known as Christopher Columbus to the English-speaking world, first set foot on the island of Cuba. Driven by the search for the fabulous wealth of the East that Marco Polo had written about centuries before, he landed on Cuba's north shore at the Bay of Bariay, where he waxed rapturous over the beauty and wrote in his log:

I have never seen a more beautiful place. Along the banks of the river were trees I have never seen at home, with flowers and fruit of the most diverse kinds, among the branches of which one heard the delightful chirping of birds. There were a great number of palms.... I felt such joy upon seeing these flowery gardens and green forests and hearing the birds sing that I could not tear myself away and thus continued my trip. This island is truly the most beautiful land human eyes have ever beheld.[1]

After Columbus's discovery of Cuba, the Spanish found traces of gold and established settlements, but they soon exhausted the early small mines. It wasn't long before the island turned out to be even more important as a geopolitically indispensable stepping-stone for the newly discovered, wealthier territories of Mexico, Central America, and Peru, and soon became the entry and exit point for all Spanish treasure fleets, earning its sobriquet "key to the New World."

By the seventeenth century Spain's colonial capital, Havana, with a population of more than ten thousand, had established itself as the Caribbean's largest commercial trading seaport, and the arrival and departure port for

all Spanish ships traveling between the Iberian Peninsula and Nueva España. The domestic architecture built during Cuba's first 150 years followed closely the current styles in the mother country, particularly along Spain's Mediterranean coast. During the centuries that followed Cuba's discovery and exploration, the inevitable envy from other powerful European nations caused England, France, Denmark, Holland, and Sweden to send explorers to expand on Columbus's discoveries and claim land for their monarchs, which led to a state of perpetual warfare that challenged Spain's self-proclaimed ownership of the New World. Spain attempted to defend her private lake, the Caribbean Sea, from these European interlopers; due to its strategic location, the island of Cuba continued to be Spain's central command station in the watery West Indies battleground.

Once sugar became the world's commodity of wealth in the eighteenth century, the island's rich soil and rapidly developing sugarcane plantations (*ingenios*) resulted in its dramatically increased wealth and its added importance to Spain. Before the beginning of the nineteenth century, sugar was king and Cuba was the world's largest sugar producer. The Cuban cities of Trinidad, Matanzas, Camagüey, Cienfuegos, and Havana were filled with magnificent mansions and stone palaces.

As the end of the nineteenth century neared, Cuban nationalists had fought two wars for independence from Spain, and in 1898 the José Martí rebellion ended four centuries of Spanish domination. By the 1920s Cuba had once again managed to become the world's wealthiest tropical nation, and Havana came to be known as the "jewel in the Caribbean crown."

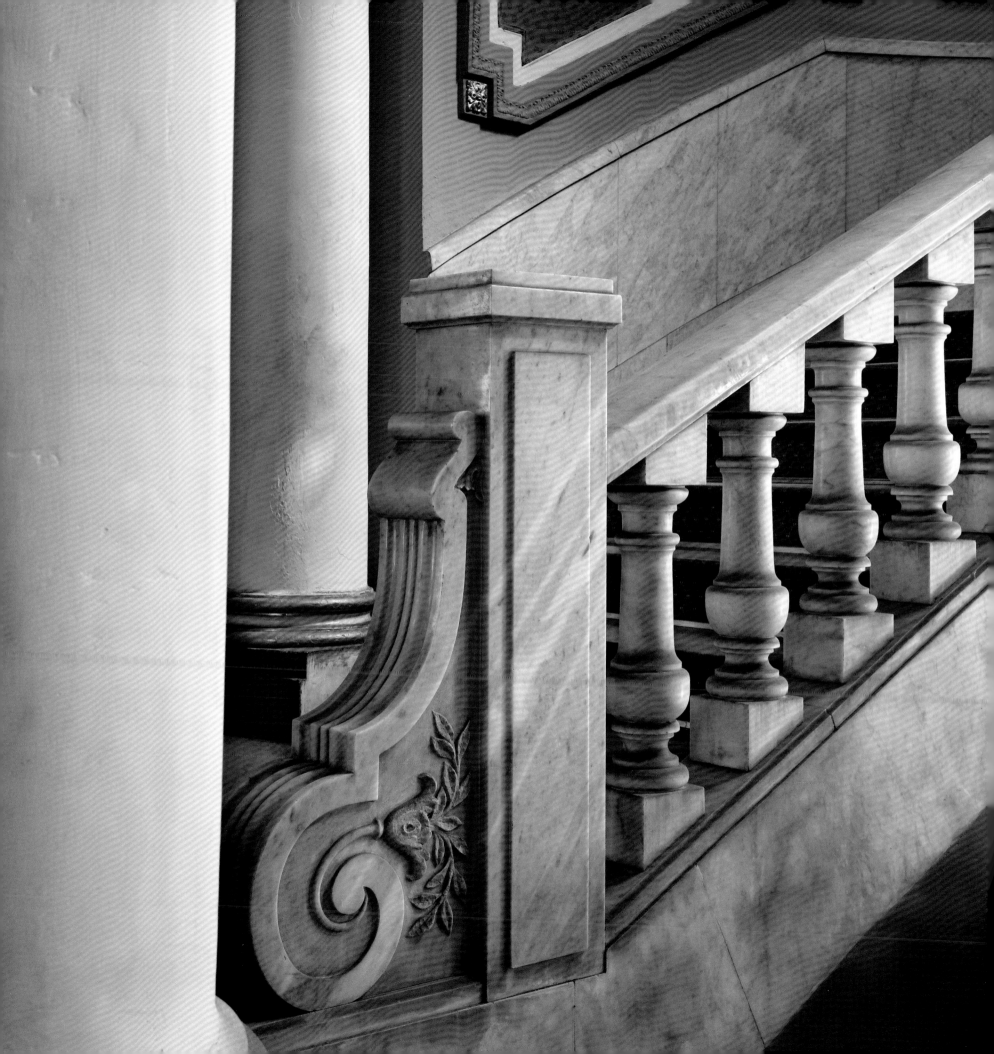

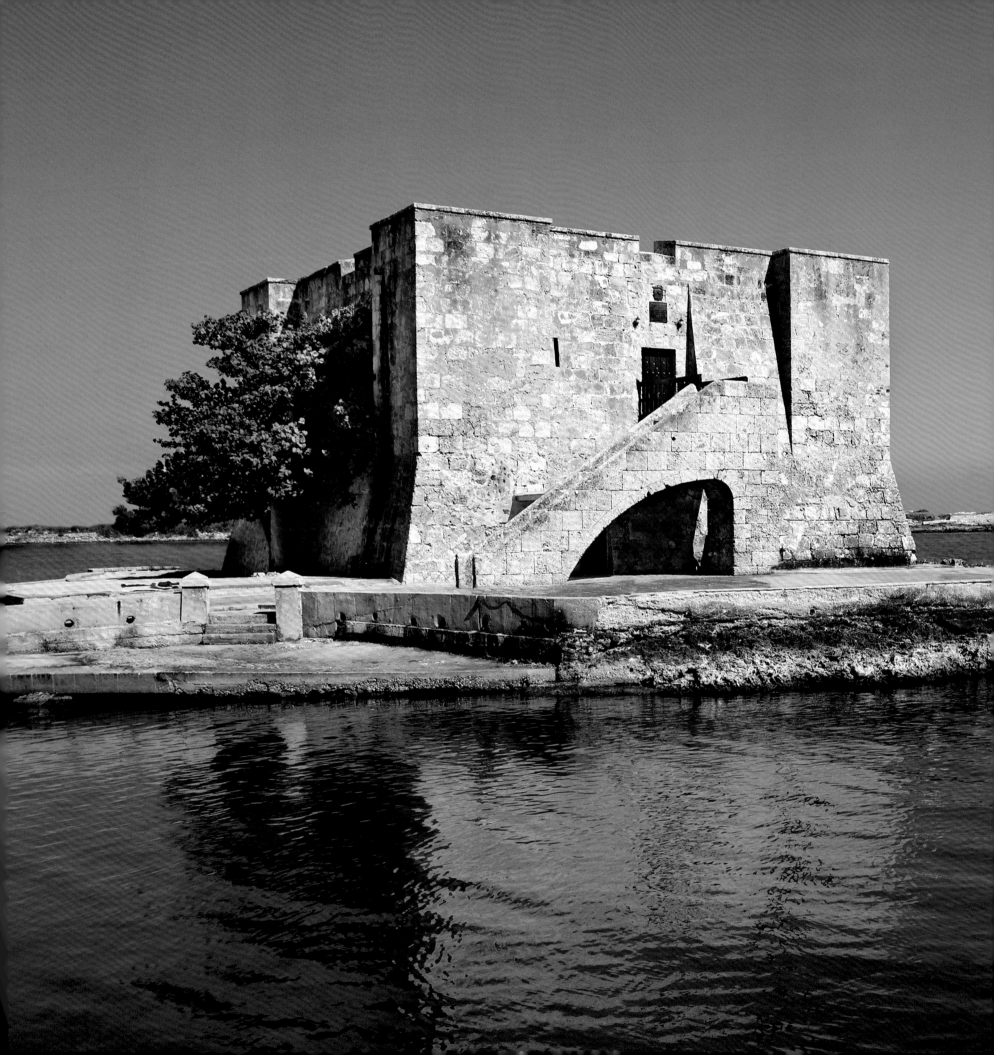

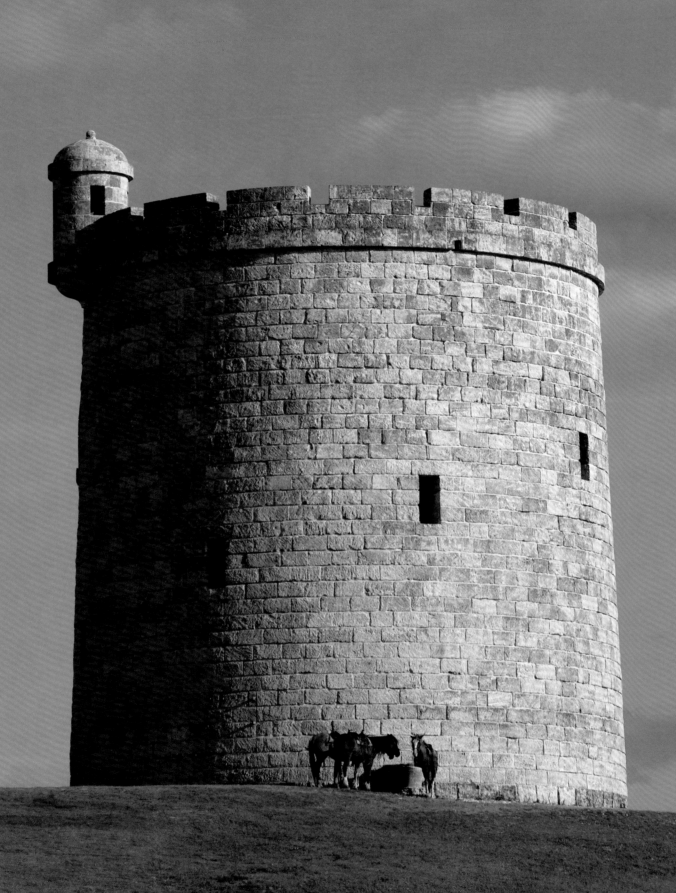

Discovery and Exploration

Christopher Columbus's intention was to discover the western route to the Far East, a land of celebrated wealth described by the Venetian merchant Marco Polo (c. 1254–1324). In 1274, Polo traveled to the court of the Mongolian emperor Kublai Khan (grandson of Genghis Khan), where he lived for more than twenty years while exploring Asia. It was in the Latin edition of Polo's travel book *Le Livre des Merveilles du Monde* (*The Book of the Wonders of the World*) that Columbus made handwritten notes referencing what he thought his location was in the Caribbean Sea on that fateful voyage in the fall of 1492.

Upon making landfall in the Bahamas, he believed he had reached the maze of islands off the Asian mainland. The logical conclusion was that he had arrived in the Sea of Cathay (an alternative name for China). The indigenous people with whom Columbus made contact in the Bahamian islands and used as guides spoke of a large island they called Colba. Thinking it must be Cipangu, the early Mandarin Chinese name for Japan recorded by Marco Polo, he set sail.

I shall … depart for another much larger island, which I believe must be Cipangu, according to the description of these Indians I carry, and which they call Colba [Cuba] … and beyond this is another island, which they call Bofio [Haiti], which they also say is very big; and the others which are between we shall see as we pass, and according as I shall find a collection of gold or spicery, I shall decide what I have to do. But in any case I am determined to go to the mainland and to the city of Kinsai [Hangzhou, China], and to present Your Highness's letters to the great Khan, and to

beg a reply and come home with it.[2]

Columbus misunderstood the local name for the island, Colba, and misspelled it in his log entry as Cuba:

This night after midnight, I weighed anchors from the island Isabela to go to the island of Cuba, which I heard from that people is very great, and with a lot going on, and therein gold, spices, big ships, and merchants.… I believe that it is the island of Cipangu, of which are related marvelous things;[3]

Columbus firmly believed that this newfound land was part of the Far East treasure-rich territory described by Marco Polo more than two centuries before, and he named it Juana, after King Ferdinand and Queen Isabella's demented daughter.

Cuba's earliest inhabitants were the Ciboney (the Arawak word for cave dwellers), a pacific and industrious people who arrived from either South America or Florida around 3500 BC. By the time the Spanish arrived, the Ciboney had been driven to the neighboring island of Hispaniola and a few isolated locations in Cuba by the more powerful Arawak Tainos, who migrated from South America via the Caribbean island chain.

It was the peaceful Arawak Tainos that Columbus described when he wrote:

So lovable, so tractable, so peaceful are these people that I swear to your majesties that there is not in the world a better nation nor a better land. They love their neighbors as themselves and their discourse is ever sweet and gentle and accompanied with a smile.[4]

Believing he had reached the Indies archipelago off the coast of Asia, Columbus named the islands Las Indias Occidentales, The West Indies, and their indigenous occupants "Indians," an appellation that has survived to this day.

The Kalinago or Carib people, Cuba's native Amerindian neighbors to the southeast in the Lesser Antilles islands, provided the eponym for the entire region: the Caribbean. "Cariba" was the Arawak name for the fierce and more warlike Caribs as well as the root of the forbidding word *cannibal*. The Caribs' legendary cannibalism (held in some suspicion by today's scholars) provided the Spanish with a pretext for their enslavement and extermination over the first century of colonization.

Two years after Columbus's discovery of the New World, Pope Alexander VI, a Spaniard by birth who, it was said, regarded the papacy as an instrument of worldly schemes with little thought of its religious significance, divided the newly found lands between Spain and Portugal by issuing the Treaty of Tordesillas. Its purpose was to secure colonizing and trading rights in the Western Hemisphere for Spain, which sponsored Columbus's exploration, and for Portugal, Spain's political ally, excluding all other European countries. The treaty established a line of demarcation about halfway between the Portuguese Cape Verde Islands, off the west coast of Africa, and Cuba; it apportioned the eastern portion (Brazil) to Portugal, and the Caribbean Sea to Spain.

Both Spain and Portugal dealt with their designated territories as conquerors and colonialists generally did: as resources to be exploited for the benefit of the mother country, without regard for the land or its inhabitants. The two Iberian kingdoms dominated the Western Hemisphere throughout the sixteenth century and generally succeeded in colonizing the New World, sending their treasure fleets back home laden with riches of gold and silver. The two countries, especially Spain, quickly became the envy of other powerful European nations, specifically England and France. France's Renaissance king Francis I (r. 1515–47), waged a series of wars against his rival, Spain's Charles I

(1519–1558) (who was also Holy Roman Emperor Charles V), and made the celebrated remark:

The sun shines for me as for others. I should very much like to see the clause in Adam's will that excludes me from a share of the world.[5]

Spain's treasure fleets and her claims of sole ownership of the New World were also aggressively coveted by England. Since he had no navy, the English king Henry VIII (r. 1509–47) invented privateering to plunder Spanish ships. His daughter Elizabeth I (r. 1558–1603) successfully continued to wage war against Spain. Her chief adviser, Sir William Cecil, lectured Spain's ambassador to England in 1562, saying, "The Pope had no right to partition the world and to give and take kingdoms to whomsoever he pleased."[6]

The heavily armed Spanish galleons transported their treasures, which included gold, silver, gems, spices, hardwoods, and animal hides, from the Spanish Main, as the English called the mainland coast and islands of the colonial Spanish empire, to Seville, Spain. These long voyages to Spain provided prime targets for sea bandits who called themselves pirates, corsairs, filibusters, freebooters, buccaneers, and privateers.

The diary of seventeenth-century buccaneer John Alexander Exquemelin, who sailed with English pirate Henry Morgan (1635–1688) and recorded his infamous and bloody adventures in *The Buccaneers of America (De Americaensche Zee-Roovers)*[7], explains best the distinction between the buccaneers, pirates, and privateers by detailed explanation but then writes that all became indistinguishable as they joined forces and gained infamy through their Caribbean exploits.

The term buccaneer is the English version of the French word boucanier *(i.e., one who cures meat by the* boucan *process). It is curious that the English pirates should have*

Opening spread
The Fuerte de Santa Dorotea de Luna de la Chorrera was built in 1654 and formed part of Havana's defensive system at the mouth of the Chorrera River.

Previous spread
Old fortress tower that serves as a water tower in the Varadero area east of Havana.

Above
One of the early colonial houses in Havana's Plaza de San Francisco created in the early 1600s.

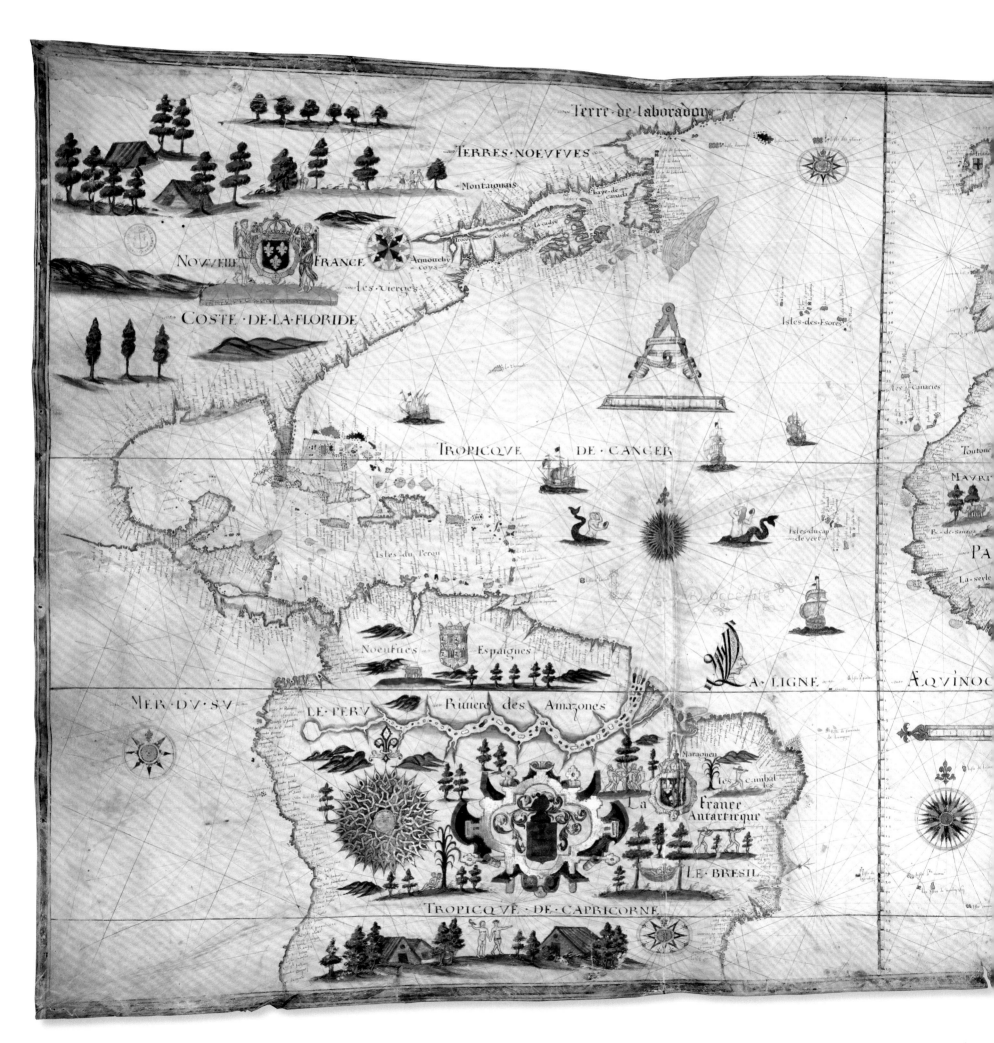

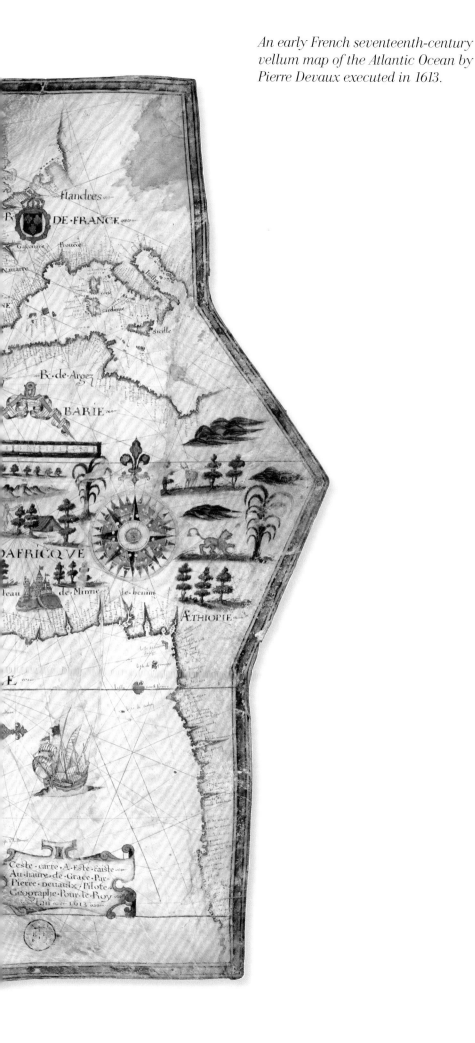

An early French seventeenth-century vellum map of the Atlantic Ocean by Pierre Devaux executed in 1613.

adopted the term from their French comrades and made it their own, while the latter simultaneously took the title Filibastier, which is the English word "freebooter" pronounced in the French manner. Another and very common appellation by which they were known was Brethren of the Coast, and by these rude warriors of all races who were accustomed to work together irrespective of nationality, this last title was deemed particularly appropriate and expressive.[8]

France was the first European country to challenge Spanish and Portuguese hegemony in the New World. Throughout the 1500s the French kings knew that the mastery of the future world was at stake and issued letters of *marque*, which sanctioned the capture of Spanish ships and the raiding of Spanish colonies by French buccaneers or pirates. In 1555 Havana, then known as San Cristobal, was attacked, sacked, and burned to the ground by French buccaneer Jacques de Sores.

Eventually England similarly challenged Spain's papally granted ownership of the Caribbean, which deteriorated relations between Spain and England during the reign of Elizabeth I. English privateers successfully plundered Spanish West Indian settlements and ships, as Henry Morgan's spectacular raid on Cuba's inland town of Puerto Principe in 1668 exemplified. Piracy had become English and French national policy, and privateers sanctioned by their monarchs joined forces with Caribbean buccaneers and pirates in bloodthirsty attacks on the Spanish for more than a century.

During the last decade of the fifteenth century, the first Spanish colonies were founded on the island of Hispaniola (named *La Isla Española* by Columbus), an island that is today shared by the Dominican Republic and Haiti. The settlement of Santo Domingo de Guzmán was established by Columbus and his brother Bartholomew on the island's southern coast near the east bank of the Ozama River,

where the capital city of Santo Domingo is today, and from where the conquistadores who conquered Mexico, Peru, Puerto Rico, and Cuba departed.

Soon after Spanish explorer Sebastián de Ocampo discovered in 1508 that Cuba was an independent island, Diego Velázquez de Cuéllar, who had been lieutenant governor of Hispaniola under Christopher Columbus's son Diego, led the first expedition to colonize Cuba in 1511. Velázquez founded Cuba's first seven towns: Baracoa in 1512, Bayamo in 1513, Santiago de Cuba in 1514, Sancti Spiritus in 1514, Trinidad in 1514, Santa Maria del Puerto del Principe (which was to become Cuba's third largest city, Camagüey) in 1515, and Havana in 1515.

In a typical response to an urgent need for shelter, the first domestic dwellings built in Cuba were no doubt constructed of palm bark and mud with roofs of thatched palm fronds much like the *bohios* or huts of the indigenous natives.

Velázquez was appointed governor of Cuba and immediately convoked a local government council (*cabildo*), which allowed him to deal directly with Spain, thereby circumventing oversight of Hispaniola's rule and Columbus's authority. He also established the *encomienda* and *repartimiento* systems exploiting Cuba's native people by allowing the colonists to force them into involuntary servitude as mine workers and plantation laborers. The *encomienda* system granted land and in many cases entire villages of natives to the Spanish. These systems were officially abolished in 1542 but coupled with the conversion to Christianity forced under pain of death; the result was the genocide of the Tainos and the eventual disappearance of Cuba's indigenous population.

Bartolomé de las Casas (1474–1566), a Spanish Dominican priest, recorded the Spanish colonial regime's enormities and atrocities in his book A Brief Account of the Destruction of the Indies. *This unbridled denunciation of Spanish*

cruelty and oppression toward the Indians, full of horrifying statistics on the number of Indians killed and other harsh accusations, was printed in 1552 in Seville.[9]

Ironically, de las Casas traveled to the New World in 1502, participated in the conquest of Cuba, and accepted grants of *repartimiento* and *encomienda*, receiving Indians and land as a reward. But by 1514 de las Casas had a change of heart, renounced his grants, and became an advocate on behalf of justice for the indigenous natives. He dedicated the remainder of his life to the protection of the natives of the New World.

From the beginning there was an absence of an indigenous labor force with a building and craft tradition in Cuba (which was not the case in Mexico and South America). Subsequently, Velázquez authorized the importation of enslaved Africans in 1513. There had been instances of African slavery in the Iberian Peninsula since the time of Arab domination, and it was the Portuguese who first established a direct link with West Africa for the specific purpose of slave trading. There are records of enslaved Africans in Hispaniola as early as 1503.

Diego Velázquez built his house, Casa de Velázquez, in 1515. A restored version of the villa, where the small amounts of gold that were discovered on the island were processed, is the oldest colonial-era house in Cuba with an exemplary version of the Mudéjar style of the period. Mudéjar, or Hispanic-Moorish, style was derived from the Moors (Muslims) who occupied the Iberian Peninsula from AD 711 to 1492 and influenced Spanish architecture and decorative arts. This fusion of Moorish and Spanish Christian aesthetic was characterized in architecture by intricately carved woodwork in ceilings and balconies, and patterned brick and stucco arches. In the decorative arts and construction techniques, intricate interlaced repeating geometric patterns are prevalent in tile work, textiles, metalwork, and furniture.

The façade of Casa de Velázquez features overhanging carved wooden screened balconies and bay windows protected by wooden latticework of Moorish influence. In fact, the Spanish Mudéjar style dominates Casa de Velázquez with its intricately carved ceilings (*alfarjes*) and patterned latticework wooden screens (*celosos*). The ceilings strongly resemble the interior of the bottom of a wooden boat, which implies that shipbuilders contributed to its design and construction by incorporating horizontal and diagonal beams, a technique known as *par y nudillo*.

It is important to remember that until approximately the mid-seventeenth century, most of the craftsmen and artisans in Spain were Moorish or descendants of the Moorish-Hispanic craft techniques and aesthetic. An example of the transference of this Moorish construction technique to Cuban architecture is in Casa de Velázquez.

The remarkably intricate interlaced patterns of the ceiling timbers are derived from those found in Arabia, where long lengths of lumber are scarce. The Moorish construction technique of piecing wood together in intricate patterns was born of the necessity to hide the joining of short timbers. The custom continued only as a decorative styling in colonial Cuba, where there was no shortage of long timbers.[10]

Within forty years of the founding of the first sixteenth-century settlements in Cuba, the population began to decrease due to the attraction of larger rewards in Mexico, Central America, and South America. By the mid-1500s the population of the island had fallen to such a level that emigration became a capital crime.

In 1561, Spain's Flota Indiana or Indian Fleet, a *flota* system of armed naval convoys, was established to protect the homeward-bound Spanish treasure ships, laden with silver and gold. A Spanish historian wrote in 1587 that the treasure ships that entered Spain contained enough to

pave the streets of Seville with blocks of silver and gold. As Havana's large natural harbor was recognized as the most ideal strategic springboard for ships to arrive and depart the New World, it soon replaced Santo Domingo as the official stop for Spanish ships and became the unofficial capital of the New World. By this time Cuba had become the most important outpost of the Spanish empire, creating a second building boom in the 1570s and '80s. In 1592, the Spanish crown granted Havana the official status of a city.

As demand for housing for the increasing number of immigrants and conquistadores rose, all houses began to be built of wood and/or stone. Driven by nostalgia to emulate the architecture of their distant homeland, the builders of the single- and two-story homes made them compact with rectangular floor plans and tile roofs. None of these early houses had patios. There are few extant sixteenth-century houses standing in Cuba, and those that are have undergone extensive alterations from their original floor plans that had living quarters upstairs and slave quarters downstairs.

With the arrival of the seventeenth century and with military fortifications either in place or under construction, the population began to increase due to the protection from pirates and marauders provided by the forts. Havana's first fort, Castillo de la Real Fuerza, took twenty years to build, was completed in 1577, and housed the governors of Cuba until 1762. Soon after two more forts, La Punta and El Morro, were built on opposite sides of the entry to Havana Harbor. During this time Spanish military engineers and architects were charged with the task of following the dictates of the Laws of the Indies, a series of regulations first promulgated by Phillip II (1527–1598), issued over numerous years, and finally codified in 1573.

The New Laws of the Indies actually derived from theological debate and were in theory intended to correct the moral transgressions associated with colonization, thus protecting the rights of native populations. In practice, *however, they served as an instrument of the state to control nearly every aspect of colonial life.*[11]

Havana, where the grid pattern was laid out, was made the island's capital in 1607. Other towns in Cuba were also laid out with streets arranged at right angles to one another in a formation based on the plan of a Roman military camp. Rectangular plazas were created and aligned with the points of the compass (to benefit from the southern and northern winds). In addition, sites were determined for municipal and military buildings. Private *palacios* were also built on these plazas, and from the sixteenth to the nineteenth century most Cuban towns attempted to adhere to this pattern.

In Cuba the earliest Spanish colonial stone constructions of domestic *palacios* were medieval and Renaissance designs laced with Mudéjar elements. Shortly thereafter, Gothic and a version of the highly decorative Plateresque style came into fashion. The Italian-inspired Plateresque style derives its name from the word *platero*, or silversmith, and is similar to the delicate filigree work of Spanish silversmiths or *platería*. It was the term associated with the elaborately decorative late Gothic and early Renaissance architecture popular in sixteenth-century Spain. At the time Spanish taste was a mix of Italian Renaissance and flamboyant late Gothic with elements of Arabic decoration. The Plateresque was a transitional style from Gothic to baroque and had a mixture of elements, combining late Gothic, Muslim, and Renaissance construction techniques and decorative motifs.

From the infancy of Spanish architectural historiography in the eighteenth century, it has generally been agreed that, after a period of transition from the Gothic, Renaissance architecture in Spain comprised two distinct phases: a period of excessive ornamentation followed by a shift toward a plainer and more moderate use of the new style.[12] Since there was no one predominant sixteenth-century architectural style in the mother country, Cuban settlements displayed various styles that defy any specific architectural

periodization. When classified or labeled they can only be defined as Spanish colonial or specifically Cuban colonial West Indian. The combination of all the varied elements that make up the architectural style of Cuba is also referred to as *mestizaje*.

By the last decade of the sixteenth century, a number of professional builders and artisans had immigrated to the island and were established, particularly in Havana.

These masons, stonecutters, carpenters, blacksmiths, and silversmiths worked on the most outstanding projects of the time, including fortresses, churches, monasteries, government buildings, and the residences of the elite.[13]

When these Spanish architects, engineers, and artists arrived in Cuba, their first impulse was to impose European designs and building traditions; thus Cuban colonial architecture and art of the period were influenced by all the various styles then current in Spain, with modifications made only for the island's tropical climate and available building materials.

From the beginning, Cuban colonial art was permeated by Mudéjar traits, in religious buildings as well as in palaces and smaller dwellings. Furthermore, conditions in Cuba were never favorable for the development of mestizo art. Besides the lack of a labor force with a craft tradition and the difficult properties of the local stone, which was porous and encrusted with sea fossils, there was another obstacle: the religious orders, which elsewhere tolerated or encouraged the contributions of native artisans, had too little influence in Cuba to shake the prevailing aesthetics. In consequence, Cuban baroque is much more restrained than that of the rest of Latin America, a fact that links it to the art of the Caribbean.[14]

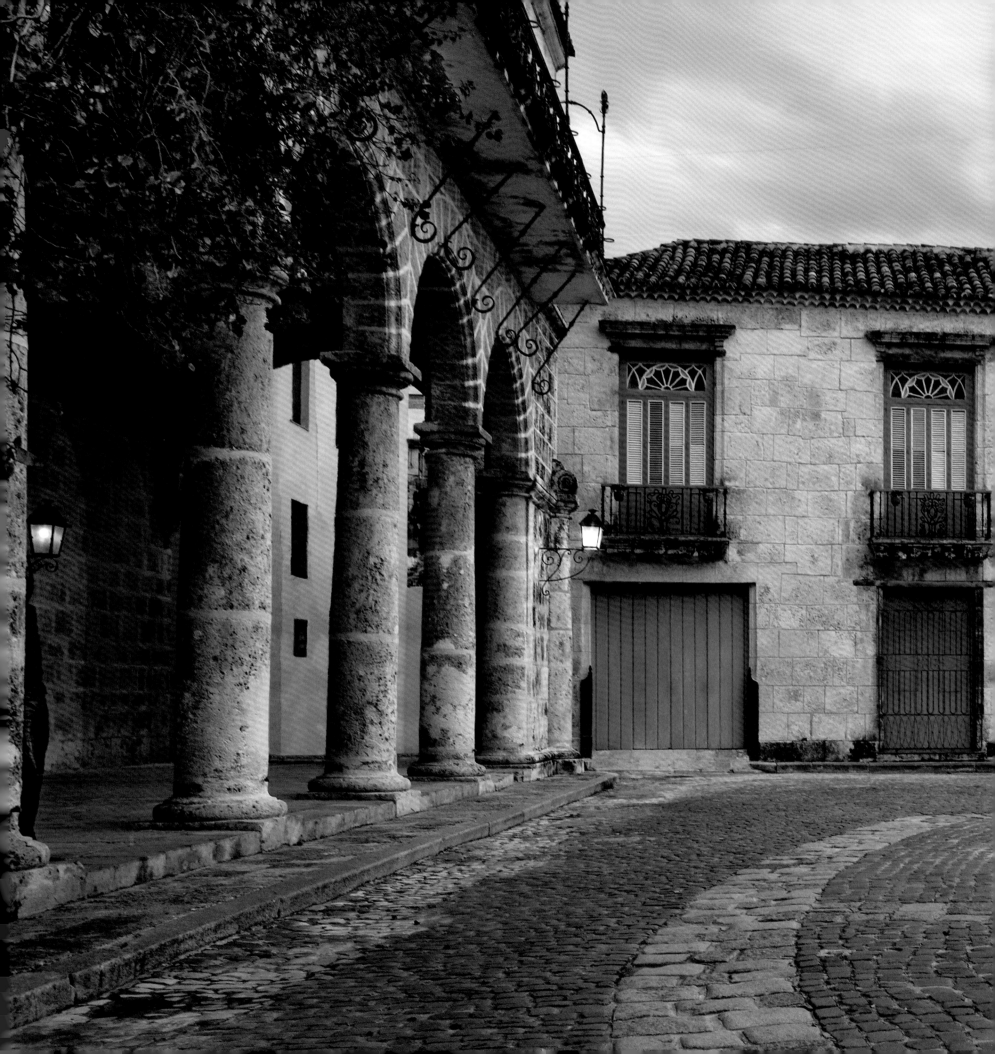

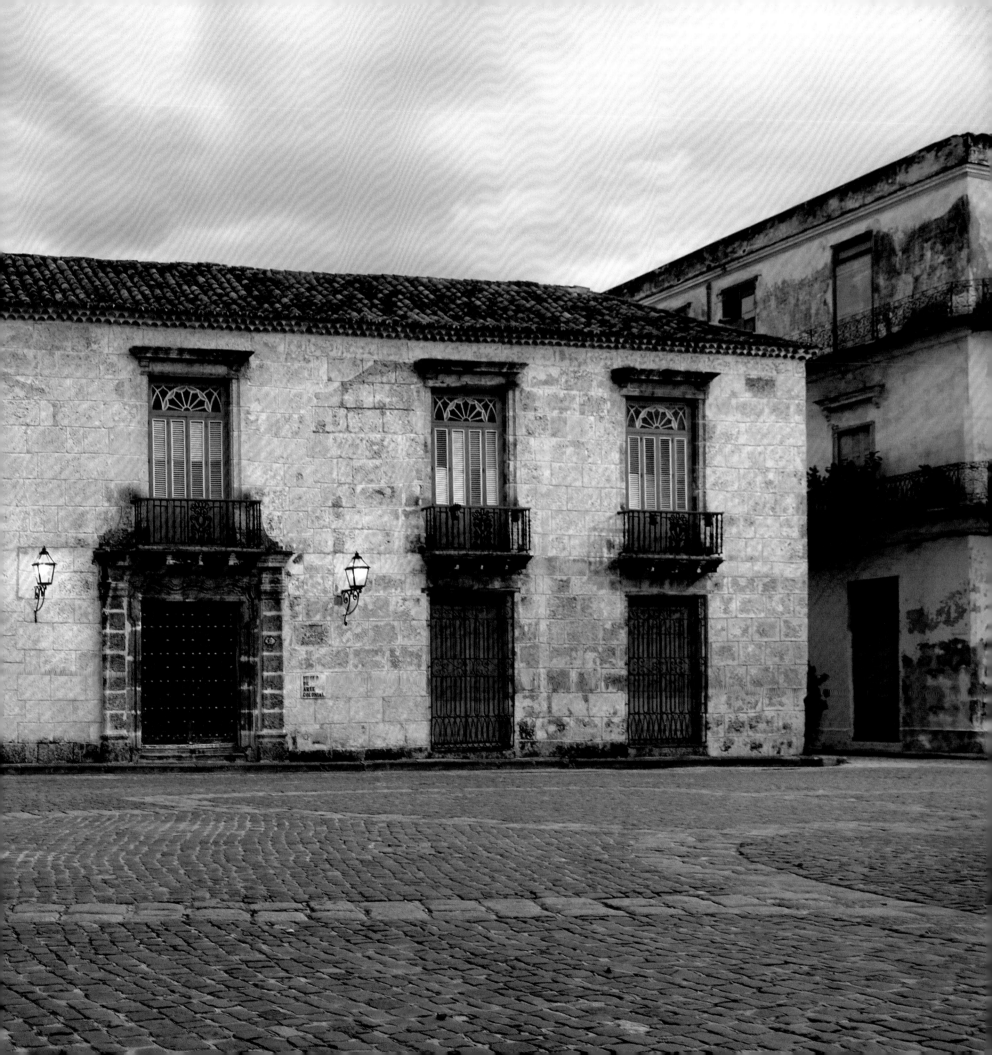

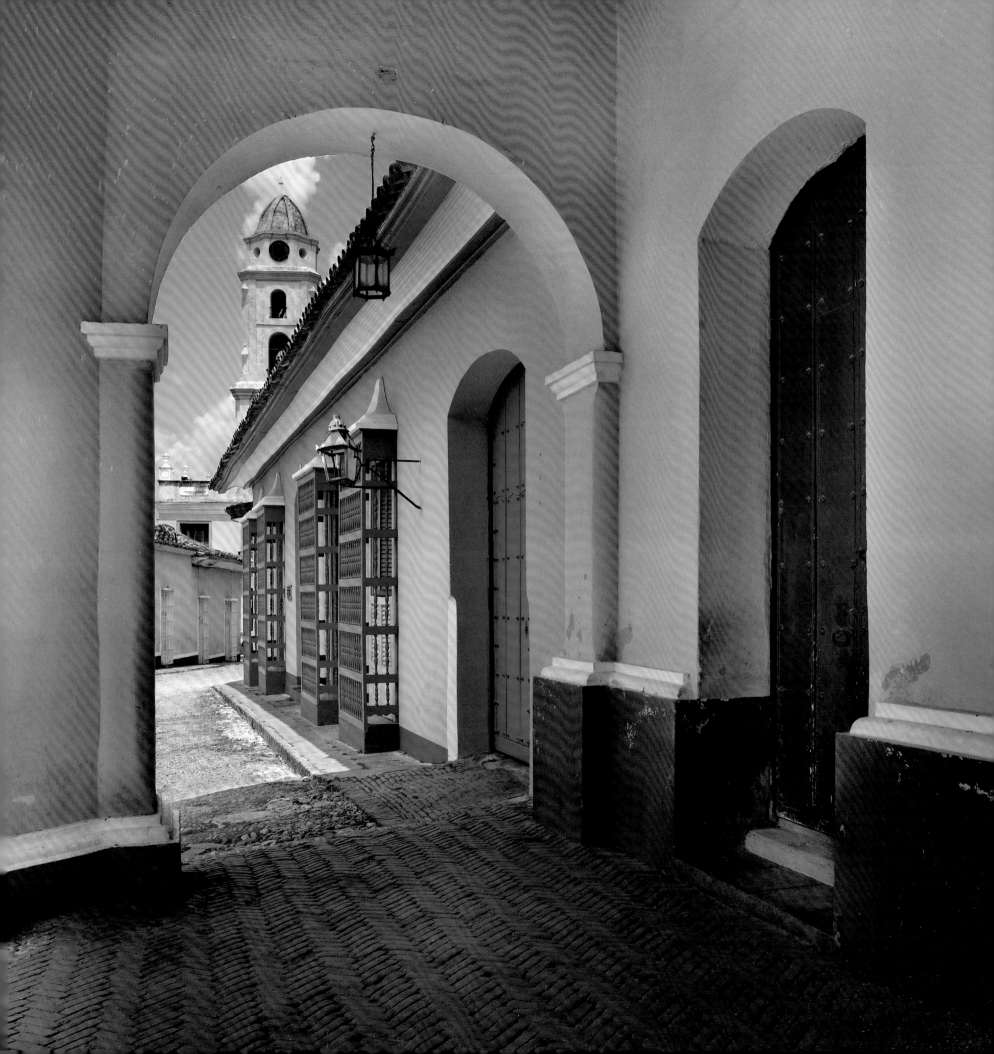

Previous spread
*The seventeenth-century façade
of Casa del Conde de Casa Bayona
in Havana.*

Opposite
*The historic town of Trinidad has
streets of river cobblestones (chinas
pelonas, or bald stones) and patterned
bricks. The tall windows of the
eighteenth-century houses have
window guards (barrotes) made of
small turned wooden columns.*

Right
*The hallway looks out through
wooden barottes, or grilles, into the
courtyard garden.*

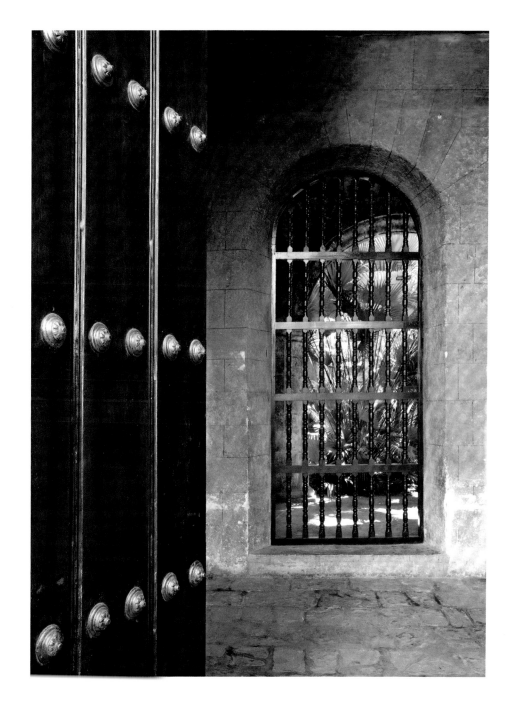

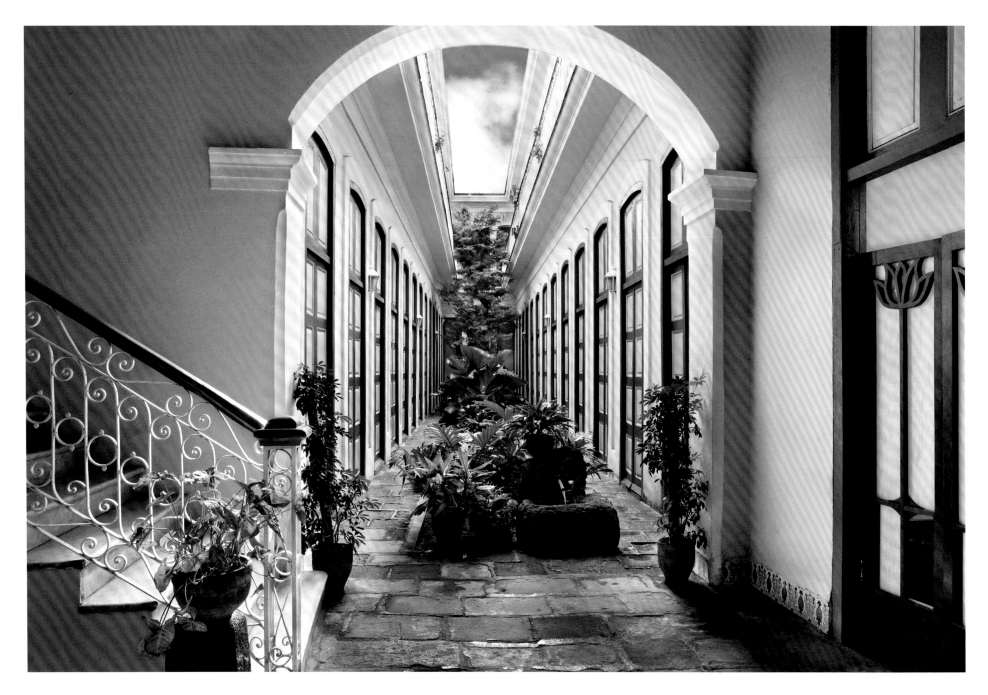

A house built between the end of the eighteenth and the beginning of the nineteenth centuries. The use of space ensures maximum ventilation.

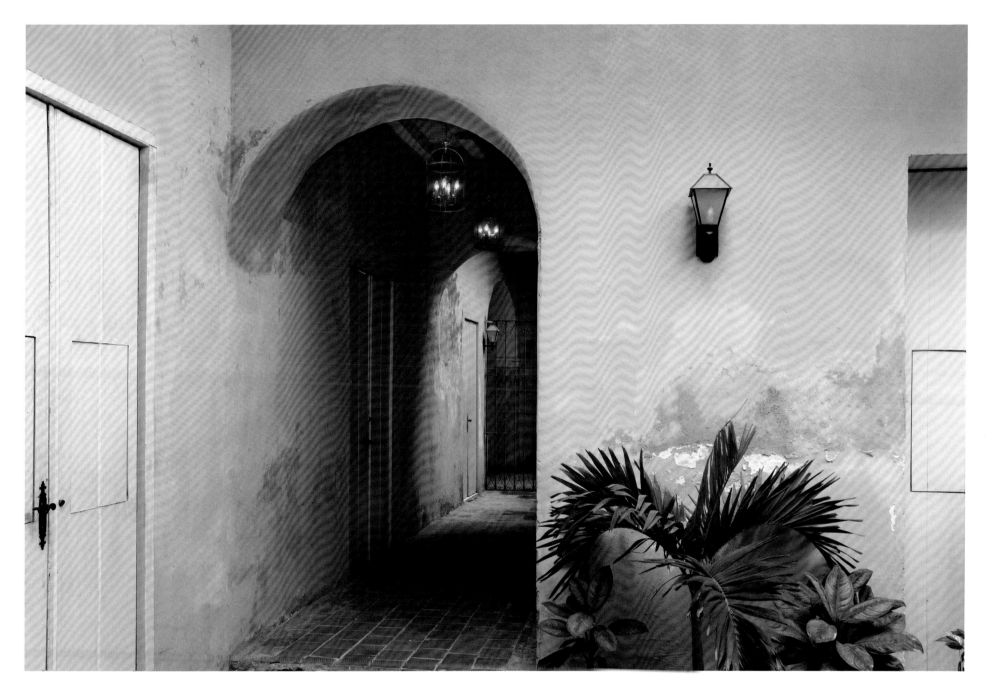

Above
A passageway between the front and rear patios. Notice the thickness of the walls that help insulate the house.

Left
A tinajone, or ceramic urn, which has been used in Cuba since the early 1700s to collect rainwater.

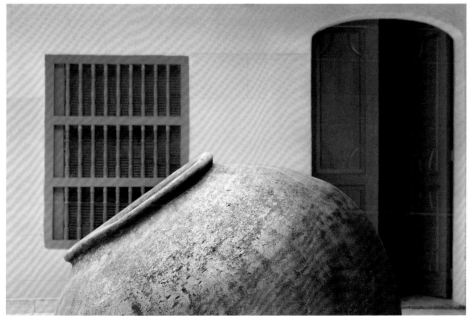

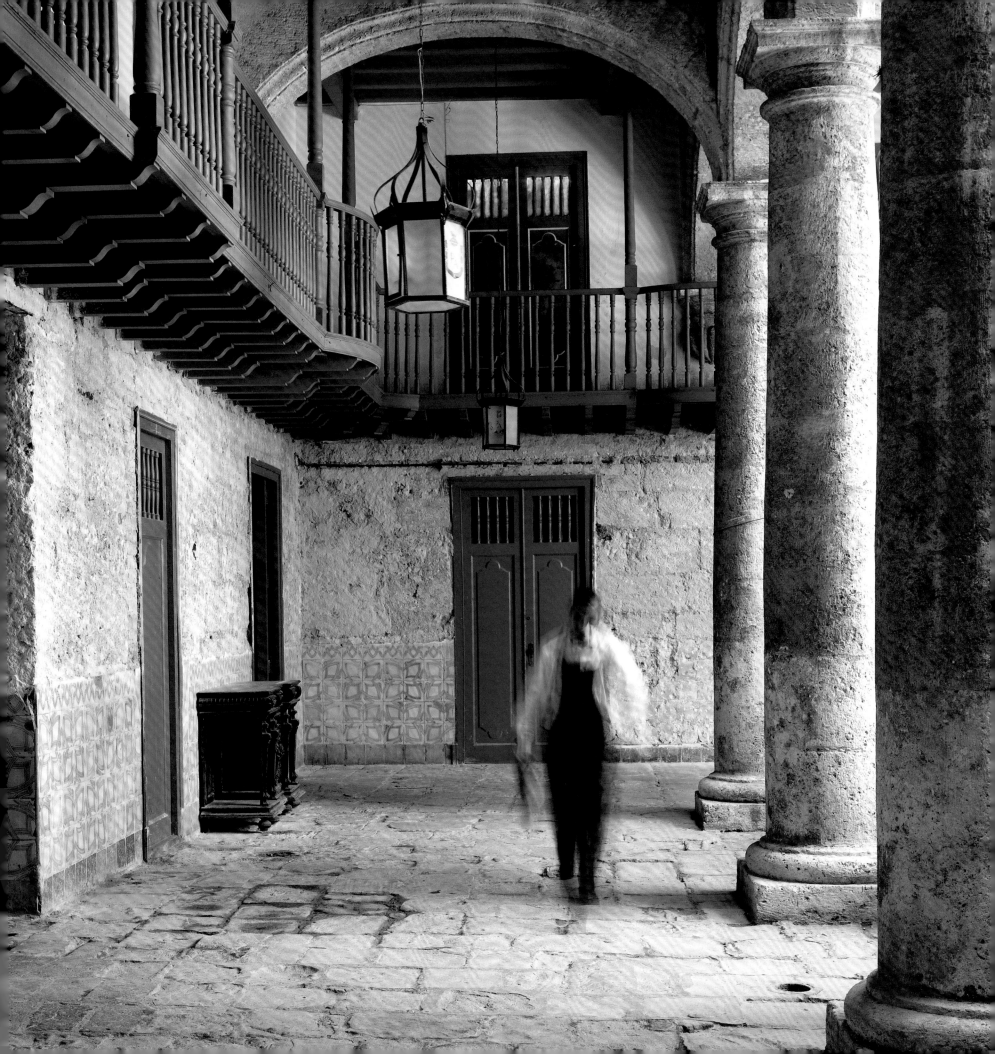

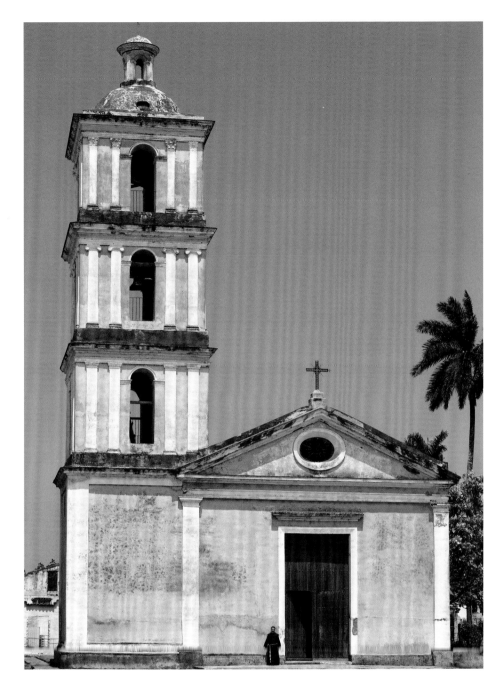

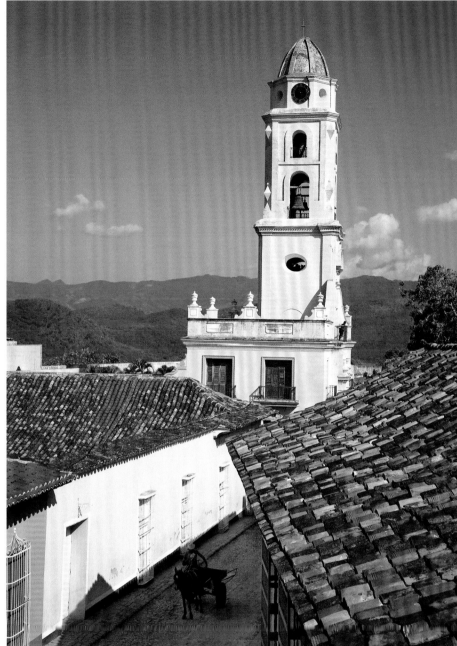

Above left
*An early colonial church in Remedios,
a town founded in 1514.*

Above right
*Trinidad's Church of San Francisco
de Asis bell tower, built in 1730, with
the Escambray Mountains in the
background.*

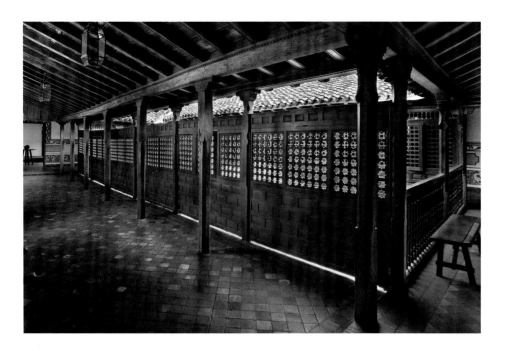

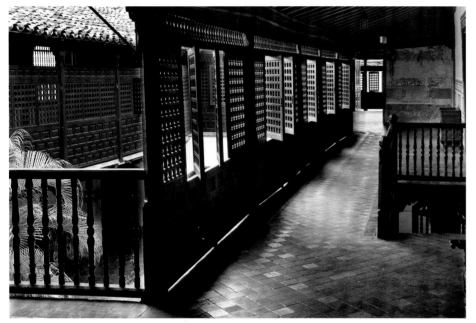

Above
*The second floor enclosed gallery
with architectural elements of Moorish
Spain or Mudéjar-style lattice screens
(celosias) that provide shade, light,
and air-flow.*

Below
*The gallery's screen panels are
designed to pivot for more light and
air circulation.*

Opposite
*The façade of Casa de Velázquez built
in 1515 by Spanish conquistador Don
Diego Velázquez in Santiago de Cuba.*

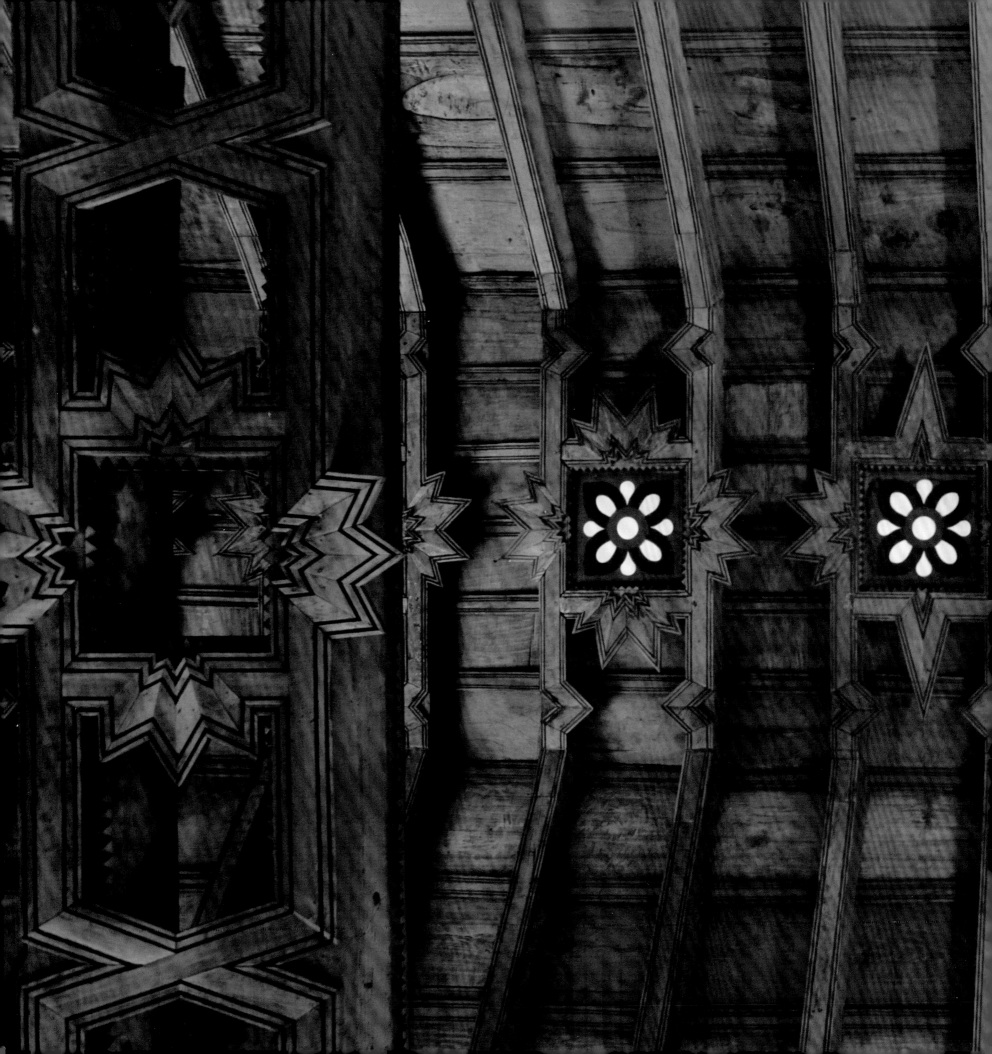

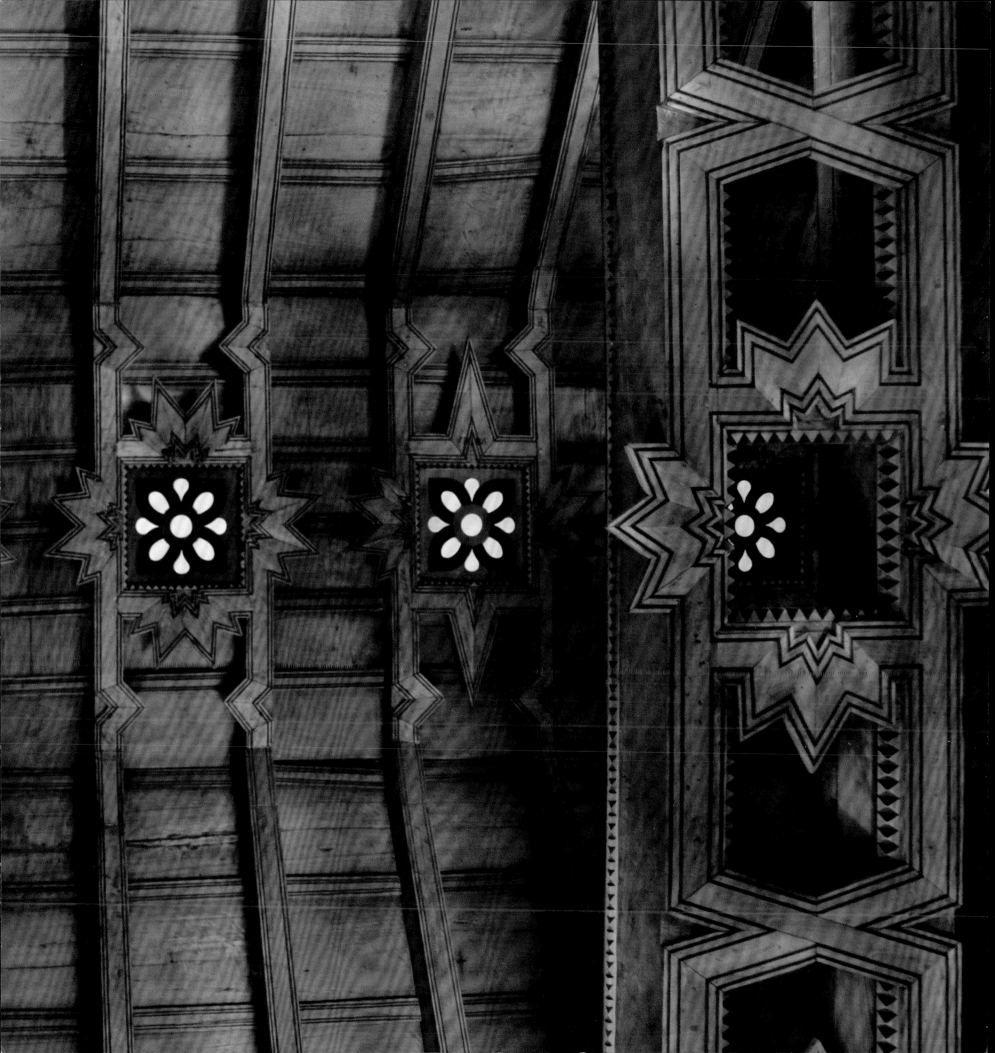

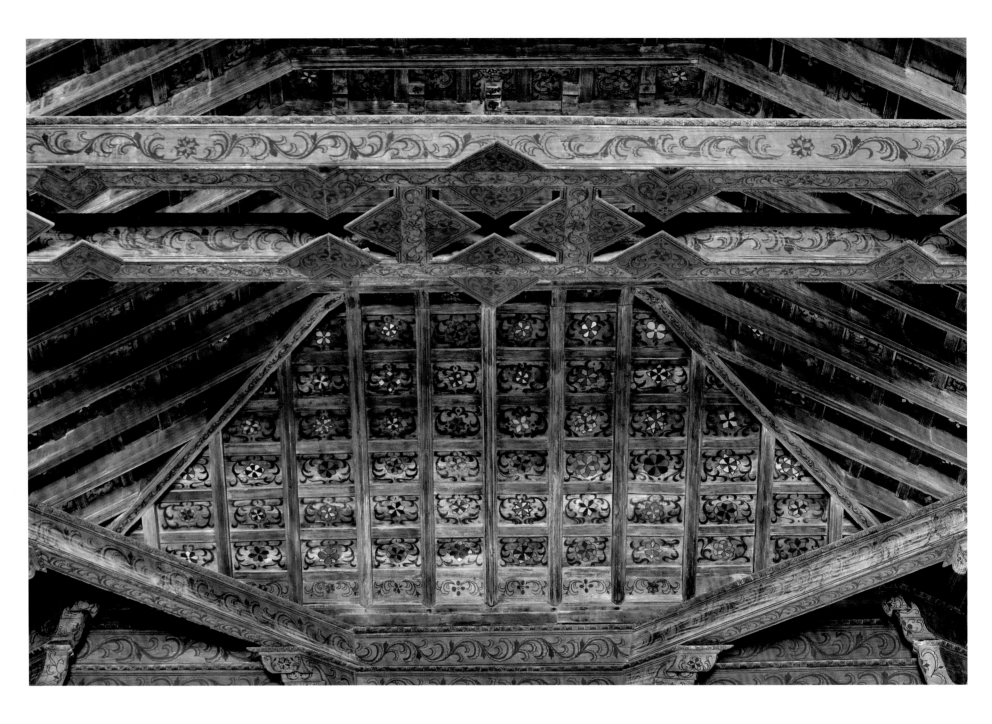

Previous spread
The Moorish Spanish (Mudéjar)
ceiling (alfarje) *of Casa de Velázquez
incorporates horizontal and inclining
beams, a roofing method called* par
y nudillo. *Star patterns signified the
magnitude of the universe.*

Opposite
Another example of a ceiling (alfarje)
*constructed of island cedar in the
Mudéjar style in Remedios. The black
detailing design was executed with a
mixture of water, charcoal, and rabbit
skin glue.*

Right top and bottom
*Interior ceiling details of Mudéjar
craftsmanship in the ornamental
designs of the cross-beams* (tirantes)
*in the seventeenth-century Casa del
Conde de Bayona.*

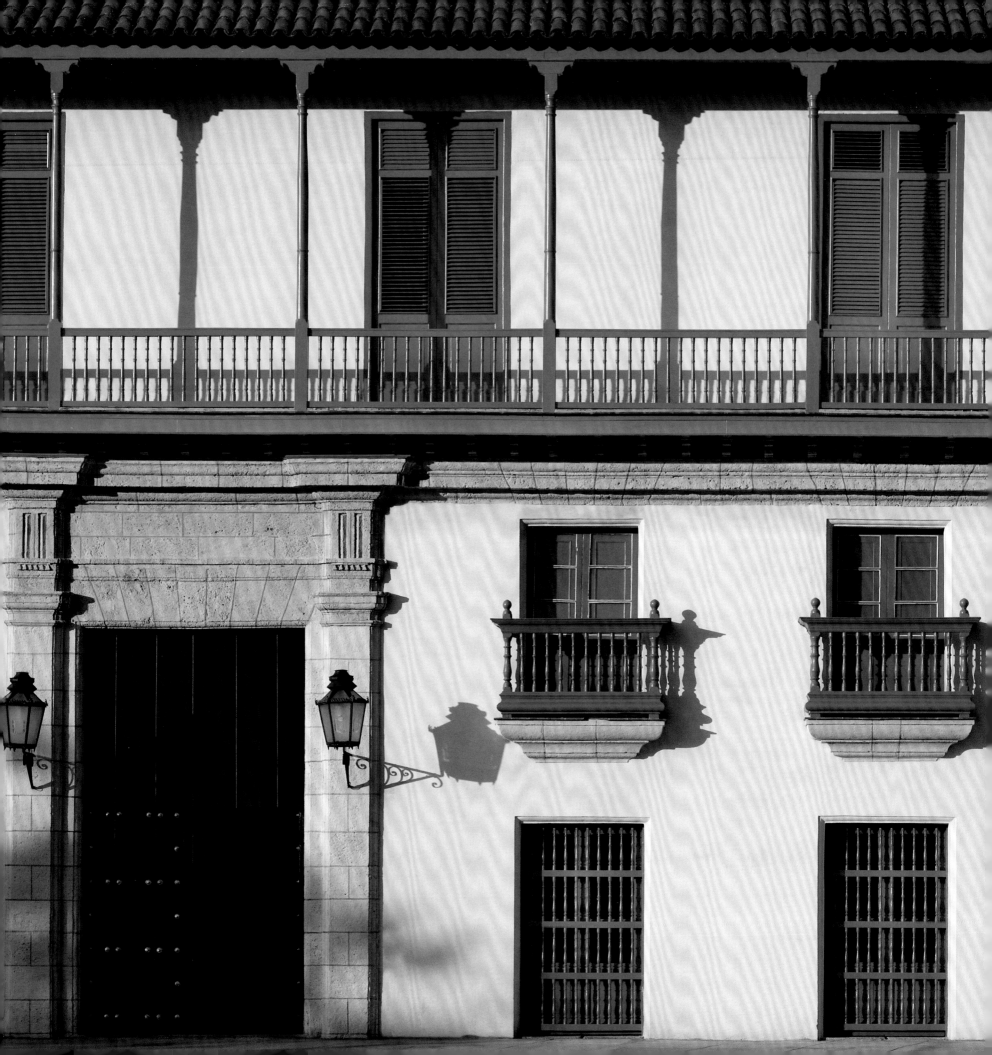

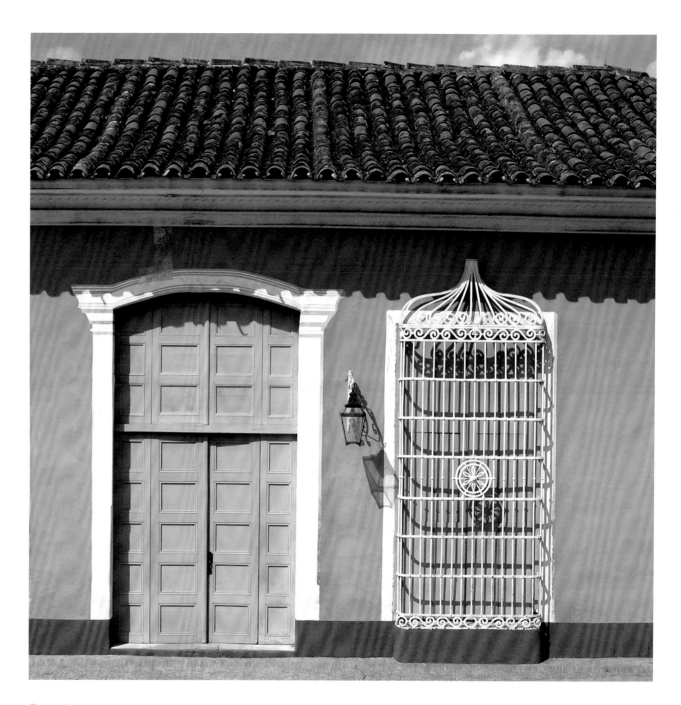

Opposite
*The façade of Casa de Mateo Pedroso
built in 1780 in Havana.*

Above
*Entrance to one of the many early
colonial houses found throughout
Cuba.*

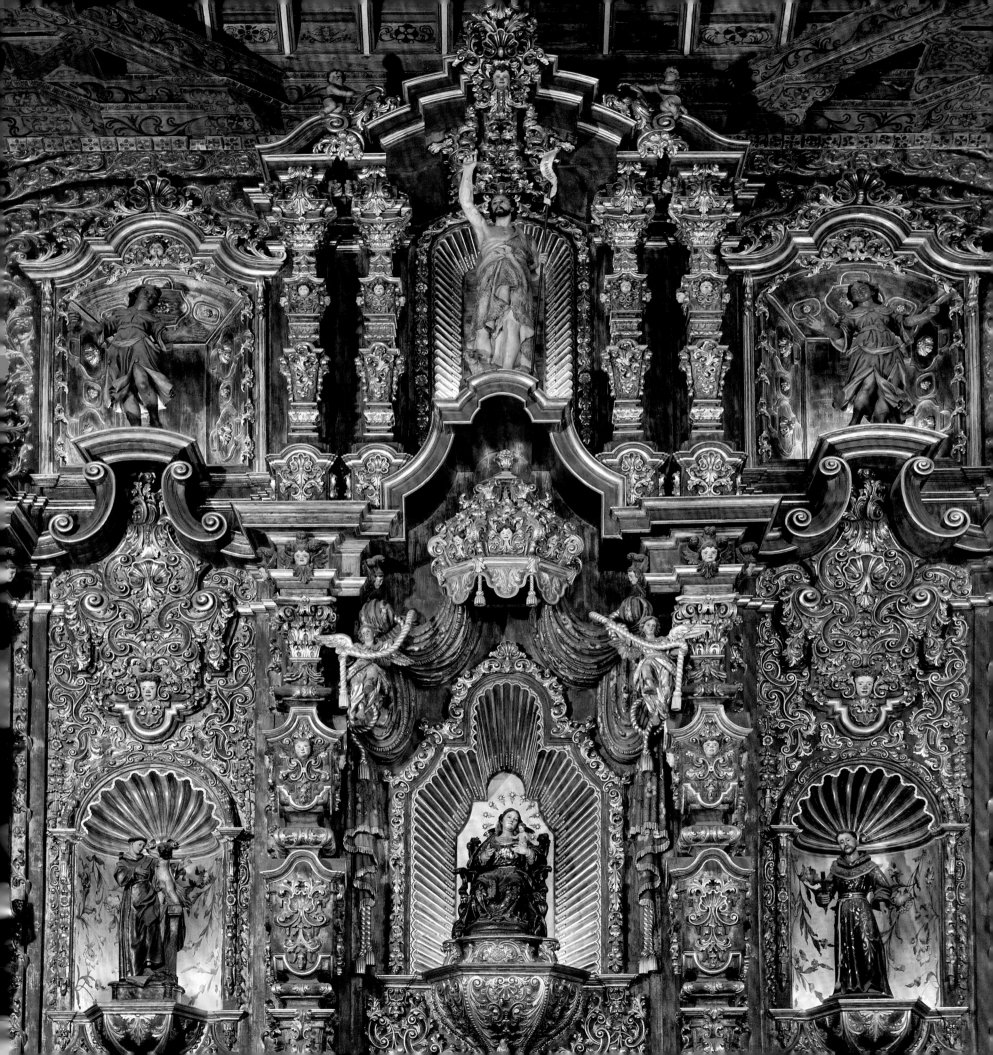

Settlement and Colonization

With the advent of the seventeenth century, an interpretation of Spain's aforementioned Plateresque style began to be applied to buildings and large residences constructed in Cuba's towns, particularly Havana. Many of these homes had ground floors devoted to a particular business or commerce. The second floor encompassed a residential area, with a low-ceilinged half-floor between occupied by enslaved servants. By midcentury Havana was officially Spain's New World capital and the first buildings in the Spanish baroque style were constructed, the majority of which were modified for the tropical sun and seasonal heavy rains and had high ceilings, covered verandas, patios, and heavily shuttered windows and doors. The greatest impact of the Spanish baroque style in Cuba is the island's ecclesiastical architecture, but that is not to say that the baroque did not flourish in the residential architecture as well.

By the end of the sixteenth century, Cuba's supply of gold was all but exhausted and the island oligarchy began to concentrate on the agricultural potential of the island. Exotic tropical hardwoods had been an extremely economically rewarding export trade for the earliest wood speculators (logwood cutters) and explorers, and when the first settlements were established more of the coastal virgin forests were harvested.

It was in these coastal forests that Cuban mahogany (*Swietenia mahagoni*) was discovered and eventually became the world's wood of choice for architectural fittings,

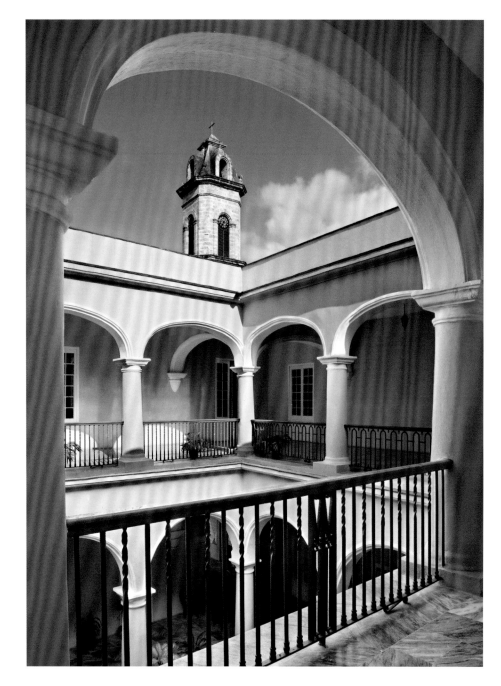

use of Cuban mahogany was to build the library and monastery choir in El Escorial, a royal palace and monastery constructed between 1563 and 1584 in the foothills of the Guadarrama Mountains outside Madrid. Other Cuban woods, including ebony and ironwood, were used as well.

Aside from mahogany, similar exotic woods such as sabica (*Lysiloma sabicu*); ausubo (*Manilkara bidentata*), often referred to as bulletwood; satinwood (*Zanthoxylum flavum*); cedar (*Cedrela odorata*); and jacaranda (*Jacaranda mimosifolia*) were exported as precious cabinetry woods.

Besides the export of island hardwoods the tobacco plantations began to prosper, and the export of the native leaf brought additional wealth to the island.

The tobacco plant (*Nicotiana tabacum*) was indigenous to Cuba, where its leaves were smoked by Amerindians. Columbus observed and wrote in his journal:

These envoys met a great number of Indians, both men and women, who were holding a small piece of smoldering tinder with which to light certain herbs with which they perfume themselves following their custom.[15]

Tobacco was the first cash crop chosen by Spanish colonists in Cuba. In 1571 tobacco was declared a medicament in Spain, and during the seventeenth century it was used only for medicinal purposes throughout Europe.

Cuban tobacco imported into Spain was subject to high customs duty and its cultivation was declared a gift of the crown. Havana, where it was said, "Nothing is more important than tobacco," became the capital of the production and dispatch of tobacco for the entire Spanish empire.

On 20 October [1614] Phillip III signed the first decree organizing the tobacco trade in Cuba, that of Cuba especially

Opening spread
An example of the thousands of more modest Cuban residences. During warmer days doors are opened and the wrought-iron grilles are kept closed for security.

Previous spread
Detail of the lavish Churrigueresque-*style altar carved from cedar and encrusted with gold leaf of Remedios's Cathedral San Juan Bautista, one of the most important churches in Cuba.*

Above
Typical of Cuba's elegant and monumental colonial mansions were enclosed courtyards that helped facilitate airflow throughout the houses.

because it was already recognized as the best in the world.[16]

By the mid-seventeenth century, the taking of snuff, made of pulverized tobacco, became fashionable and was one of both Europe's and the New World's most sought after and desired luxuries.

A practice that became popular among ladies during the seventeenth century was the use of snuff. This odd ritual continued into the next century and was considered elegant in elite circles of colonial society. The snuffbox was de rigueur for both men and women as a stylish way to carry a day's ration of tobacco … it was common to see ladies opening their little boxes and taking a pinch of snuff that they inhaled. When the inevitable sneeze seemed imminent, they would politely cover their noses with ornately embroidered handkerchiefs.[17]

During the last half of the 1700s Cuba exported an annual average of one thousand tons of tobacco to Spain, and by the 1800s production reached the three-thousand-ton mark.

Spain's demand for tobacco eventually coincided with the popularity of coffee. The coffee plant (*Coffea arabica*) was probably introduced into Spain during the seventeenth century, but no precise date has been definitively established.

A variety of coffee known as "Hope of Asabiaca" was apparently brought to Cuba in 1748 by a Havana municipal official named José Gelabert.[18]

Gelabert's hacienda was named La Aurora, and he purportedly brought the cultivable coffee seeds from Haiti. Cuban coffee plantations (*cafetales*) sprang up in the foothills of the Sierra Maestra as coffee could be planted in the mountainous regions of the island, although sugar could not, around Guantanamo in the eastern end of the island, and in the Pinar del Río area in the west. By the nineteenth century there were more than two thousand coffee plantations on the island exporting as much as twenty thousand tons total per year.

Due to tobacco, coffee, cotton, and sugar, agricultural production began to expand and produce a great deal of wealth. With this newfound agricultural affluence came the construction of larger, more luxurious homes.

Sugar, also referred to as "white gold," was a commodity of wealth and the "economic miracle" that brought untold riches to Cuba during the eighteenth and nineteenth centuries. Sugarcane (*Saccharum officinarum*) was first domesticated in New Guinea and brought to India, where its healing properties were recorded around 300 BC. The Indian sugarcane species reached Persia by the seventh century and Arabs introduced it to the eastern Mediterranean a century later. The Crusaders eventually introduced sugar to Europe, and by the fifteenth century it began to be cultivated in Madeira and the Canary, Cape Verde, and Azores islands, off the coasts of the Iberian Peninsula.

At first sugar was an aristocratic luxury, prohibitively expensive and consumed only by royal courts and wealthier Europeans. By the time Columbus discovered the West Indies, the cost of sugar had dropped and it began to percolate downward to the middle classes and became part of many Europeans' diets.

Columbus brought the first sugar plantings to the Spanish Caribbean on his second Caribbean voyage; its cultivation began in earnest on Cuba's neighboring island Hispaniola in the early sixteenth century, where both settlers and sugar technology emigrated from the Canary Islands.

Spain's pioneering New World sugarcane cultivation arrived in Cuba, where the island proved ideal for its proliferation during the seventeenth century. Because of the island's large landmass, fertile soil, and natural harbors, Cuba began to

prosper from the export of the "sweet white gold" and its by-products. Although the island's sugar production lagged behind the French colony in Saint Domingue (Haiti) and the English in Jamaica, estimated Cuban sugar production was half a million *arrobas* (5,500 tons) by the mid-eighteenth century.

The first large-scale sugar plantation—with three sugar mills under construction in the area of Matanzas—was established in Cuba in 1576. These primitive mills with wooden rollers were powered by mules or oxen, and the juice was caught in earthenware traps. … These simple methods of production continued throughout the seventeenth century.[19]

Cuba's sugar industry did not extensively prevail for nearly a century; however by the 1700s, with the popularity of teahouses, coffeehouses, and chocolate parlors throughout Europe, sugar did eventually become the most important and valuable agricultural commodity on the island.

Unfortunately, the production of sugar became inseparable from the exploitation of West African enslaved labor. Sugar cultivation in the Canary Islands and Madeira brought the institution of slavery into the Atlantic, and it is thought that the first enslaved Africans to work the sugar plantations in Cuba came from the Canaries or Iberia.

It wasn't long before Spanish colonialists realized that the long-term and true wealth of Cuba lay not in gold but in sugar, *oro dulce* or "sweet gold," and began to import enslaved West Africans by the tens of thousands to labor on the sugar plantations.

The success of Cuba's colonial agricultural systems of tobacco, sugar, and coffee, together with the extensive development of the necessary towns that were to grow into cities and houses that would become country mansions, depended on slave labor. Newly arrived enslaved African workers were referred to as "black ivory" or "black gold" and were the indispensable basis of the island's colonial economy.

Spain's King Ferdinand was succeeded by Charles I, who granted licenses to supply enslaved Africans to the Caribbean. These concessions-of-monopoly contracts (*asientos*) were a tax-free license that allowed the importation of African slaves into the Spanish New World. In addition, to avoid Spanish taxes Cuban planters and mercantilists relied on French, English, and Dutch slave traders to smuggle an unrecorded number of slaves to the island throughout the centuries.

Although the Spanish were the only Caribbean colonial power that was not directly involved in the Atlantic slave trade—in that they didn't have a garrison slave fort or fortified settlement on Africa's west coast—the Spanish government saw to it that tens of thousands of slaves were brought to the islands to work in the gold and silver mines, the haciendas, *palacios*, and tobacco and sugar plantations of the empire.

The Spanish took no direct part in the African end of the trade during this period, but their American possessions were the ultimate destination of perhaps one-fifth of all slaves that reached the New World in the late seventeenth century. Fearing Protestant pollution of their Catholic realm and a breach of their monopolies on gold and silver, the Spanish forbade almost all trade between their settlers in America and other Europeans. Spanish settlers got their slaves by welcoming foreign ships to their ports in violation of royal commands, by going to Jamaica, Curaçao, and other places to trade, and by taking advantage of a major legal concession called the asiento, *in which a Spanish or foreign merchant combine received, in return for a large advance on the duties it would owe and other contributions to the Spanish crown, a near monopoly on the legal delivery of slaves to Spanish American ports.*[20]

Throughout the seventeenth and eighteenth centuries, as the Spanish government continued to award *asientos*, Cuba's slave trade became one of the island's largest commercial enterprises. It was no secret, held no moral stigma, and involved no shame for the Cuban slave merchants as they made fortunes. As was recorded in 1685:

Everybody knows that the slave trade is the source of the wealth which the Spaniards wring out of the West Indies and that whoever knows how to furnish them slaves, will share their wealth.[21]

Cuba's economic development was once again purchased at a very high price in human bondage and suffering. Two centuries earlier with the enslavement and eventual extermination of the indigenous Amerindians, and now with the importation of enslaved West Africans, large profits were realized and the island's wealth continued to grow.

As tobacco and sugar production continued to expand and the importation of slaves increased, wealthier colonists built larger and more elaborate houses, filling them with the luxuries that were imported from Spain, the Far East, and other European countries. Two- and three-story *palacios* were designed and constructed around a central courtyard or patio. The mostly urban mansions had tile-roofed timber balconies and arcades on the ground and upper floors. An example would be the two-story house Casa de Antonio Hocés Carrillo; built in 1648, it epitomizes Havana's seventeenth-century stately homes.

Unlike on the French, Dutch, English, and Danish islands, the largest and most luxurious residences in Cuba were not on the sugar plantations (*ingenios*) or coffee plantations (*cafetales*). Cuba's landowning plantocracy preferred to reside in the cities or towns nearest their plantations, and their palatial residences and *palacios* became the plantation owners' showplaces and signatures of wealth.

Havana's two-story Casa del Conde de Bayona is one of the island's finest examples of seventeenth-century domestic architecture. Restored in the 1720s, the house has a central courtyard with side stairs and an *entresuelo* (a mezzanine with half-story proportions where servants lived). Casa de la Ohrapia also exemplifies a seventeenth-century aristocratic residence. Built in the late 1660s by Martin Calvo de la Puerta, it has the trilobate arches and other baroque decorative details popular during the period.

Historical records reveal that enslaved Africans and their descendants, together with the few indigenous Amerindians who were left, comprised the majority of the labor force that built the skillfully detailed stonework in Cuba's *palacios*, forts, churches, coffee and sugar plantation houses, and the sugar mills that accompanied them.

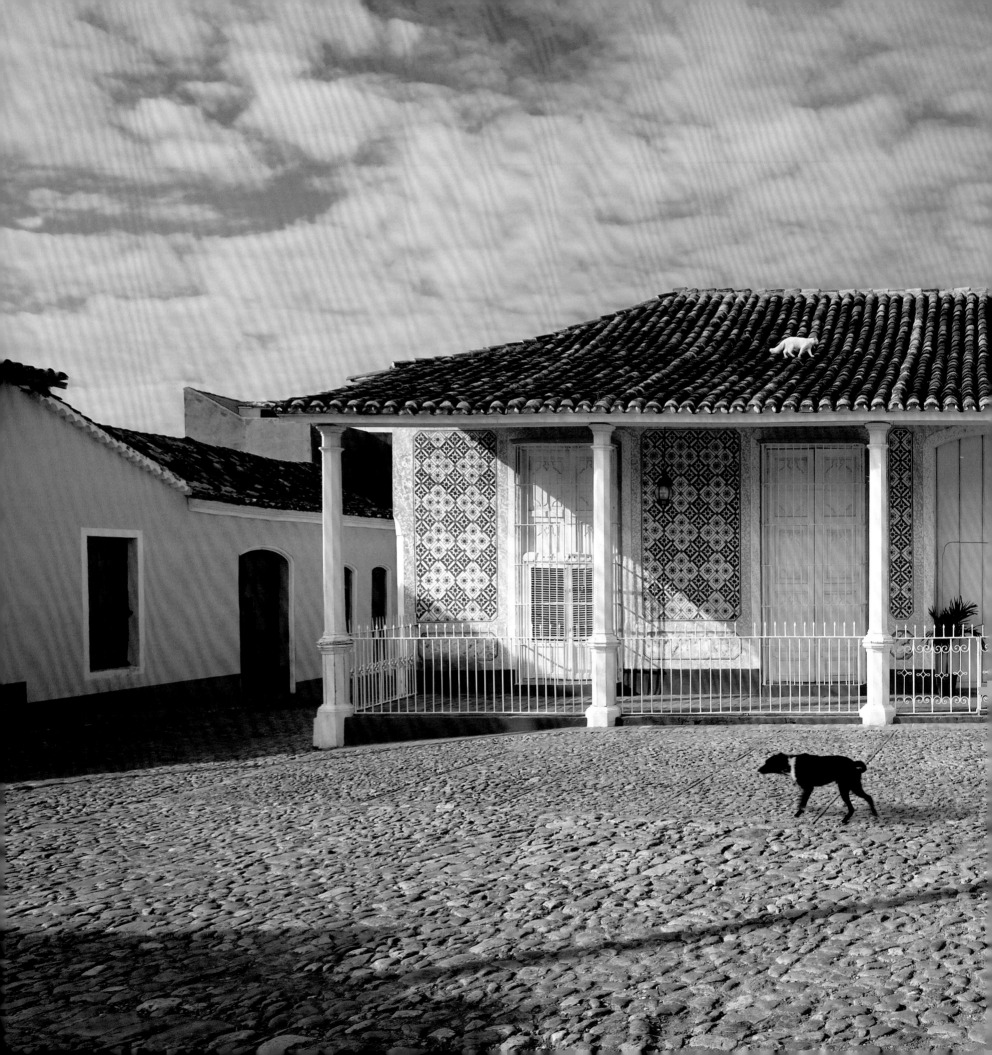

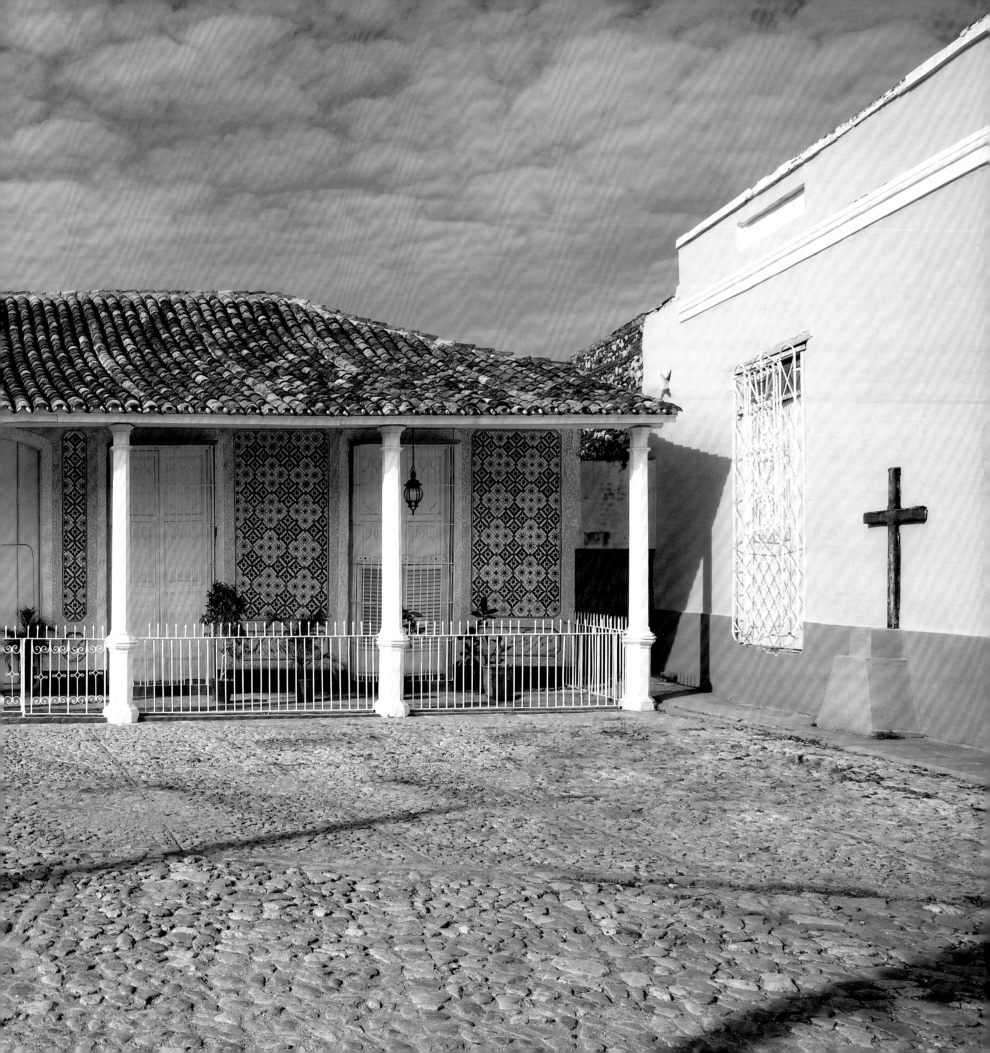

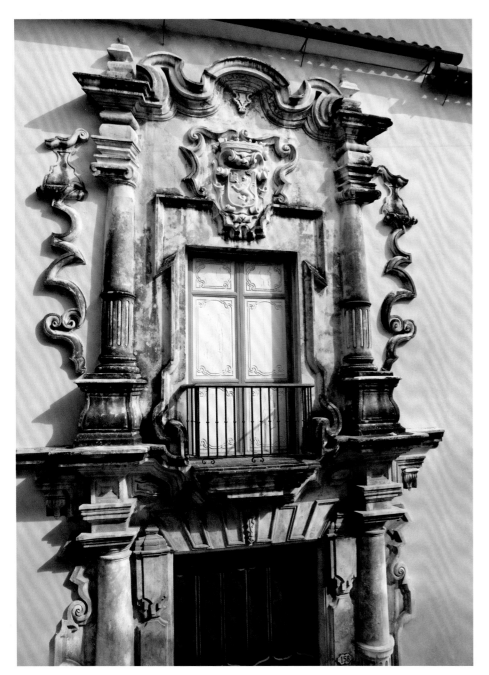

Previous spread
An eighteenth-century Trinidad residence. The portico was added in the early nineteenth century.

Left
The front doorway of the 1660s residence La Casa de la Obra Pía, one of the jewels of Cuban Baroque architecture. The stonework for the door was executed in Cádiz, Spain, in the late 1600s and shipped to Havana.

Opposite
The entryway and vestibule (zaguán) and its baroque mixtilinear arch of La Casa de la Obra Pía.

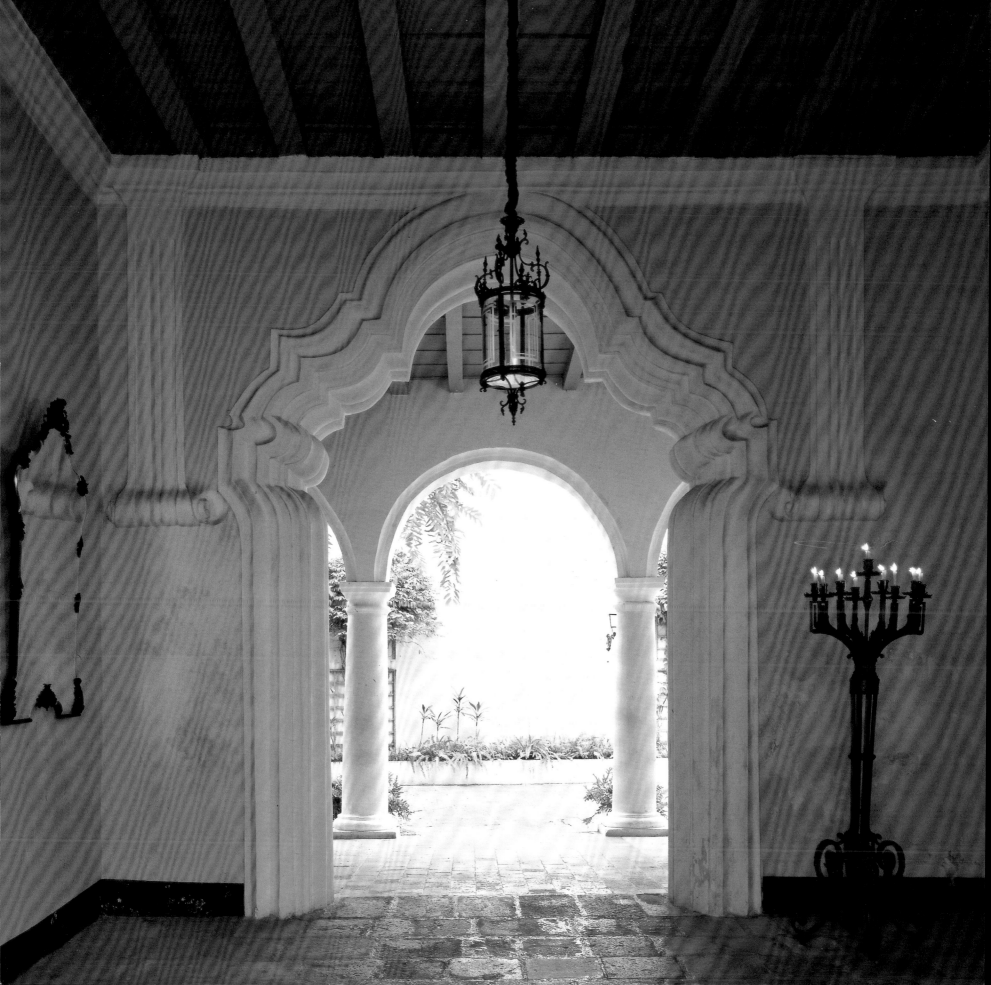

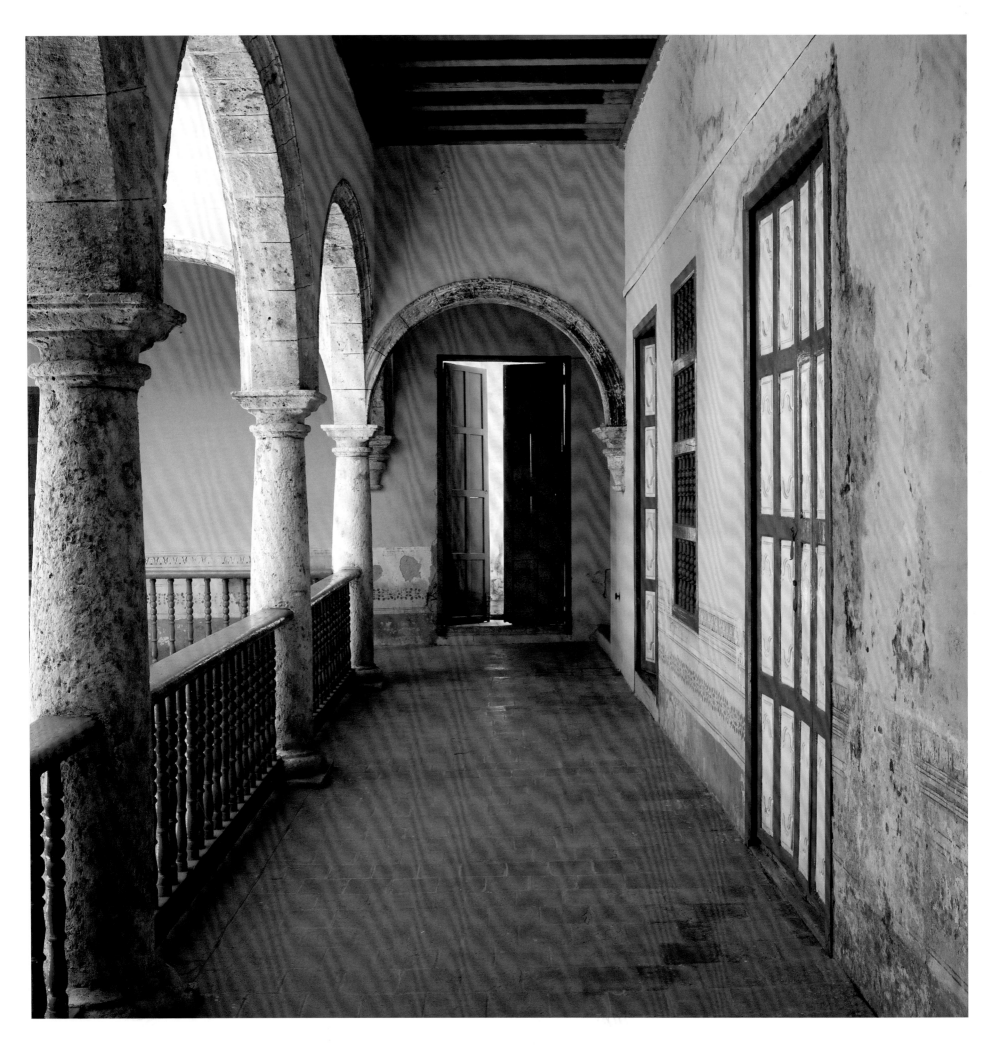

Opposite
The spacious second-floor gallery surrounds the interior courtyard of Casa del Conde de San Juan de Jaruco that was rebuilt from remnants of an earlier eighteenth-century house.

Right
The boldly proportioned marble staircase of Casa del Conde de San Juan de Jaruco built in 1737. The windows have turned mahogany spindles (rejas) for ventilating screens.

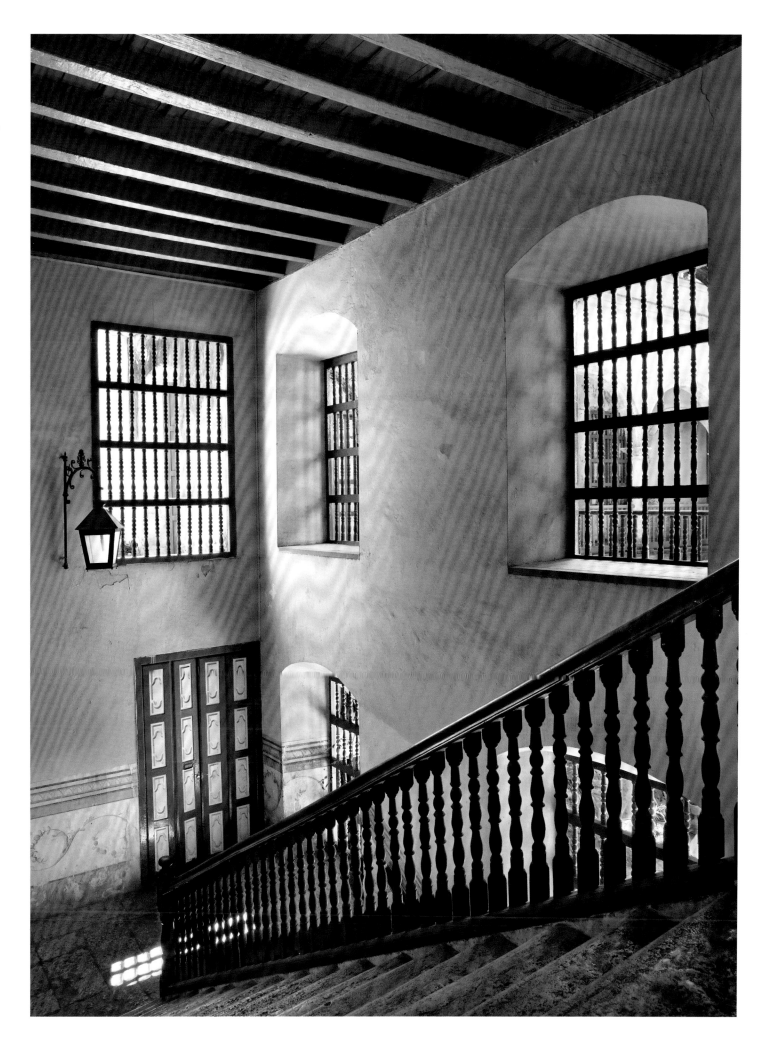

*Examples of Cuban residential
interior doorways showing curvilinear,
trilobed, and mixtilinear baroque arches.
These multicurved arches are indigenous
to the colonial architecture throughout
Cuba, especially in Camagüey.*

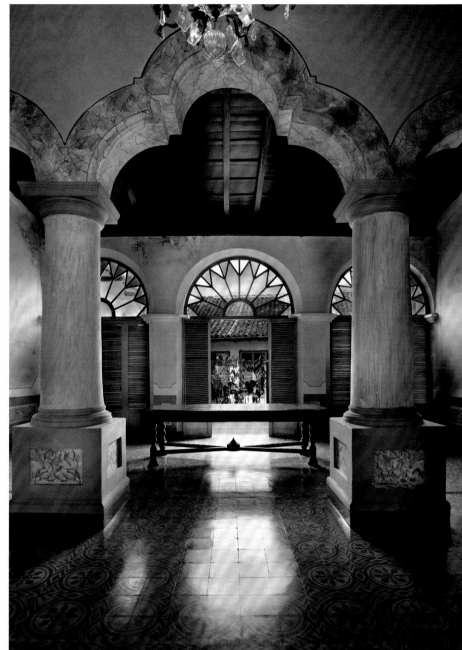

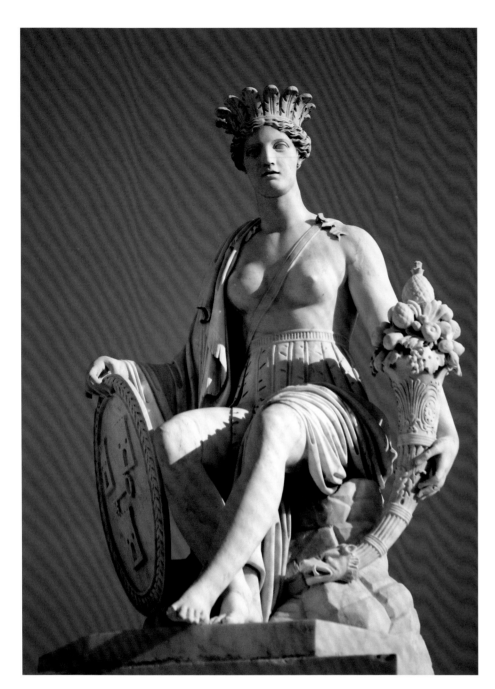

Left
An 1837 Carrara marble statue by Italian sculptor Giuseppe Gaggini of an Amerindian maiden holding a cornucopia and a shield bearing the arms of Havana. The statue is known as La Noble Habana *and has become a symbol of the city.*

Opposite
Early eighteenth-century galleries on three levels at San Francisco de Asis monastery.

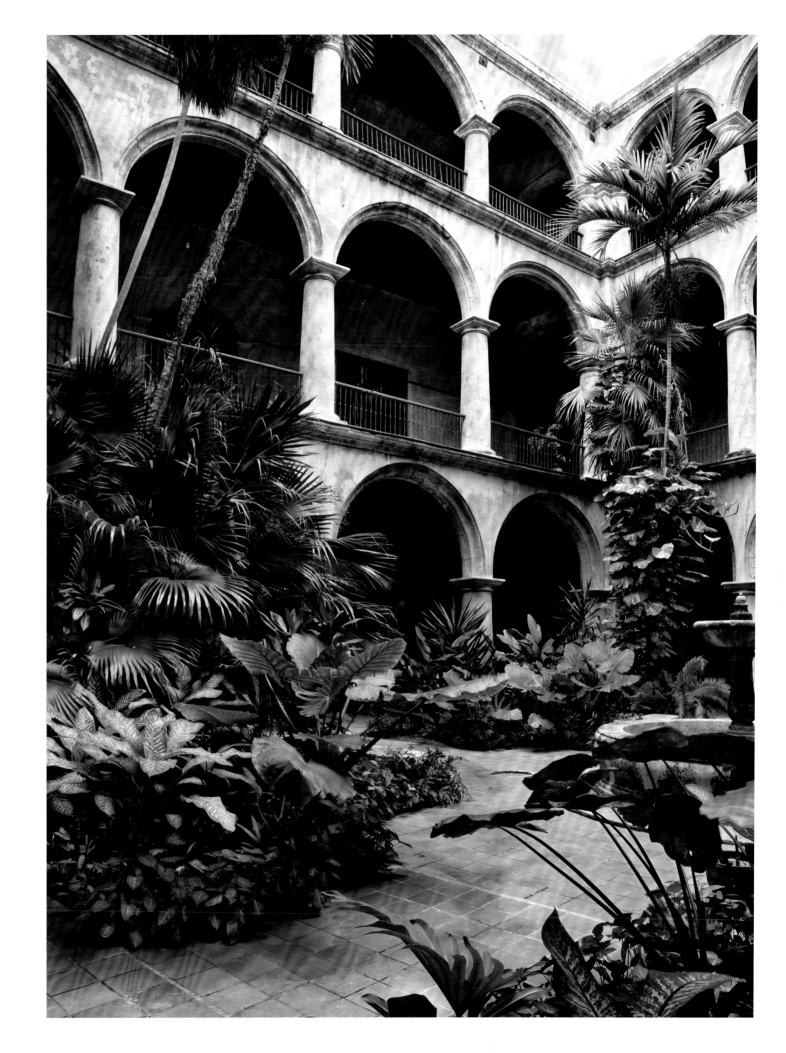

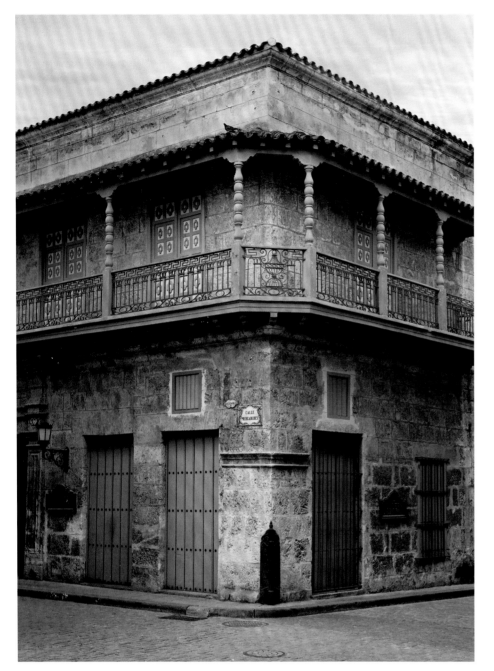

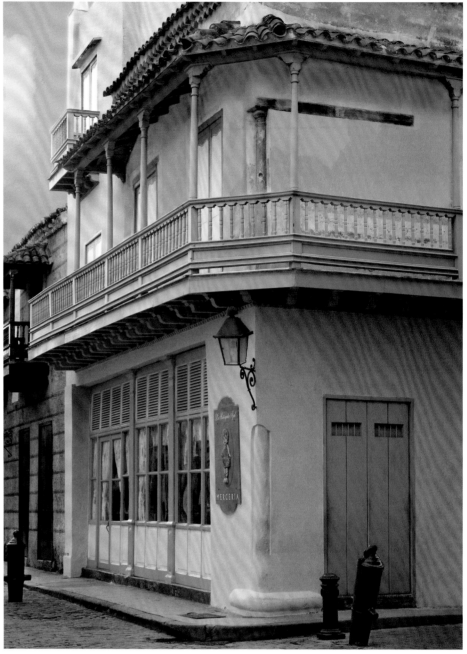

Above left
Casa de Franciso A. De Basabe built in 1728 in Havana.

Above right
Another early eighteenth-century two-story residence with a continuous balcony in Havana.

Opposite
The dining area, bedroom, and detail of the kitchen with its white-and-blue-patterned tiles on the colonial kitchen stove, all in an 1810 residence in Santa Clara.

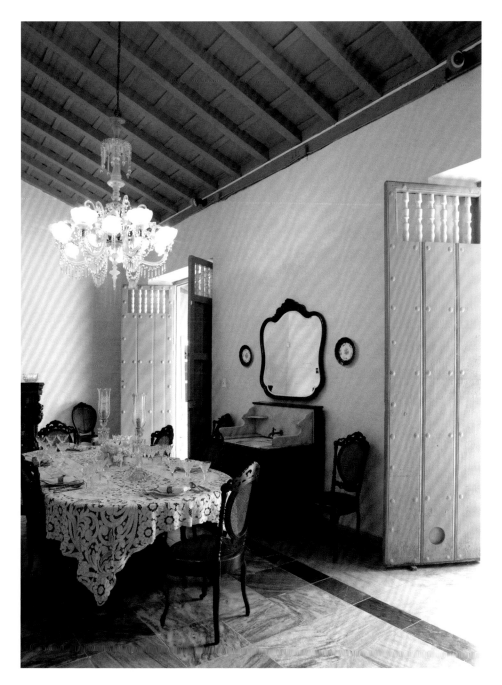
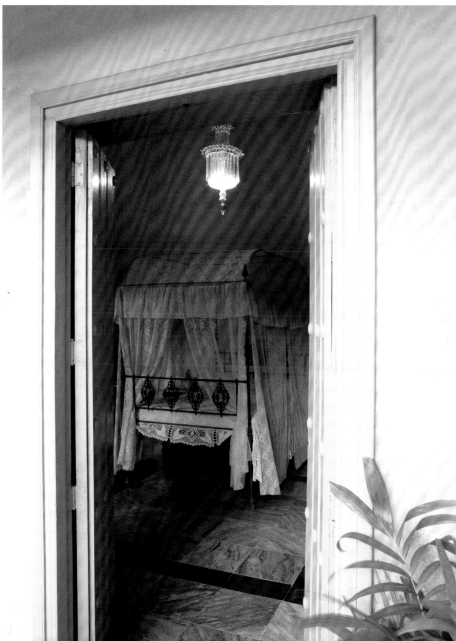
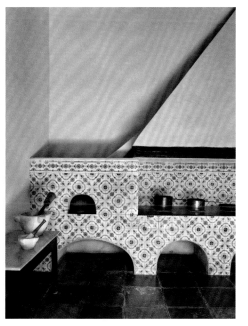

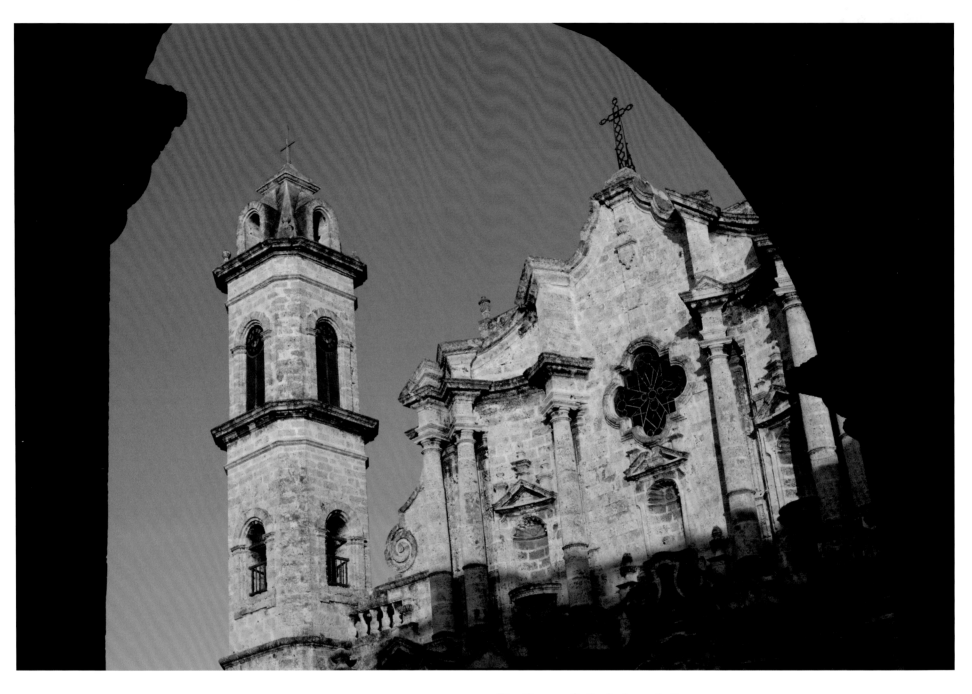

The Havana Cathedral was built in the mid-1700s. Its exuberant rhythmic, scrolled, and undulating façade make it the quintessential example of Cuban baroque.

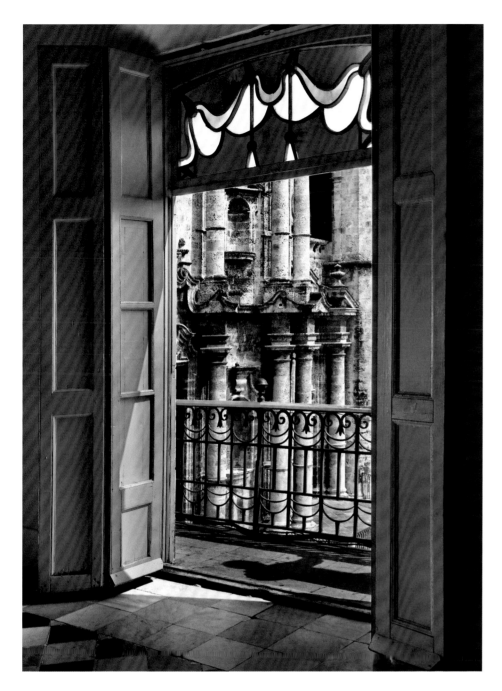

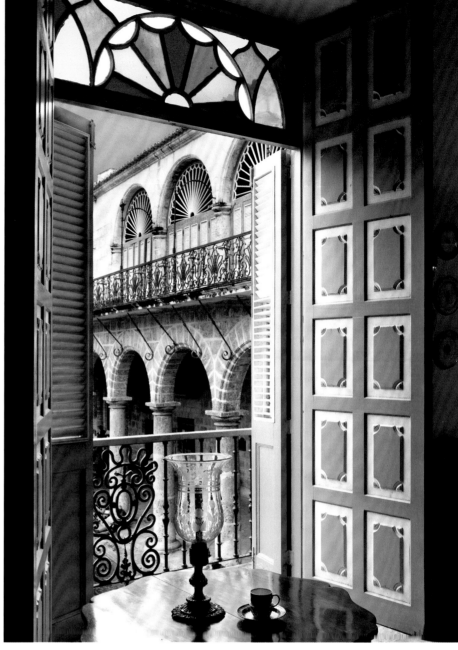

Above left
Looking out the second-floor balcony of Casa del Marqués de Aguas Claras toward the Plaza Catedral de la Havana. Notice the stained-glass window (mediopunto).

Above right
A view from the early eighteenth-century Casa del Conde de Casa Bayona on the Plaza de la Catedral.

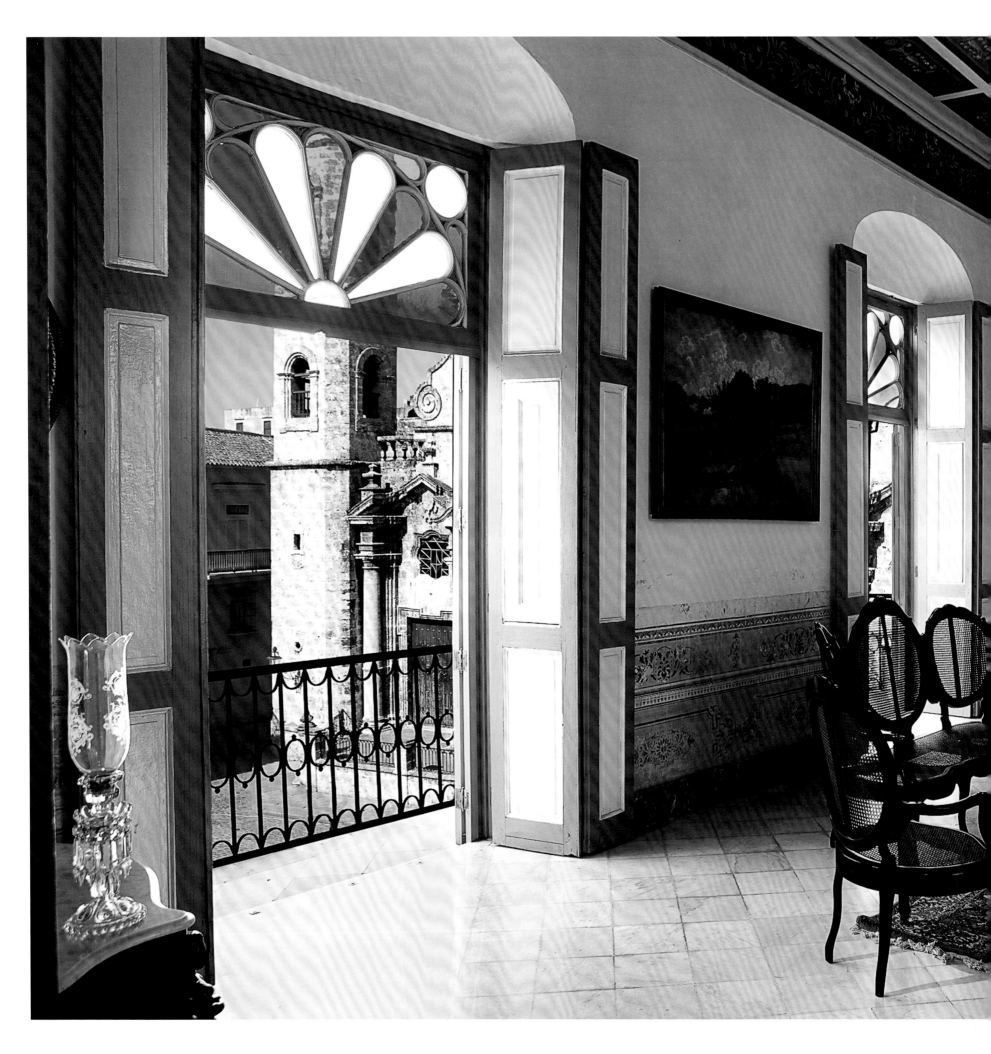

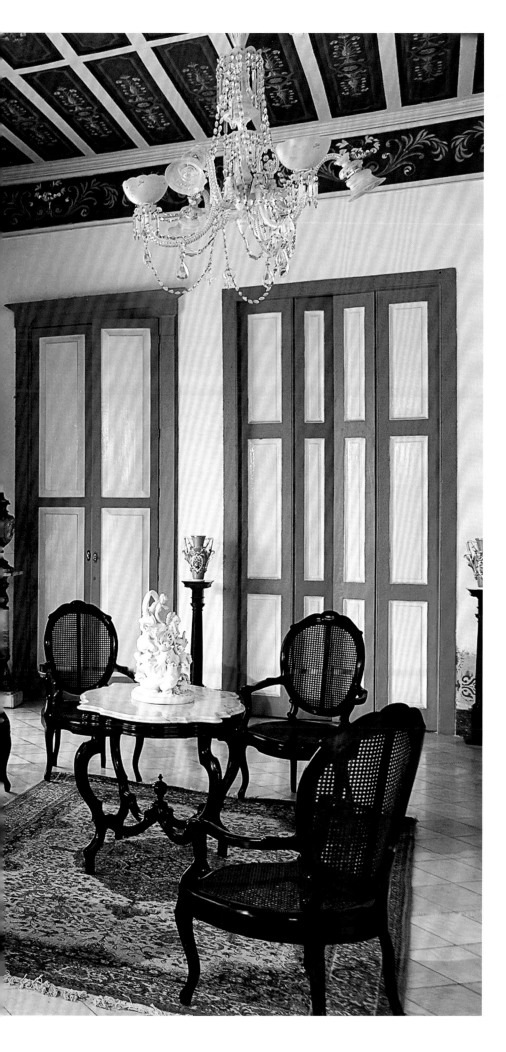

Two views from the eighteenth-century residence Casa del Conde de Casa Lombillo.

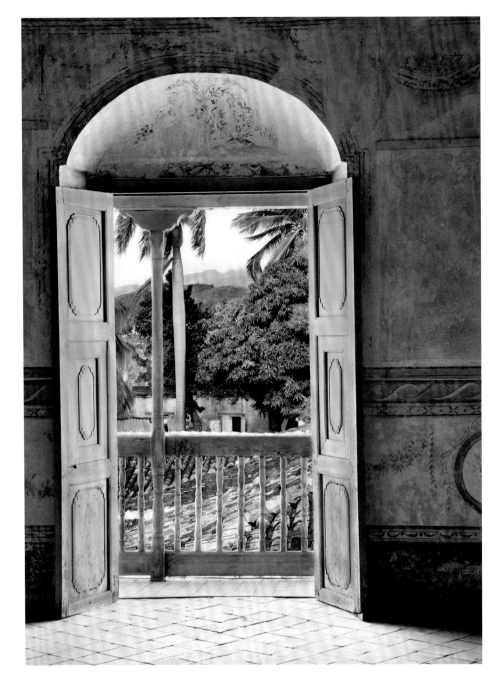

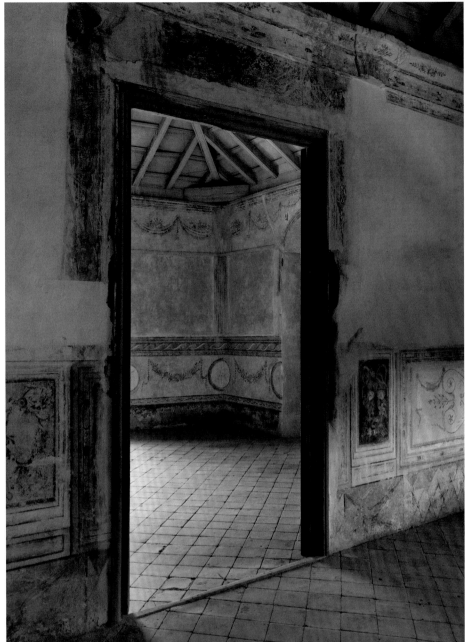

Above left
*Overlooking Trinidad's Plaza Mayor
from the colonial residence Casa
de Aldemán Ortiz with its delicate
skirting of wall frescoes.*

Above right
*Original hand-painted frescoes
adorning the walls of Casa de
Aldemán Ortiz.*

Opposite left
*Details of the interior hand-painted
murals in Trinidad.*

Opposite right
*An interior staircase with fading
"Cuba-blue" walls.*

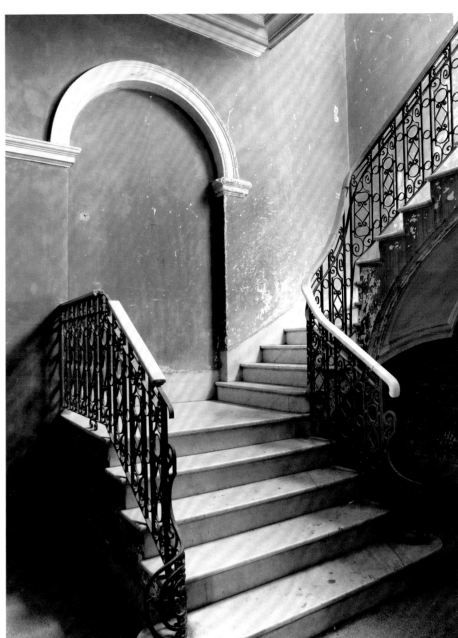

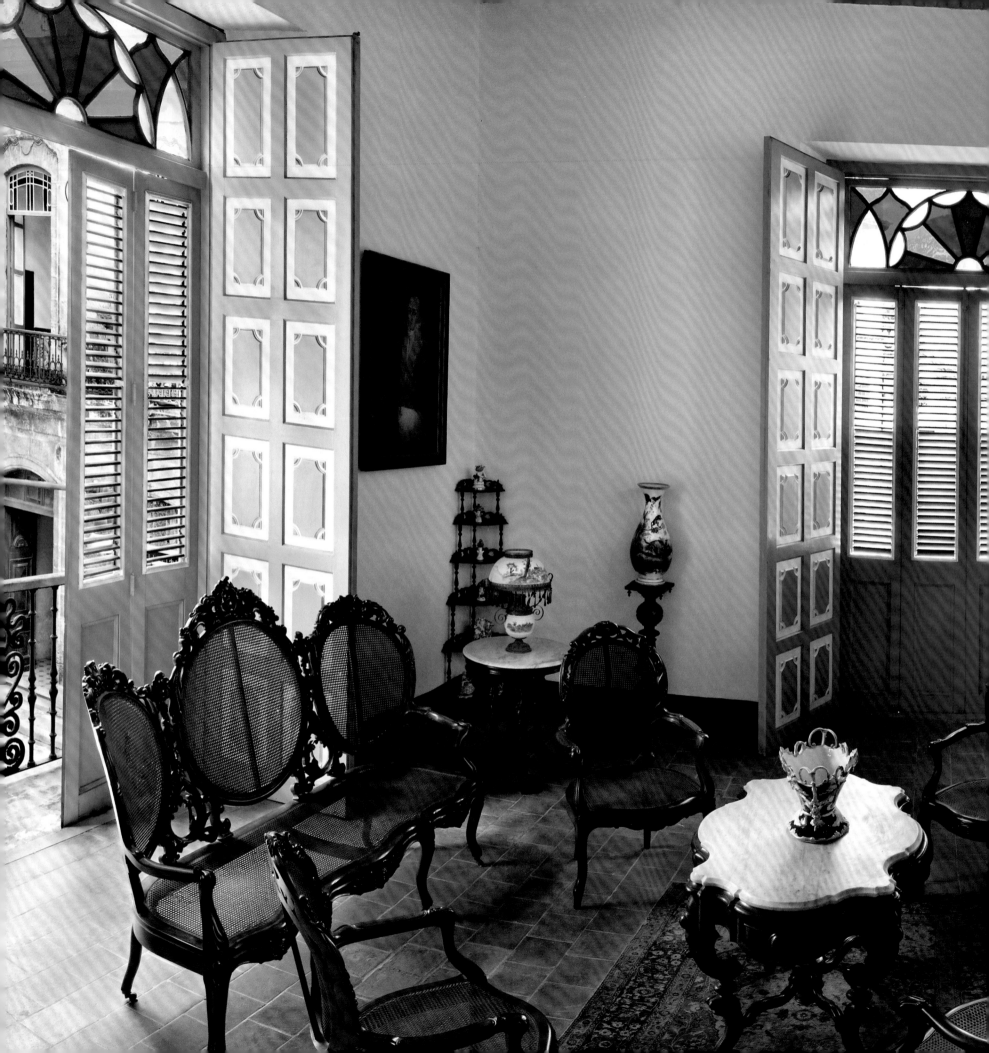

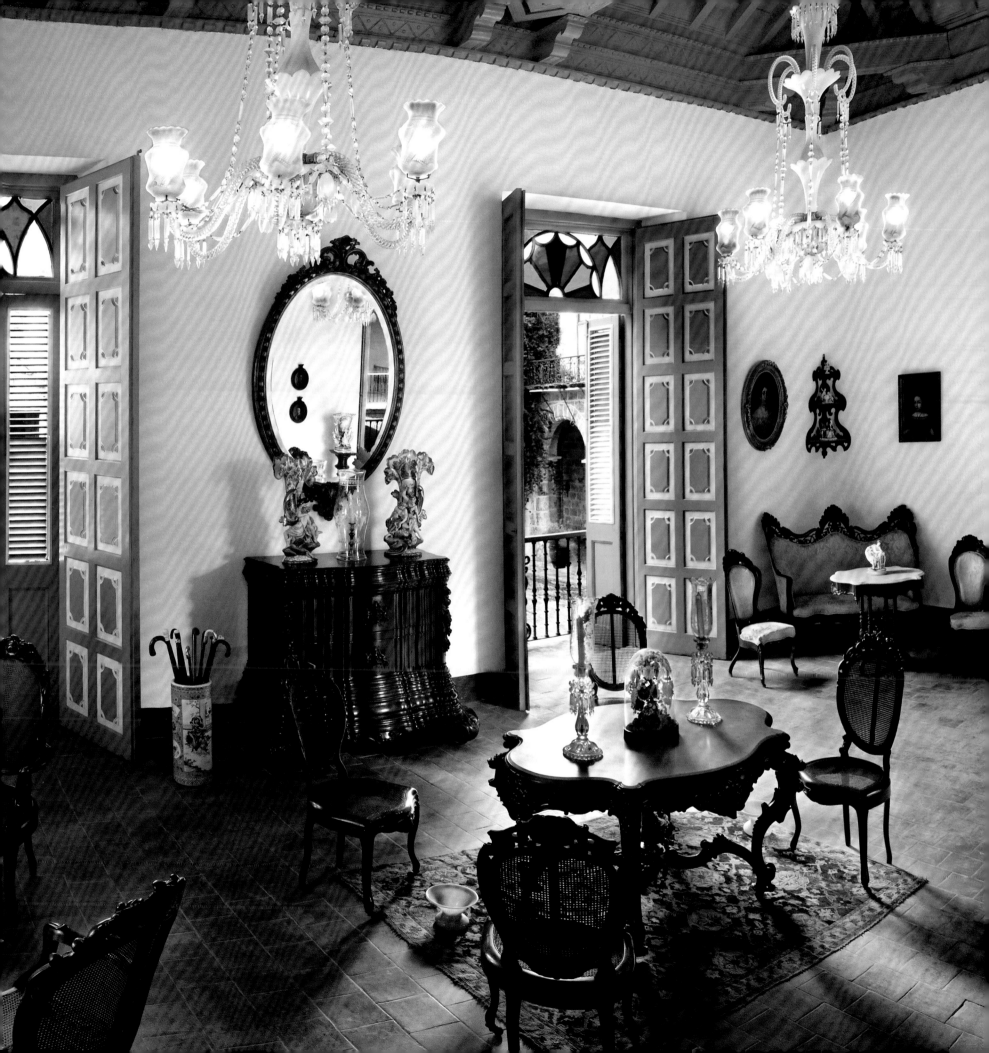

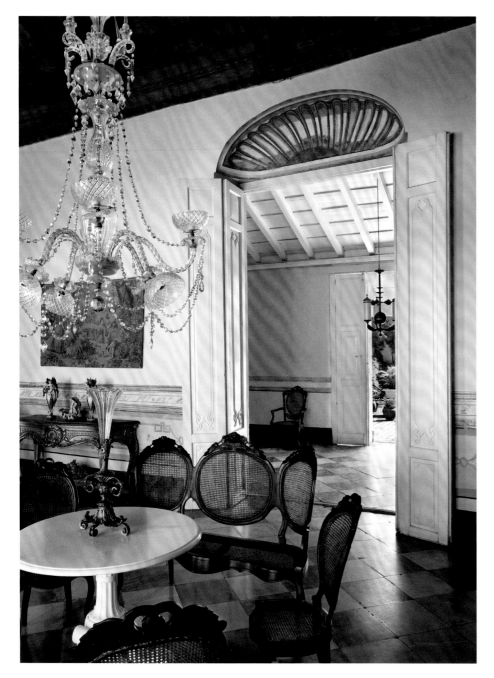
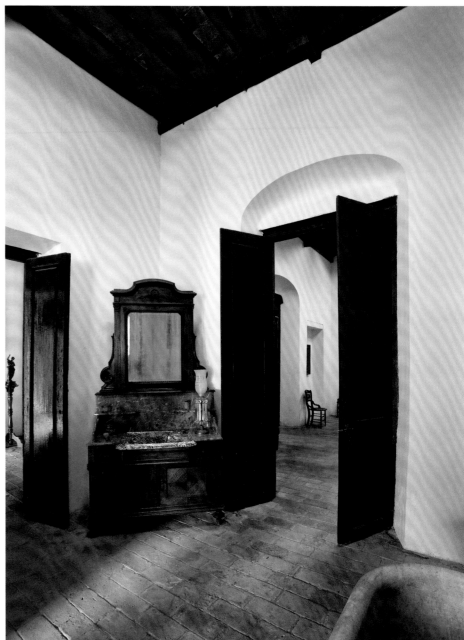

Previous spread
An early eighteenth-century residence Casa del Conde de Casa Bayona houses a collection of eighteenth- and nineteenth-century Cuban furniture and decorative arts.

Opposite left
A room in the eighteenth-century Trinidad mansion of the Sánchez Iznaga family with the inner courtyard in the background.

Opposite right
A colonial residence that has been kept intact in Camagüey. Notice the marble bathtub in the foreground.

Right
Interior of second-floor salon with nineteenth-century island crafted mahogany furniture.

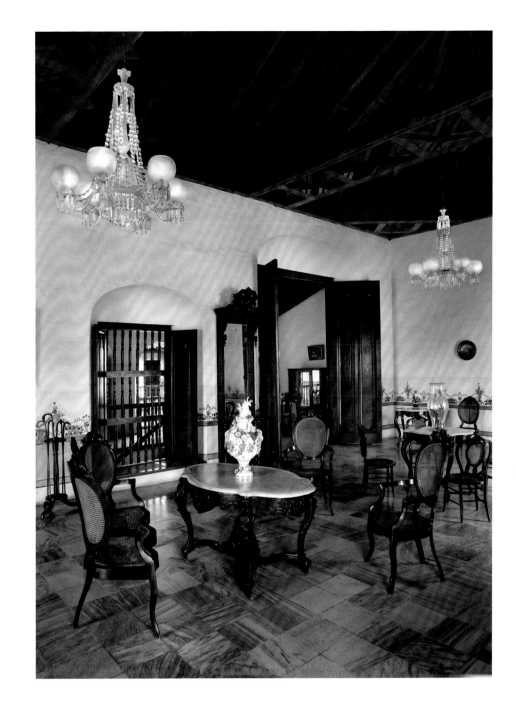

Above
Moorish-Spanish inspired ceramic tiles were imported from Spain and are found throughout the island.

Right
Vibrant nineteenth-century, Moorish-designed patterned tile work in a residential entrance hall.

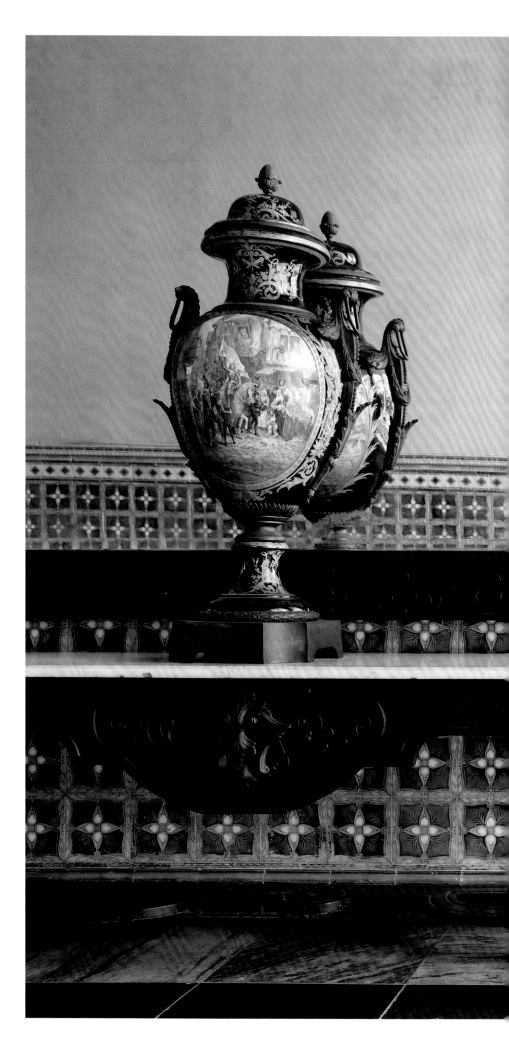

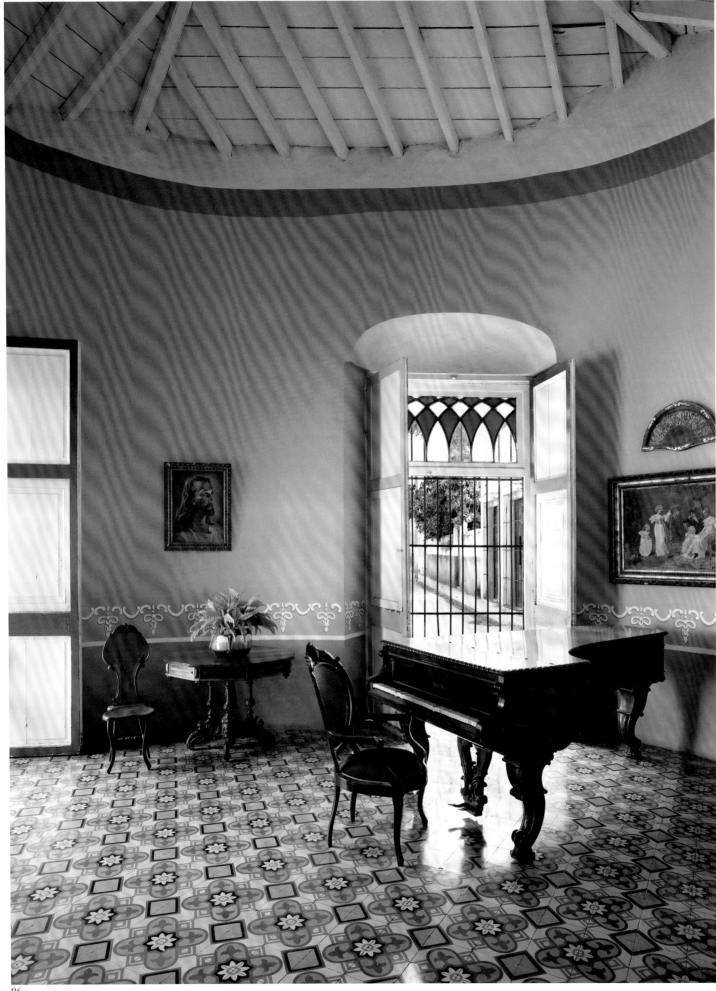

Opposite
This oval room with its semicircular wooden ceiling is atypical of the colonial residences in Cuba.

Above
Hinged shuttered windows, referred to as wickets, are cut into doors to allow light and air entering the home to be controlled.

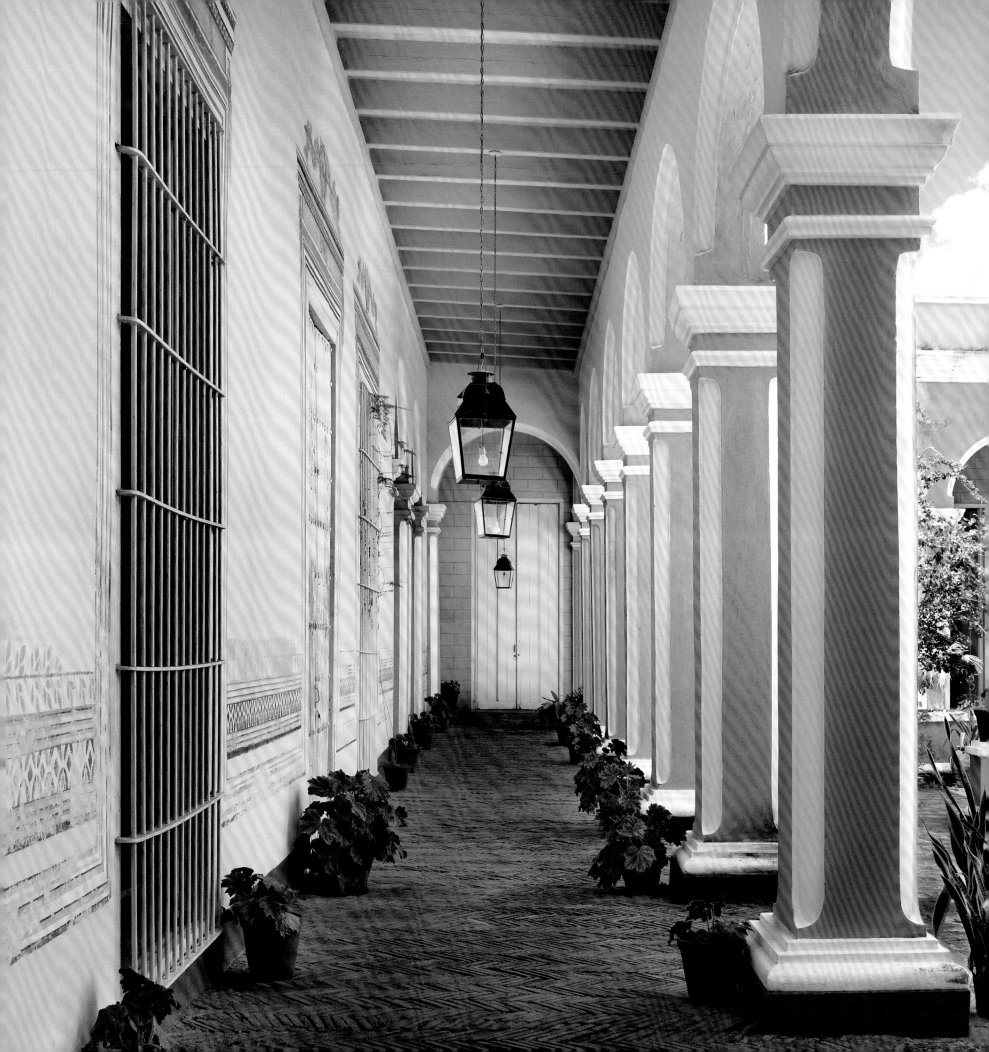

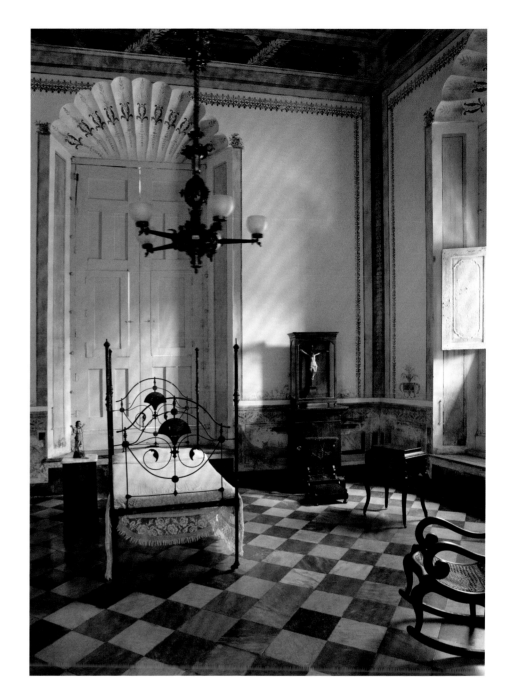

Opposite
*The porticoed gallery that surrounds
the interior courtyard of the Palacio
de Justo Cantero in Trinidad.*

Above
*A bedroom in Palacio de Justo
Cantero with the original marble
floors and painted walls from the
early 1800s.*

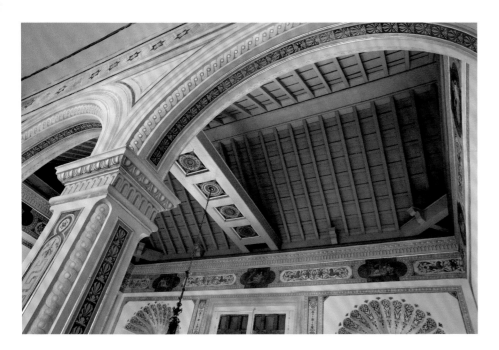

Above and opposite
*Interior walls of Palacio de Justo
Cantero are decorated with
neoclassical hand-painted murals
by Italian artists from Florence,
which are found in rooms
throughout the mansion.*

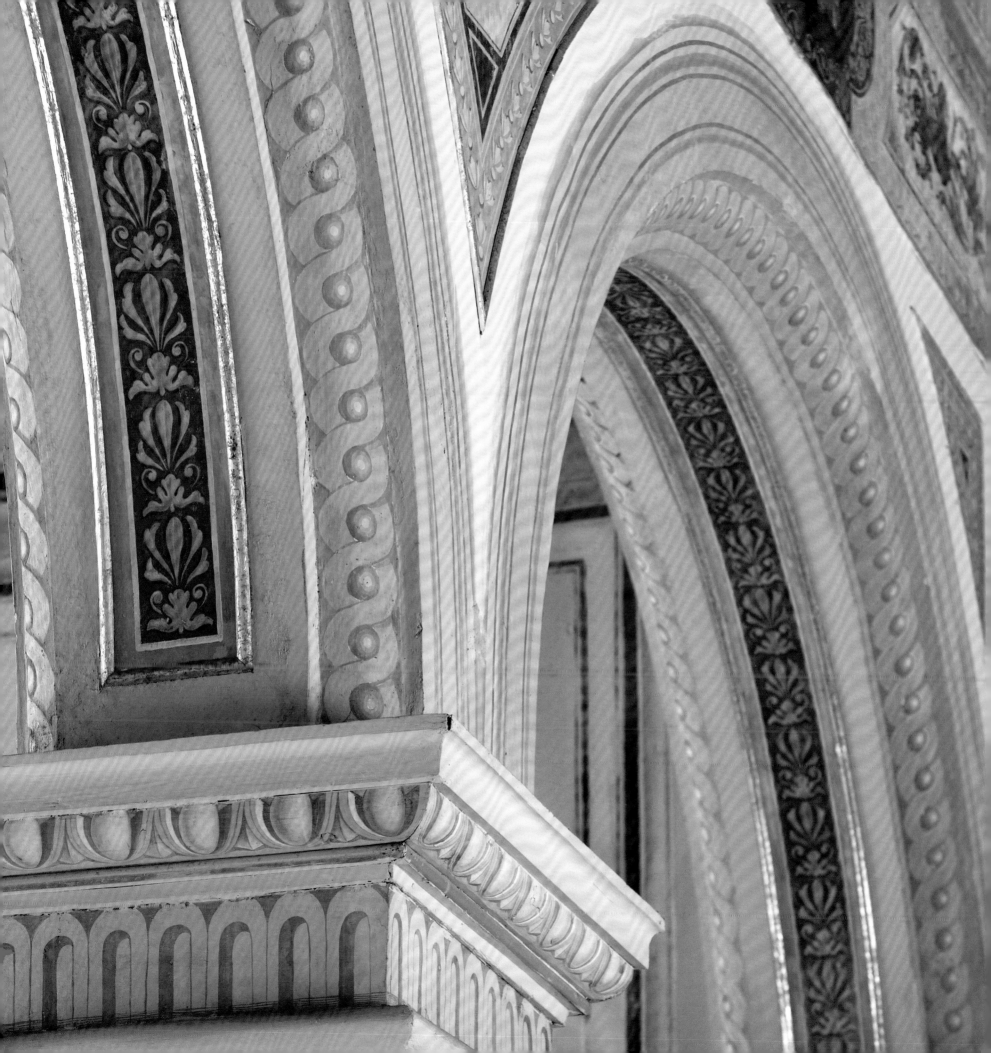

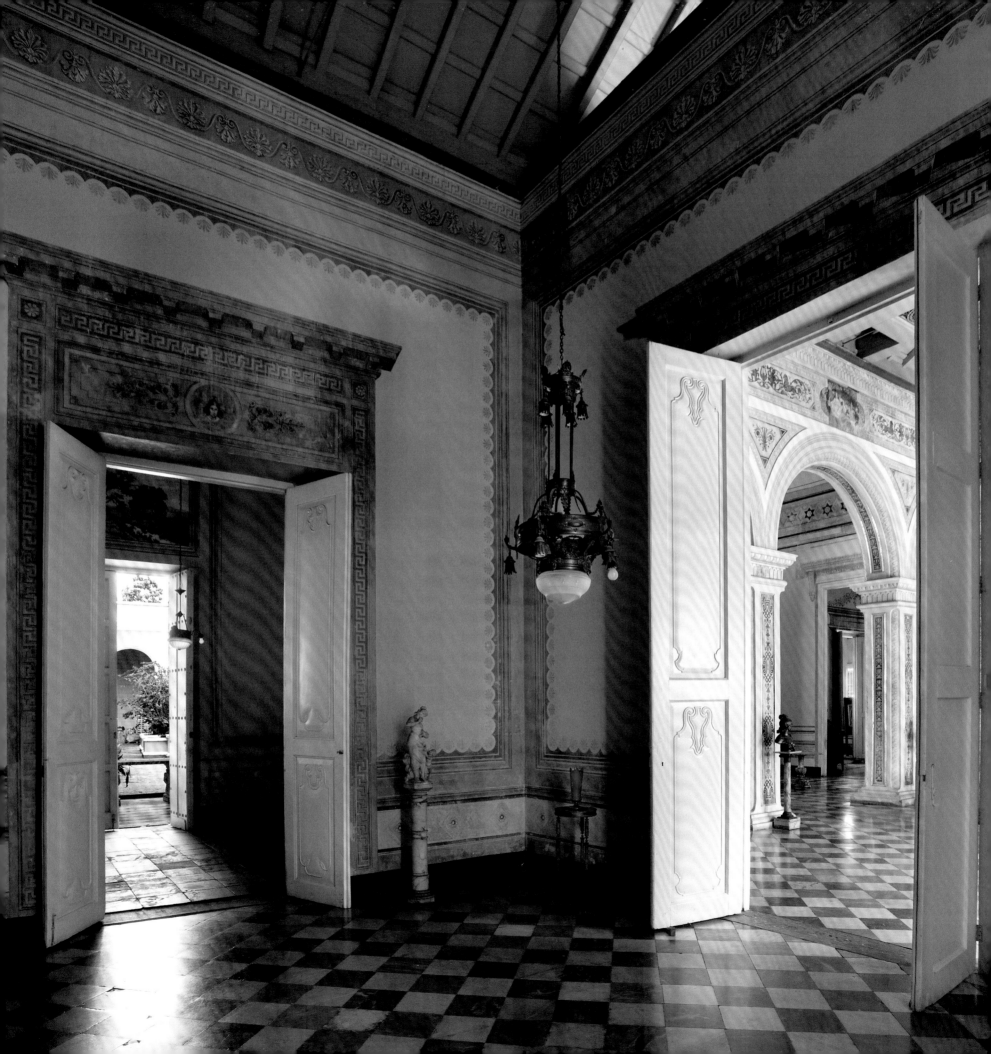

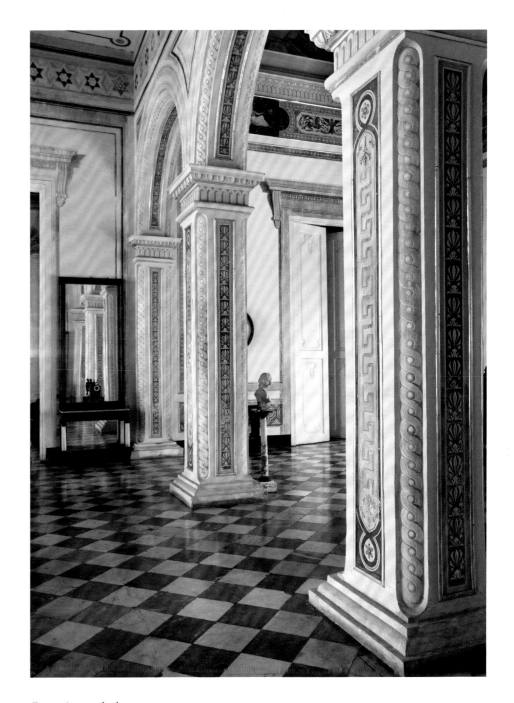

Opposite and above
*Built in the early nineteenth century
by Don Mariano Borrell y Padrón
in the neoclassical style, Palacio de
Justo Cantero is an example of the
voluminosity and verticality of Cuba's
colonial palaces.*

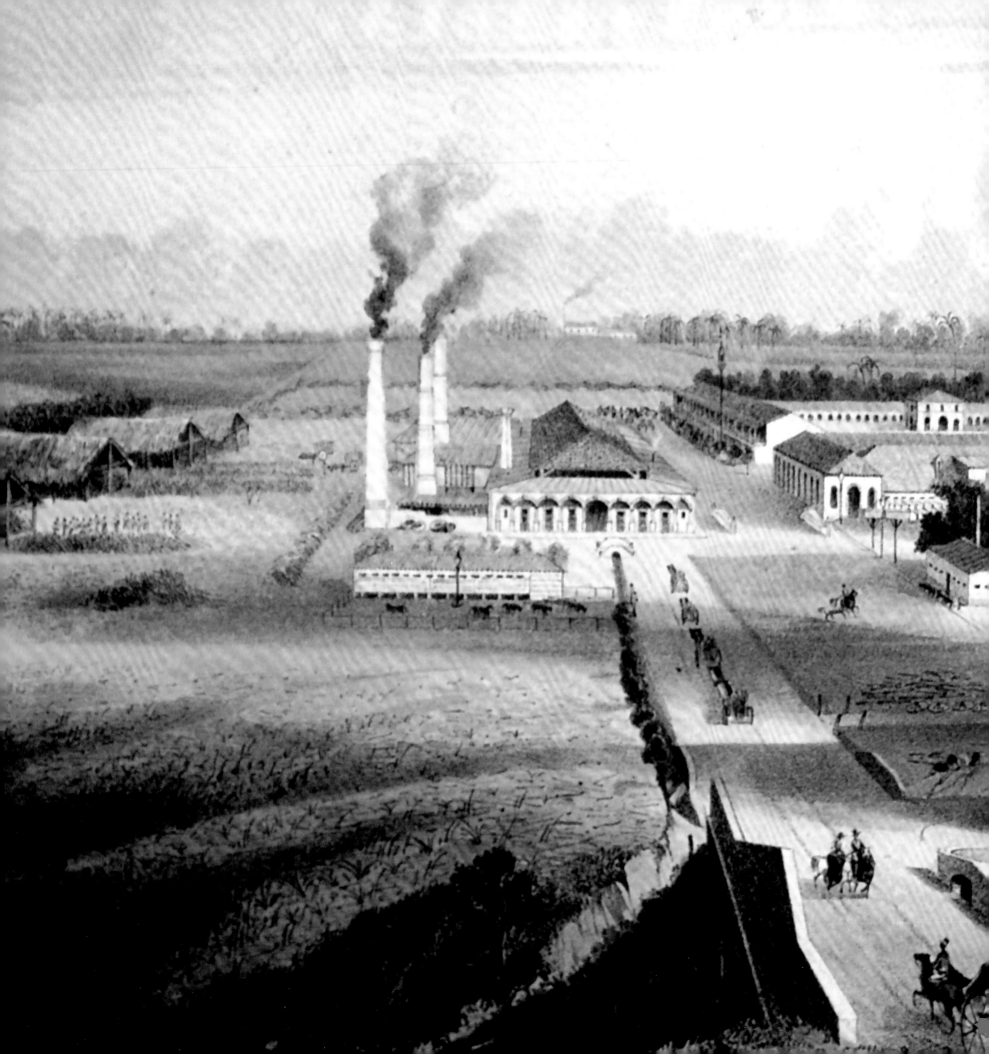

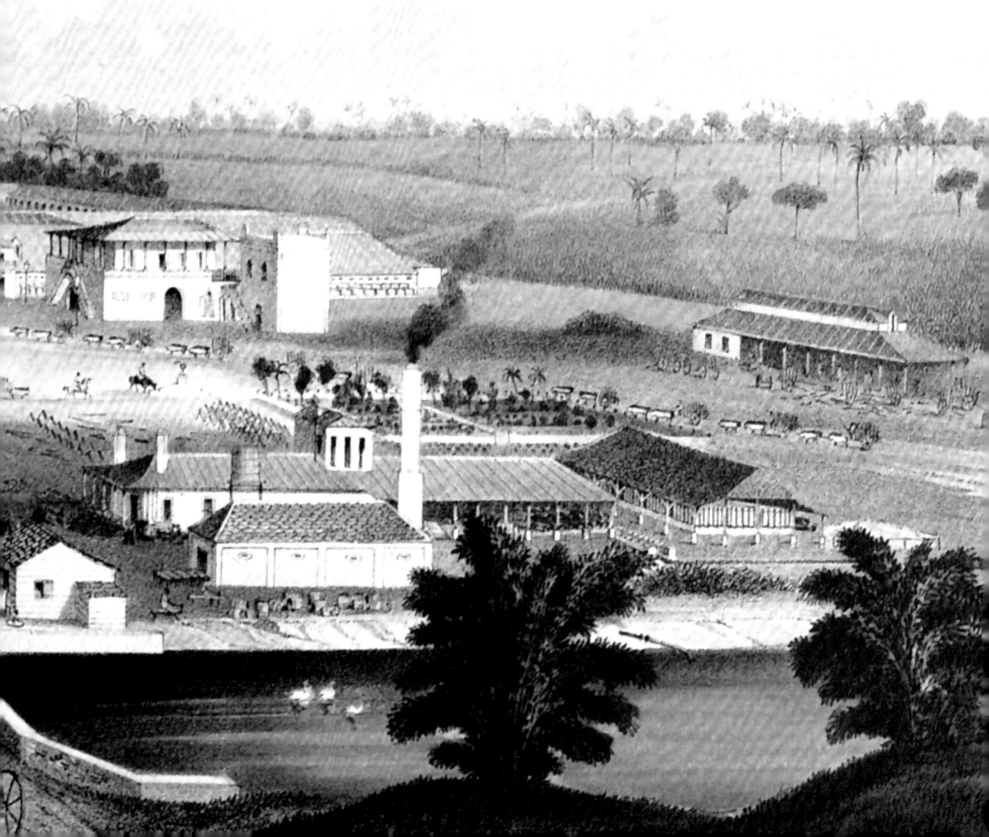

3

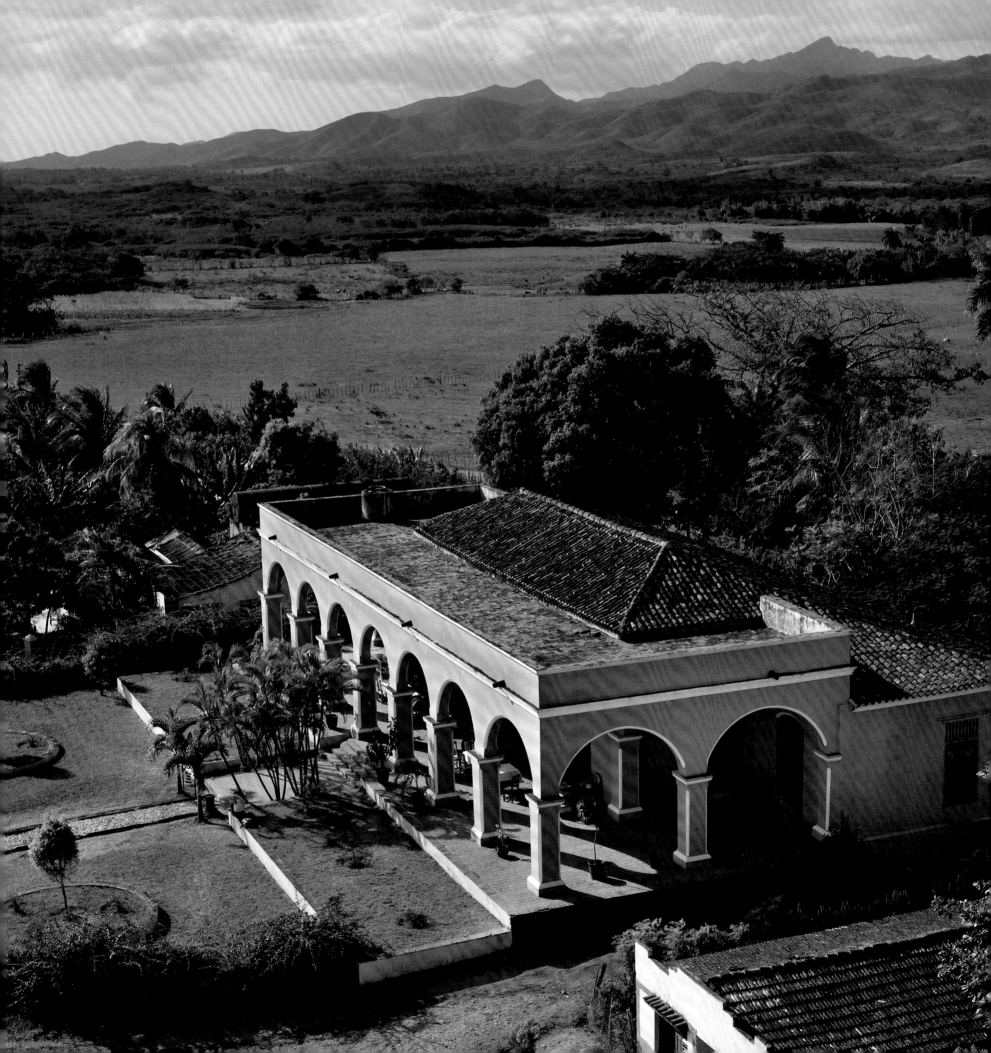

Era of Sugar Prosperity

Previous spread
*An early nineteenth-century lithograph
of Ingenio flor de Cuba by French artist
Eduardo Laplante in the 1850s, which was
considered to be the finest sugar estate on
the island, with more than 3,000 acres of
land and a luxurious great house (casa de
vivienda) in Cuba's Villa Clara province.*

Opposite
*Aerial view of an eighteenth-century sugar
plantation great house Ingenio Manacas
located in the Vallé de los Ingenios.
It belonged to the Hernández de Iznaga
family who owns several townhouses in
the nearby town of Trinidad.*

Page 99 top
*Ingenio Guaimaro, a nineteenth-century
sugar estate great house.*

Page 99 center
*Palacio de Domingo Aldama, a residence
designed by architect Manuel José Carrera
and built in 1844.*

Page 99 bottom
*A Spanish Revival-style façade of the
early twentieth-century Presidential
Palace in Havana, the Cuban president's
residential quarters.*

By 1700 a century had passed since Cuba had been declared the "threshold and key to the New World" by Philip II, king of Spain, and the viceroyalty of Spain's New World now included the north coast of South America, Peru, Central America, Mexico, Florida, a large swath of the southwestern United States, and the Philippines. The Philippines' importance to Cuba lay in the fact that the trade route linking China and Spain, first established in the mid-sixteenth century, was an important ingredient in Cuba's economy.

The trade ships, or what was called the Manila Galleons ("Manila Flotilla"), brought Asian goods such as pearls and precious stones, porcelain, silks, spices, lacquerwork, and ivory to Mexico's west coast, where they were transported overland to the Yucatán Peninsula and then on to Spain, stopping only in Cuba. This allowed the merchants and wealthy patrons of the island not only to be the first to see and experience these expensive Asian wares, but to purchase and display them in their homes even before the king and court of Spain.

Prior to his death Charles II of Spain declared Philip, who was Duke of Anjou and grandson of France's Sun King, Louis XIV (r. 1643–1715), the inheritor of the Spanish throne as Philip V. The accession of the French Bourbon dynasty to the Spanish throne in 1700 resulted in a monumental change in trade and shipping between New Spain and Europe, with Cuba benefiting enormously with new access to European goods.

In addition to the exotic Asian imports by way of the Philippines, there were European luxury goods brought from Spain, Italy, and France to South America and Mexico, again stopping first in Cuba during the voyage.

With the conclusion of the War of the Spanish Succession (1701–1714) and the ratification of the Treaty of Utrecht, English and Dutch shipping and trade began with the Spanish colonies and even more foreign influence and goods flooded the island. Such items included:

Spanish rugs destined for luxurious drawing rooms and bedchambers; gold and silver thread that added a touch of elegance to intricately embroidered imported fabrics; lace from Flanders or Lorraine for trimming garments and household linens; Flemish paintings of landscapes and mythological themes; Spanish and Italian escritoires made of fine woods; fancy German tablecloths; Venetian glass; tortoise shell writing desks from Italy; small bottles from Castile; glass picture frames from Flanders; upholstery and drapery materials from Brussels; jet ornaments from Santiago de Compostela; and so forth. Any person of means was expected to flaunt his or her wealth by forming an ample collection of such objects, always keeping them in plain sight.[22]

During the previous century the dominant architectural style in Spain had been that of the elaborate baroque and its variations, which featured fanciful façade decorations and elaborate curvilinear decorative motifs and elements.

The diversity and complexity of height and volume were most pronounced in interior elevations and the façade, which had heavy relief split moldings, flesh-colored ornate tablets, a multiplicity of panels, wreaths, and multilinear forms.[23]

In Cuba during the 1700s domestic architecture was a more gradual process of adaptation and assimilation, and two distinct architectural fashions were popular. Mudéjar construction techniques, carpentry, and profusely decorated geometric patterns, along with the elaborate baroque movement, continued to be evident through anachronistic features. A more austere trend was also popular, one that was plain except for decorative elements and architectural fittings on the façades usually around the covered porticoes (*portales*).

This fashion is most evident in Camagüey, called the "Corinth of the Caribbean" and Cuba's third largest city, where the heavy baroque architectural elements seen in Havana are missing. Spanish and European architectural trends and the need to adapt to the tropical island climate eventually brought about a specific style, that of the Cuban baroque. The Cuban baroque style of urban houses had enclosed inner courtyards surrounded by arcades, balconies that faced the street, and ornamental façades. Rich materials of glass, tile, and plasterwork adorned interior surfaces.

The patio or inner courtyard, which had its origin in ancient Roman as well as Arab design and construction, was the structural nucleus of Cuba's aristocratic *palacios*. The island's colonial baroque style also adopted traditional Spanish architectural features such as the loggia and the similar portico.

Cuba's colonial houses are characterized by an original handling of space and the practice of superposing volumes in a vertical hierarchy (commercial premises or reception rooms on the ground floor, servants' quarters and service areas on the first floor, family quarters on the second floor) so as to create, with balconies, blinds, grilles, guarda vecinos, *partitions, and arcade gates, a subtle system of passages and barriers between private and public areas.[24]*

By this time all of the larger urban houses were built of the readily available native limestone-like stone called iron shore or *coquina*. Though structurally sound, it was a fossilized coral stone comprising of millions of compressed mollusk shells and coral skeletons.

The "ultrabaroque" or Churrigueresque style, so popular during the same period in the Spanish colonies of Mexico and Peru where native Indian motifs were integrated and produced designs of unparalleled exuberance, was not translated to Cuba. Both the lack of skill sets of Cuba's builders and craftsmen and the limits of the local *coquina* stone could not measure up to the complexity of carvings and design that were required.

The engaged columned façade of the Catedral de la Havana (San Cristóbal Cathedral), built in 1748 with its ornate sculptured profusion of plasticity and detailed angles and shapes, contributes to its famously Cuban baroque expression. The dramatic assembly of the column-framed niches chiseled into stone and asymmetrical towers flanking the façade makes it one of the island's monuments to the baroque style that twentieth-century Cuban writer Alejo Carpentier describes as "music turned into stone."

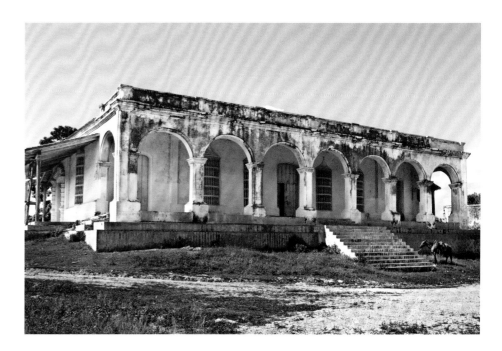

The Cuban baroque style also permeated domestic architecture, and the proliferation of *palacios* in the new style transformed the appearance of the island's urban towns and cities. Its fashion of profuse sculptural ornament was most evident in details such as the façades, door frames, arch and gable profiles, and interior plasterwork.

By 1733, all Cuban governmental administrative agencies and offices had been declared under the jurisdiction of Havana's authority. Subsequently, the capital city attracted more immigrants, commerce, construction, and wealth. At the time Geronimo Valdés, one of Cuba's "builder-bishops," initiated and oversaw a sizable increase in ecclesiastical construction of new churches, convents, and monasteries. He also founded, in 1728, the University of Havana (Real y Pontificia Universidad de San Gerónimo de la Habana) and together with Spanish-trained military engineers and architects developed other military and civil architecture. In addition to the ecclesiastical, military, and civil developments, construction of domestic architecture also increased in number and importance. The austerity of Casa del Conde de Casa Bayona and Casa de Juana Carvajal, both built in the 1720s in Havana, soon lost favor and stylistic changes and new, more exuberant curvilinear baroque fashions began to appear in the *palacios* and private homes.

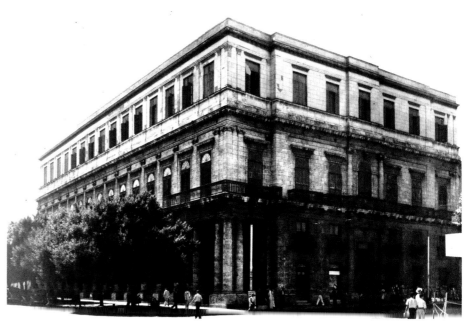

Palacio del Conde Lombillo and Casa del Conde de San Juan de Jaruco, both built in the 1730s, together with Casa del Marqués de Ancos (1746) and Casa del Marqués de Aguas Claras (1751), were among those private homes that brought Havana

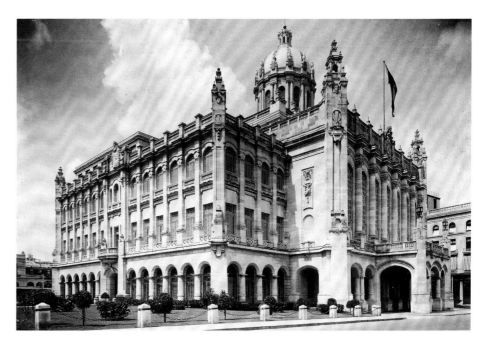

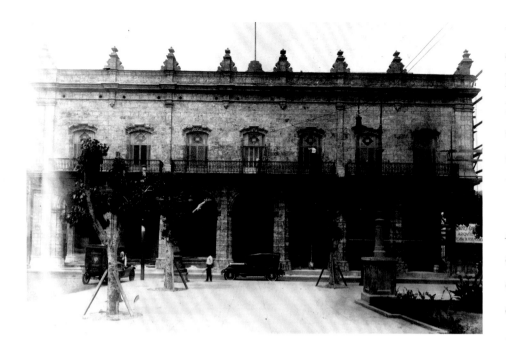

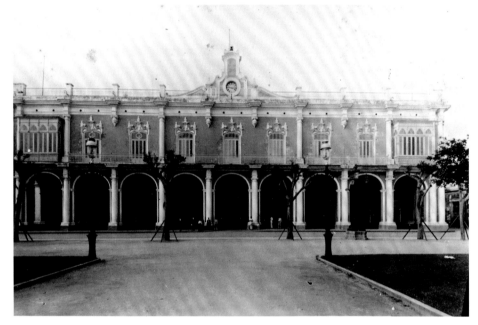

Above and below
*Both Palacio del Segundo Cabo (top) and
Palacio de los Capitanes Generales (bottom)
were built in the 1790s and were designed
by military engineers. They epitomized the
Cuban ideal of late baroque grandeur.*

Next spread
*Original frescoes painted by Italian
architect and artist Daniele Dall'Aglio
in the early nineteenth-century Ingenio
Guaímaro located in the Valley of the
Sugar Mills near the town of Trinidad.*

the title of being the "City of Palaces." All have mammoth doors opening into a cavernous courtyard and are surrounded by imposing arched columns. These baroque-style urban mansions also contained the most fashionable furnishings and embellished interiors, many with elaborately carved Mudéjar ceilings (*alfarjes*), imported Italian marble floors, radiant glazed tile work (*azulejos*), and spectacular fanlights (*mediopuntas*).

During the first half of the eighteenth century, Havana—crossroads of the Indies—ceased to be a mere hub of American commerce, and became a thriving city, exploring the bounty of the tropics: tobacco (despite the state monopoly decreed in 1717), sugar, salted meat, hides, livestock, and hardwoods. It was an expensive city, where wages were higher than in Spain or Holland.[25]

In 1759 the Spanish Bourbon monarch Charles III (r. 1759–88), known as the Reformer's King, inherited the Spanish throne and the Seven Years' War. Initially a war between Britain and France (familiar to Americans as the French and Indian War), Spain was dragged into it. The result was England's invading Cuba in 1762, launching the largest military operation the island has ever experienced from a foreign power, and capturing Havana.

The conquest of Havana was the last major engagement in the Seven Years' War, and the British occupied Havana for less than a year until the Treaty of Paris, marking the French and Spanish defeat, was signed in 1763. The brief British occupation ended the trade restrictions and shipping mono-polies previously imposed by the Spanish government, opening the port of Havana to free trade. Foreign merchant vessels flocked to Cuba, and this influx of foreign commerce changed the social, political, and economic fabric of Cuba forever.

The short period of English rule also brought about burgeoning commercial activity and a widening of Havana's citizens' horizons with a desire to further improve their homes and living conditions.

One description of Havana at the time was:

During the British occupation, Havana's residents had enjoyed their ability to purchase coveted consumer goods from the British merchants that had descended upon the city. With the return of Spanish rule, the government had instituted a degree of comercio libre, *or free trade, which, while not the economic freedom of unrestricted laissez-faire, was a vast improvement over the previous system.*[26]

During the last half of the eighteenth century, the Cuban baroque style reached its peak. The heavily ornamented style became the expansion of artisans, who adapted their vision to the island conditions in Havana, Santa Clara, Matanzas, and the island's smaller cities, whether it was in the *palacios* built for the Creole aristocracy or the single-story provincial homes with finely tuned mahogany window grilles (*rejas*).

During the last decades of the century, construction continued and Cuban domestic architecture became even larger and grander. The prosperous oligarchic capitalists of Cuba continued to seek only the latest in the fineries of Europe, and they imported from France, England, and Holland as well as from Spain. The island's wealthiest sugar aristocrats, *sacarocracia*, and slave traders continued to contribute to Cuba's economic development as well as what had become its renowned style and fashion.

The design of *palacios* and grand private houses during this period can be epitomized by the residence of the Second Commander of Havana, Palacio del Segundo Cabo, which was completed in 1772. The construction was directed by Cuban engineer Antonio Fernández de Trevejos y Zaldivar, and the structure has an arcaded loggia with seven arches on the front facing the Plaza de Armas Carlos Manuel de Céspedes, referred to today simply as Plaza Armas. The design is essentially a transitional one, lending the Cuban baroque to the latest fashionable architectural trend of the day, the neoclassical. The newly emerging neoclassical style was based on the rediscovery of the Greek and Roman classical periods and was most fashionable when the island's prosperity was at its height. Stylistically the neoclassical elements of Palacio del Segundo Cabo include its symmetry and linear interpretations integrated well with the baroque ornamental treatments centered on moldings over the windows and portal arches.

Adjacent to Palacio del Segundo Cabo is Palacio de los Capitanes Generales, considered by many Cuban colonial architectural aficionados as the "greatest exponent of eighteenth-century Cuban architecture." It was used as the official seat of Havana's town council and the residence of the captain general (governor). Construction began in 1776 and continued until 1792. Its design echoes that of the Palacio del Segundo Cabo but with nine large arches in the Roman arcade. Decorative emphasis includes baroque window and door moldings and engaged columns, dividing the second story into five sections with corresponding balconies. These two late-eighteenth-century *palacios* on Plaza Armas set a high standard for luxury in their day and influenced the design and style of large private houses built afterward.

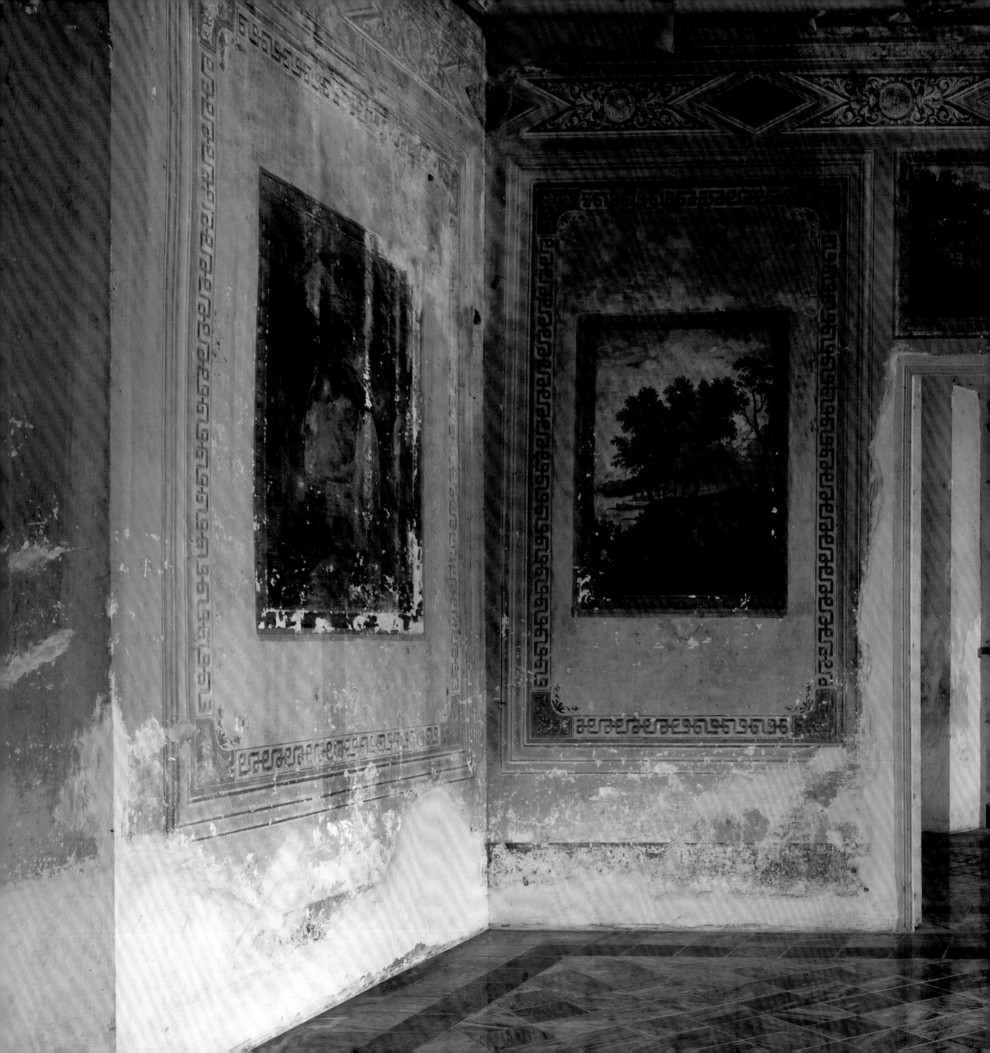

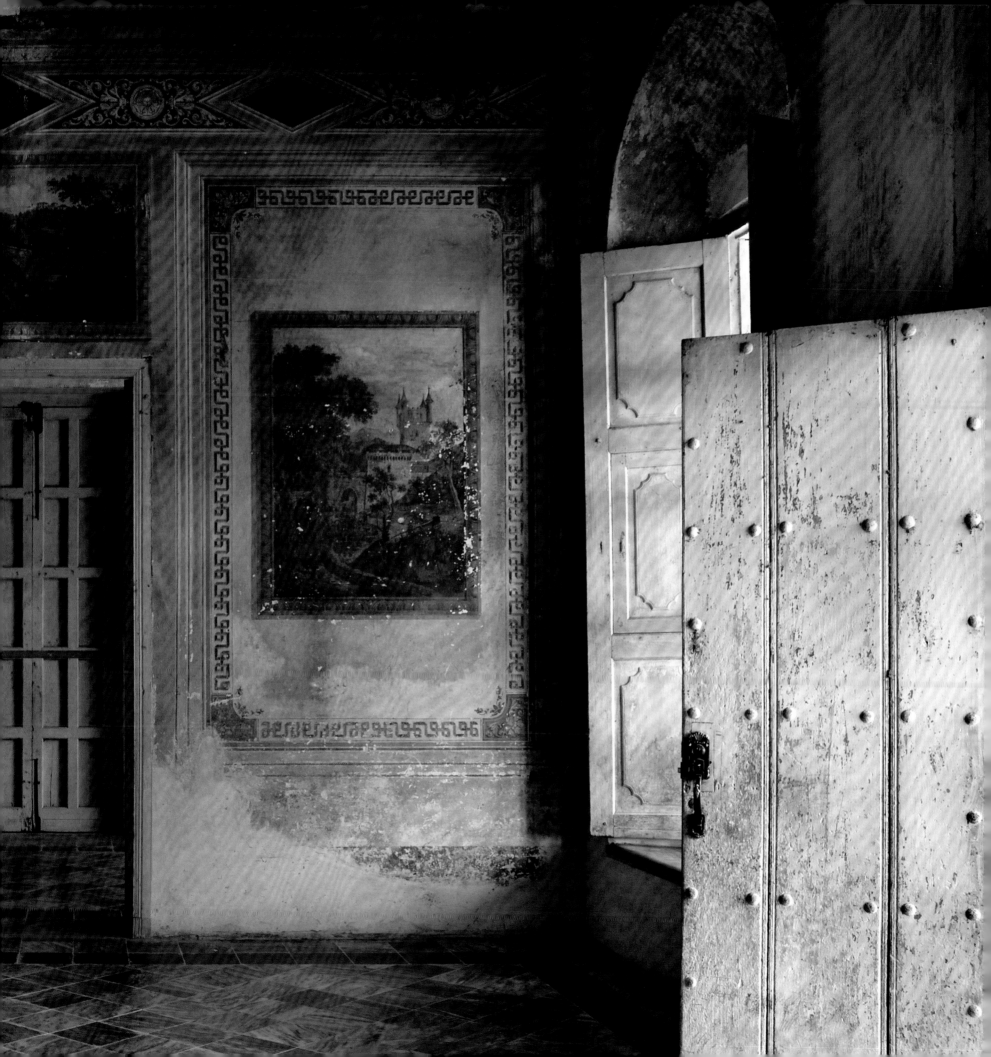

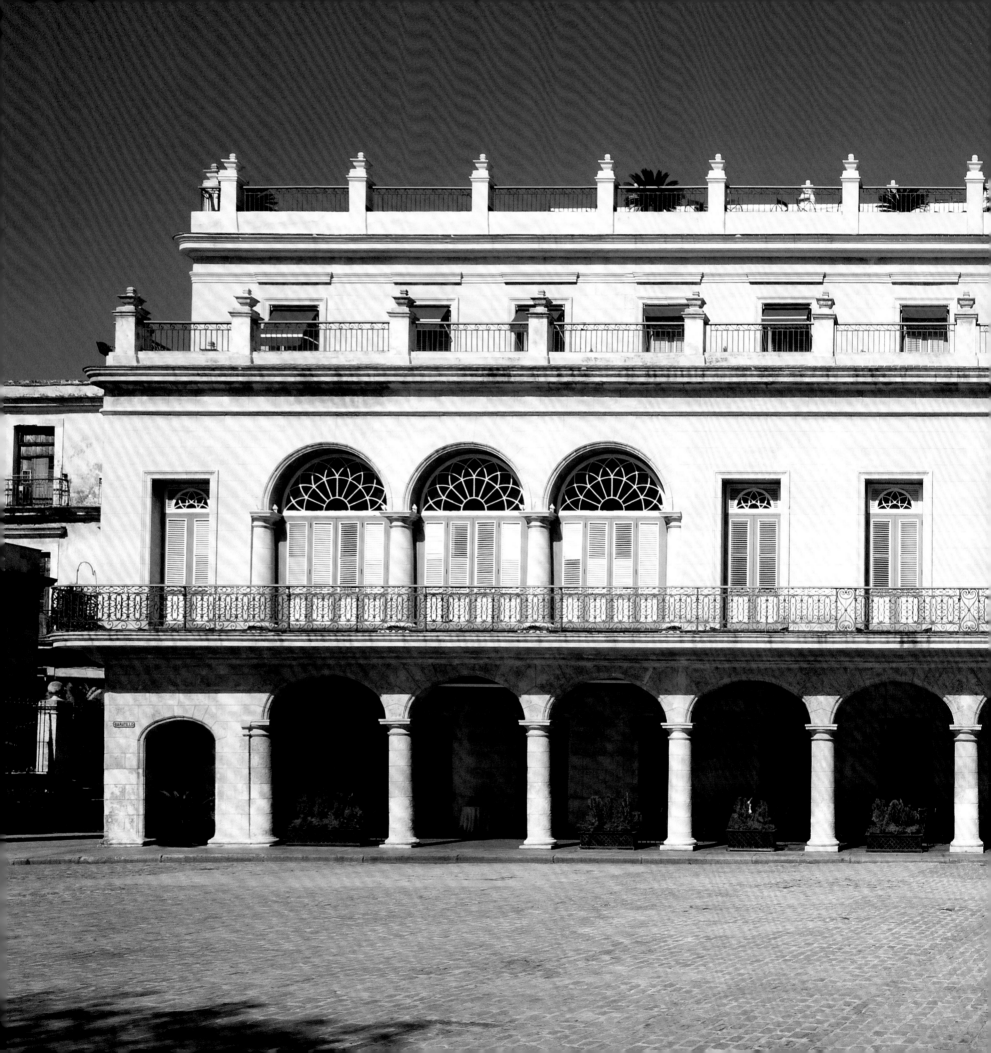

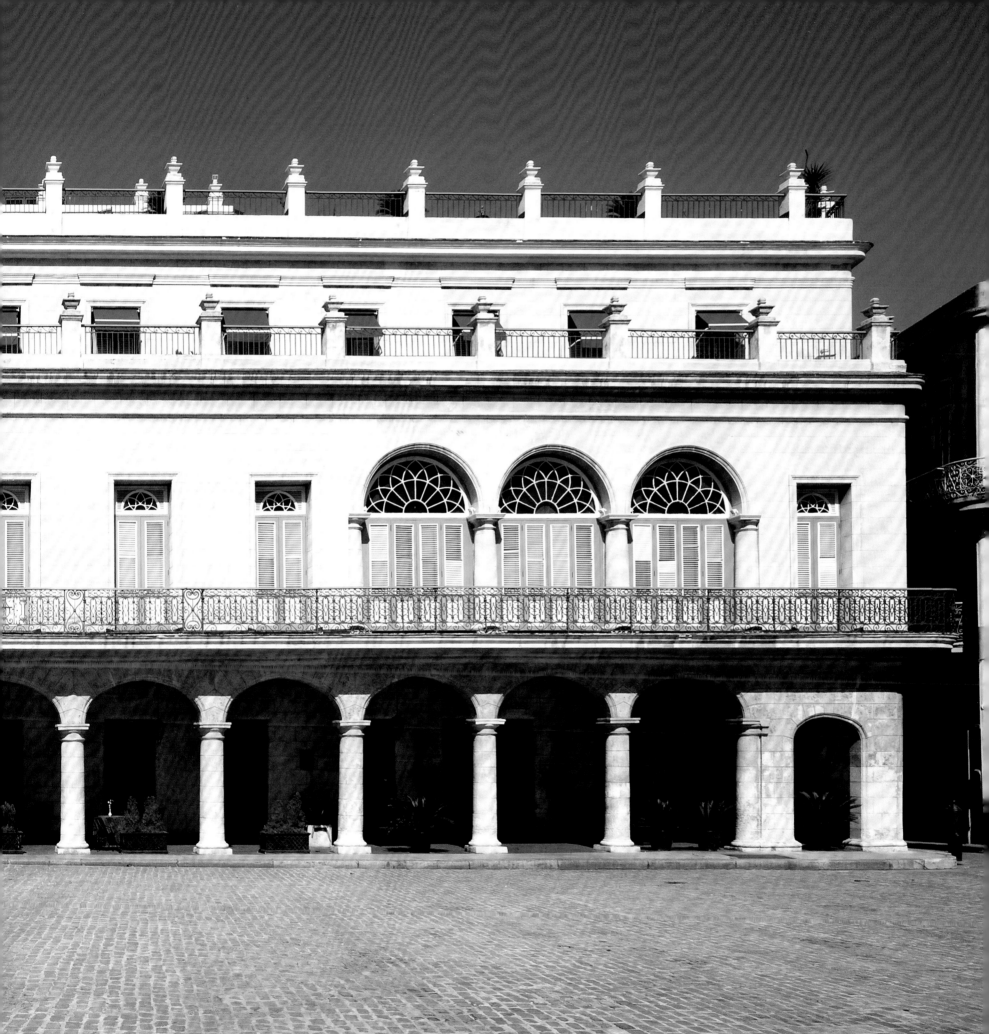

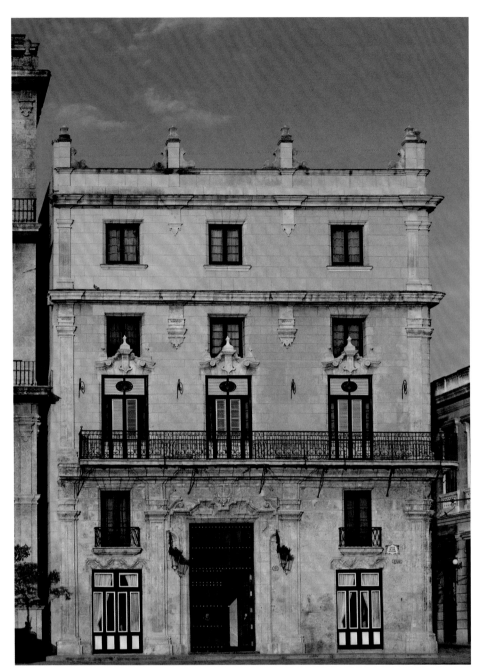

Previous spread
Casa del Conde de Santovenia was built in 1784 and purchased at the beginning of the nineteenth century by the Count of Santovenia.

Left
Palacio de Antonio San Miguel y Segalá dates to the 1790s and was one of the last baroque mansions built in Havana.

Opposite
Palacio San Miguel's salon and sweeping marble staircase.

Next spread
A typical example of nineteenth-century one-story neoclassical residential architecture in Camagüey.

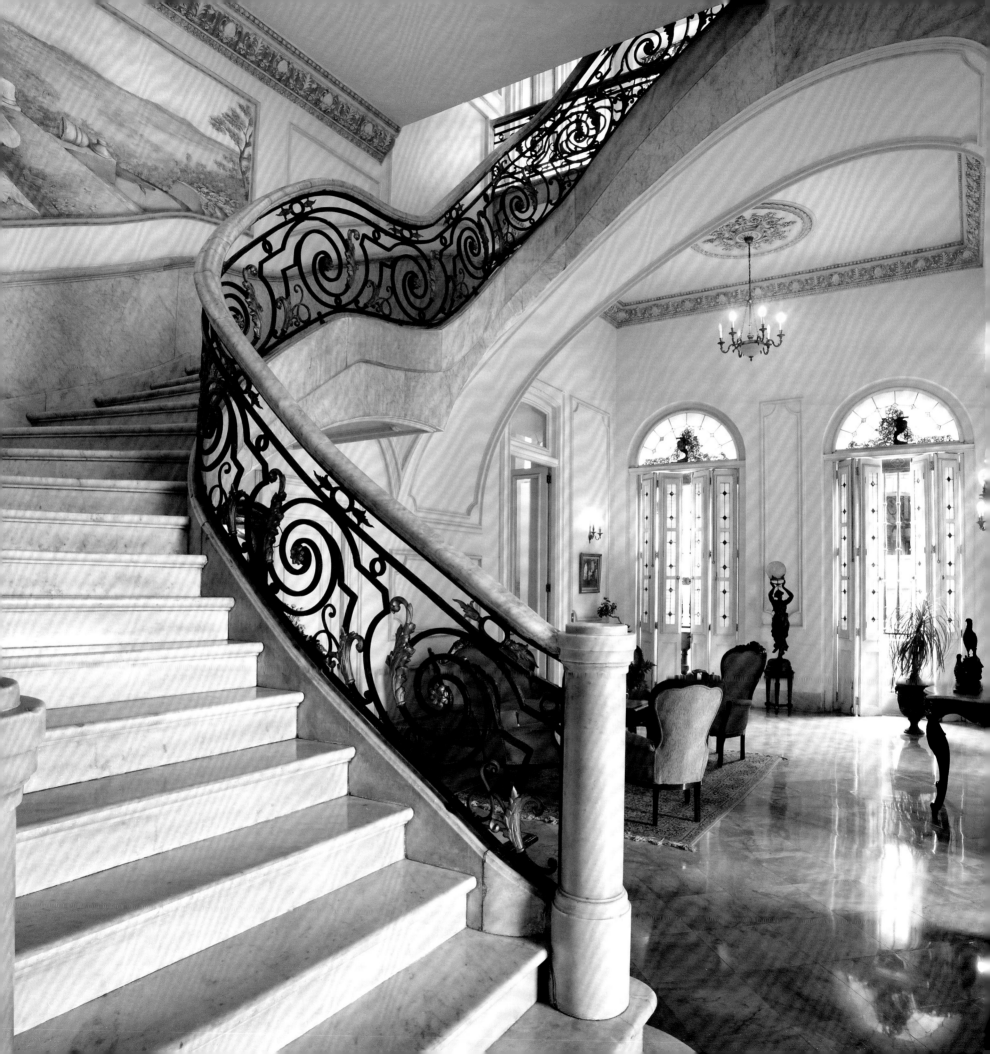

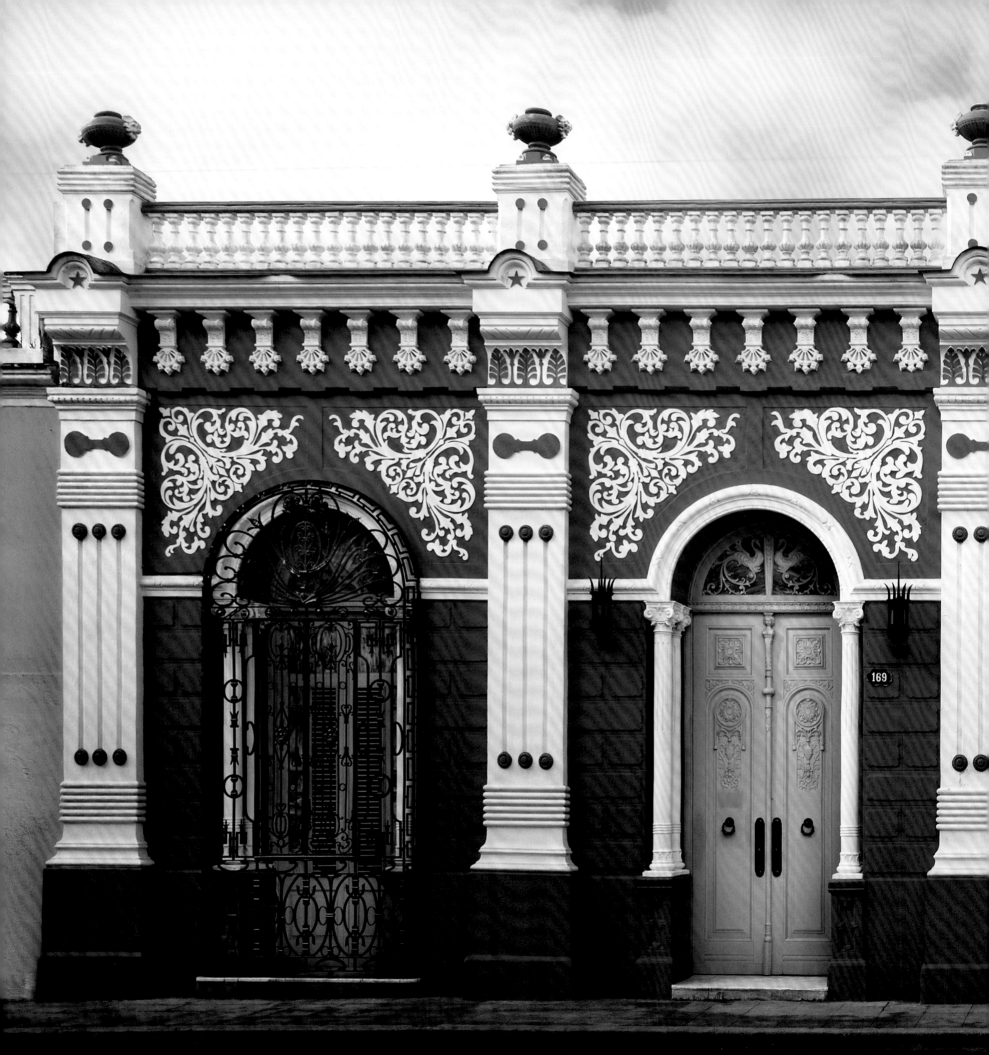

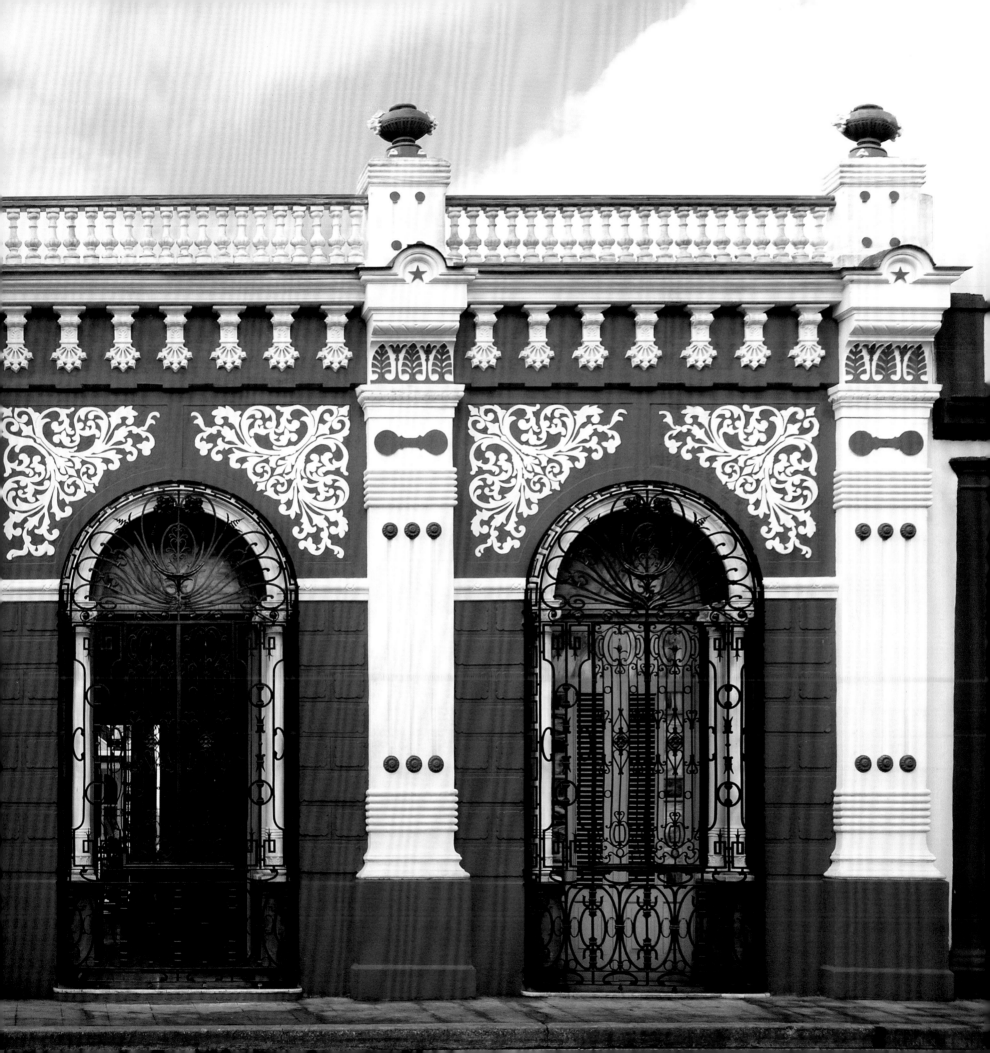

*One of the finest examples of a
nineteenth-century pharmacy in Cuba.*

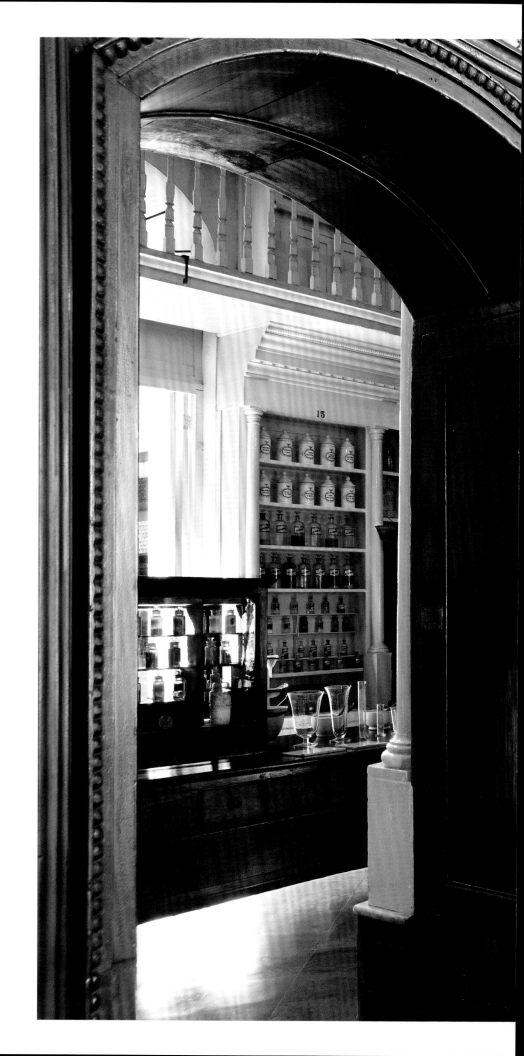

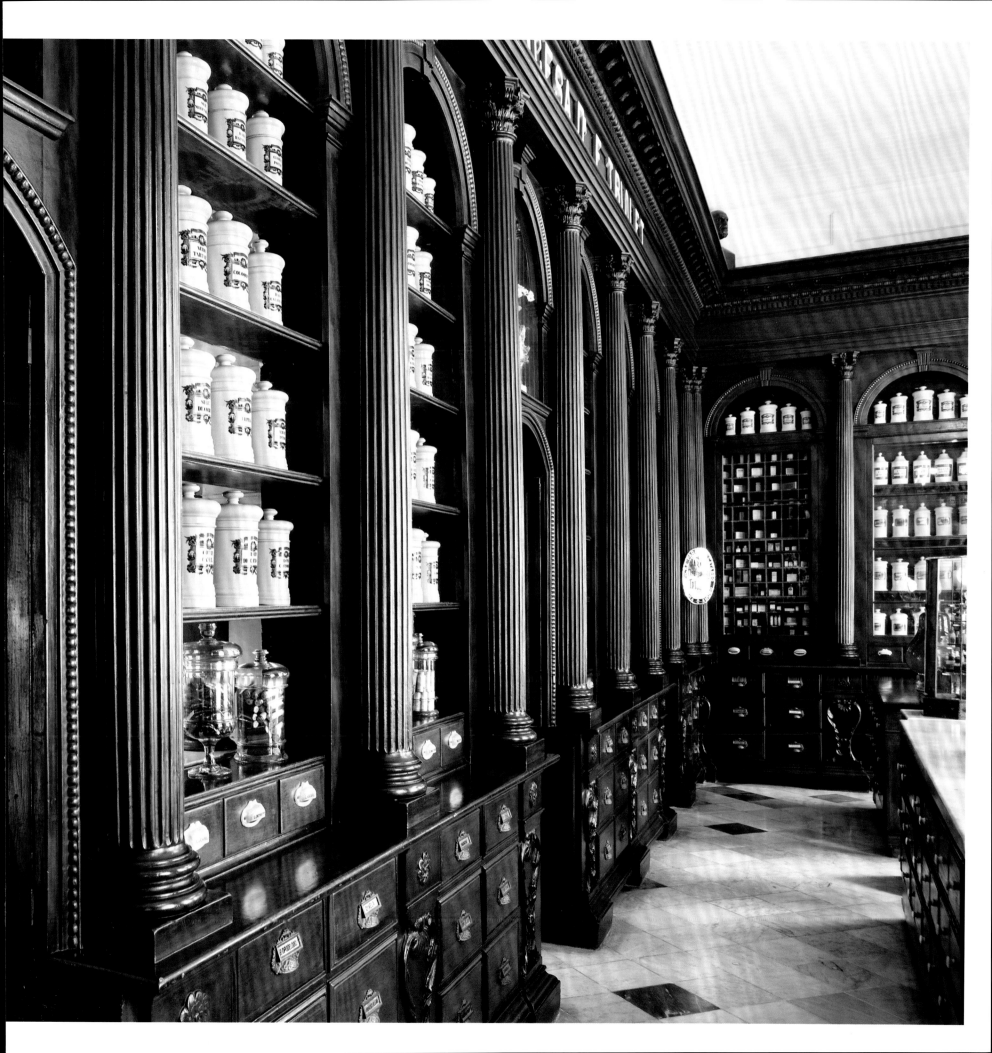

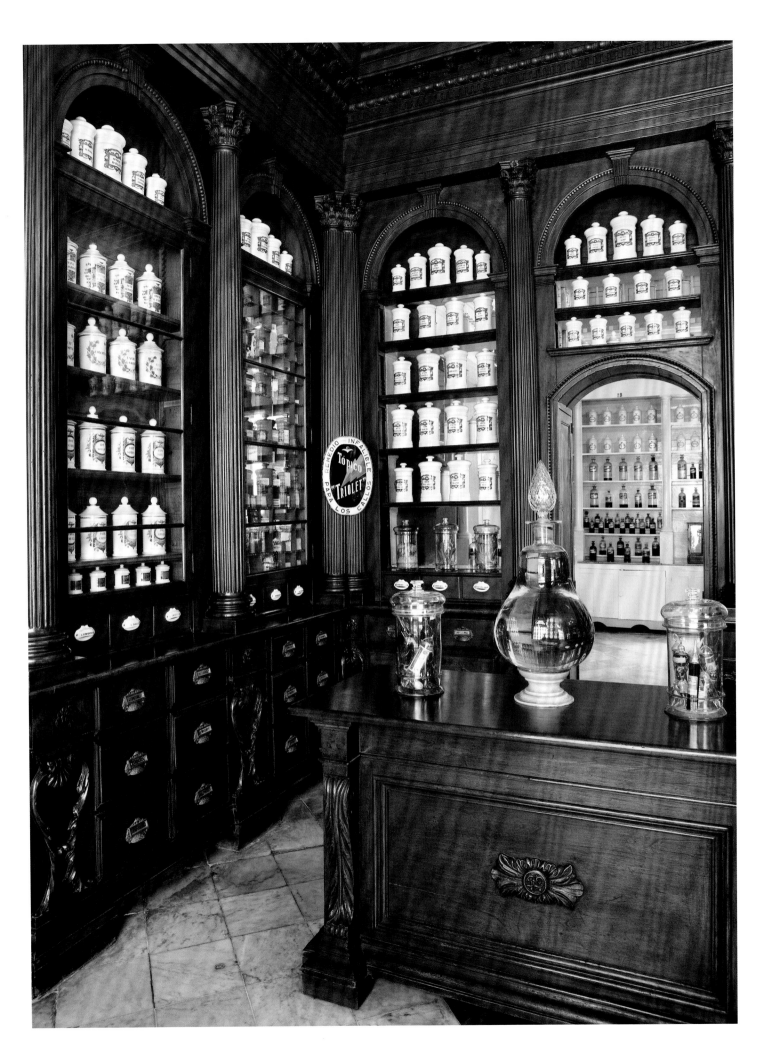

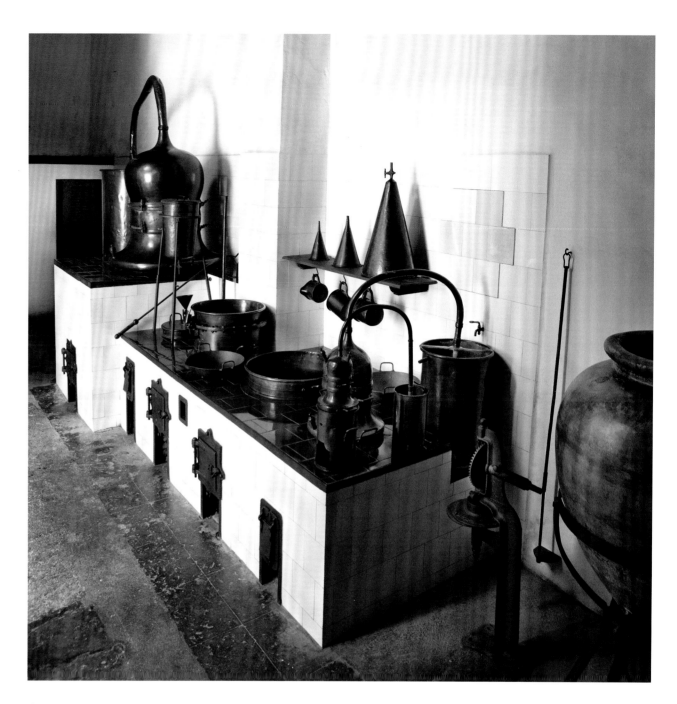

Opposite
*Built in the 1880s by French
pharmacist Ernesto Triolet. The
mahogany cabinets and shelves store
the hand-decorated original French
porcelain vases and jars.*

Above
*The pharmacy's laboratory and
kitchen where medicines and
remedies were created and packaged.*

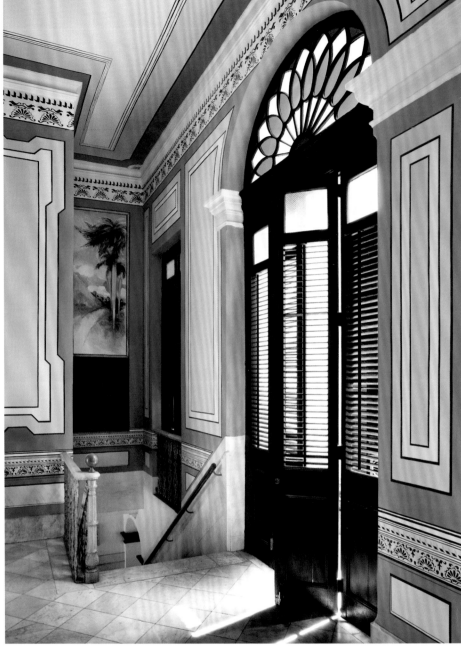

The second-floor residence above the pharmacy where succeeding generations of the Triolet family lived until 1964.

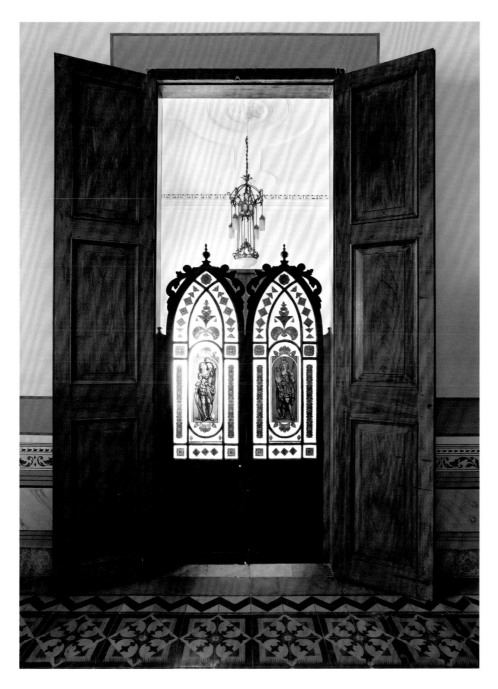
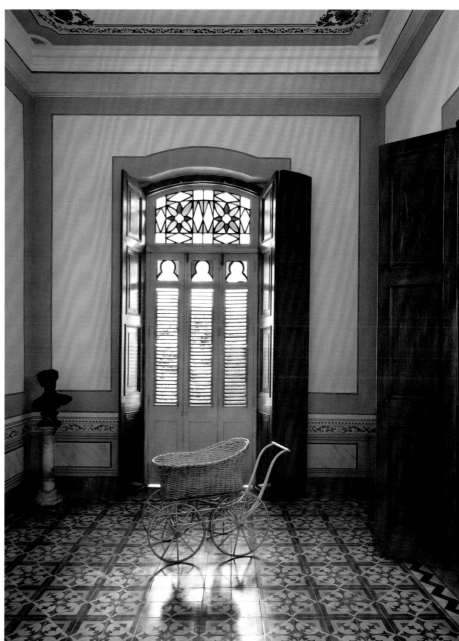

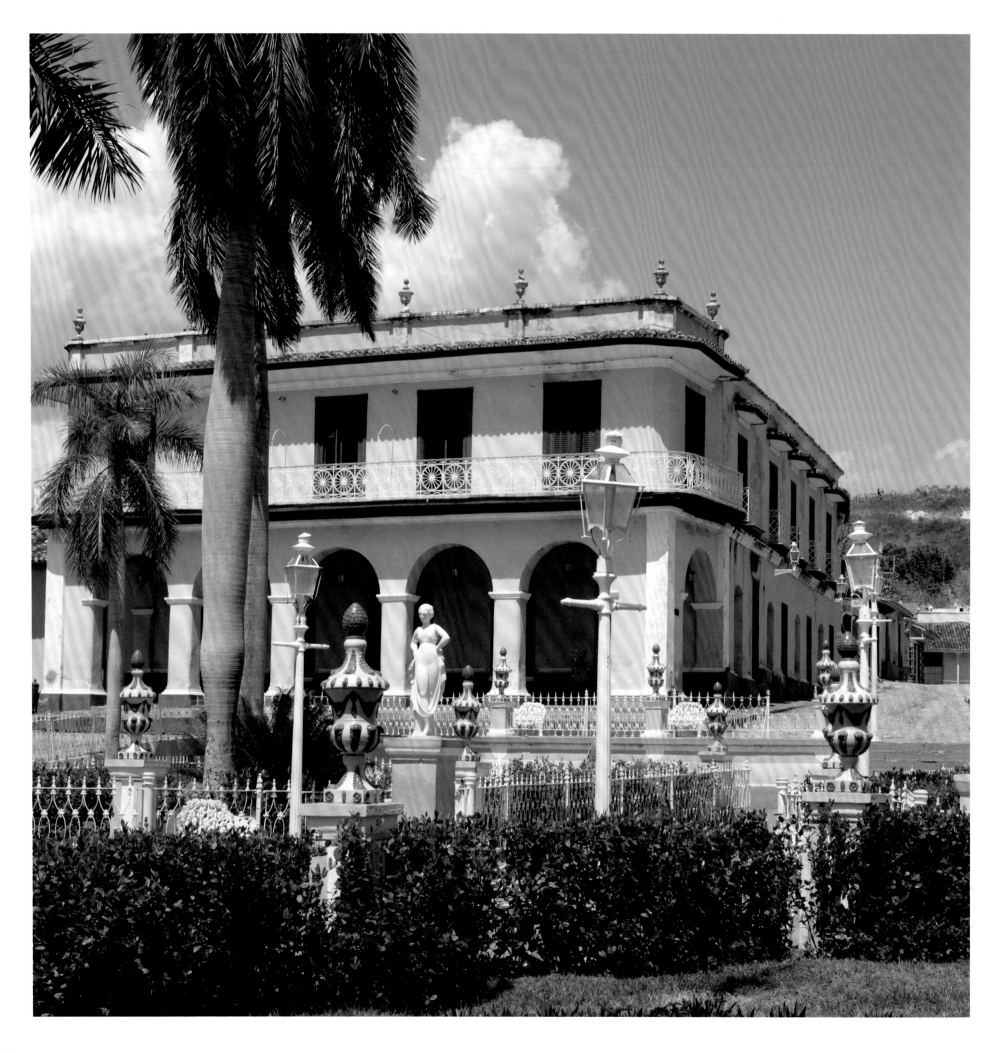

Opposite
Exterior of Palacio Brunet, a
two-story mansion that was first
constructed in 1740 on
Plaza Mayor in Trinidad by a
wealthy sugar baron.

Right
The two-floor residence features
a Carrara marble floor, cedar-
coffered ceilings, Sèvres porcelain,
island-made mahogany furniture,
and hand-painted frescoes.

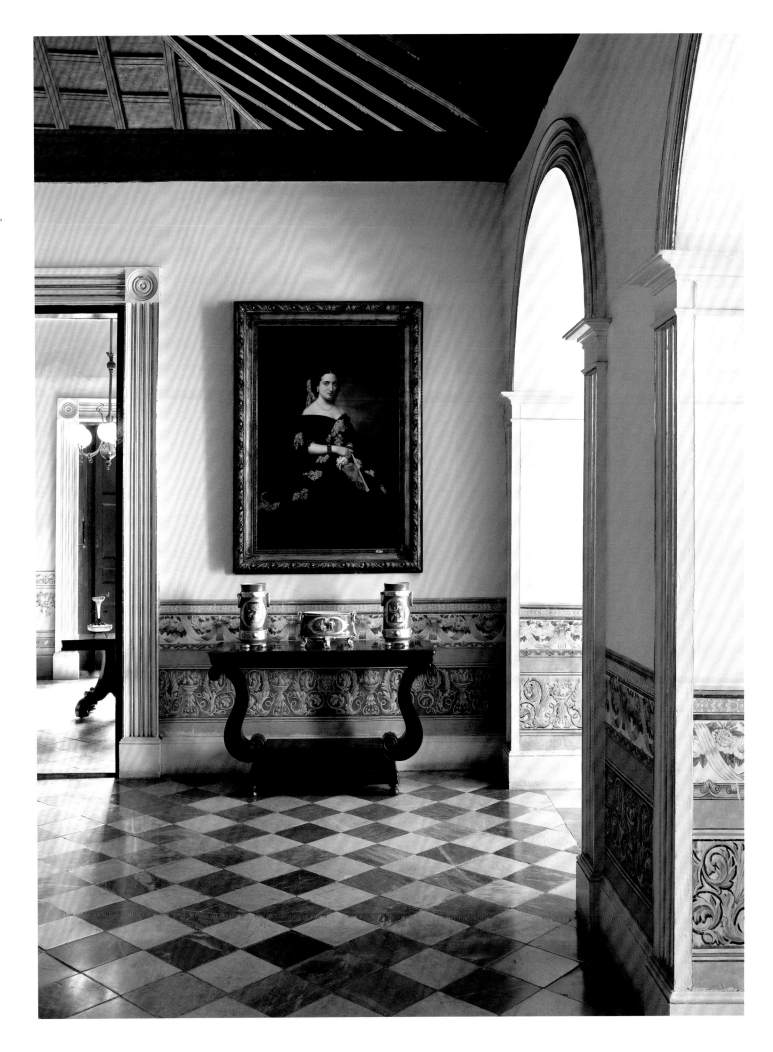

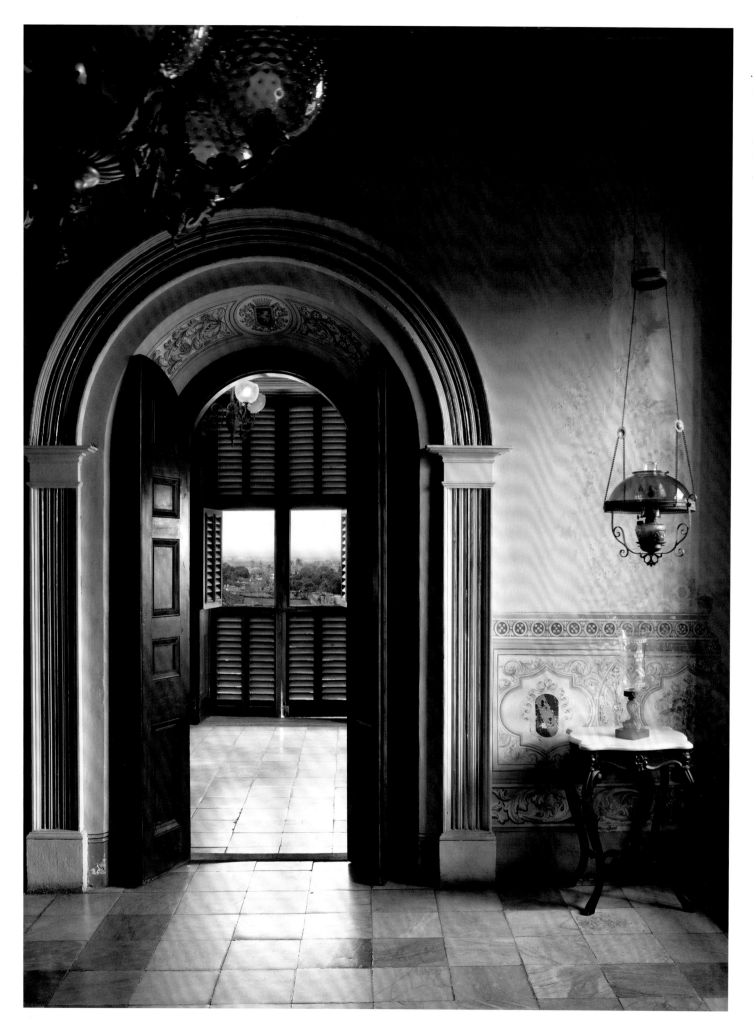

Left
Elegant original hand-painted frescoes decorate each room of Palacio Brunet.

Opposite
Palacio Brunet was rebuilt in 1812 as the residence of the wealthy Borrell family in Trinidad.

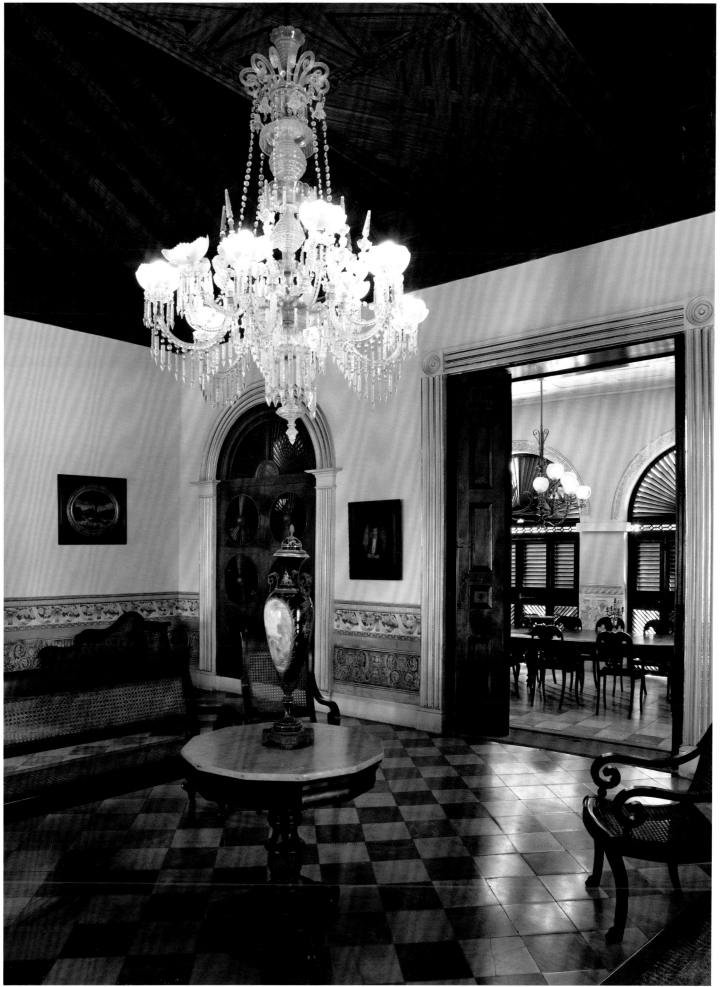

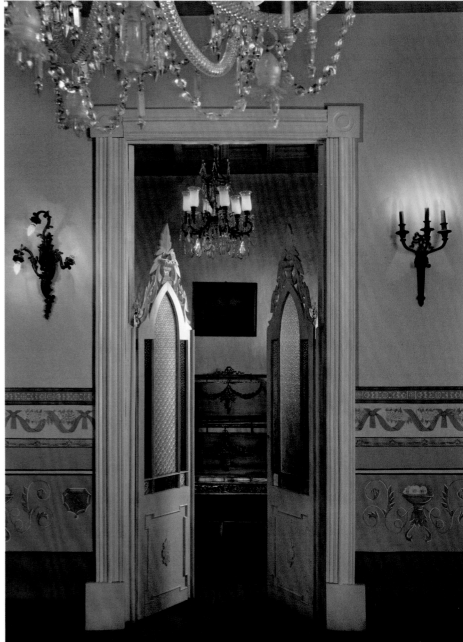

Above left and right
Mamparas, *or glassed door-screens,*
are a ubiquitous architectural feature
throughout Cuban houses. They
provide privacy while allowing light
to enter and air to circulate.

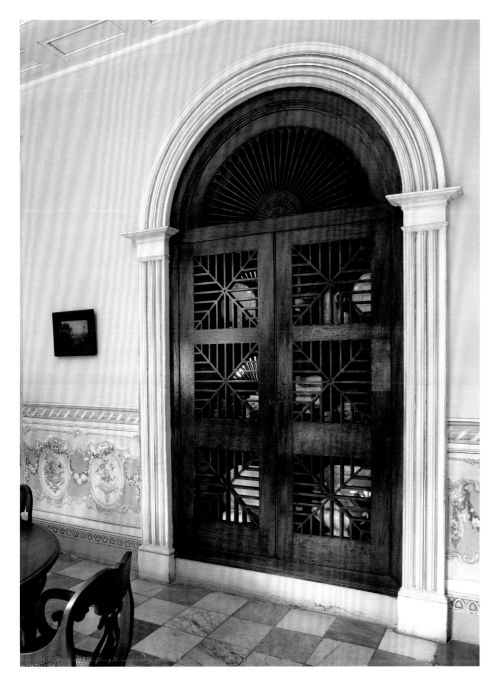
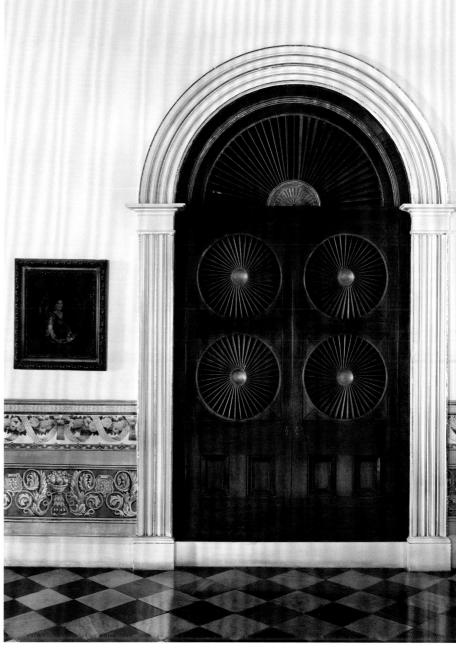

Above left and right
A built-in architectural fitted mahogany china cabinet with differently designed doors on either side allowed access from both the dining area and the living room and in addition provided airflow from room to room.

Left
Wide marble staircase with hand-carved mahogany railing, original frescoes, and the Borrell family chest.

Opposite
The elegant dining area still retains its original hand-painted frescoes, the fanned wooden mediopuntos, *and louvered windows that filter light and allow air to circulate.*

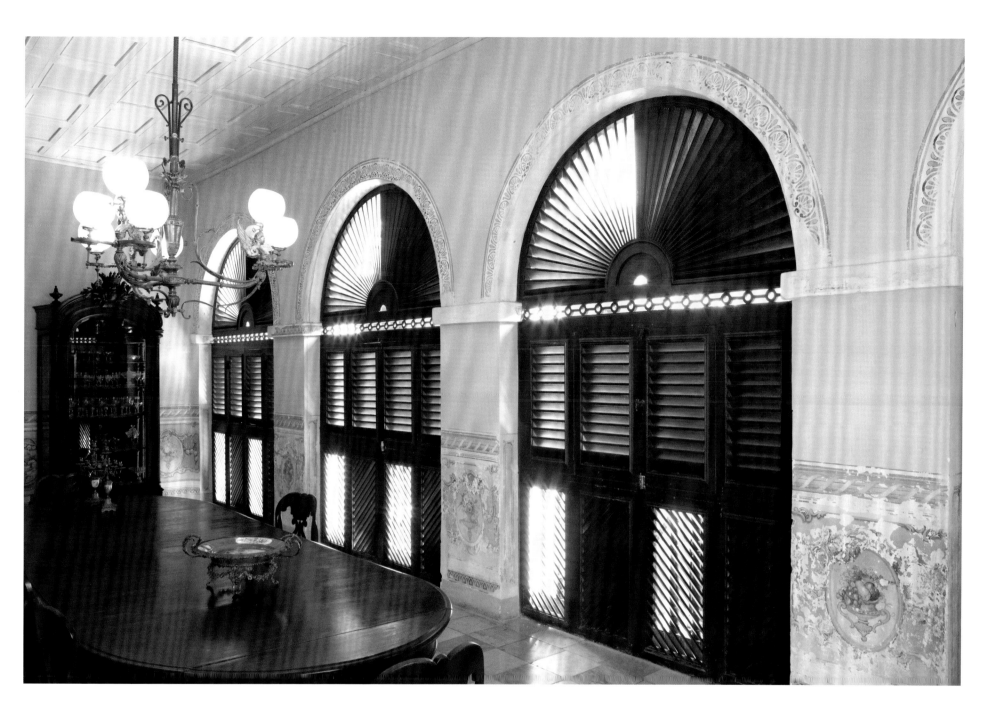

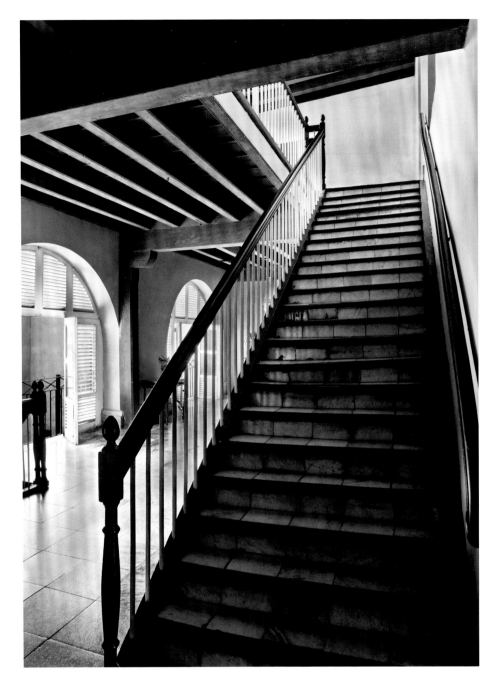
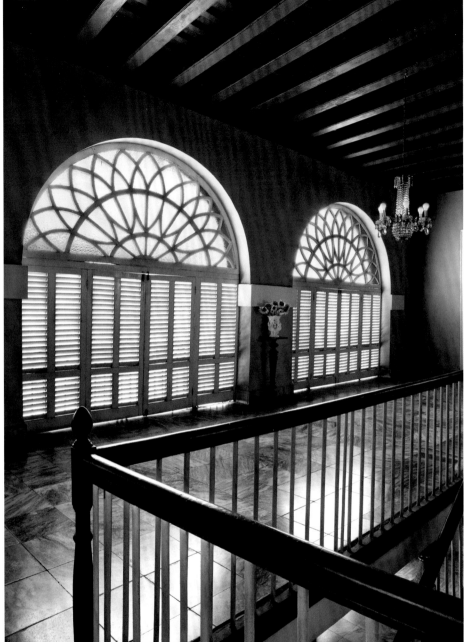

Opposite left and right
*The rear loggia of the Palacio
del Junco, constructed in 1838
in Matanzas, where the detailed
mediopuntos, or fanlights, were
designed to help light the room
and the louvered doors below
provided ventilation.*

Right
*Typical of nineteenth-century wealthy
Cuban homes are small family
dining areas when the large formal
dining rooms were not needed.*

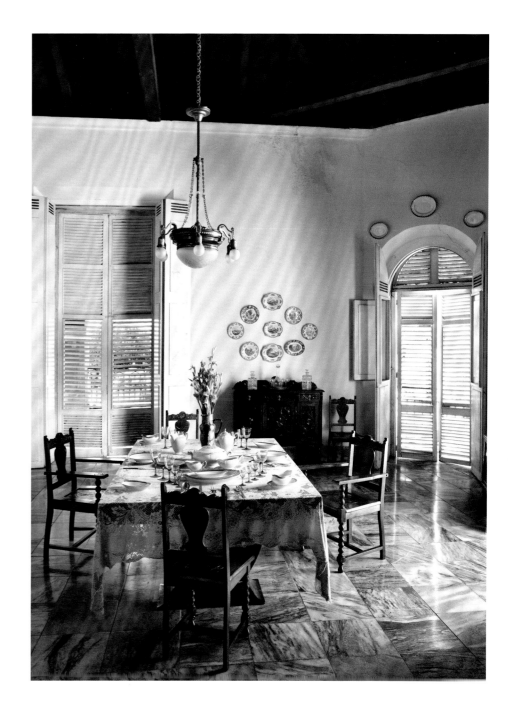

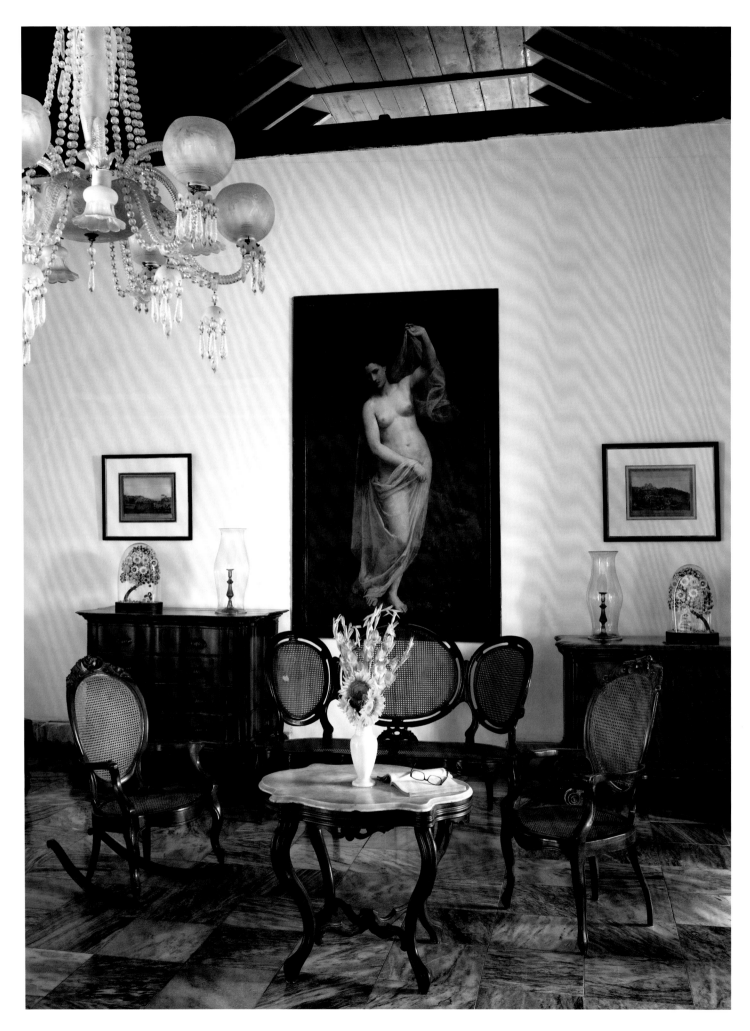

Left
The second-floor salon in nineteenth-century urban mansions had walls that did not reach the ceiling in order to provide more ventilation throughout the house.

Opposite
Large rooms with thick walls, marble floors, and numerous doors and windows were ubiquitous in Cuban colonial residences.

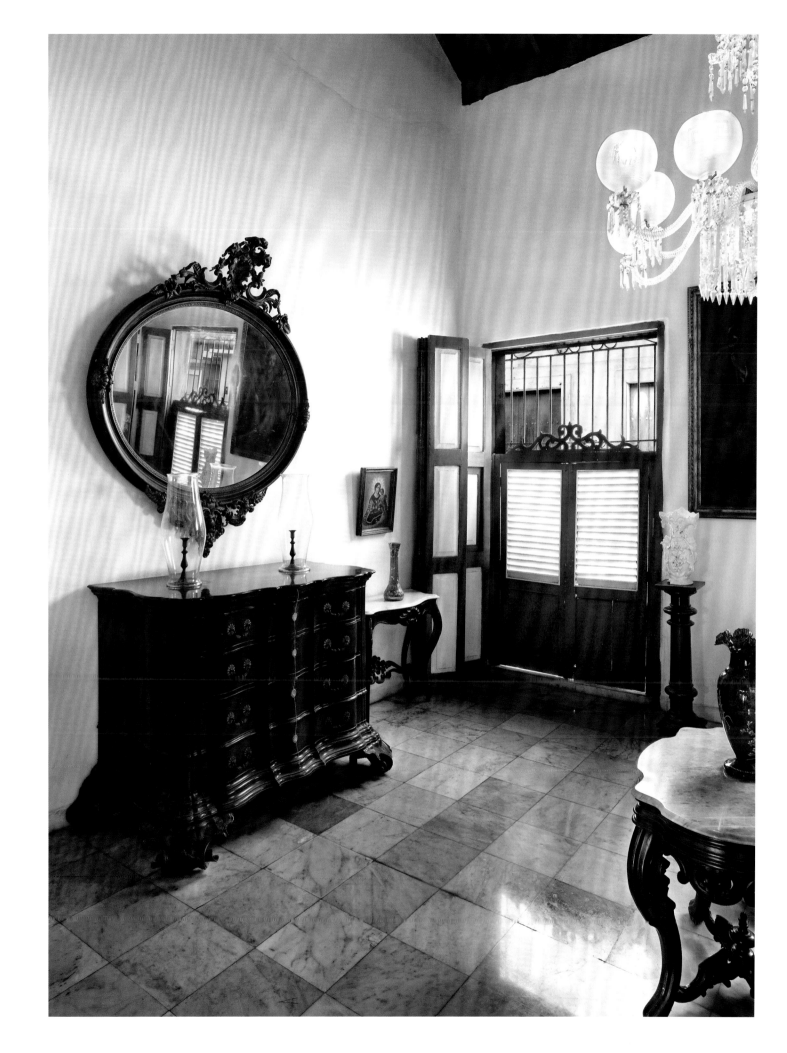

Left
Many Cuban residences have extremely high ceilings, often twenty to twenty-five feet in height.

Opposite
Often people slept with doors and windows open but were always protected by wooden or iron grilles (rejas).

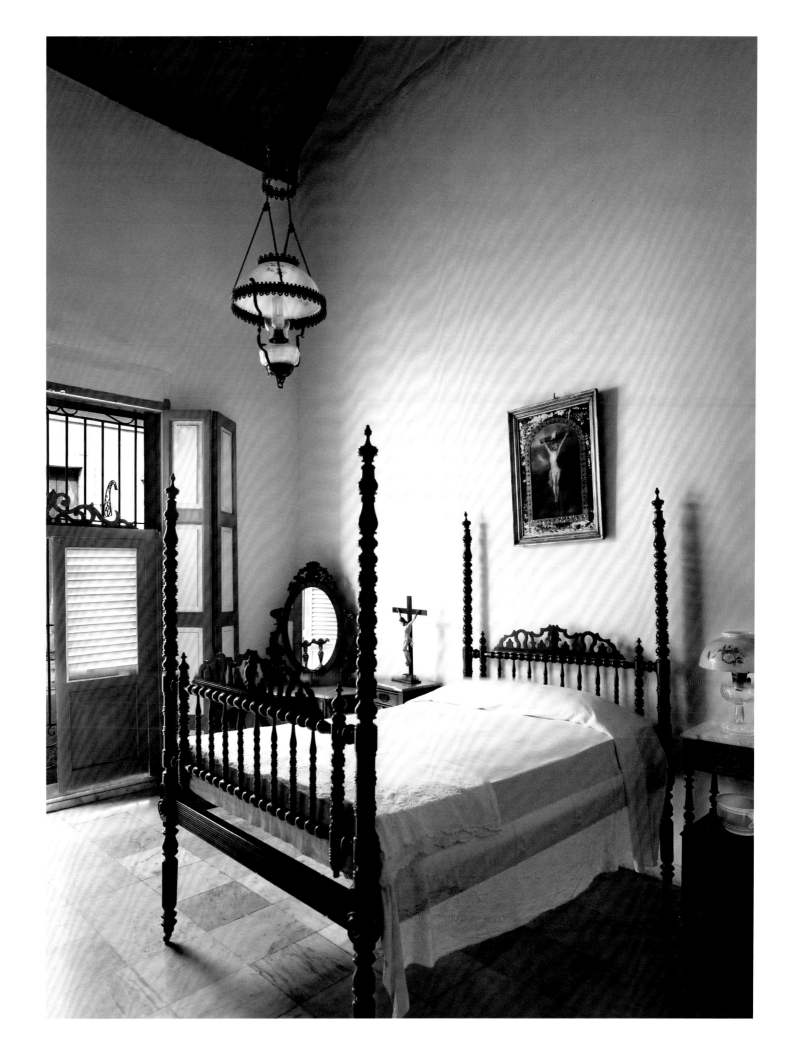

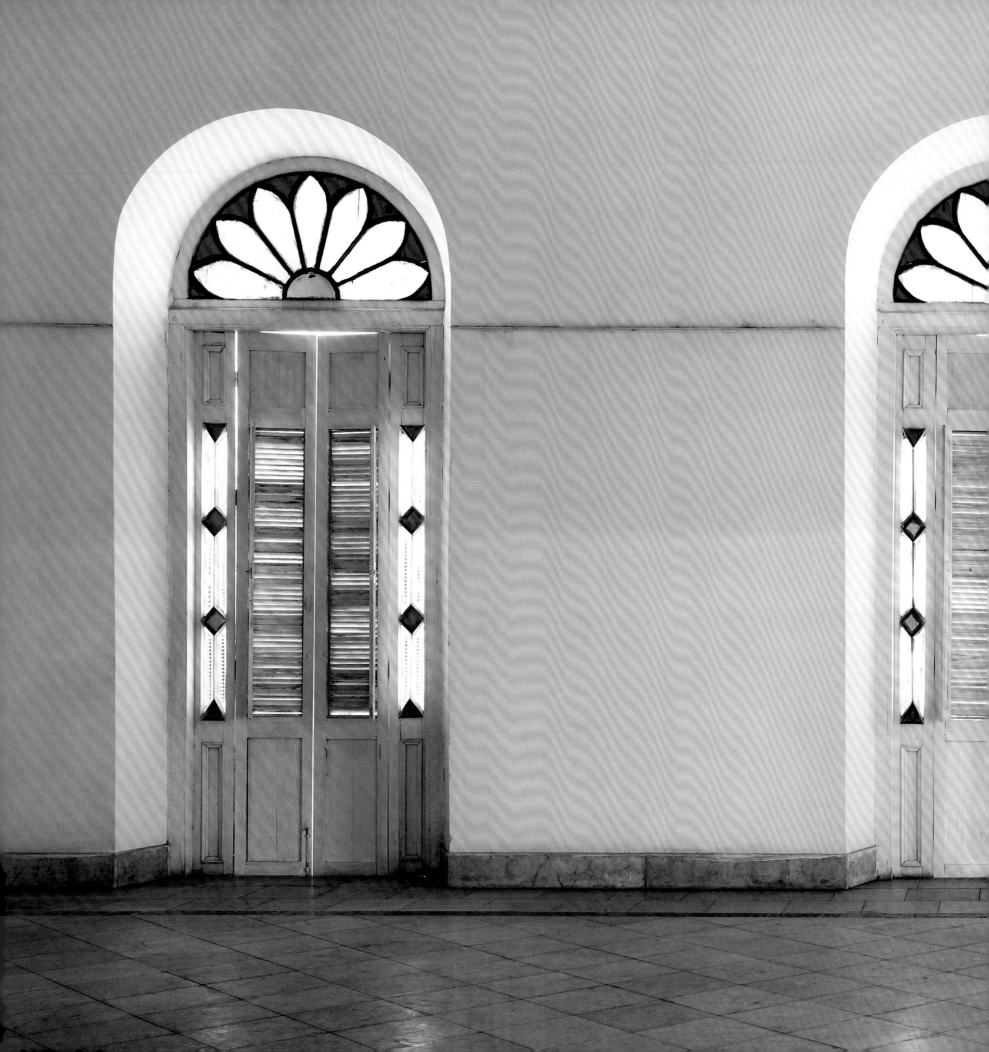

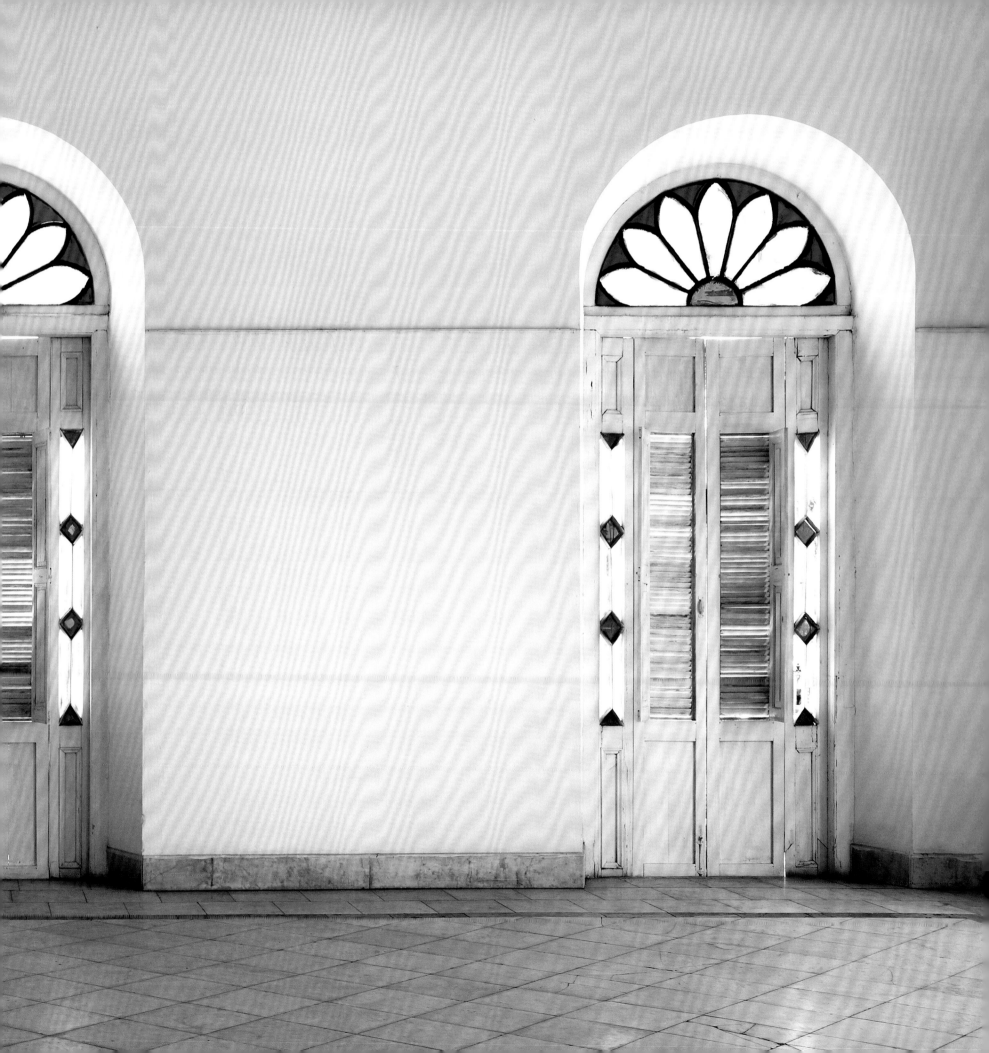

Previous spread
*The stained-glass windows
(mediopuntos) are typical of Cuba's
Creole craftsmen and were created
in the mid-eighteenth century to
protect houses from the glare of the
tropical sun.*

Left
*The front salon of a modest Cuban
residence in Trinidad.*

Opposite
*An example of original frescoes in
a nineteenth-century Camagüey
residence.*

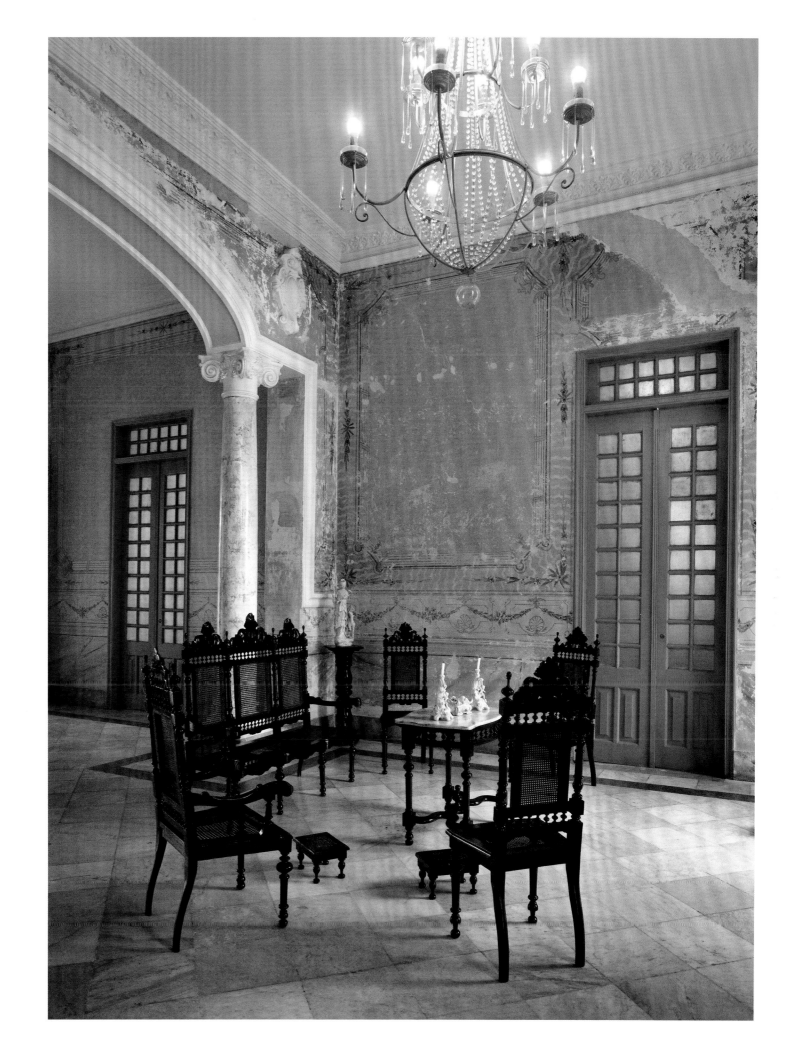

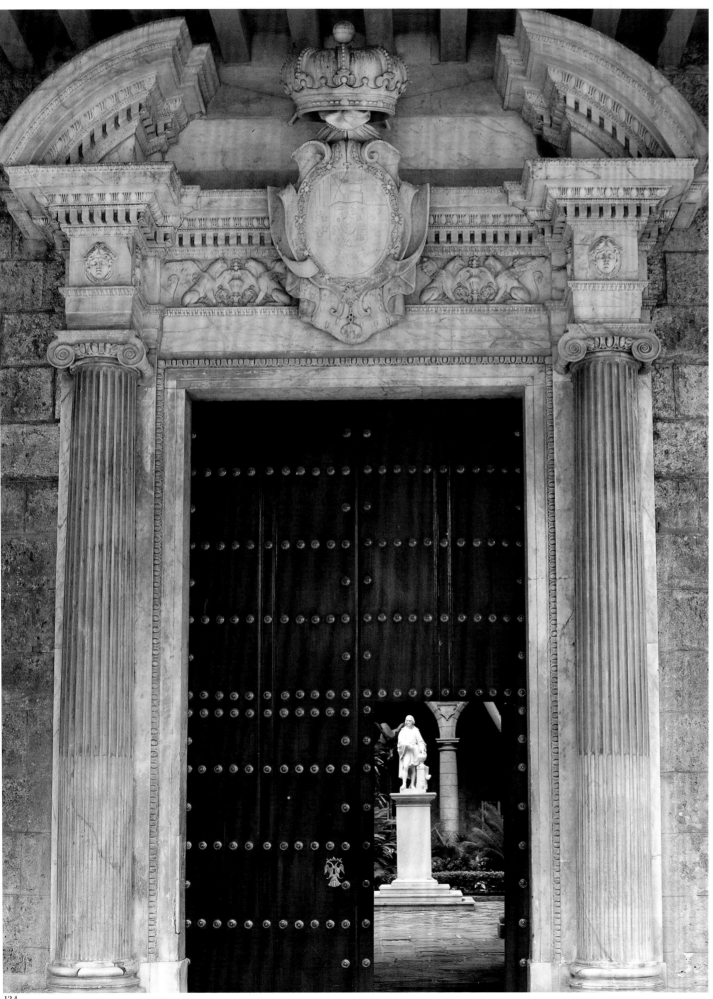

Left
The monumental marble doorway to the governor's residence, Palacio de los Capitanes Generales, in Havana was carved by Italian sculptor Giuseppe Gaggina in 1790. The hand-wrought iron studded mahogany plank doors are in a style referred to as a la española.

Opposite
The inner courtyard of Palacio de los Capitanes Generales, where one of many marble sculptures stands next to a terracotta urn, or tinajone.

Next spread
The inner courtyard of Palacio de los Capitanes Generales is surrounded by two levels of neoclassical galleries fronting the central patio.

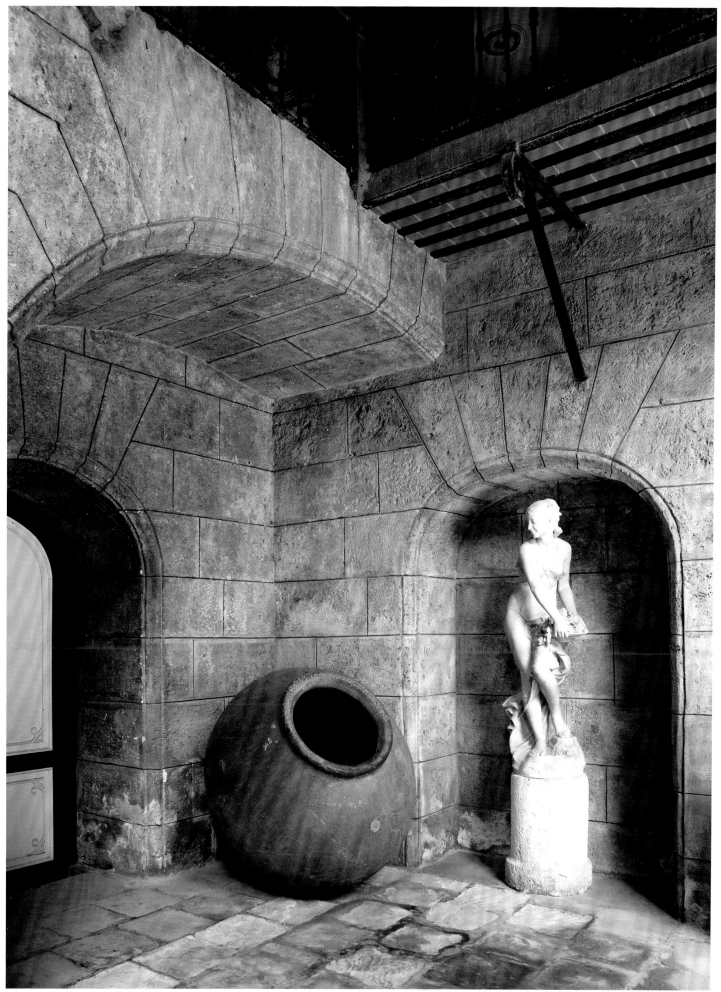

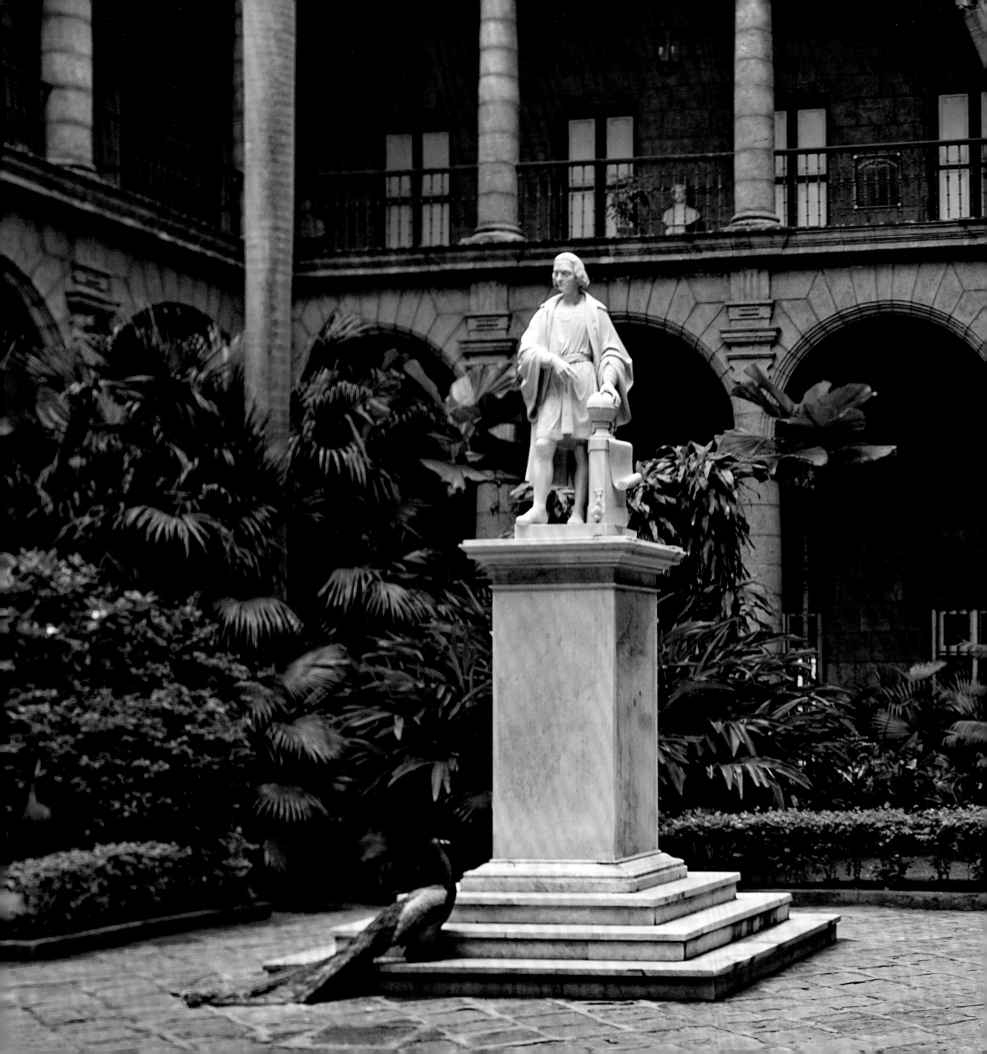

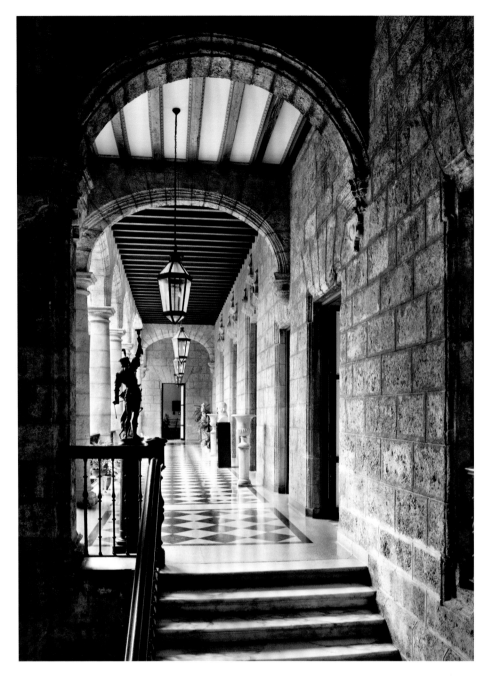

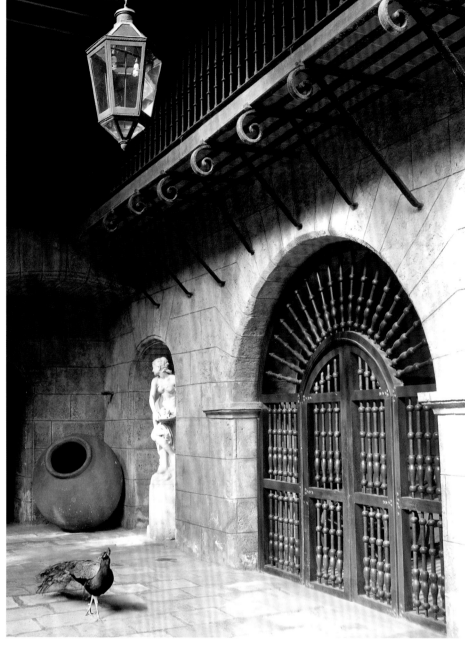

Above left
A portion of the second-floor gallery.

Above right and right
*The courtyard entrance to the stables
and carriage house.*

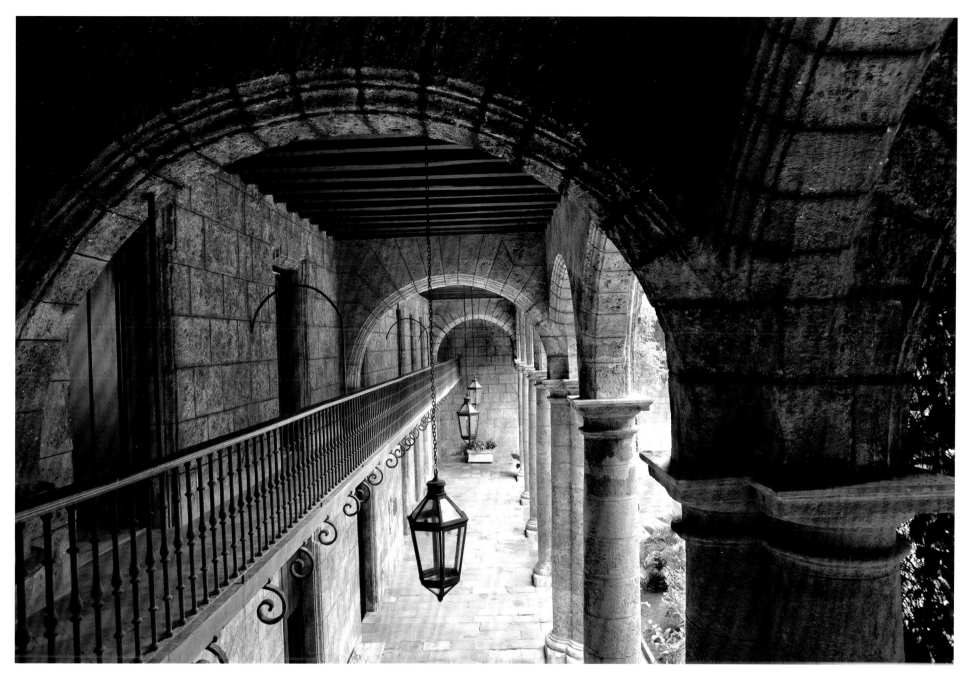

Above
*A view of the low ceiling mezzanine
(entresuelo) constructed as a hidden
partial floor from which servants
could be summoned.*

One of the many ground-floor reception rooms of Palacio de los Capitanes Generales. The vestibule (zaguán) is seen through the doors on the left, and the inner courtyard through the doors on the right.

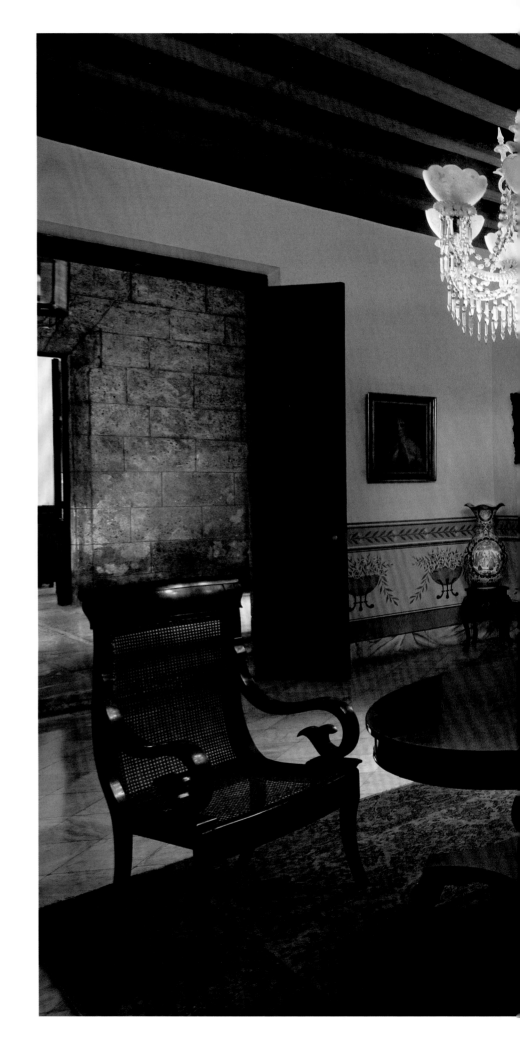

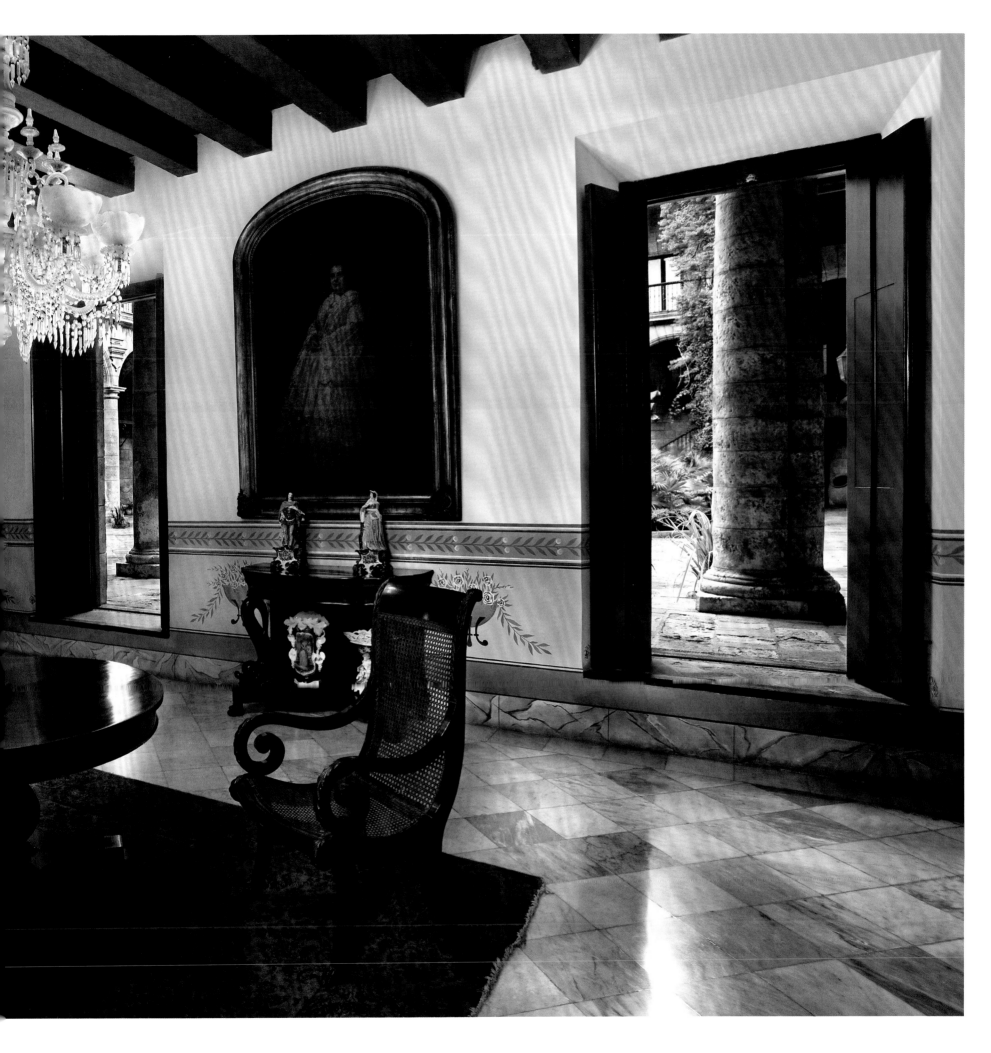

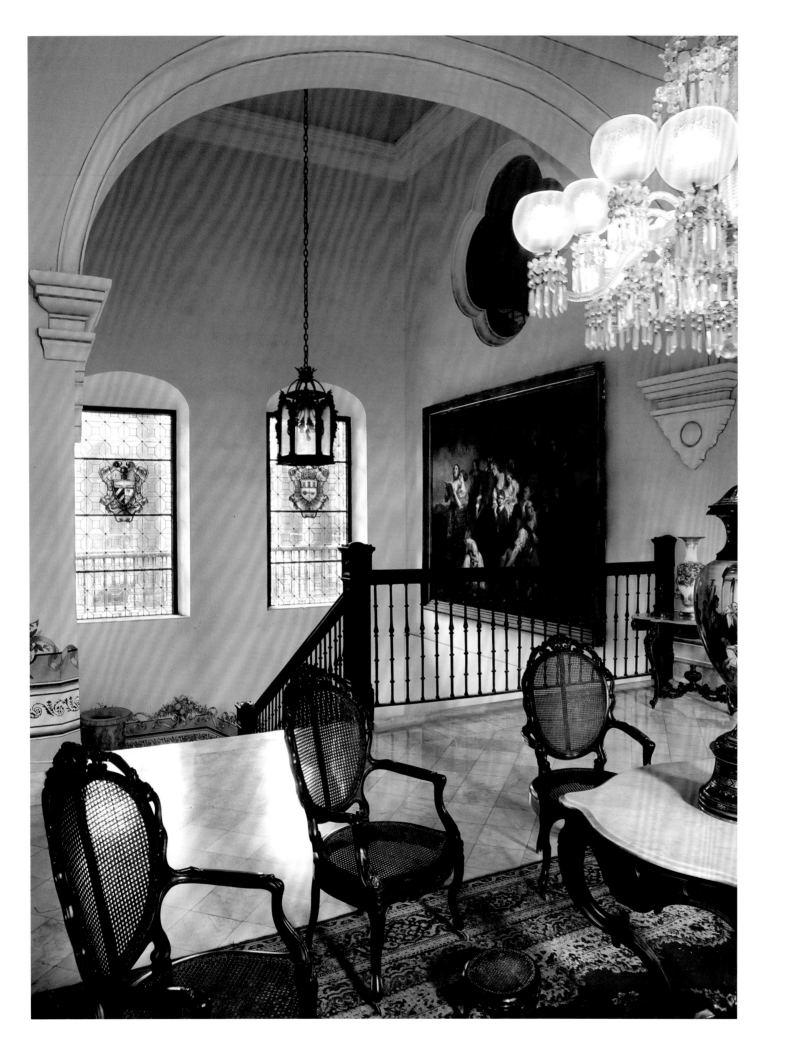

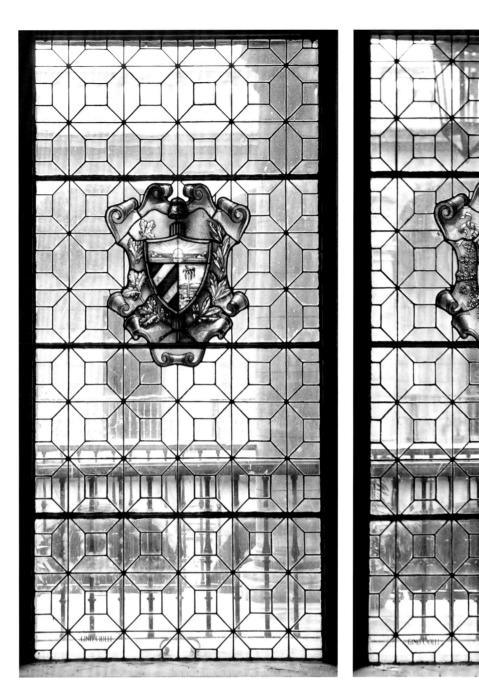

Opposite
*A second-floor informal reception
room, or* saleta, *with a wide staircase,
below stained-glass windows, leading
to the ground floor.*

Above left and right
*Detail of the pair of stained-
glass windows.*

Next spread
*The formal dining room of Palacio de
los Capitanes Generales.*

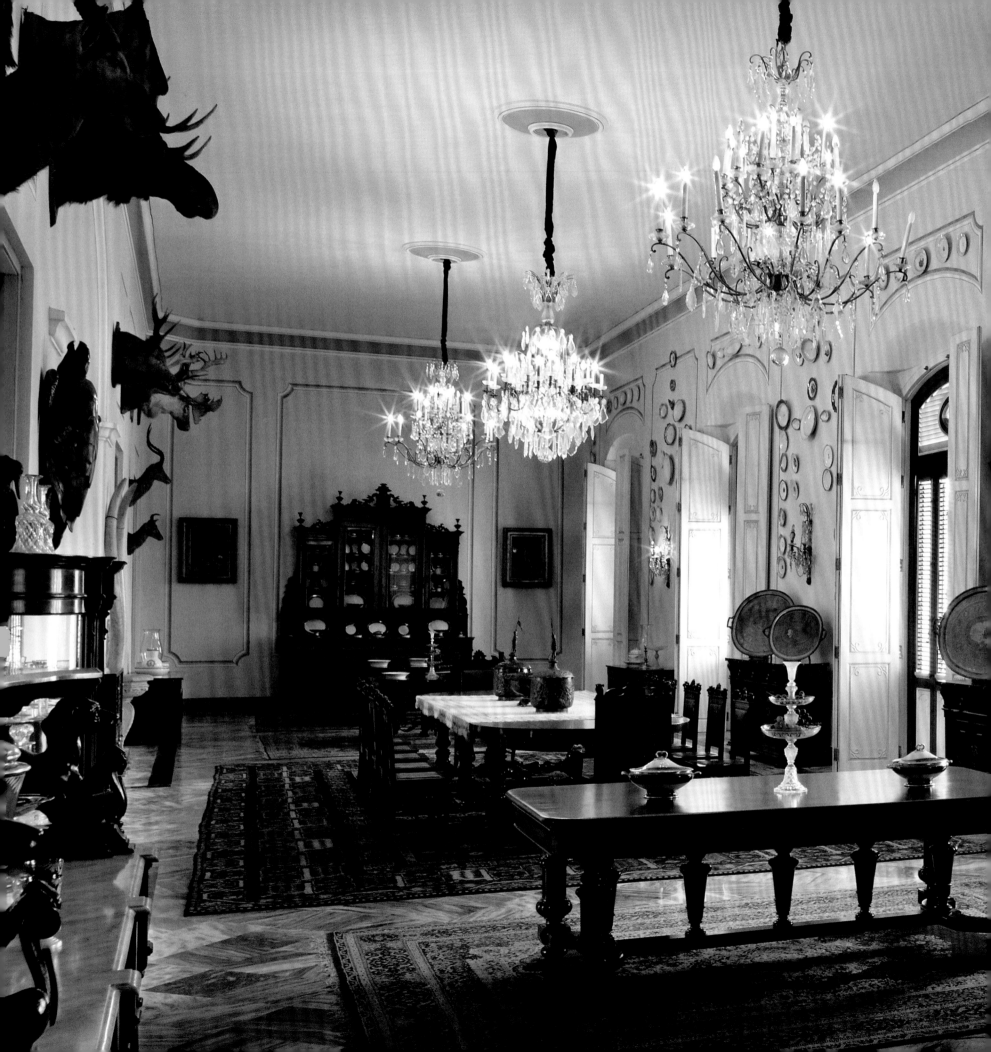

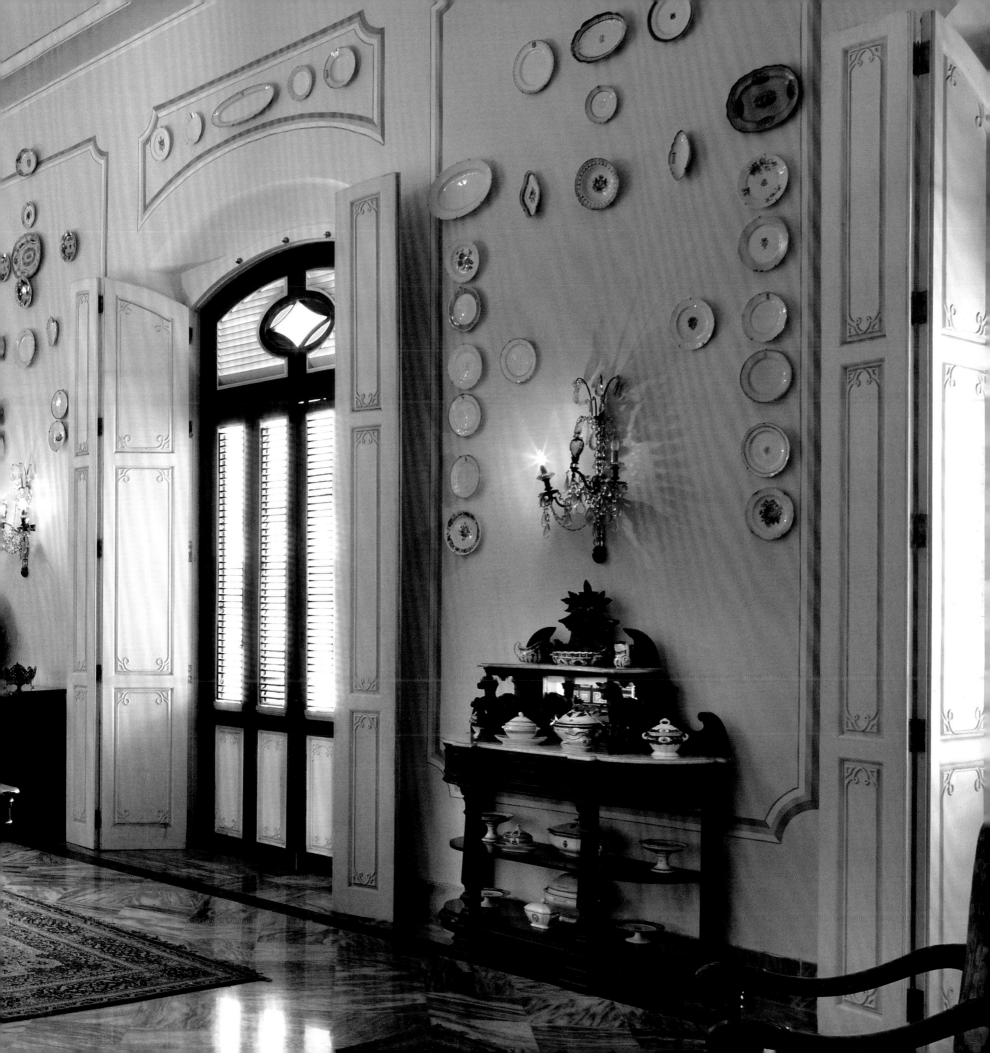

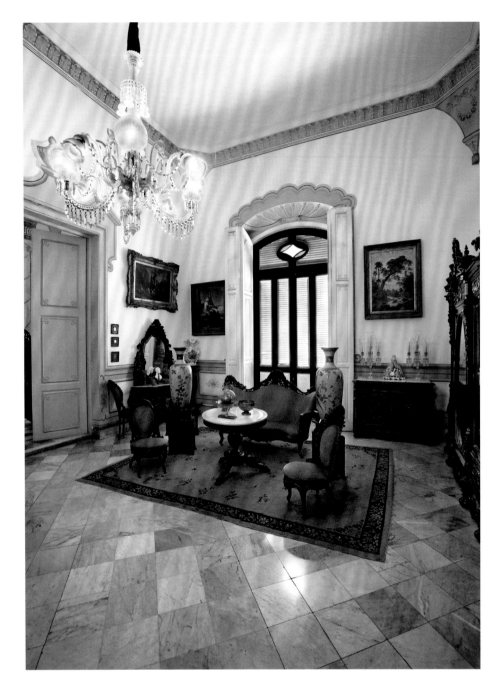

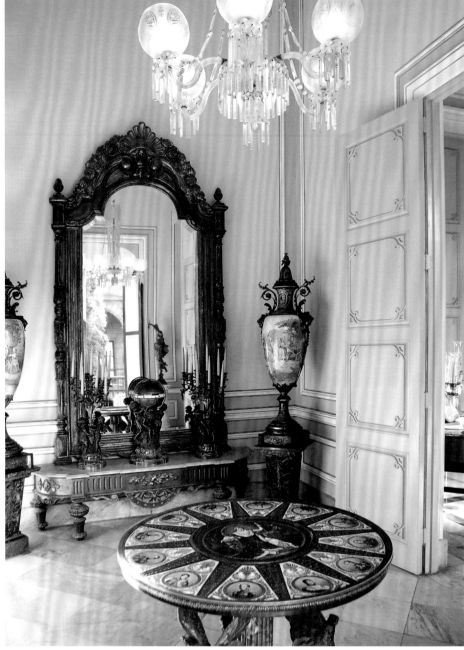

Above left
A sitting area in one of the bedrooms of Palacio de los Capitanes Generales.

Above right
The lavish interior decoration of Palacio de los Capitanes Generales was typical of residential palaces of the nineteenth century.

Opposite
The Sala del Cabido *(Hall of the Town Council), where the governor presided at Havana town council meetings.*

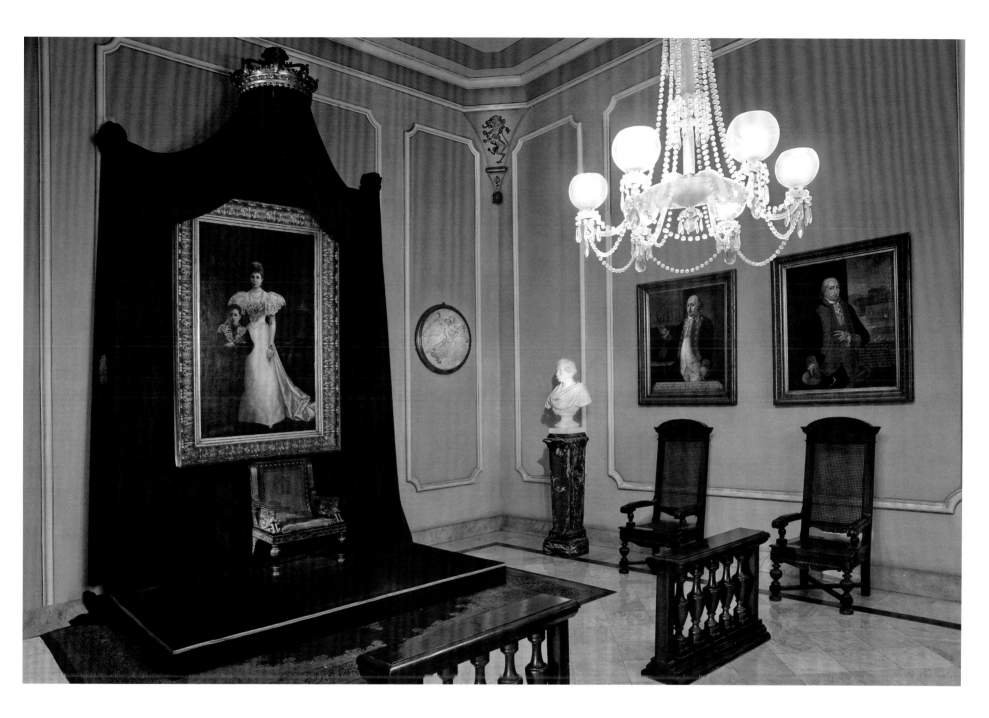

Opposite
One of two hand-carved Italian marble bathtubs in the palace. Both were in use during the 1800s.

Right
A lady's dressing table in the bathing area.

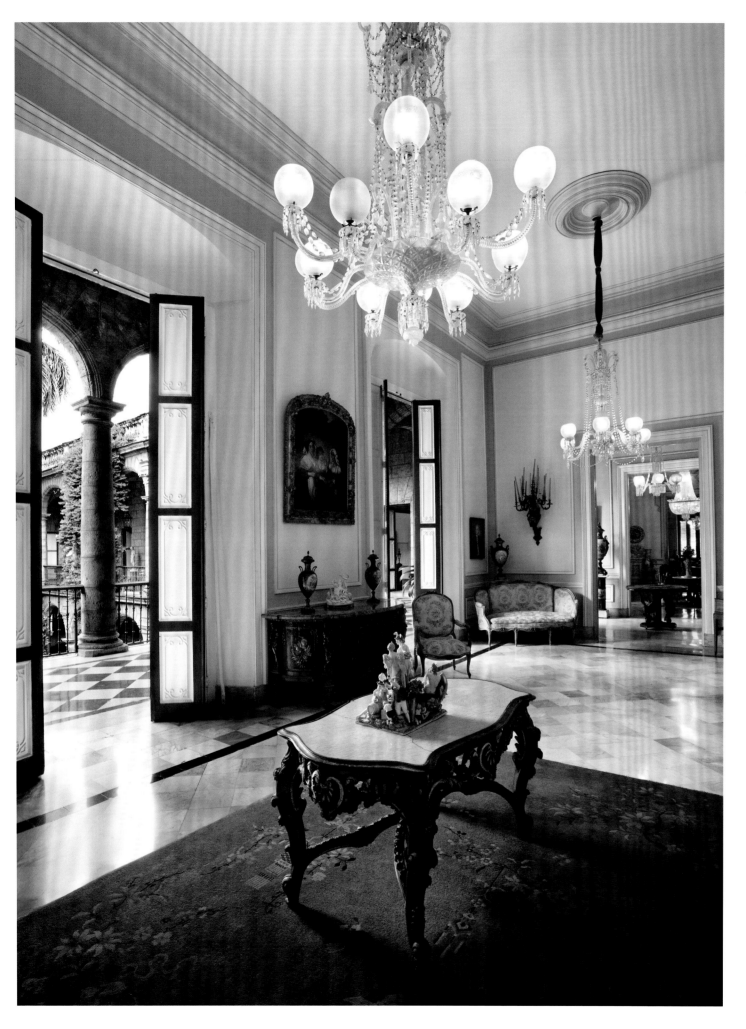

Left
Entrances from the second-floor gallery to the palace's White Hall, an antechamber used for formal receptions.

Opposite
A view of the carved-stone Tuscan columns and imported marble floors of the second-story gallery of Palacio de los Capitanes Generales, one of the last baroque palaces constructed in Havana.

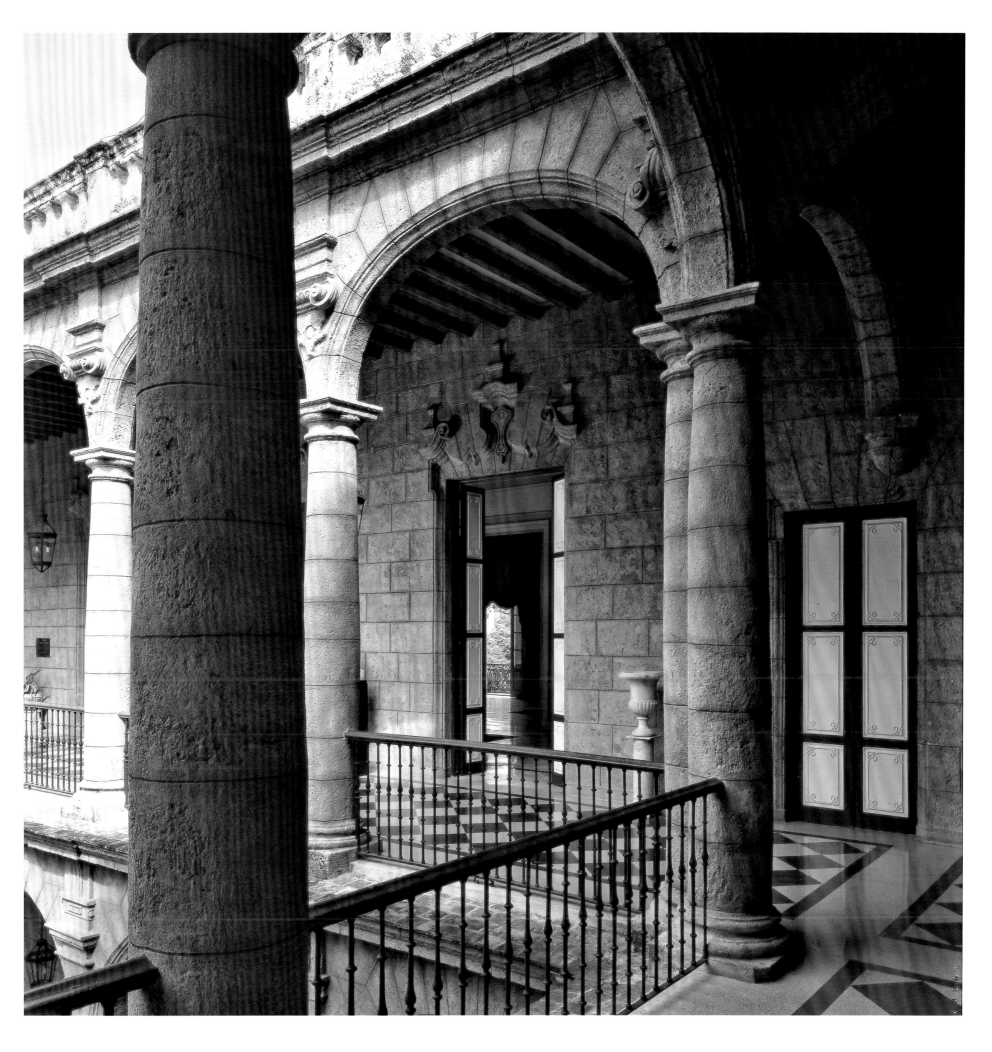

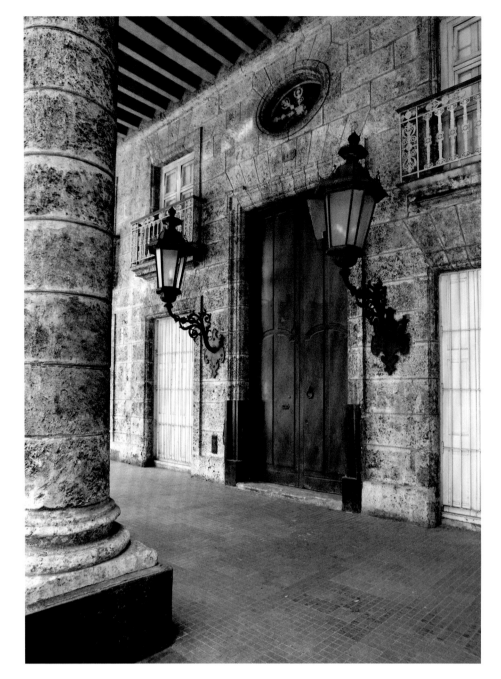
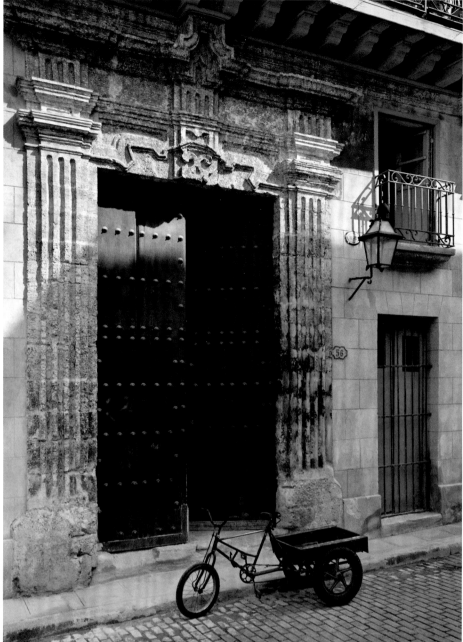

Opposite left
The main entrance to the Palacio de Domingo Aldama, one of the most outstanding nineteenth-century residences in Havana and the largest house built at the time.

Opposite right
Another nineteenth-century Havana palace portico door. Most are twelven to fifteen feet high, heavily barred and studded, and furnished with ornamental bolts and knockers.

Right
All of these palaces and mansions had high double doors to allow carriages to enter, and a smaller wicket door set in one or both of the larger doors for pedestrian traffic.

Next spread
Havana and its grand colonial architecture was referred to as "Ciudad de las Columnas," or City of Columns by Cuban novelist Alejo Carpentier. It still retains its prodigious walls of columns.

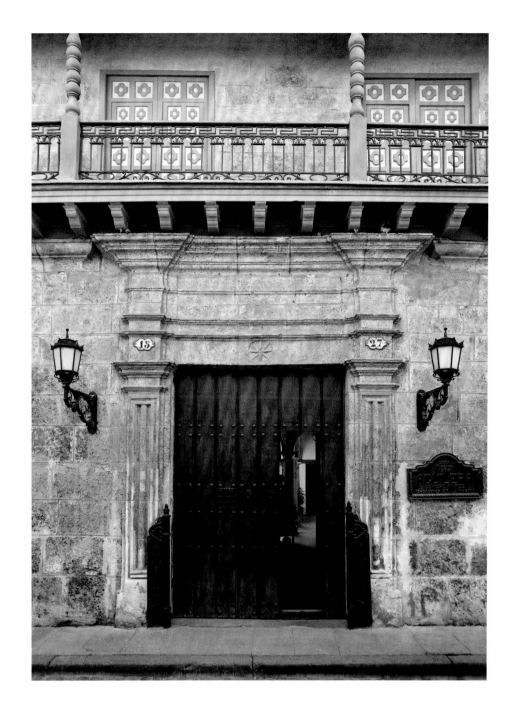

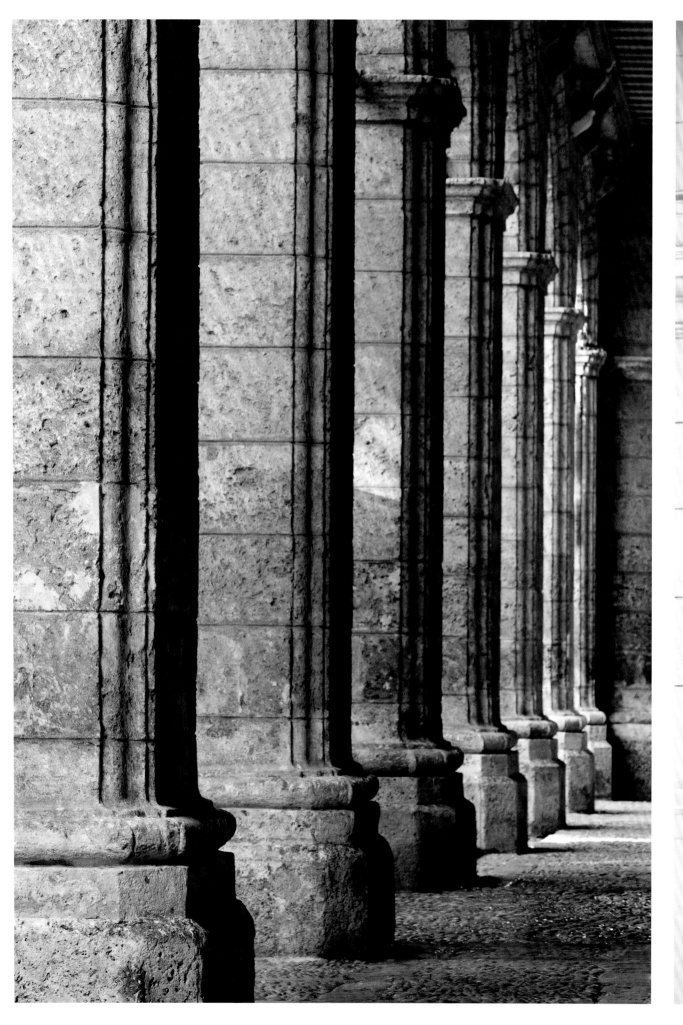
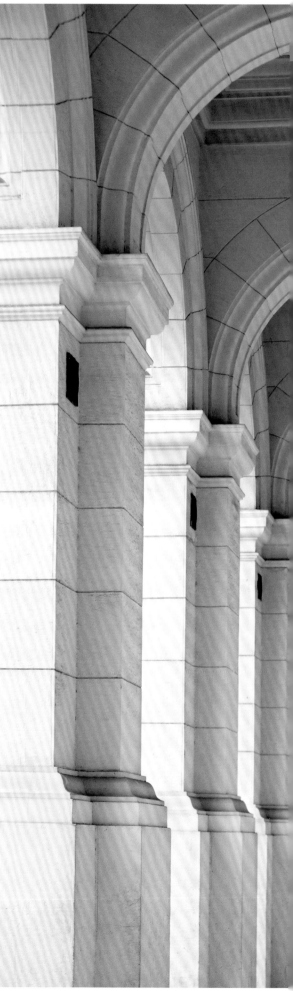

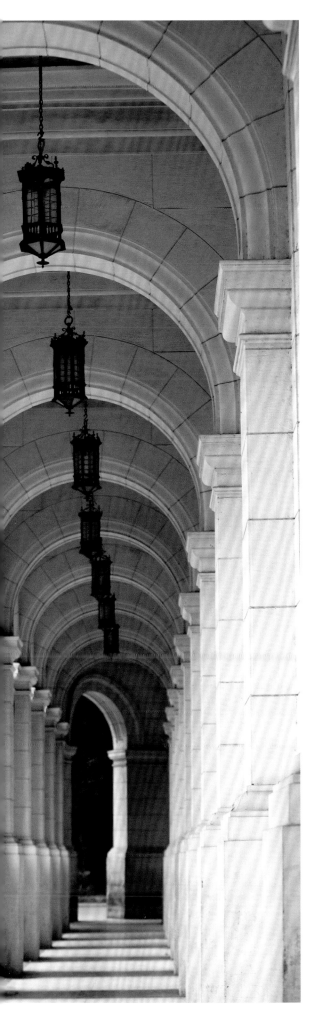
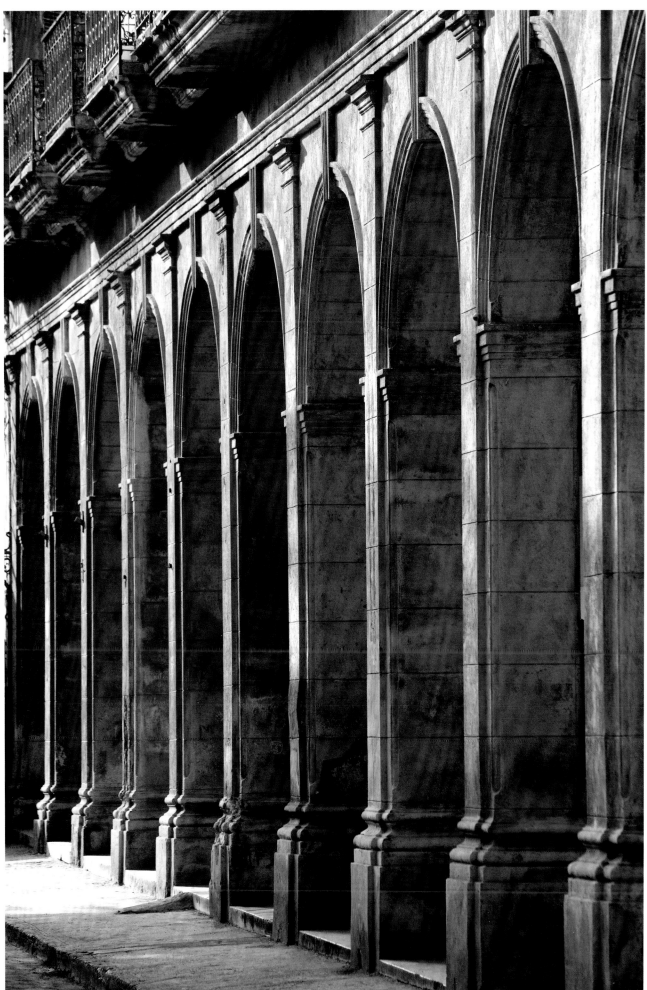

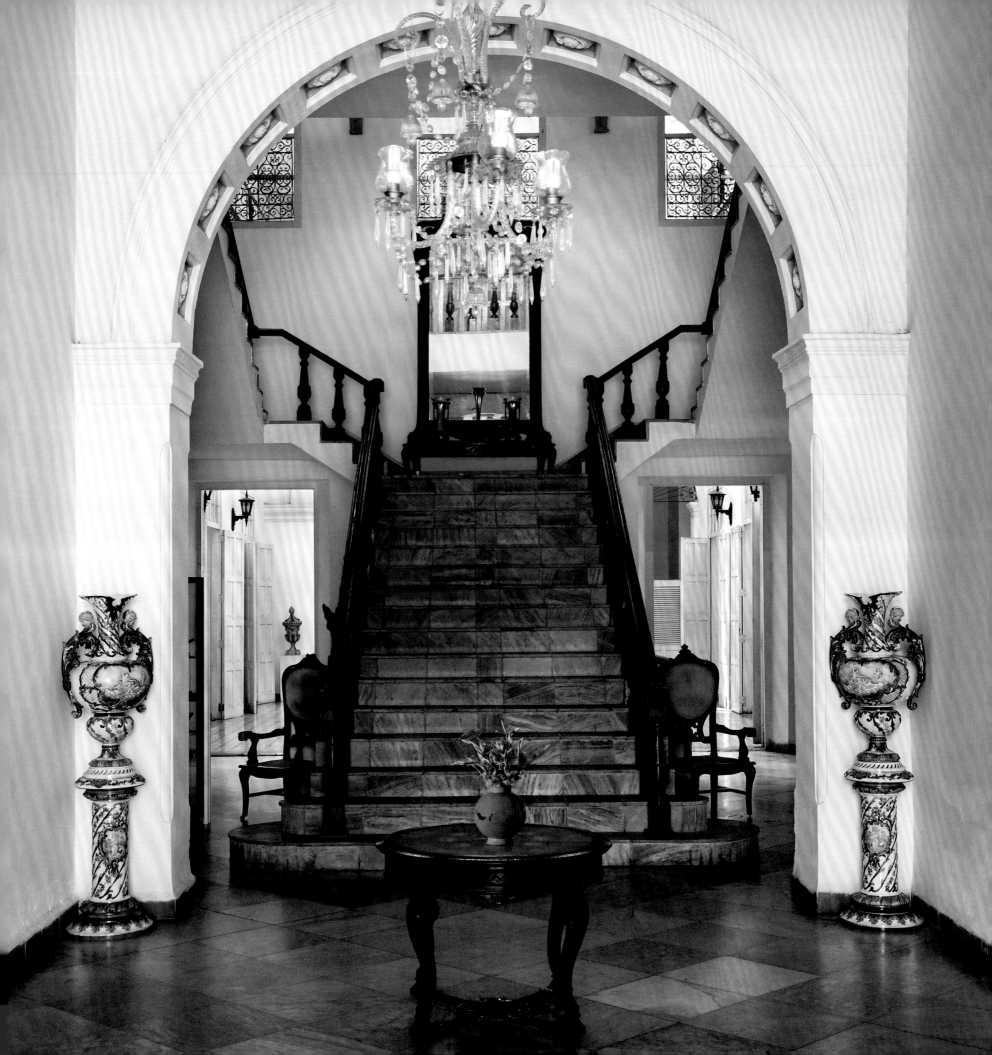

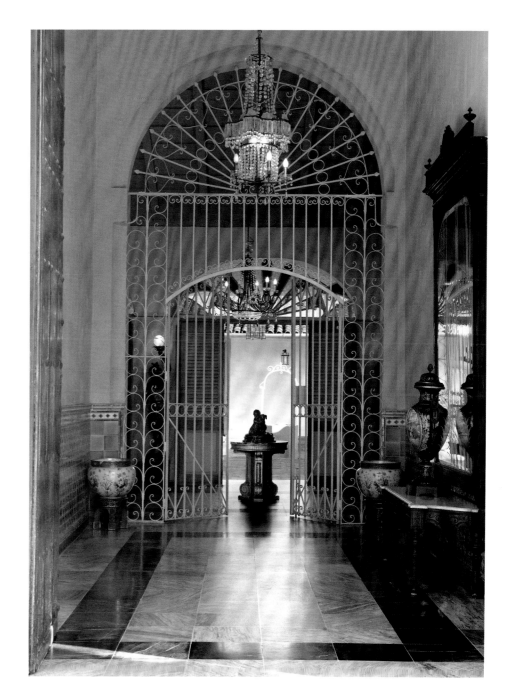

Opposite
*A residential front entrance hall
with double staircase illustrates the
nineteenth-century luxurious and
sophisticated lifestyle of Cienfuegos'
nobility.*

Above
*The entrance to the palacio of a
prominent nineteenth-century family
in Santa Clara.*

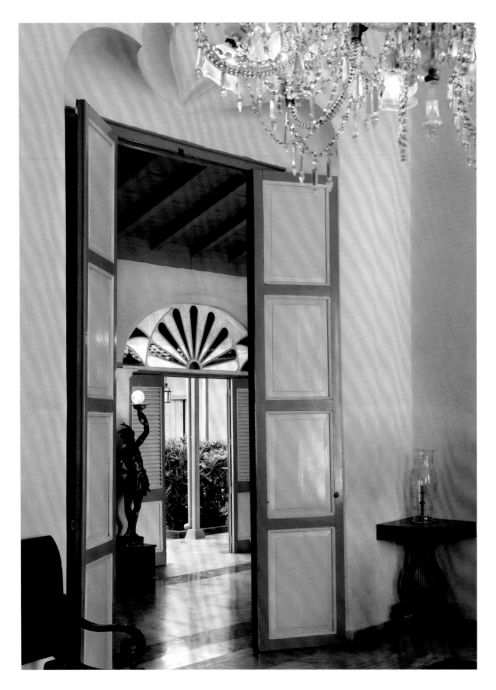

Above
*A room leading to the central courtyard
of the Santa Clara residence.*

Opposite
*The wide ground-floor gallery of the
Santa Clara mansion built in 1810.*

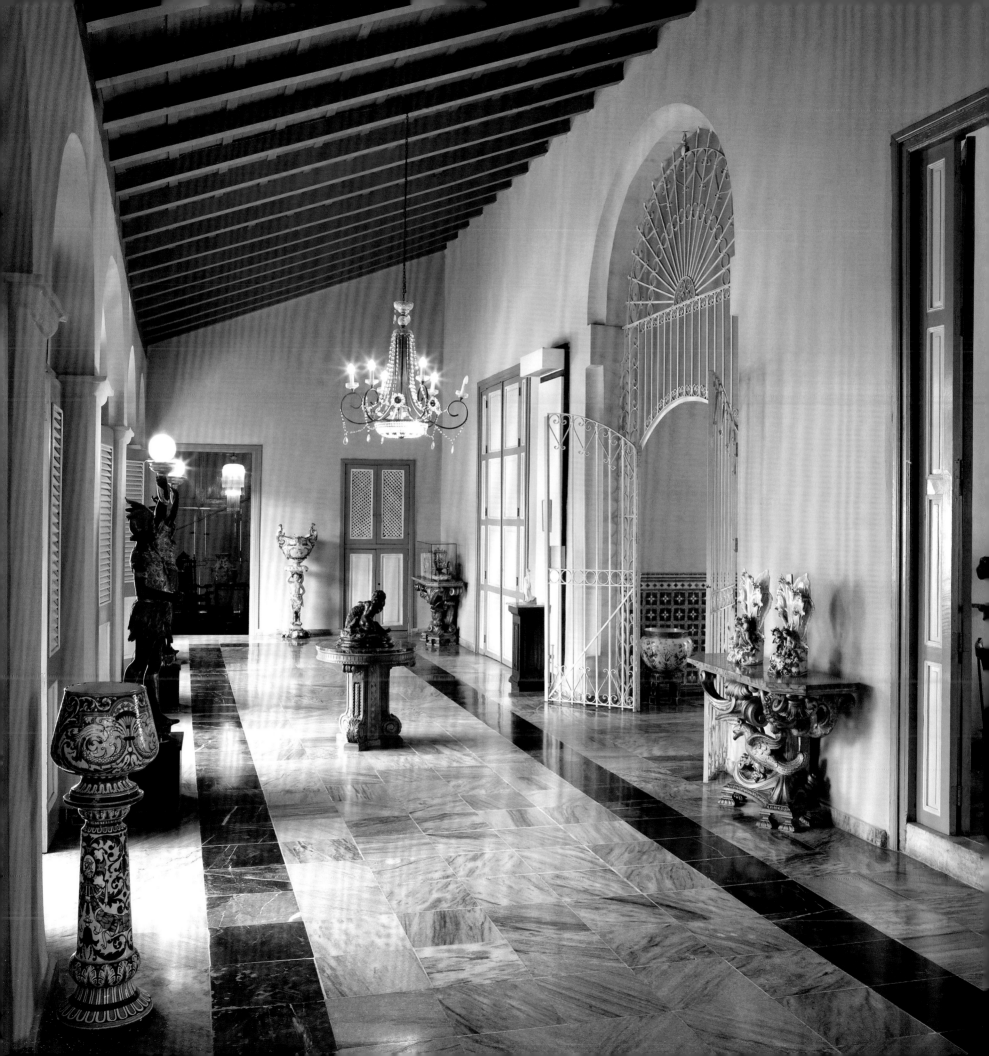

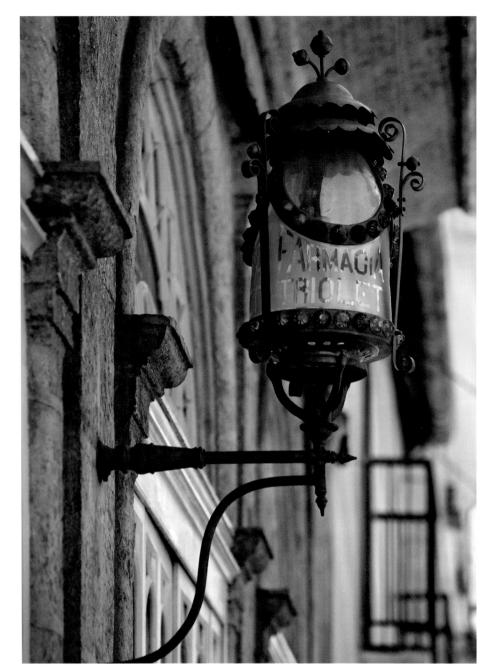
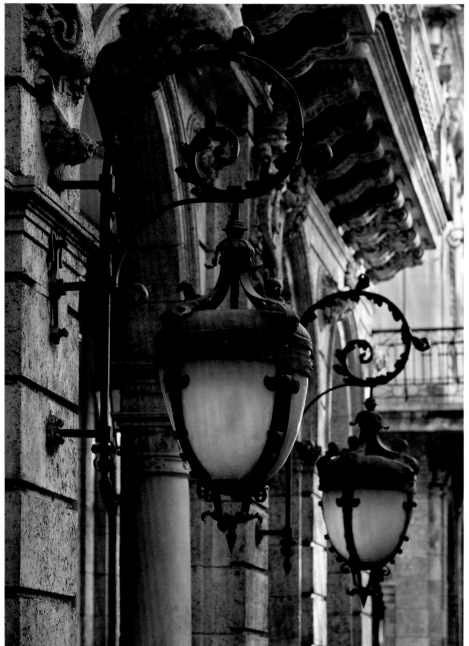

Examples of wrought-iron gas-lamp holders found throughout the island.

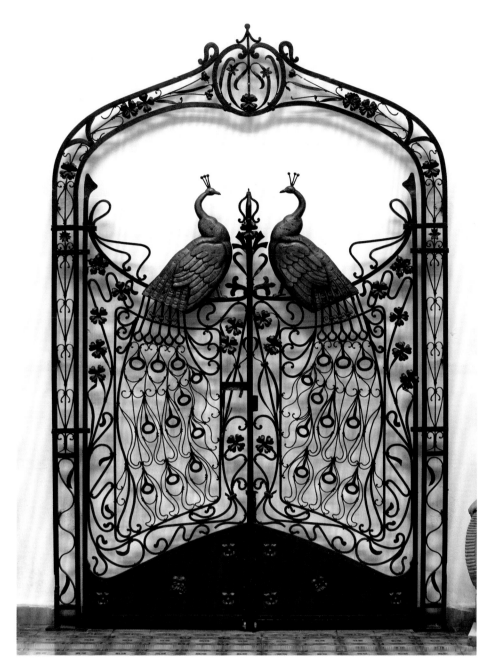

The extraordinarily intricate colonial
wrought-iron gateway craftsmanship
executed in Cuba is world renowned.

Independence and Traditionalism

During the nineteenth century Cuba entered a new phase of development, one that many historians consider the beginning of the island's modern era in that central factories were established for the processing of sugar, railroads were built, free trade was further established, and foreign capital was invested in the island.

This new century of expansion and prosperity proved unprecedented in Cuban history. The sugar barons and slavers profited so richly that the Spanish crown began to take a renewed interest in its colonial empire. During the first quarter of the nineteenth century, wars for independence raged throughout Latin America, and Spain was progressively driven from its Latin American mainland colonies. This caused a migration of Spanish loyalists to Cuba, then known as the "Ever-Faithful Isle," and brought about a new earnestness to adhere to Spanish policies and politics on the island.

Throughout the 1800s vast Caribbean wealth, mostly produced by sugar, was flaunted by an absentee island plantocracy. Different from the absentee British sugar barons who lived in London, the Danish plantocracy in Copenhagen, and the French *grand blancs* in Paris, the Spanish Cubans and loyalists chose to stay and live on the island, where they exhibited their ostentatiously noble ambitions. One of many examples of the Cuban sugar planters was:

The royal ambitions of the Cuban sugar planters were strikingly demonstrated by an incident which took place in Trinidad, one of the most fertile areas in Cuba, and one

of the chief centers of the sugar industry. Three of the leading planters of this city, Becquer, Iznaga, and Borrell, envious of the reputation and magnificence of Havana, decided to challenge the capital's supremacy. They planned a competition among themselves to build palaces which would put those of Havana in the shade. The competition was soon converted into a personal rivalry between the three grandees. A rumor arose to the effect that Becquer lacked the funds to complete his grandiose plan. To disprove the falsity of the allegation, he decided to pave his palace with gold coins. His scheme was frustrated, however, because the Captain-General of the island pointed out that it was forbidden to walk on the king's head, which appeared on the coins.[27]

It was further rumored that to avoid reproach Becquer then proposed to lay the mosaic of gold doubloons on their edges.

The "Bourbon enlightenment" by which Spain's King Charles III ruled Cuba was not necessarily accepted by all members of the Cuban aristocracy. There was a division between the native, or first-generation, Spaniards (*Peninsulares*) and the Cuban-born Creole members (*Criollos*). The Spaniards, many of whom held new pseudotitles created and awarded by the monarchy to give them incentive to immigrate to the island, were assigned influential government jobs and held high posts in public life and commerce. The Creoles who owned the biggest plantations and principal sugar manufacturing and slave trading enterprises were largely responsible for the development and success of the island's economy, and in time a passionate loathing grew between the two privileged classes of islanders. Consequently, Cuba's wealthy Creole class began to feel alienated from Spain, which ultimately drove the colony toward a desire for independence from the mother country.

The baroque style began to bow out entirely with the beginning of the nineteenth century, and Cuba's "sugar palaces" were designed in the more fashionable neoclassical style with tall classical columns and engaged pillars, both with classical-order capitals. In addition, there were large enclosed, but airy, courtyards and patios with surrounding galleried arcades incorporating columns, balconies with intricately carved classical arches, and shuttered windows and doorways.

The brilliance of the new nineteenth-century taste is best exemplified by Palacio de Domingo Aldama. Considered to be the most outstanding residential *palacio* in Cuba, this enormous mid-nineteenth-century residence was designed by Venezuelan-born Manuel José Carrerá, one of the most prestigious architects of the day, and was constructed entirely of ashlar masonry by slaves. Built for the Spaniard Domingo Aldama and his son-in-law, Domingo del Monte, the colossally grand building is actually two large residential mansions expressed on the exterior as a single *palacio*. The best example of Cuban neoclassicism occupies nearly an entire block and has three façades bordering the streets that make up the city block.

Its principal façade has a majestically wide semipublic architrave portico with tall columns that have Doric pedestals and capitals. This very large Tuscan-like colonnade was one of the first to appear in Cuba and immediately became a fashion and a widespread influential architectural feature, particularly in Havana. Porticoes had been constructed in earlier colonial houses but never to this scale, and in the nineteenth century they became a fashionable necessity and an integral feature in any aristocratic home.

Palacio Aldama's second-floor façade is a series of engaged Ionic pilasters alternating with French windows crowned by classical cornices, opening onto a long, elaborate cast-iron balustrade balcony.

The Palacio Aldama's interior was appointed with only luxurious details, such as the first water closet built in Cuba—long before they existed anywhere except England. The *palacio*

contain[s] a varied range of marble floors, sumptuous details in iron and bronze, wonderful use of precious woods for the doors and doorframes, and rich classical moldings on both walls and ceilings; some ceilings are also decorated with murals inspired by those of Pompeii. These interiors were filled with richly carved furniture, Chinese and Japanese bronzes, Persian rugs, Gobelin tapestries, majestic sconces, and great alabaster jars.[28]

Another example of unbridled luxury in Cuba's neoclassical movement is in Palacio de la Marquesa de Villalba, intended to be an Italian Renaissance palace but with a towering portico so typical of Cuban architecture during the time. The *palacio* was designed by Cuban architect Eugenio Rayneri y Sorrentino for the Count of Casa-Moré in an area of Havana that became available after the seventeenth-century city-fortification wall was demolished in 1863. Built in part from stone that was taken from the city wall, the grand mansion is an extraordinary example of Cuban neoclassicism and is similar to the Aldama Palace not only in its classical features but in that it consists of two great houses unified by a single consistent three-sided façade.

Cuba's neoclassical style continued, manifested in the *palacios* and grand *mansiones* throughout the island and in the somewhat smaller freestanding country houses or villas (*quintas*) that began to appear on city outskirts and in Havana's El Cerro district.

El Cerro was originally an area of summer residences built in the neoclassical style, one more extravagantly Italianate than the next. The most elegant and luxurious of the summer villas erected was the Quinta del Conde de

Previous spread
Alabaster statue of Mata Hari in the entrance of Palacio de Joaquín Gómez, dating from 1838.

Above
One of the many nineteenth-century neoclassical marble statues placed throughout Havana.

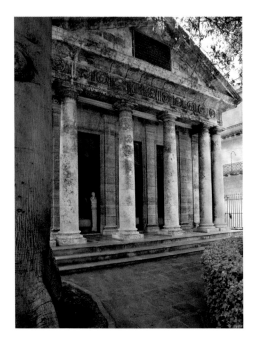

years it was used as a summer residence, it was frequently visited by world-famous celebrities and families of Havana's aristocracy. In 1872 the third son of Tsar Alexander II (r. 1855–81) and heir to the Russian imperial throne, Grand Duke Alexis, stayed at the house. The portico extends along the entire façade and is composed by a rhythmical colonnade linked by iron railings.

Among the many *quintas* that were constructed, probably the most atypical one is Quinta Palatino, built in 1905 by Charles Brun on the Las Delicias estates. Nicknamed "the castle" because of its French feudal architectural design, it was also called "The Monkey's Villa," which referred to the collection of nearly two hundred monkeys and apes that owner Rosalia Abreu had. In her memoir, Isadora Duncan described her visit to the house in 1916:

Another house where I visited was inhabited by a member of one of the oldest families who had a fancy for monkeys and gorillas. The garden of the old house was filled with cages in which this old lady kept her pets. Her house was a point of interest to all visitors, whom she entertained lavishly, receiving her guests with a monkey on her shoulder and holding a gorilla by the hand.... I asked if they were not dangerous and she replied nonchalantly that apart from getting out of their cages and killing a gardener every now and then, they were quite safe. This information made me rather anxious and I was glad when the time came to depart.[29]

One of Cuba's best examples outside of Havana of pure neoclassicism in domestic architecture is Palacio de Justo Cantero, built in Trinidad the first quarter of the nineteenth century. Considered to be one of the island's most luxurious period palaces, it has Carrara marble floors, finely painted frescoed walls, and Roman-style baths with a fountain that once spouted eau de cologne for ladies and gin for the gentlemen.

Throughout the century, Spain continued to rule Cuba poorly with a colonial policy based on exploitation and for the benefit of the native-born Spaniards (*Peninsulares*). In 1868 the planter Carlos Manuel de Céspedes liberated the enslaved workers on his plantation; because of this action, what is known as the Ten Years' War for independence from Spain began. Generalo Máximo Gómez and Antonio Macéo liberated much of the island, but in 1878 the rebel movement collapsed. It was taken up again in 1892 by one of Cuba's most important writers, José Martí, when he joined forces with Goméz and Macéo and launched the War of Independence in 1895.

The emancipation of Cuban slaves in 1886 and the final success of the War of Independence in 1898 brought about the decline of the sugar economy and the beginning of the dissolution of Cuba's plantocracy.

The Teatro Tomás Terry was built in 1886. World-famous figures such as Sarah Bernhardt and Enrico Caruso performed there.

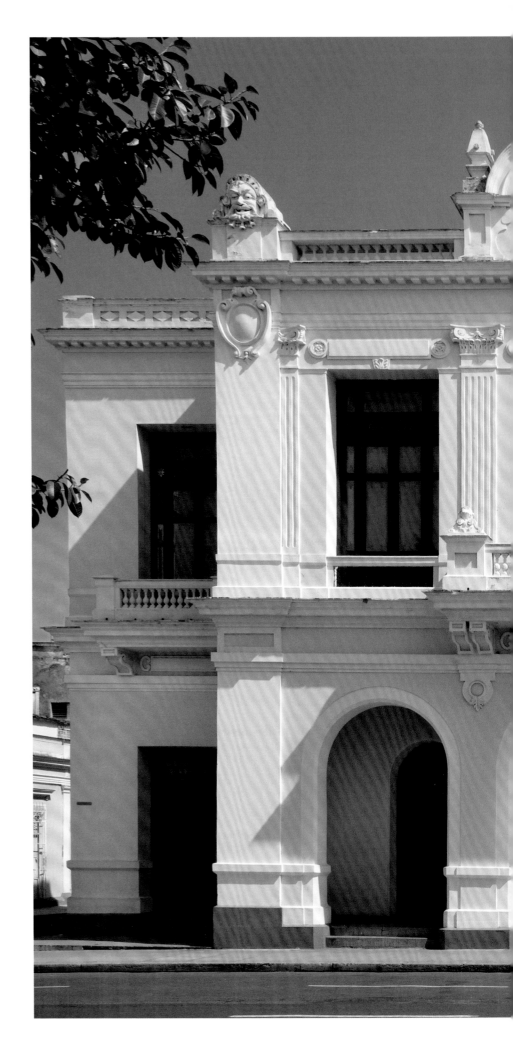

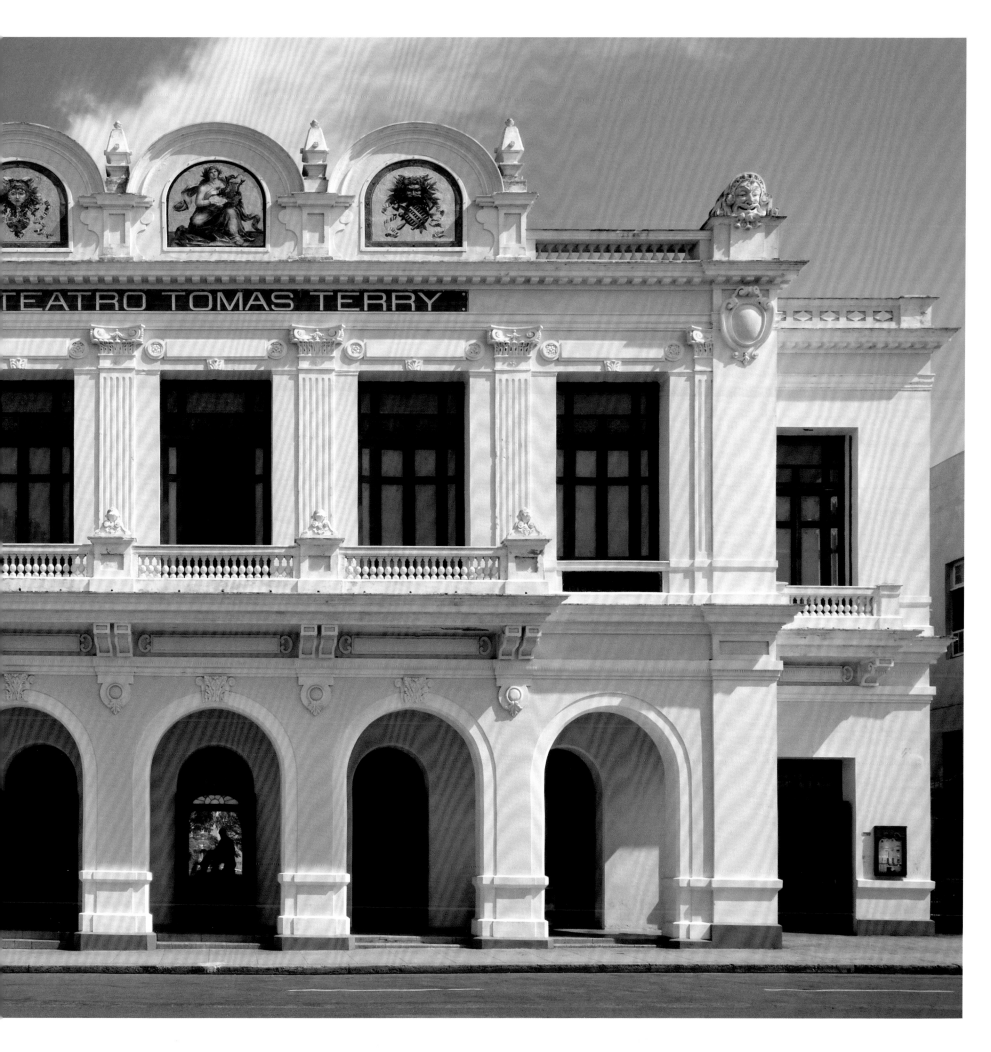

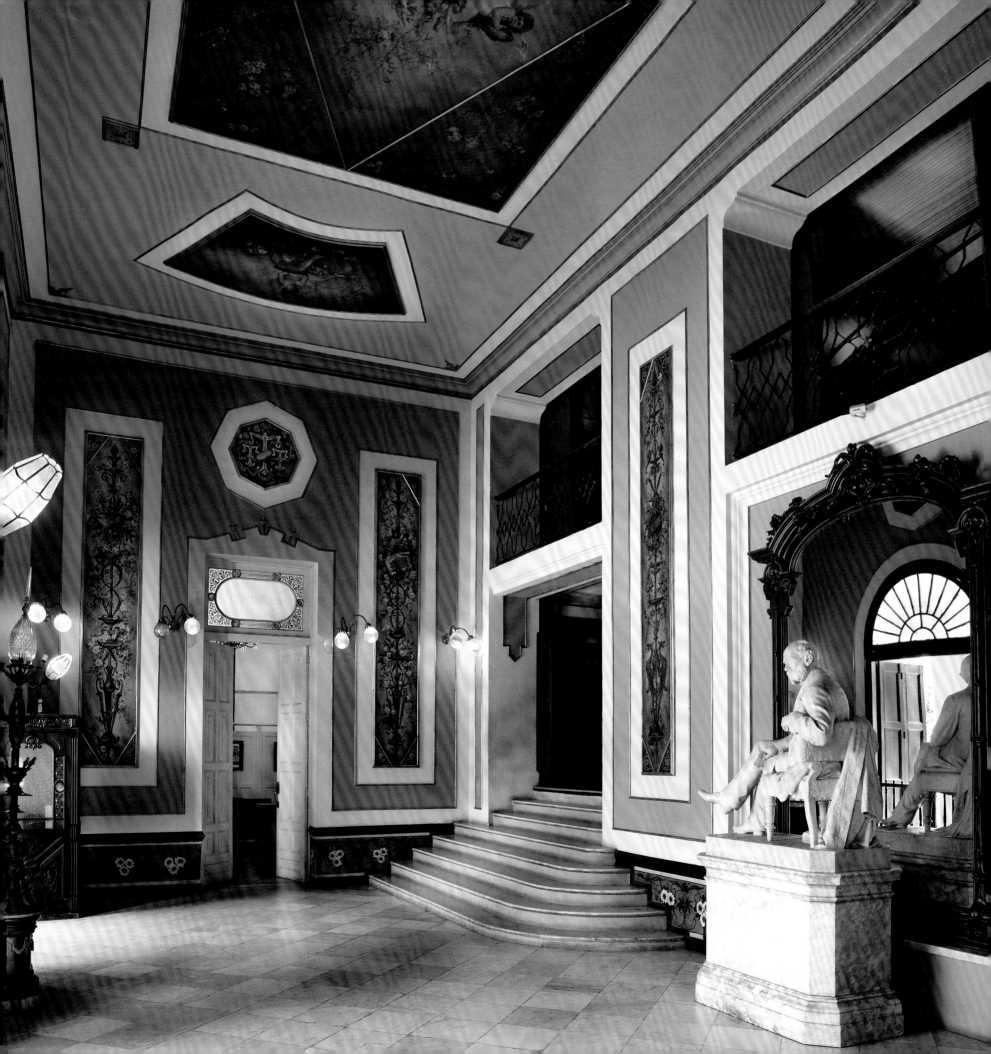

Opposite
*Lobby of the theater designed by
Lino Sánchez Marmal.*

Above
*Detail of ceramic depiction of one of
the Three Graces made by the Salvatti
workshops in Venice, which crowns
the building's façade.*

Next spread
*The Teatro Tomás Terry was designed
as an Italian-style theater with a
U-shaped, two-tiered auditorium
and a large ceiling fresco by Camilo
Salaya, a Philippine-Spanish painter.*

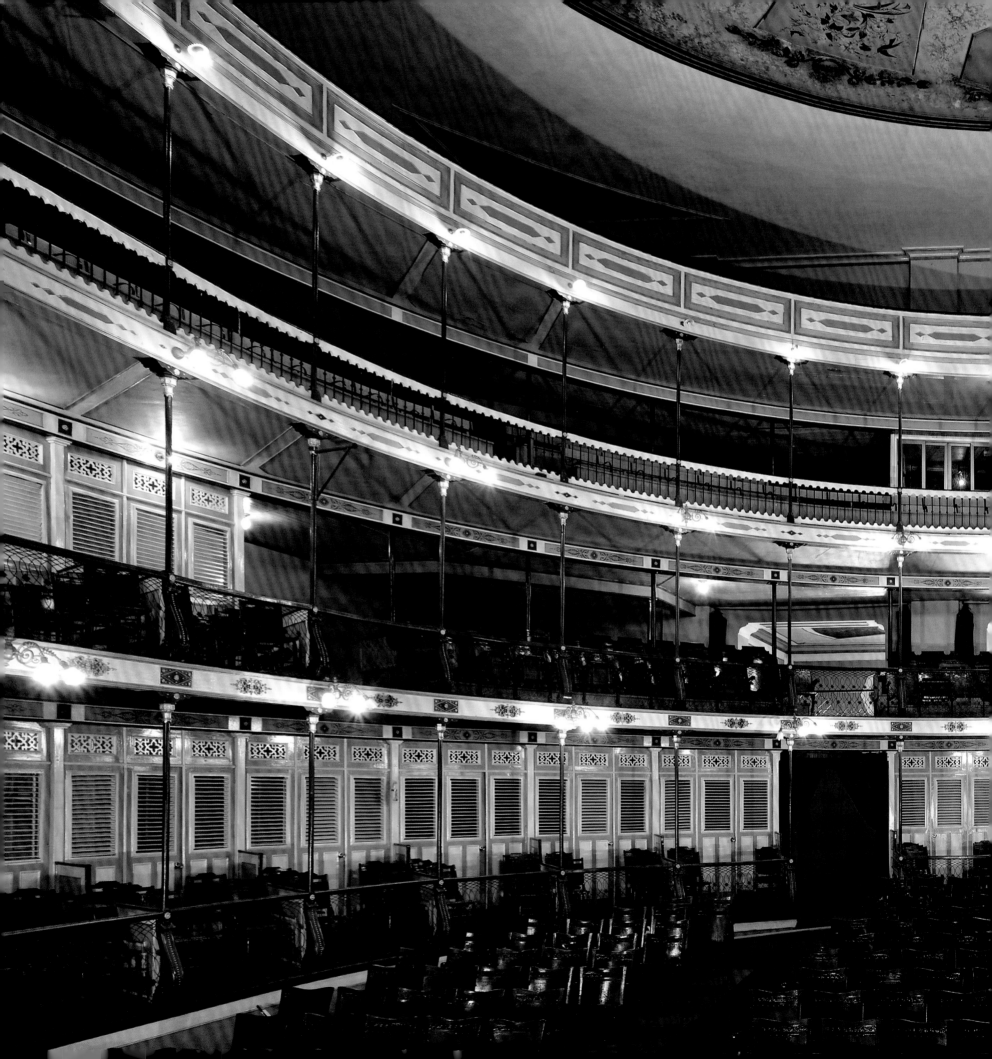

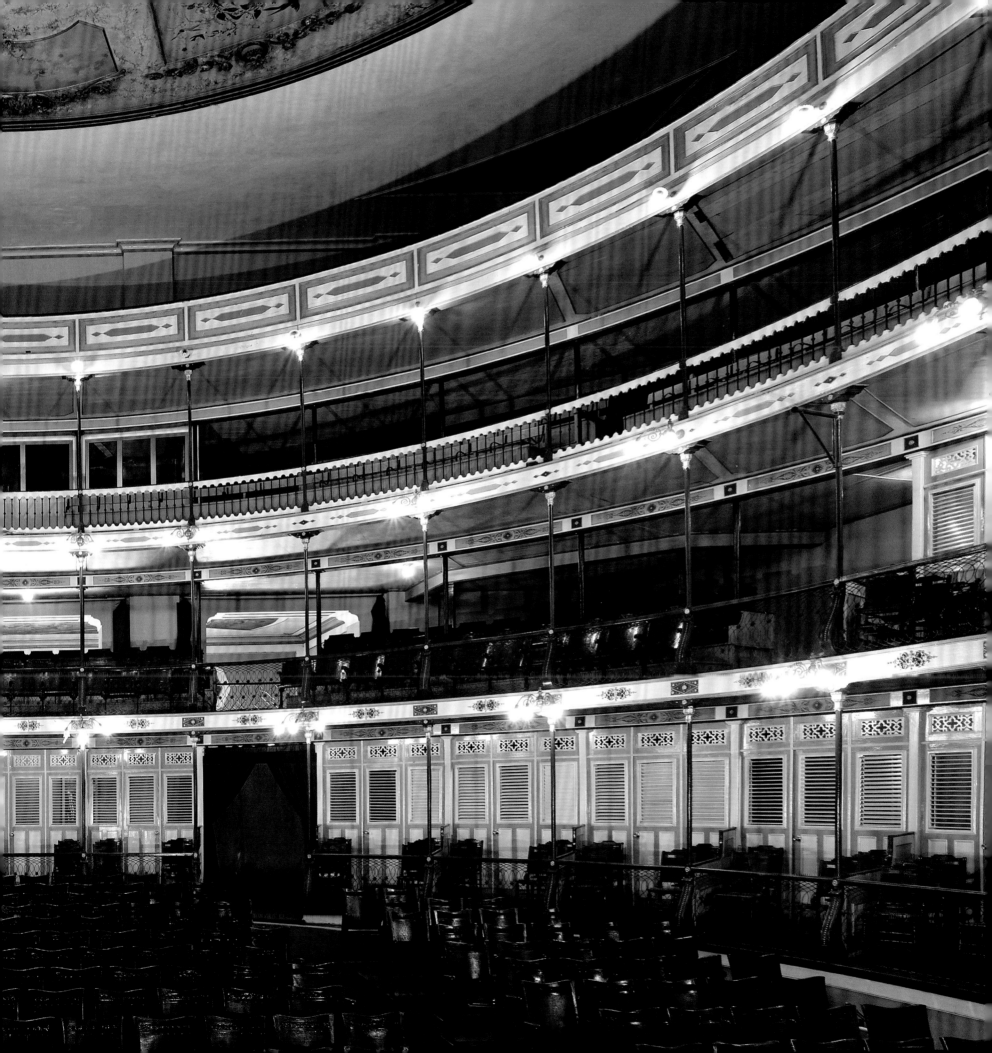

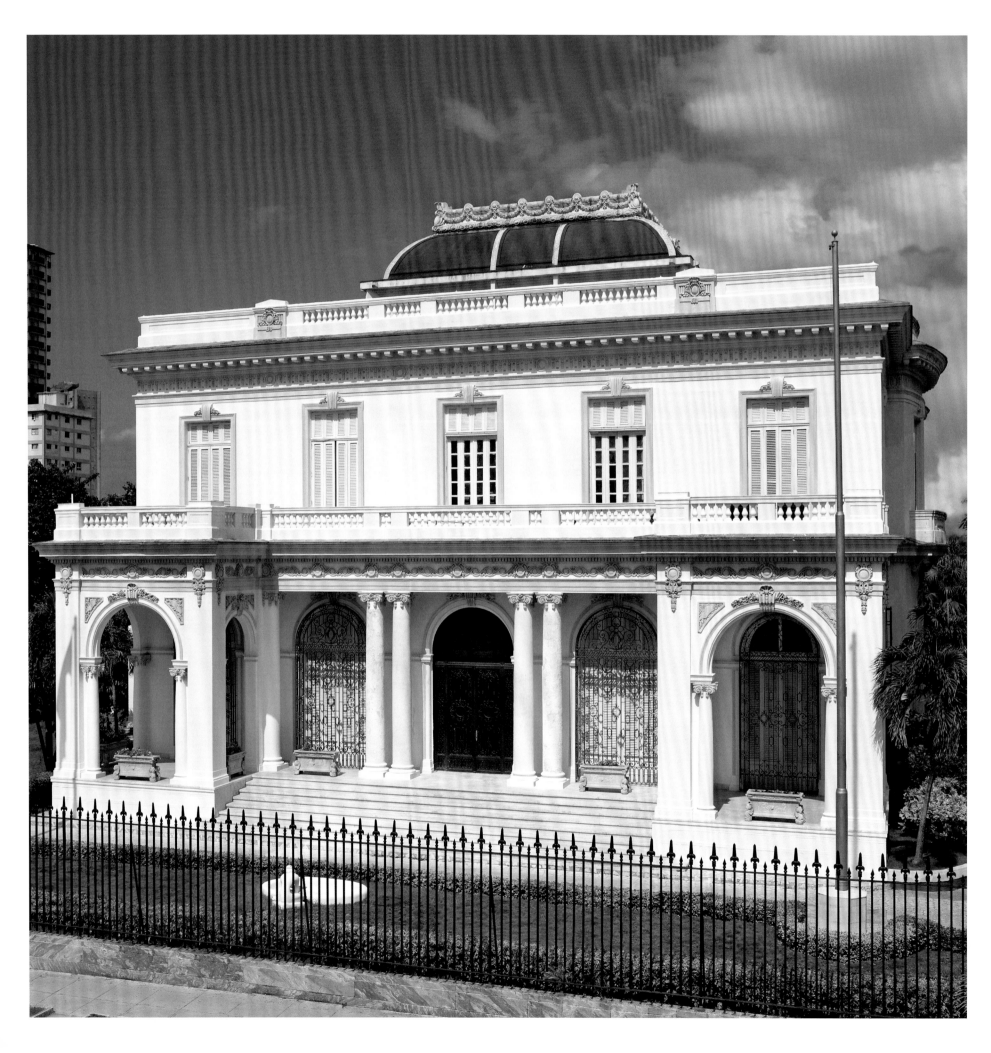

Opposite
One of the most impressive houses of the early twentieth century, Casa de la Condesa de Loreto, is located in El Vedado, Cuba's most important urban initiative developed during the colonial era.

Right
Second-floor salon of the turn-of-the-twentieth-century mansion showing a set of painted and caned furniture from the period.

Next spread
The El Cerro area of Havana was the site of luxurious early nineteenth-century neoclassical villas built by Havana's upper classes as summer homes (casas quintas). Construction of Quinta de los Condes de Santovenia began in 1832 and was completed in 1841.

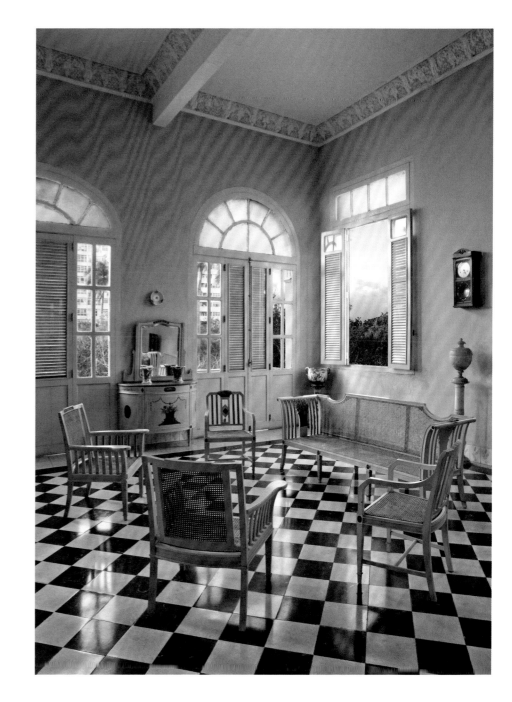

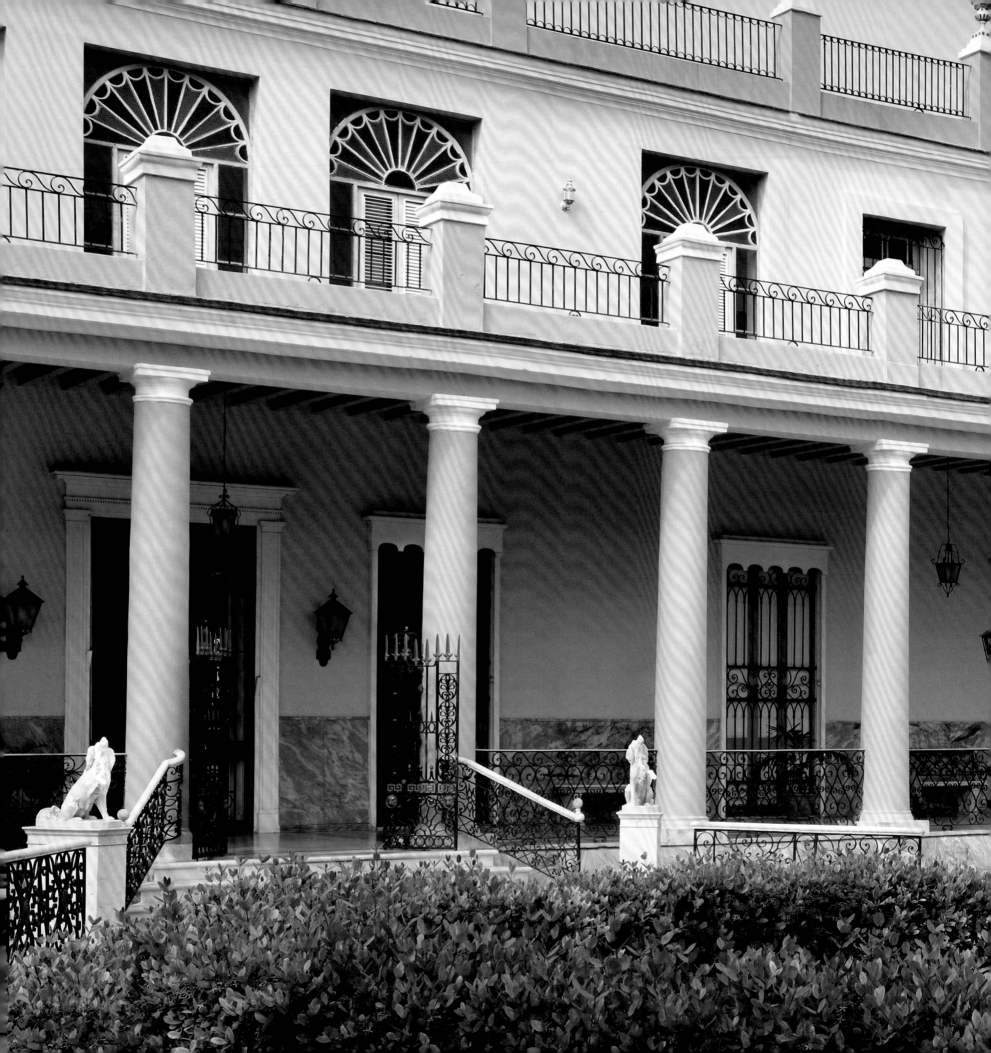

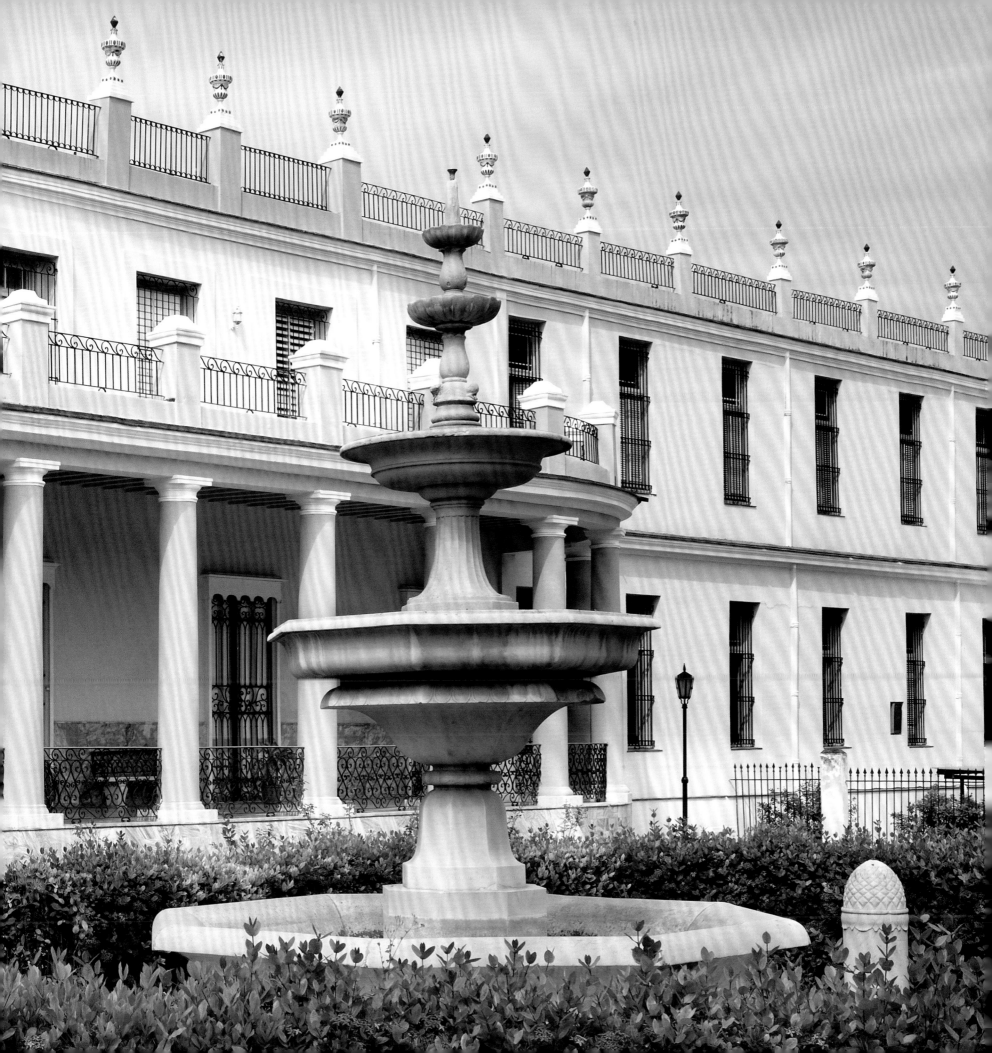

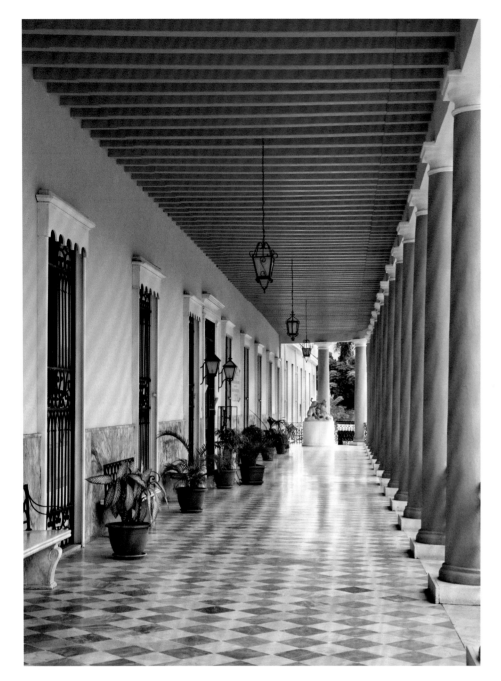

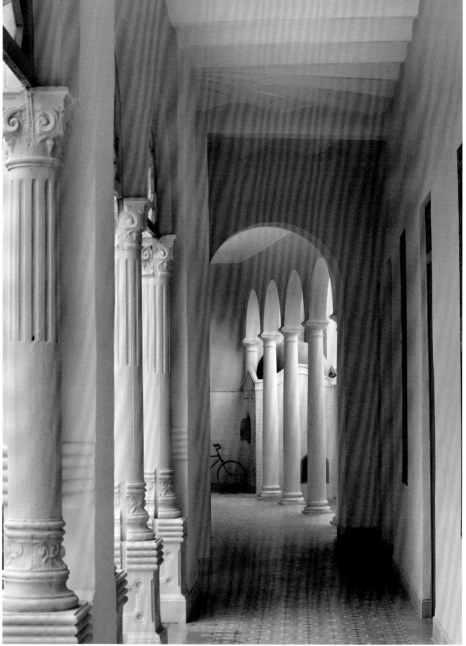

Above left
*The classical portico colonnade of
Casa del Conde de Santovenia,
considered to be the quintessential
summer villa of its day.*

Above right
*One of the interior galleries that
surround the inner patio.*

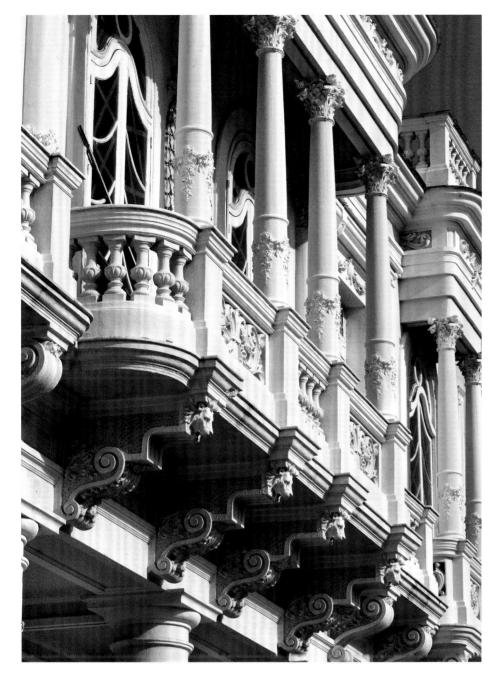

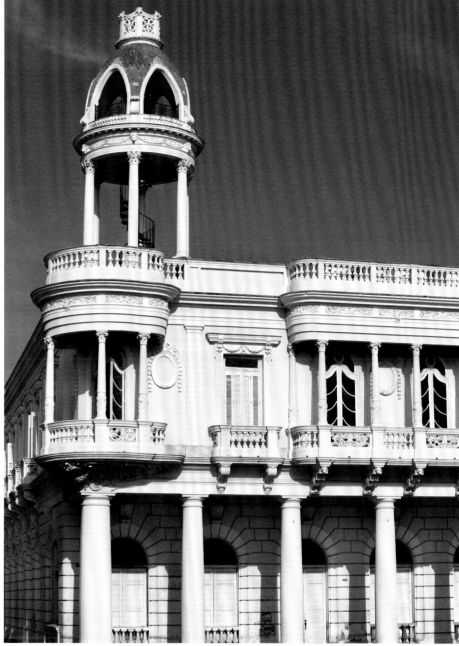

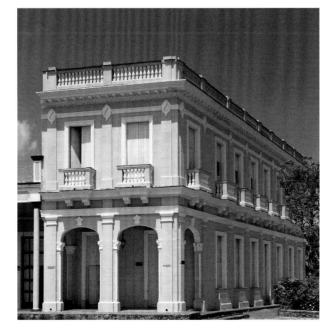

Above left
Detail of Palacio Ferrer's façade.

Above right
Palacio Ferrer in Cienfuegos was built in 1890 by a sugar millionaire and is architecturally a blend of baroque, neoclassical, and Moorish elements.

Left
Typical of smaller nineteenth-century residential mansions throughout the island is this one in Remedios.

The neoclassical-style firehouse built in Mátanzas in 1898 was one of Cuba's first republican-era civic buildings.

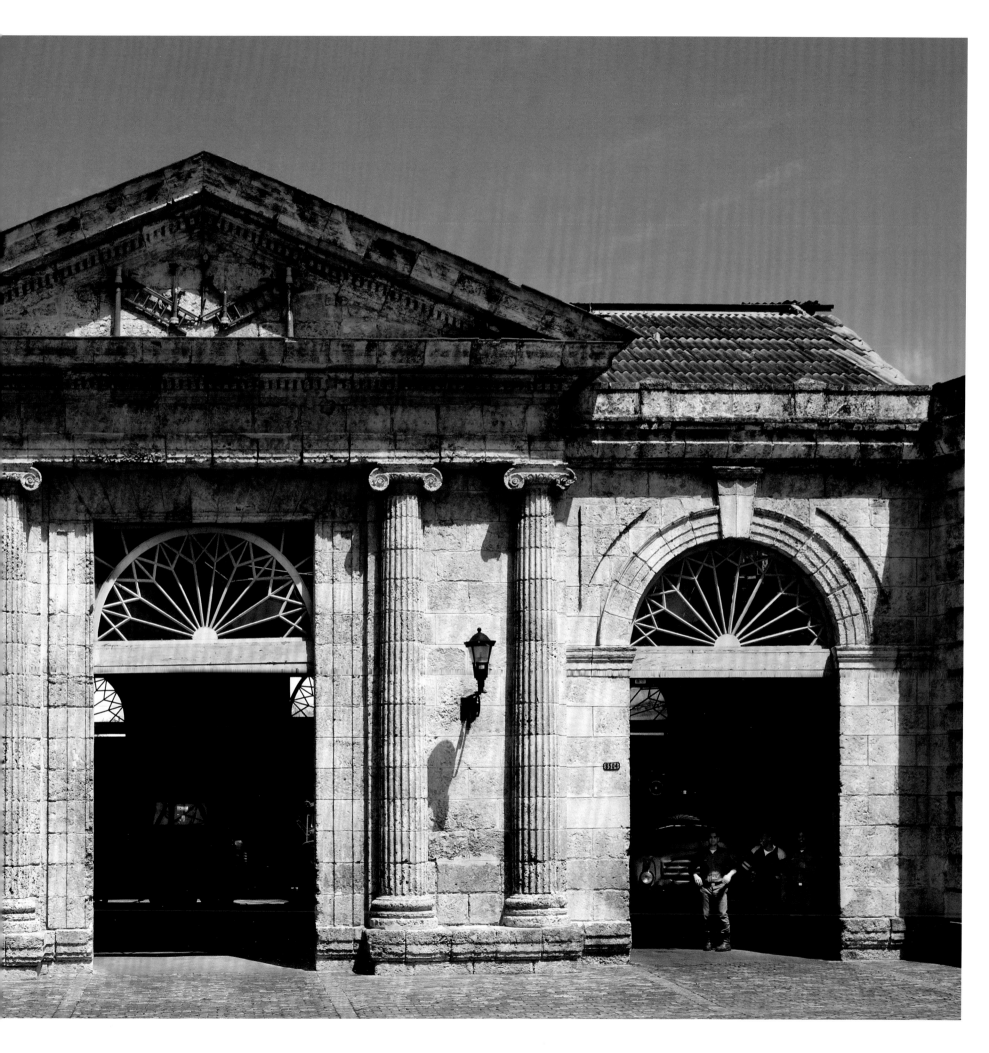

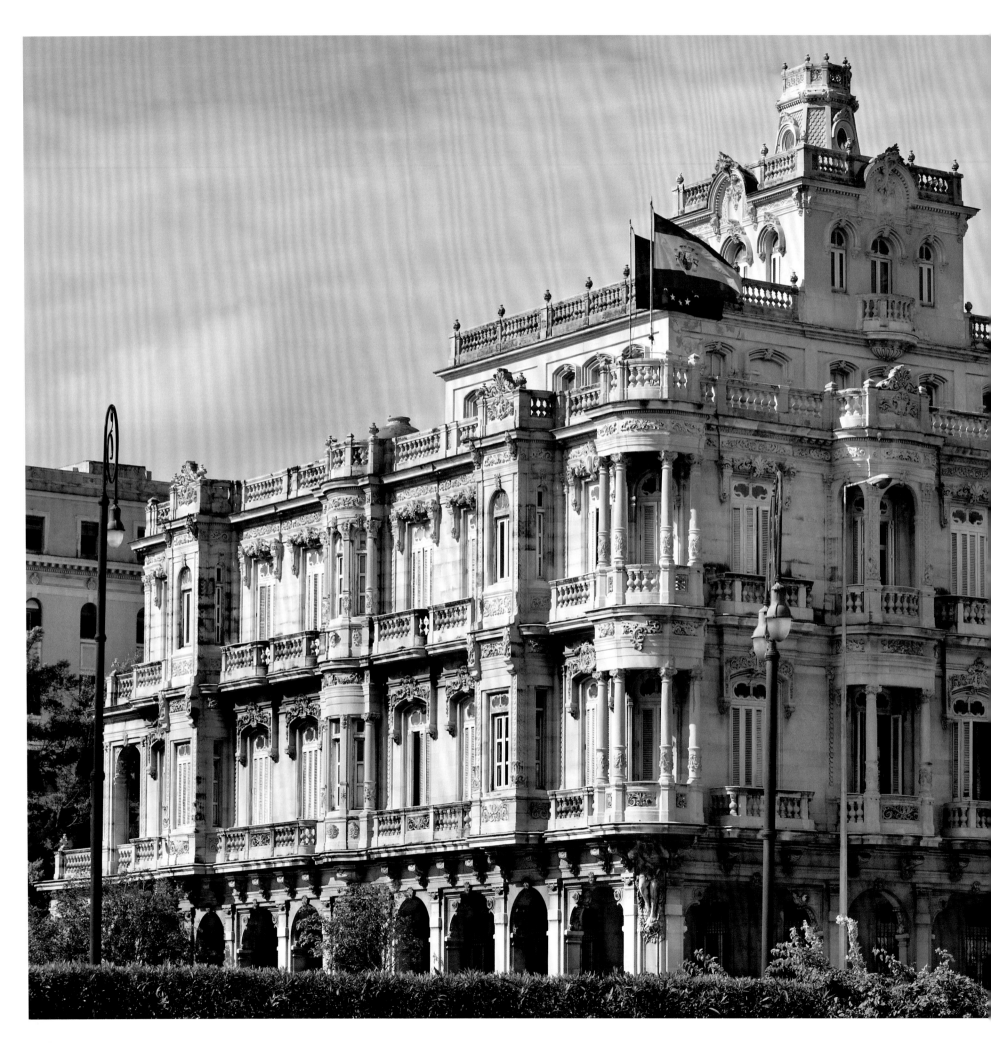

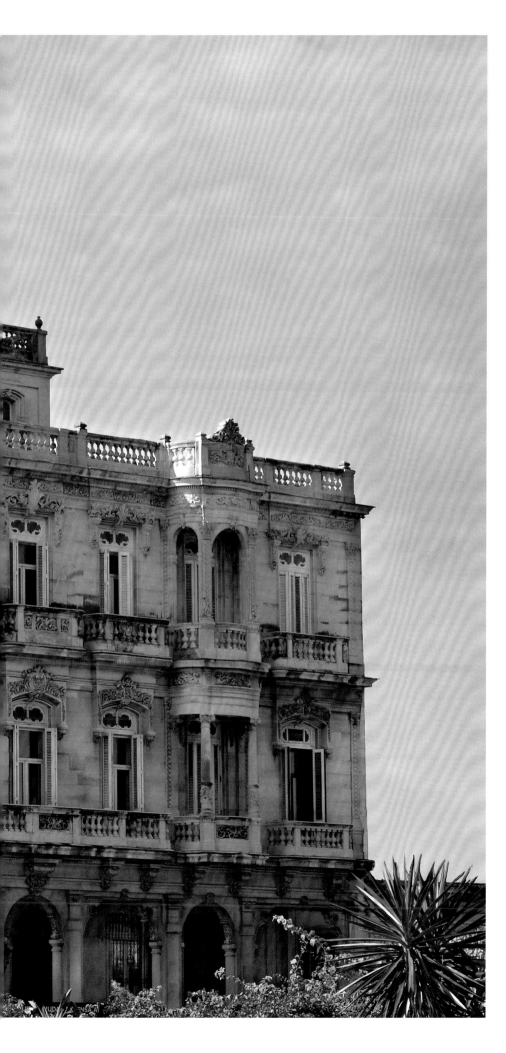

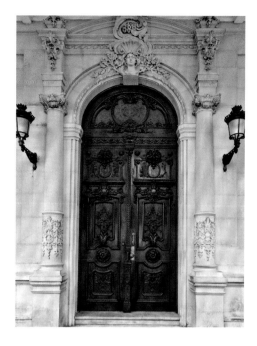

Opposite
Casa de Dionisio Velasco was built in 1912, has a richly decorated façade, and was the first grand mansion of the Republican era. It was designed by Francisco Ramirez Ovando and includes a ground-floor portal and lucetas.

Above
One of the elaborate mahogany doors of the Casa de Dionisio Velasco. Cuban master builders and craftsmen would choose decorative motifs for doors from design publications of the day.

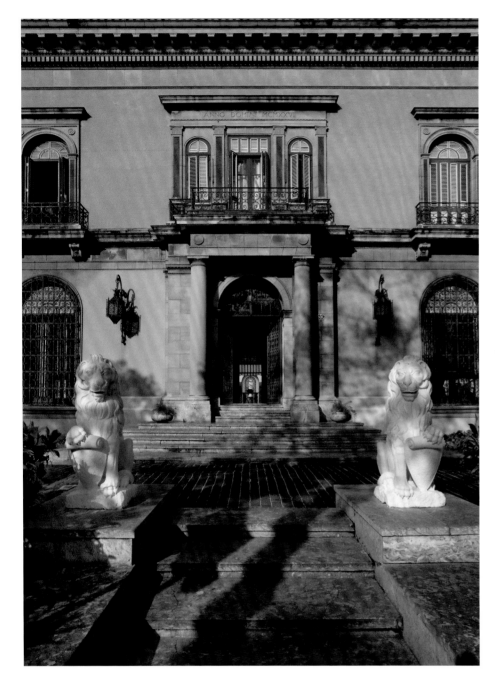

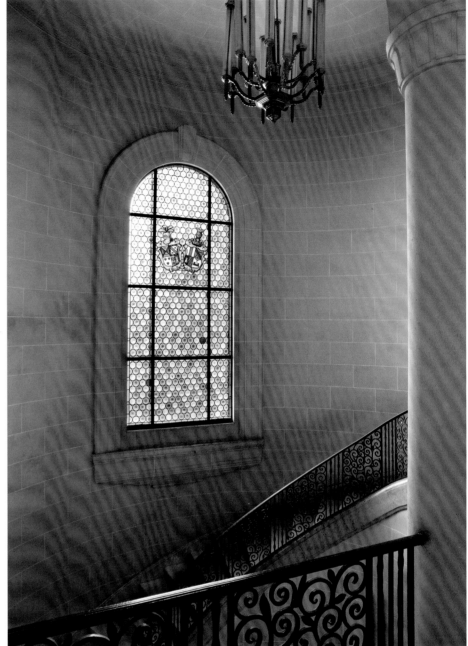

Above left
Casa de Juan de Pedro y Baró y Catalina de Lasa is the home of Cuba's favorite love story. Based on a famous Florentine palazzo, it was built in 1926.

Above right
The stairwell of the Baró y Catalina de Lasa house was the first project designed by the architects Evelio Govantes and Félix Cabarrocas.

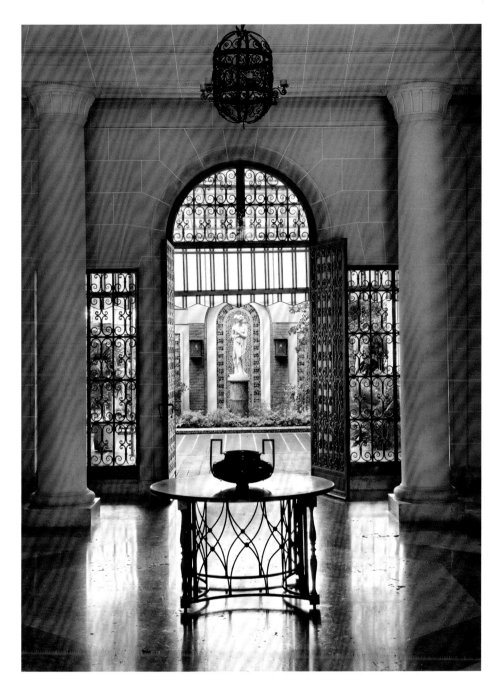

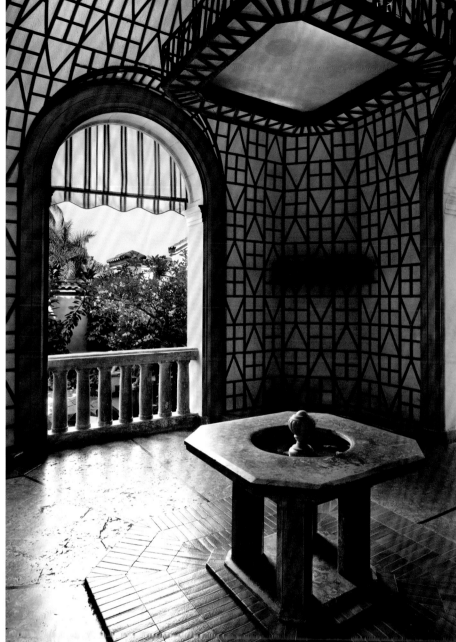

Above left
Entrance to the house and a view of the courtyard and gardens, which were designed by Jean-Claude Nicolas Forestier, the originator of Havana's first Master Plan (1926-28) as well as other gardens, parks, and plazas in the city.

Above right
The art deco style Palm Room of the house, decorated by French designer René Lalique.

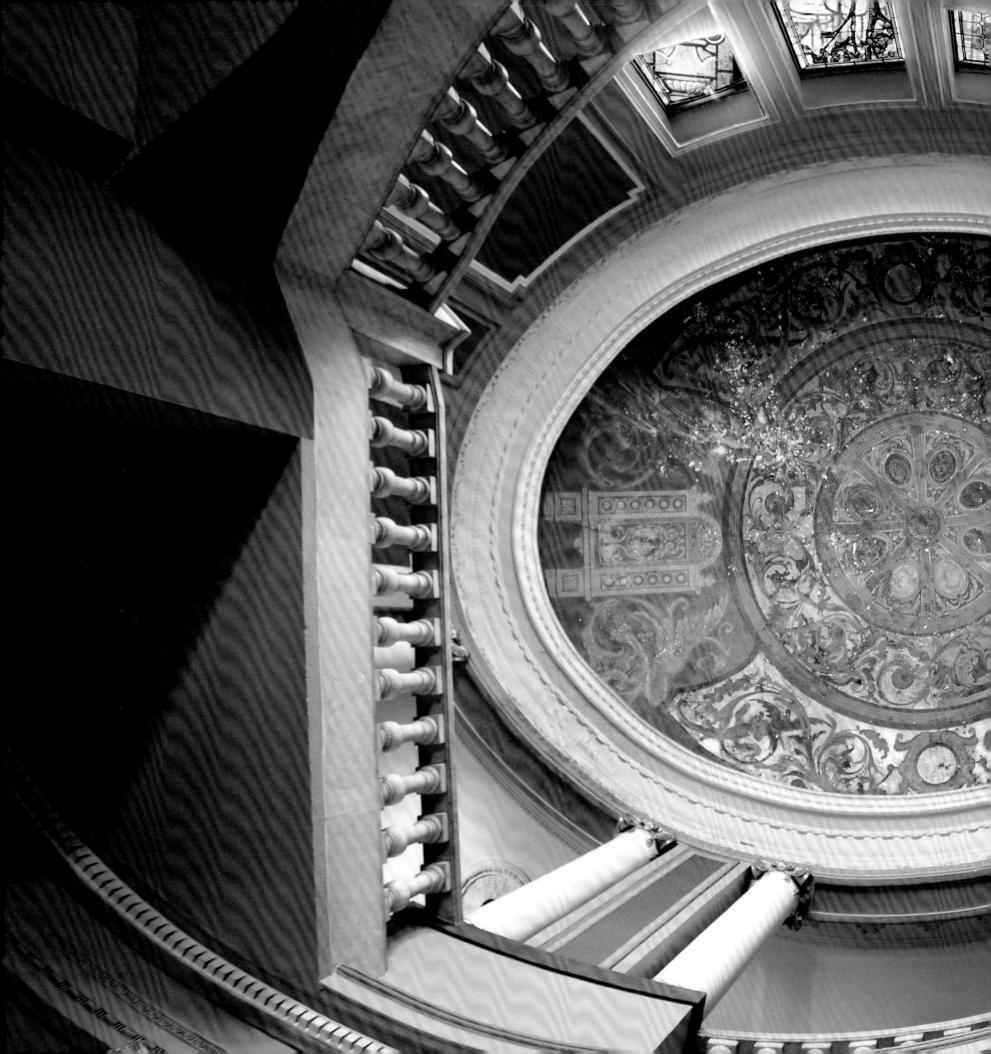

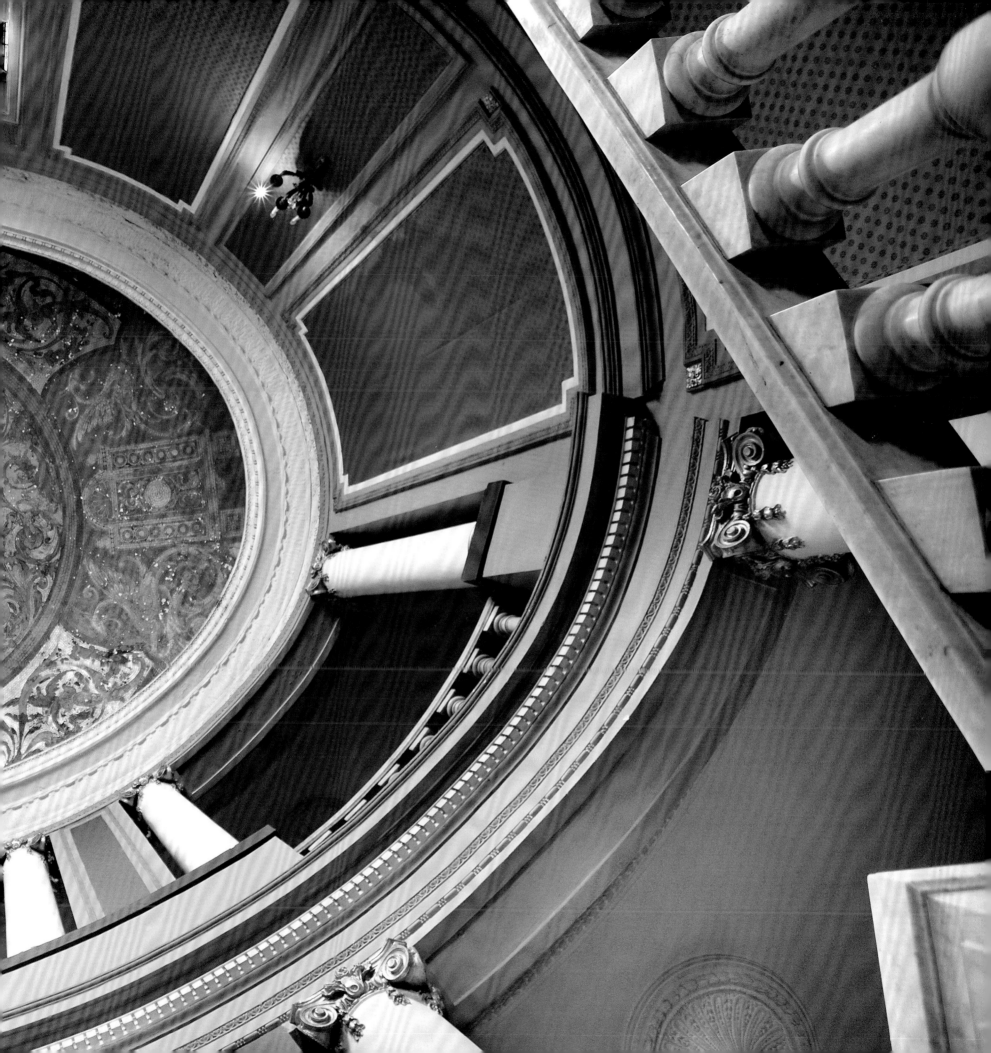

Previous spread
Elaborate dome above the lavish marble staircase of Casa de Fausto G. Menocal.

Right
Designed in the French classical-revival style by architect Adrián Macia and his French colleagues, Palacio de la Condesa de Revilla de Camargo was commissioned by wealthy sugar magnate José Gómez Mena and built in 1926 for his sister María Luisa, the Countess of Revilla de Camargo.

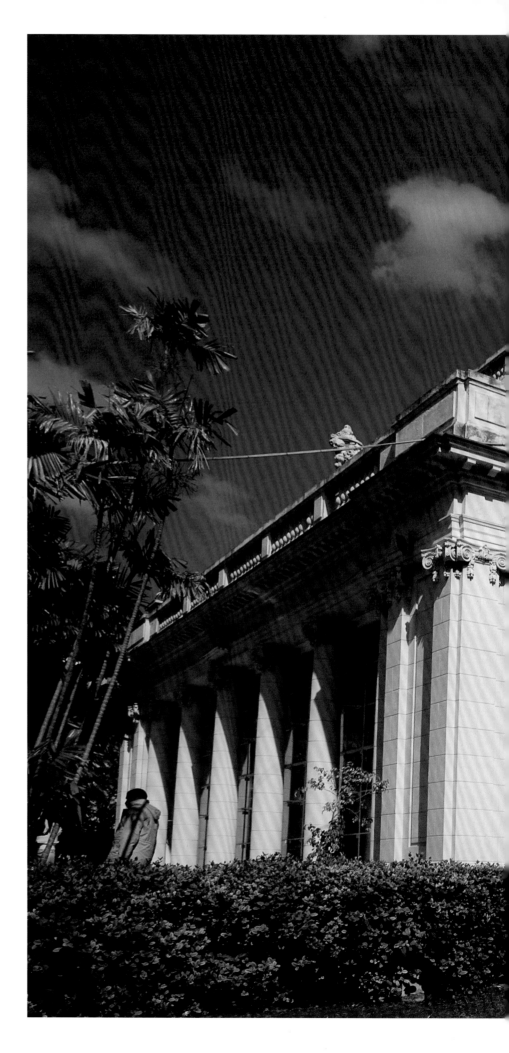

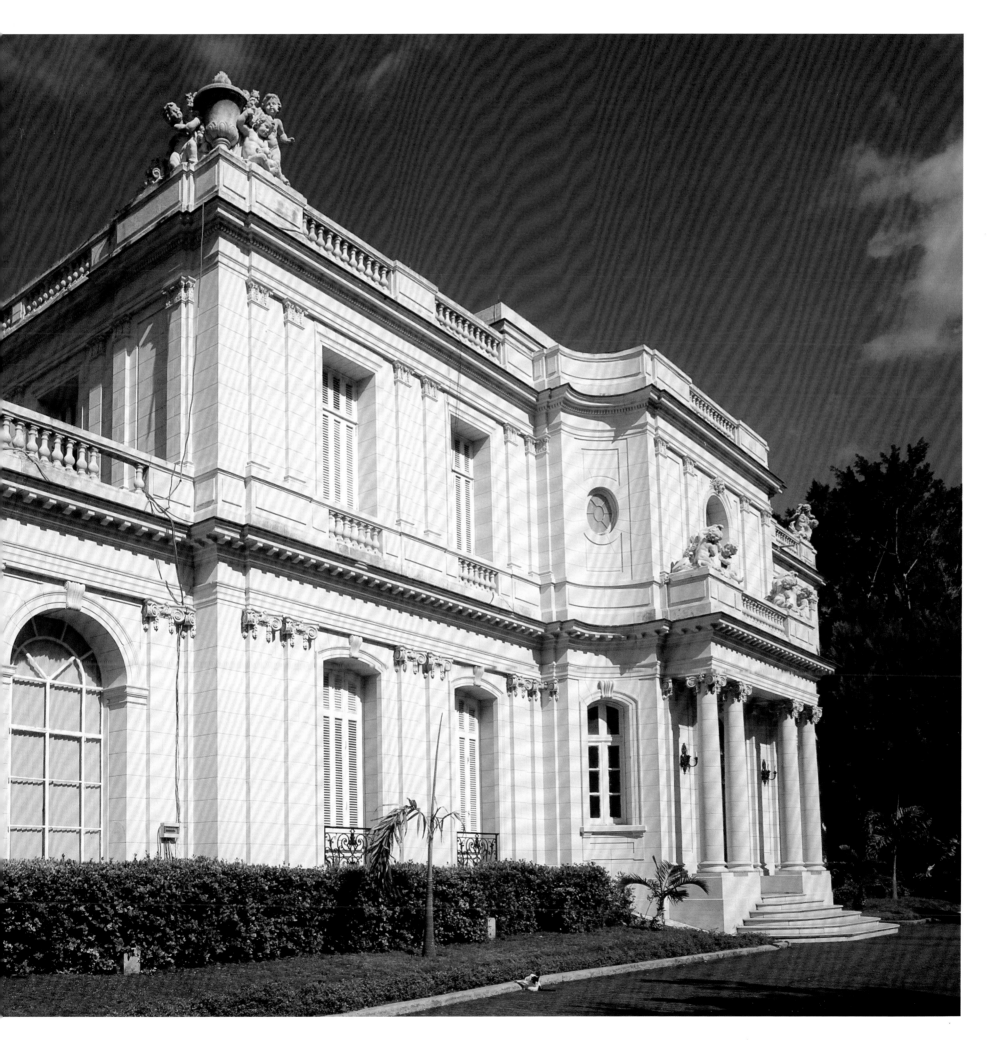

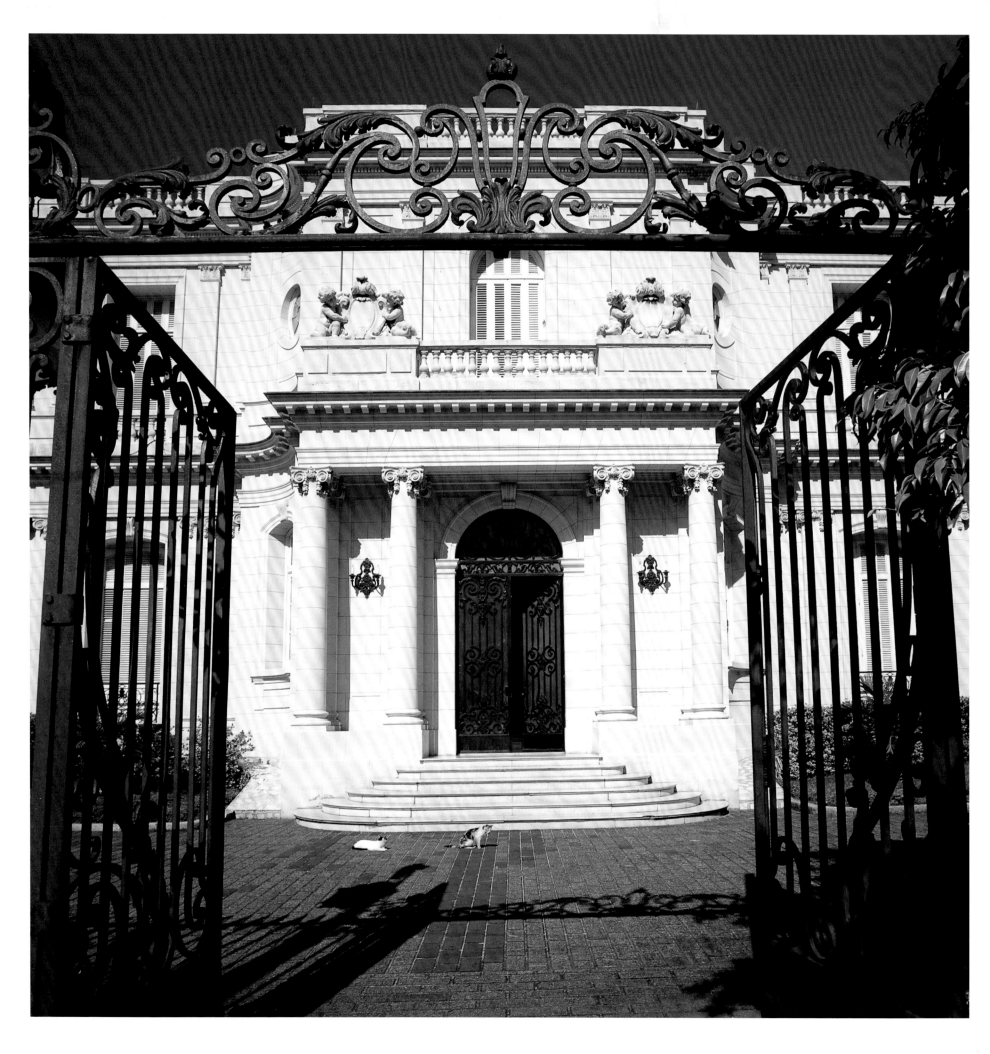

Opposite
The main gate to the palace of the Countess of Revilla de Camargo. The façade and the doorway framed by four Ionic columns reflect the architectural influence of both French and North American Beaux Arts design.

Right
The double-height entrance hall leads to one of the most beautiful residential staircases in Cuba.

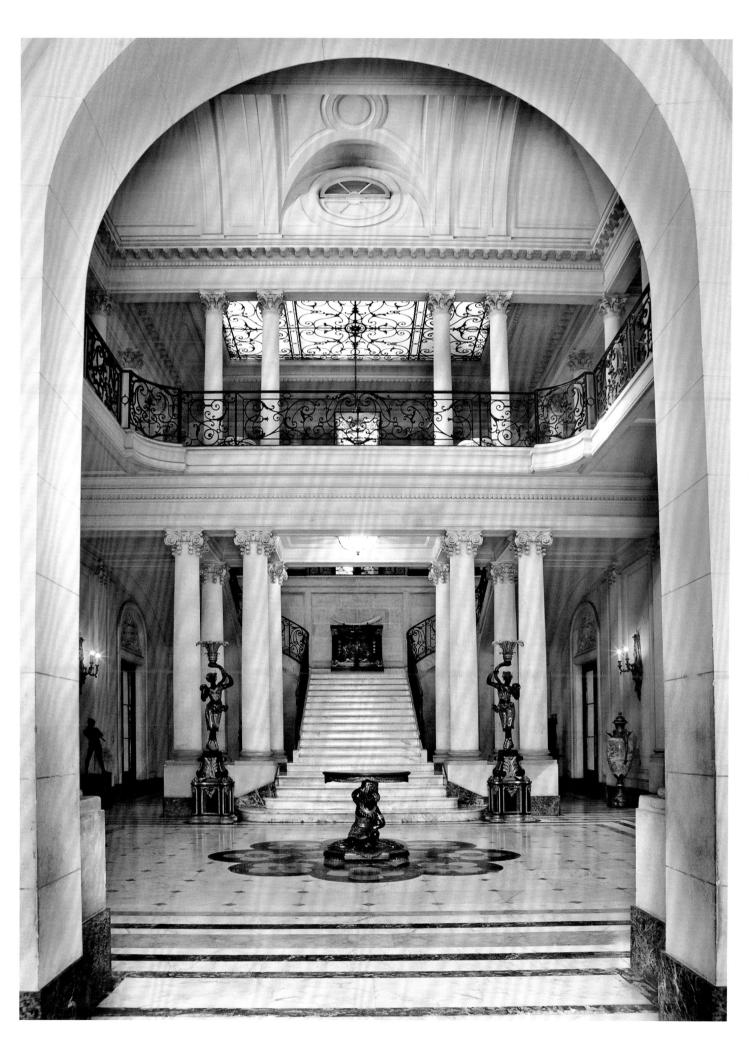

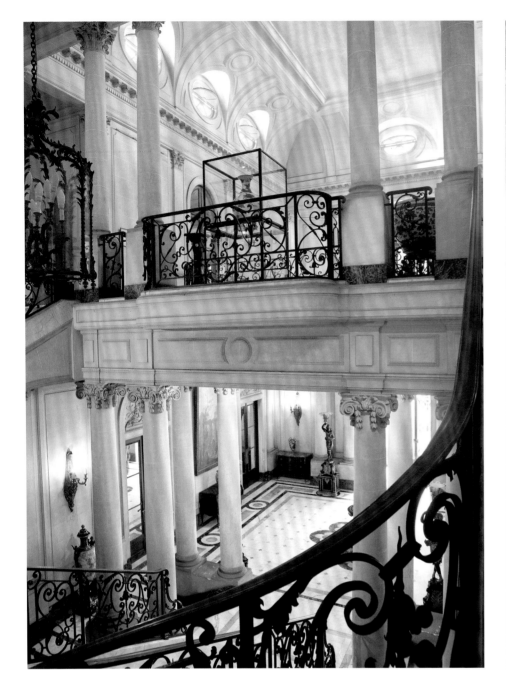

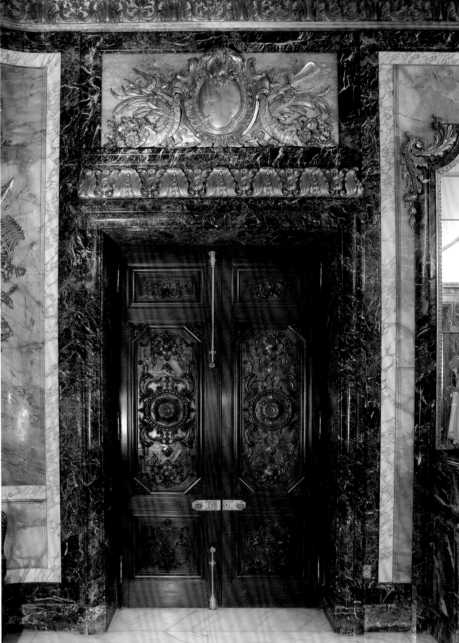

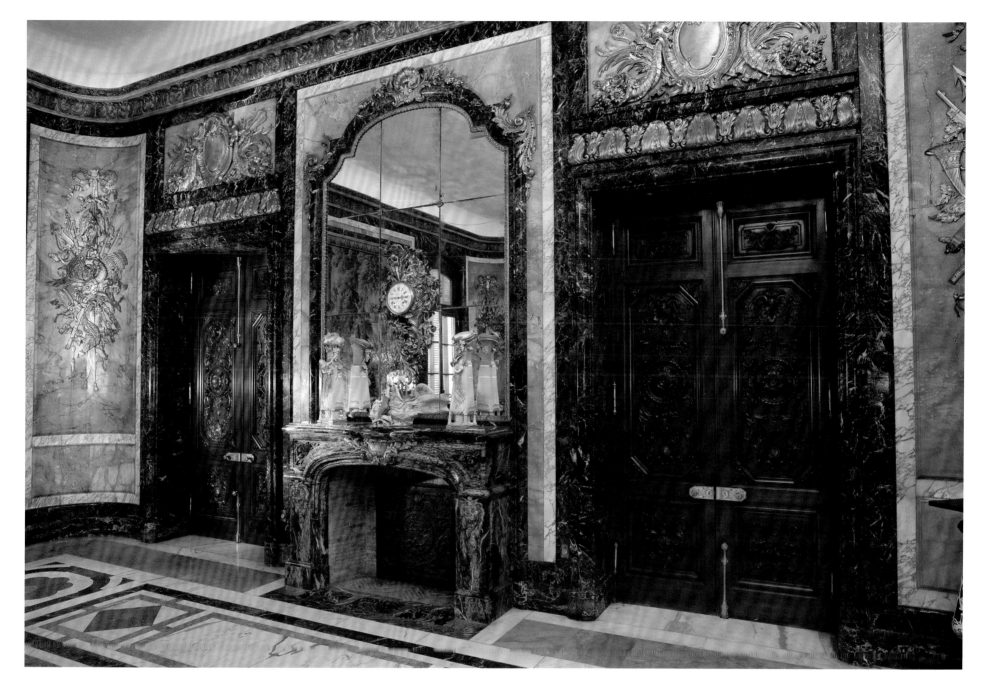

Opposite above left
The most spectacular feature of the palatial residence is its interior design and decoration with the majority of the work executed by Maison Jansen. House of Jansen was a Parisian interiors office founded in 1880 and considered the first truly global design firm.

Opposite above right
Detail of one of the many carved Cuban mahogany doors.

Opposite below
Two of the Tiffany lamps that are among the Sèvres, Limoges, and Meissen porcelains that are part of the furnishings and objets d'art of the house.

Above
Carrara marble floors and walls with elaborately carved mahogany doors are featured in the dining room.

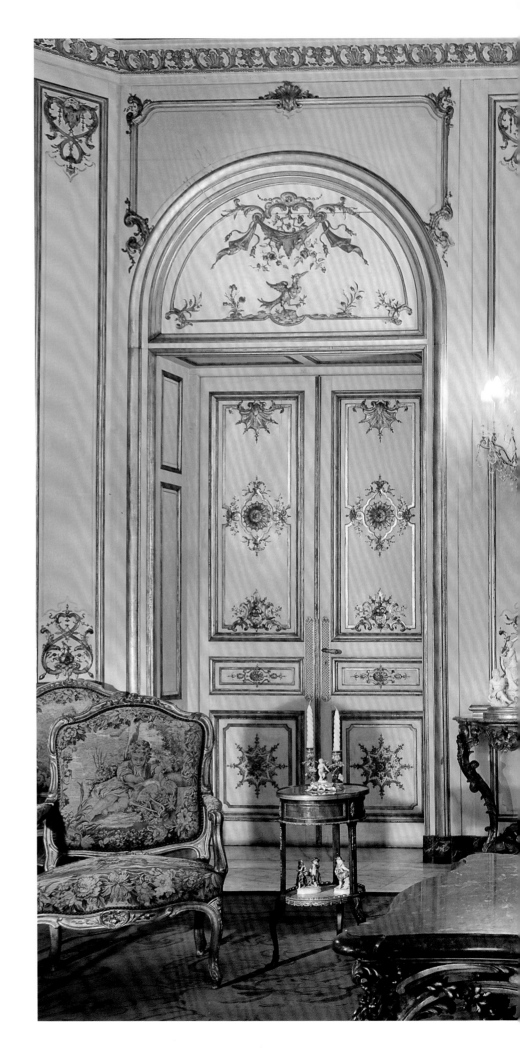

The collection of eighteenth-century French furniture that was a symbol of wealth and status with considerable prestige for the owners of the mansion.

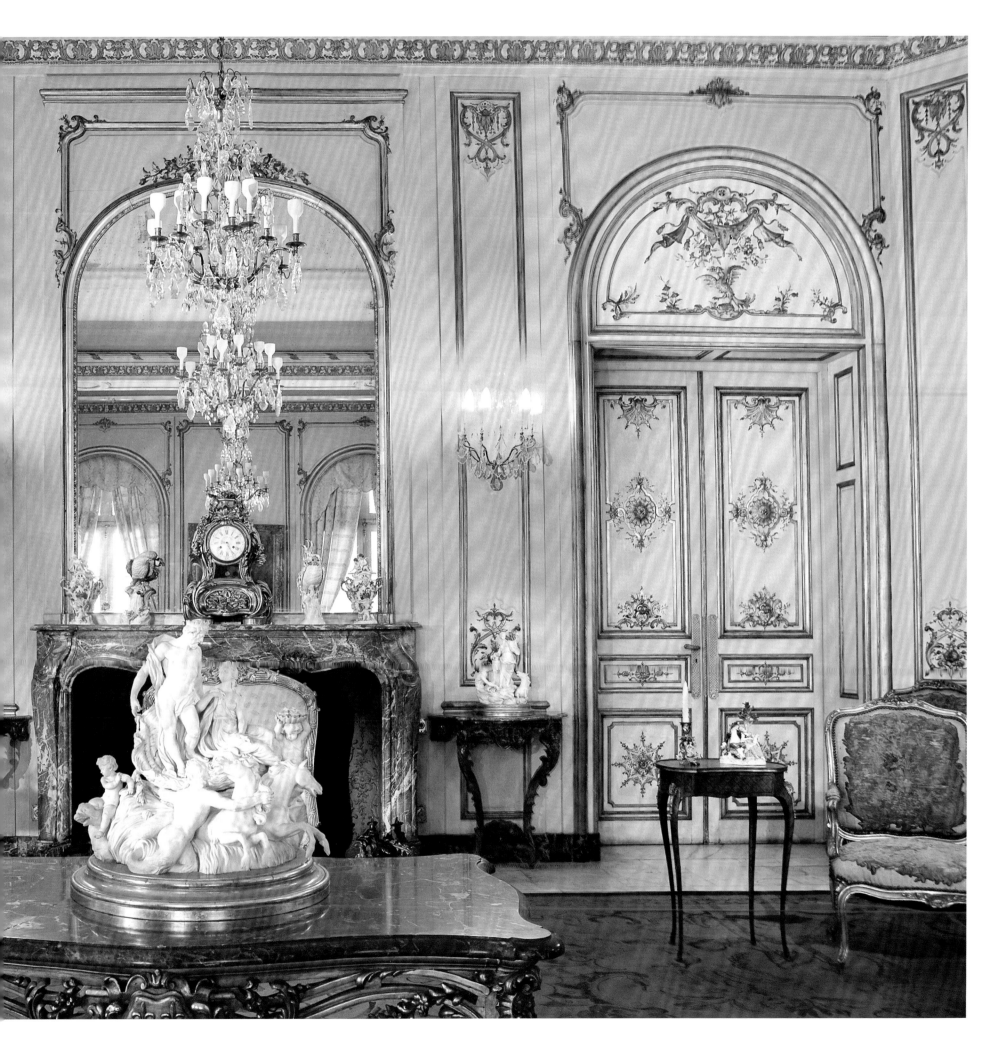

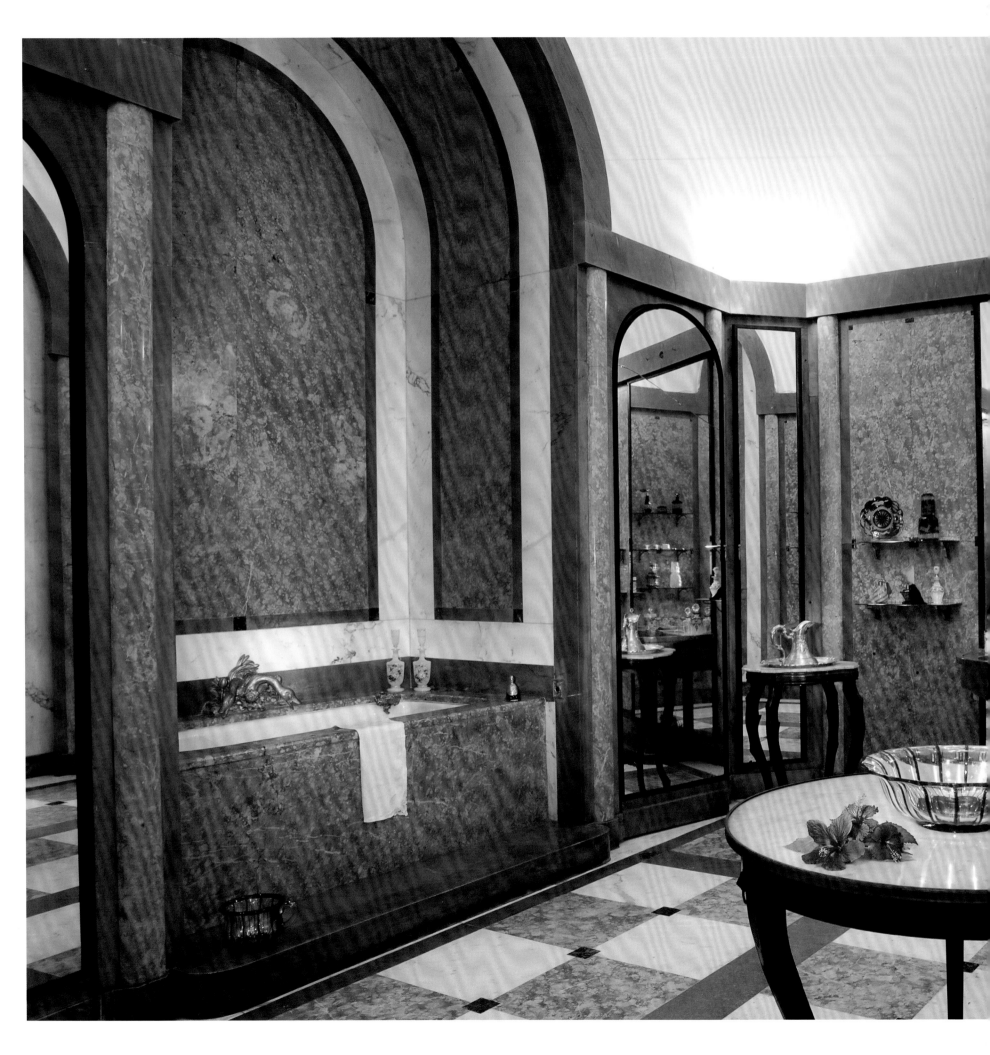

The pink, white, and gray marble
bathroom surrounded by mirrors
was in the most fashionable art deco
style of the day and showed the
extravagance that wealthy sugar
tycoons considered tasteful.

The Quinta de las Delicias (Estate of Delights) was designed after French feudal architecture and was the first "folly" ever built in Cuba. Constructed in 1906, the castlelike residence's owner, Rosalía Abreu, was known for her eccentricities, especially that of having a collection of monkeys roaming the property's surrounding gardens.

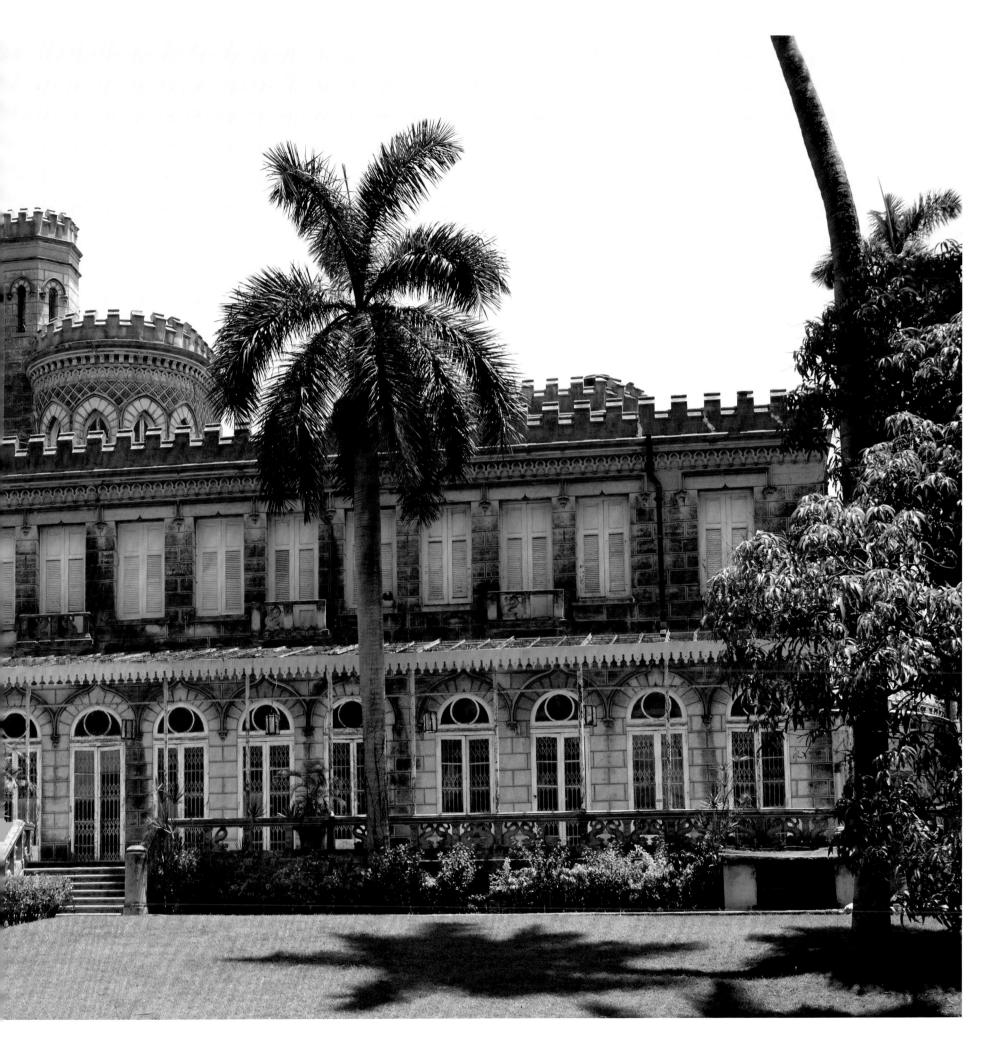

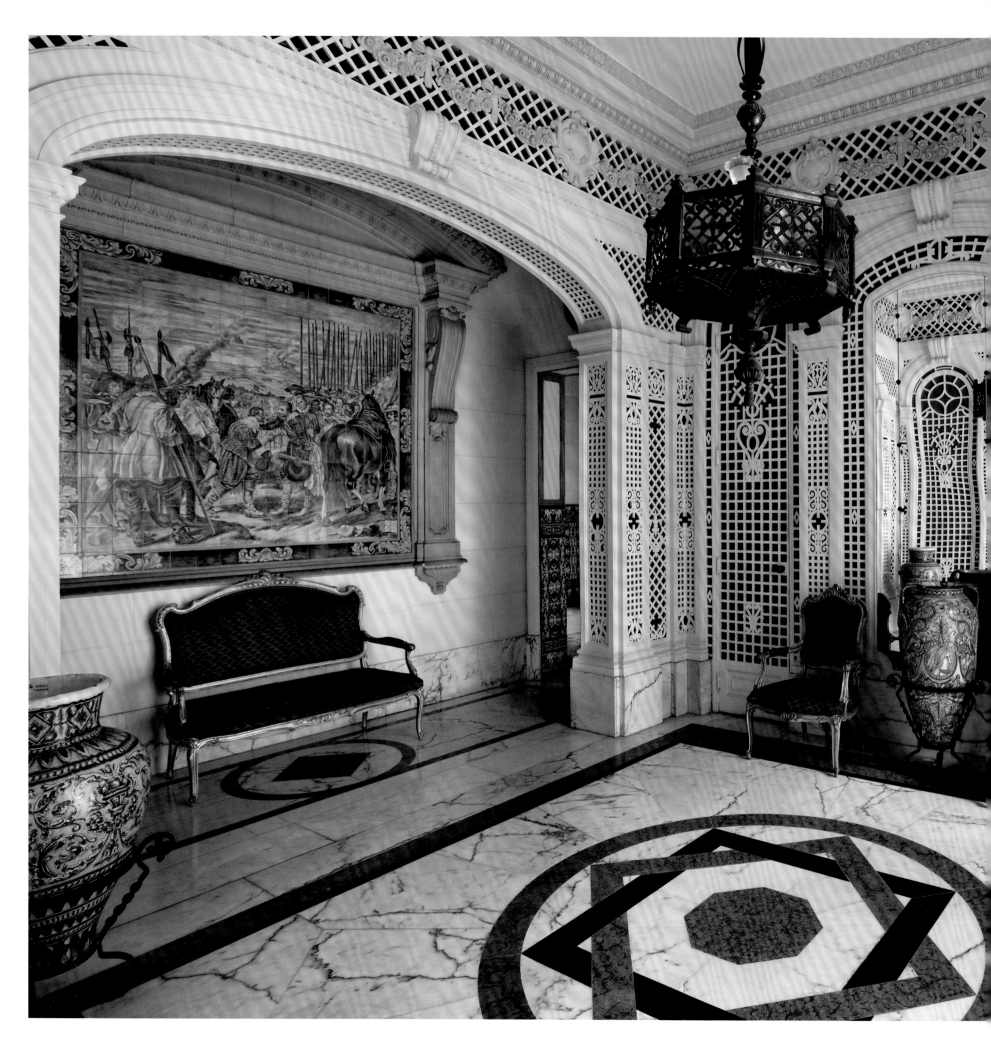

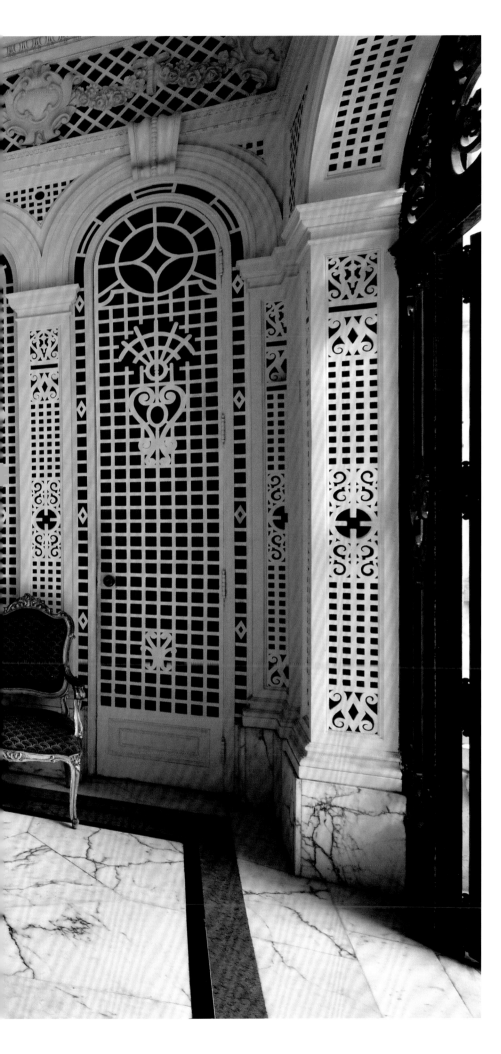

Left
A salon interior of the Solis family home in El Vedado. The Solis family built El Encanto, Havana's most fashionable department store of the twentieth century.

Above
Detailed mosaic ceiling in Las Delicias's porte cochere *depicting a classical charioteer urging his horses.*

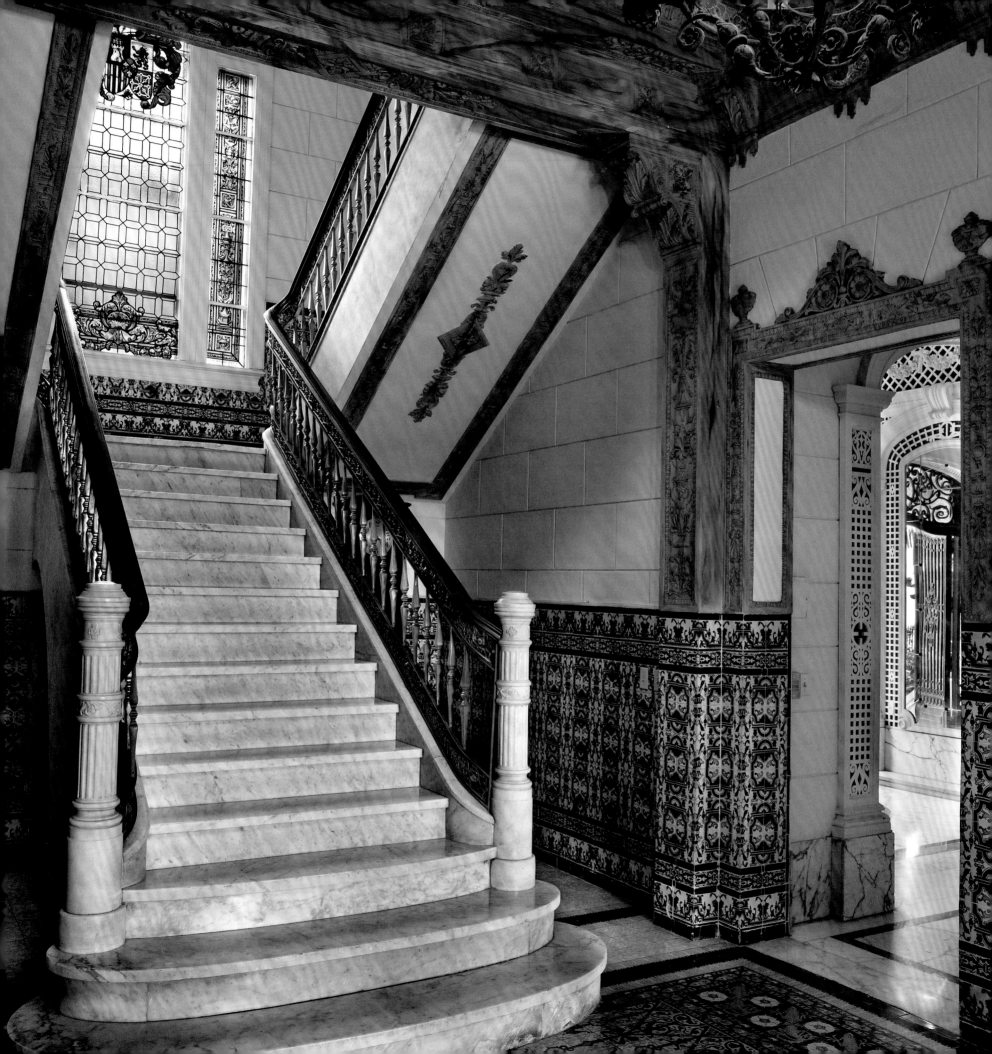

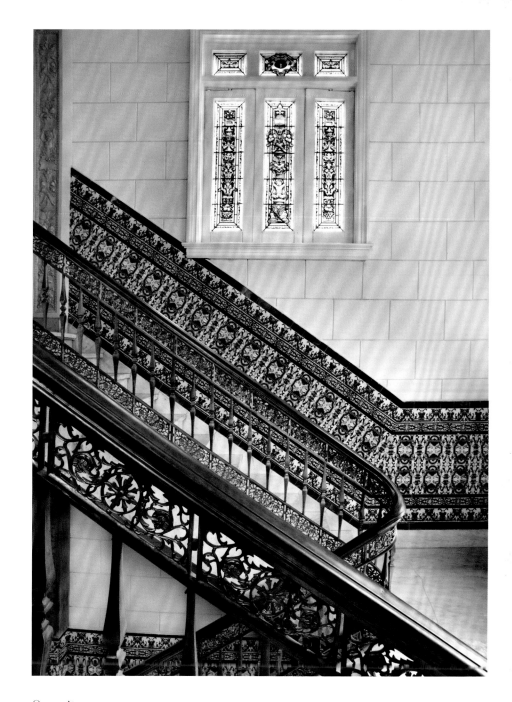

Opposite
*Entrance hall and staircase to the Solis
house that was constructed in 1922.*

Above
*Detail of the iron staircase and stained
glass window from the mansion's landing.*

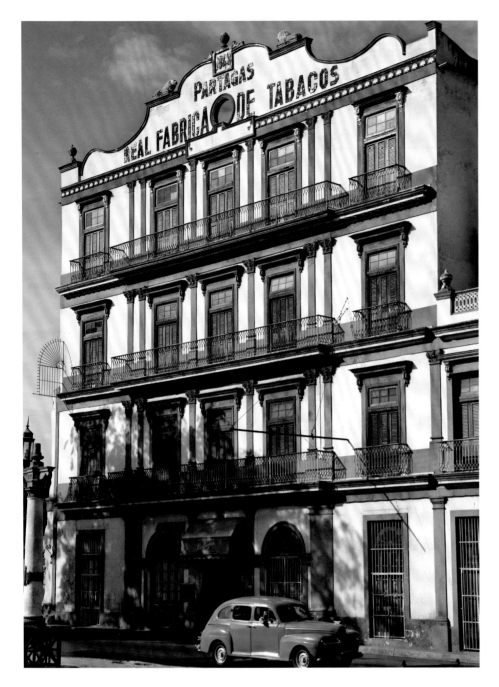

Above
*Real Fábrica de Tabacos Partagas, built
in 1845, is Cuba's largest cigar factory.
With its neoclassical façade it is a good
example of Havana's nineteenth-century
industrial architecture.*

Opposite
*An example of a building's façade
constructed on Plaza Vieja in Havana
in the first decade of the 1900s.*

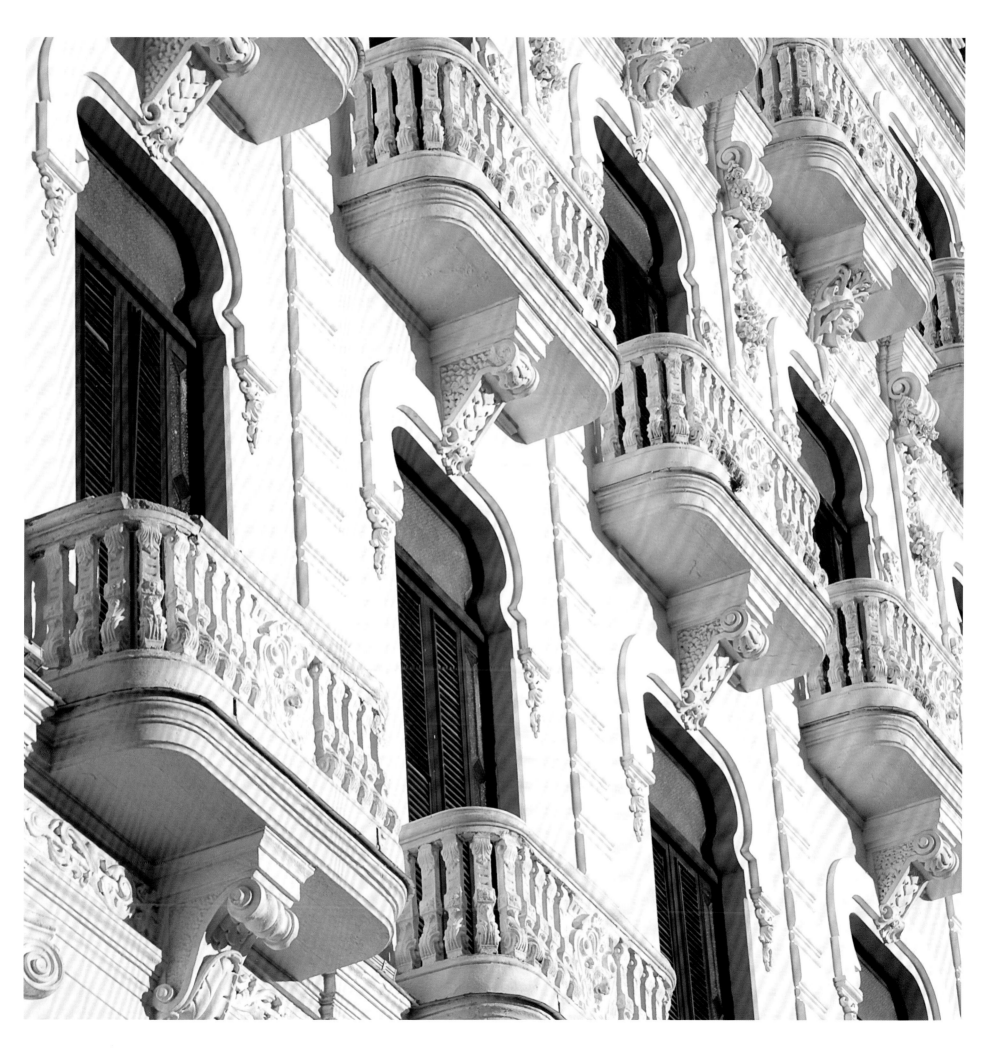

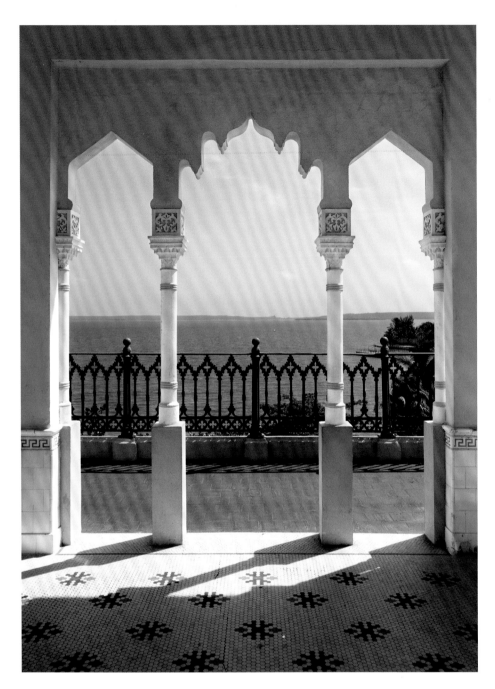

Left
View of the Caribbean Sea from the roof of the neo-Mudéjar-designed Palacio del Valle in Cienfuegos.

Opposite
The ostentation of Palacio del Valle reflects the vast fortune acquired by the sugar planter Aclicio Valle, who built the mansion in 1912.

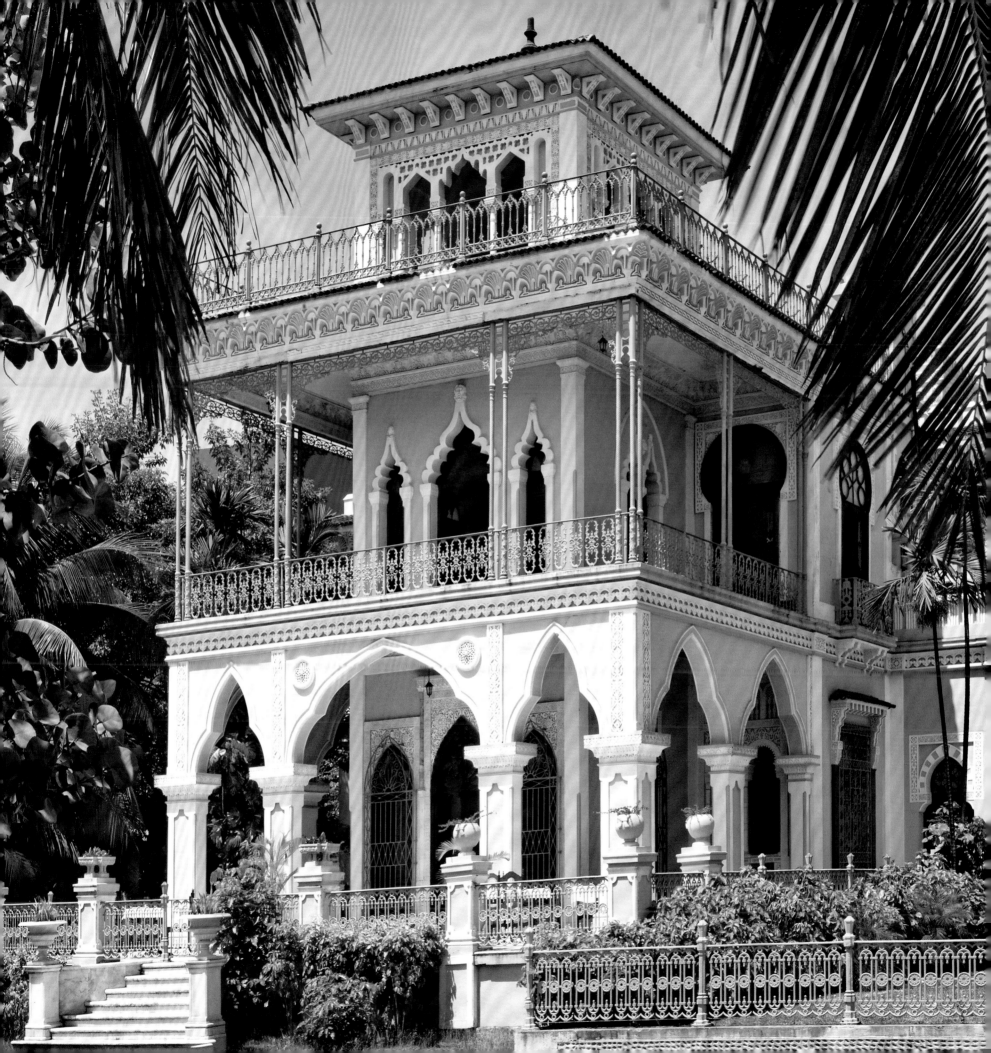

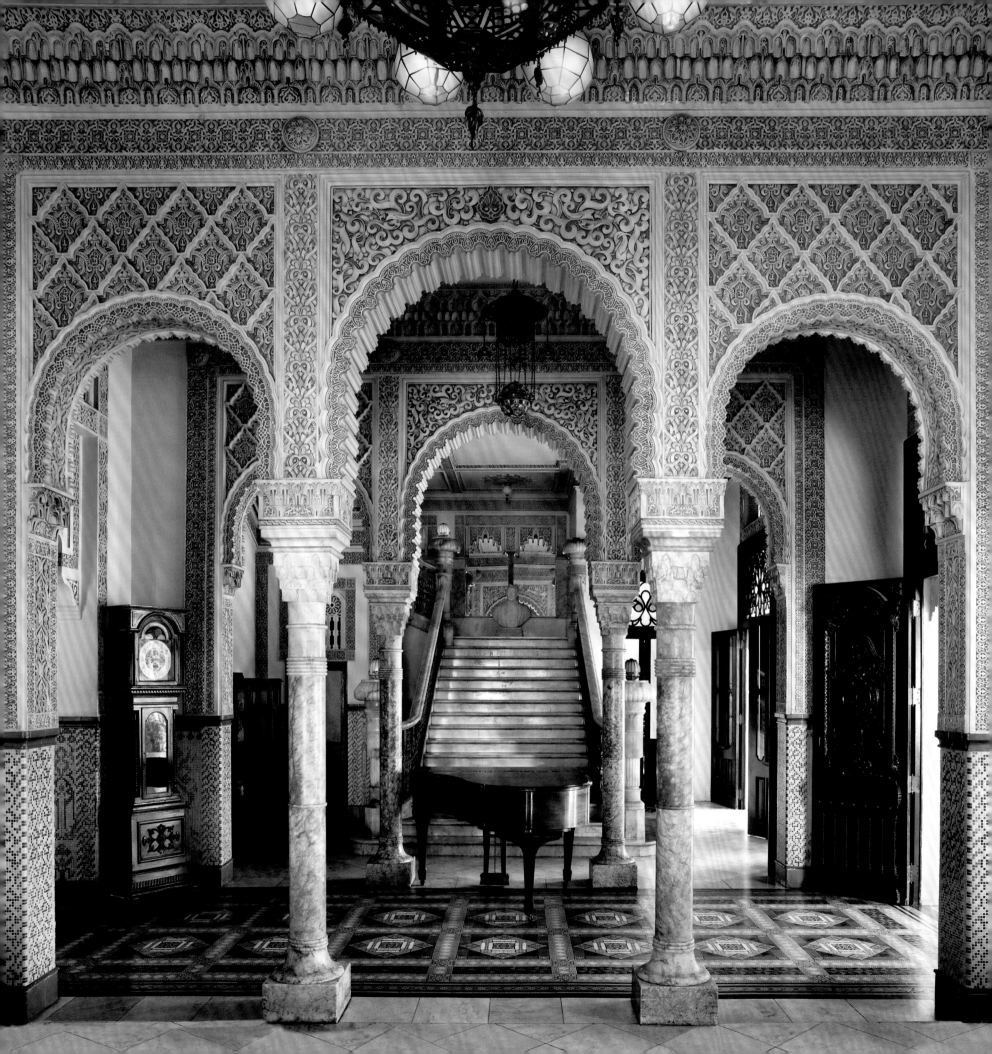

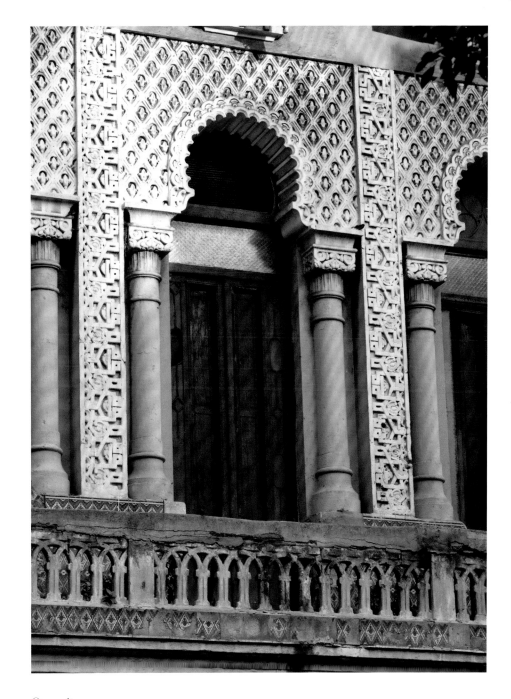

Opposite
*Moroccan craftsmen were imported
to do the interior decor on Palacio
del Valle.*

Above
*A richly decorated façade that
incorporates classical columns
and Mudéjar arches into the neo-
Moorish detailing of a residence
on Havana's Paseo del Prado,
a parklike promenade.*

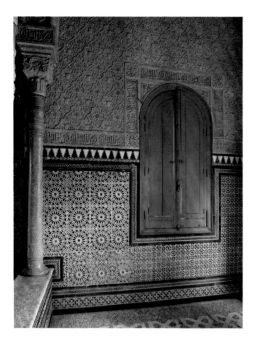

Above
*An example of the intricate tile work
(azulejos) found throughout Cuba.*

Right
*The extensively ornamented
pavilion at the Jardines de la Tropical
was influenced by designs from
the Alhambra in Granada, Spain.*

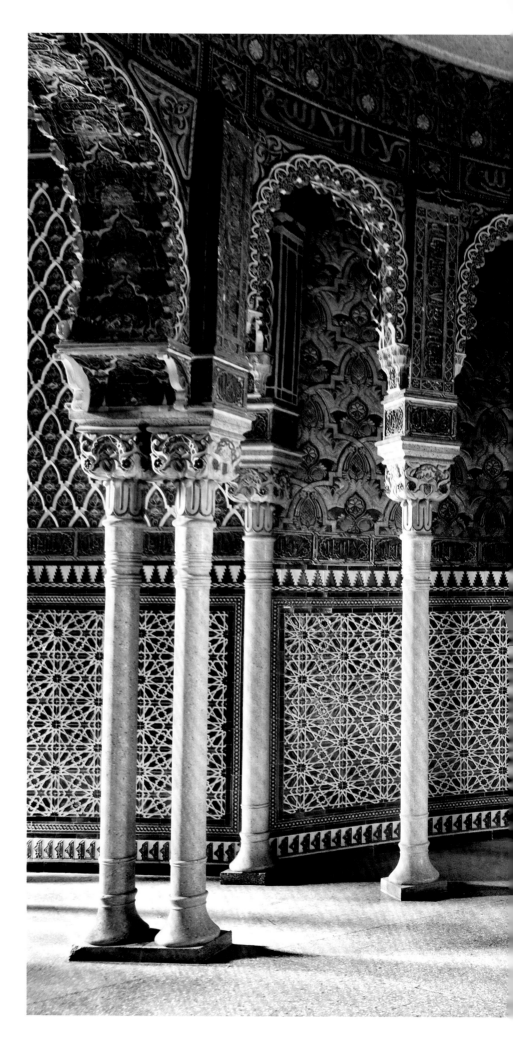

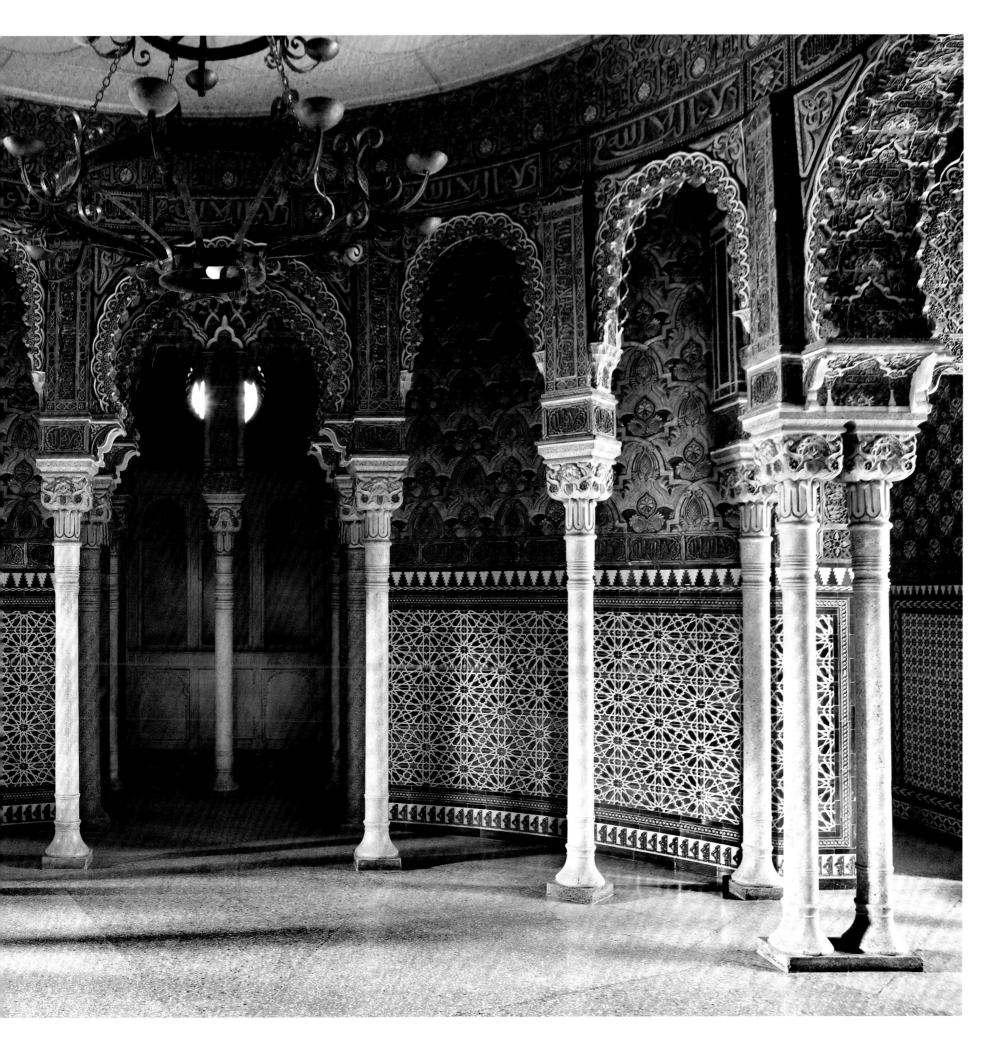

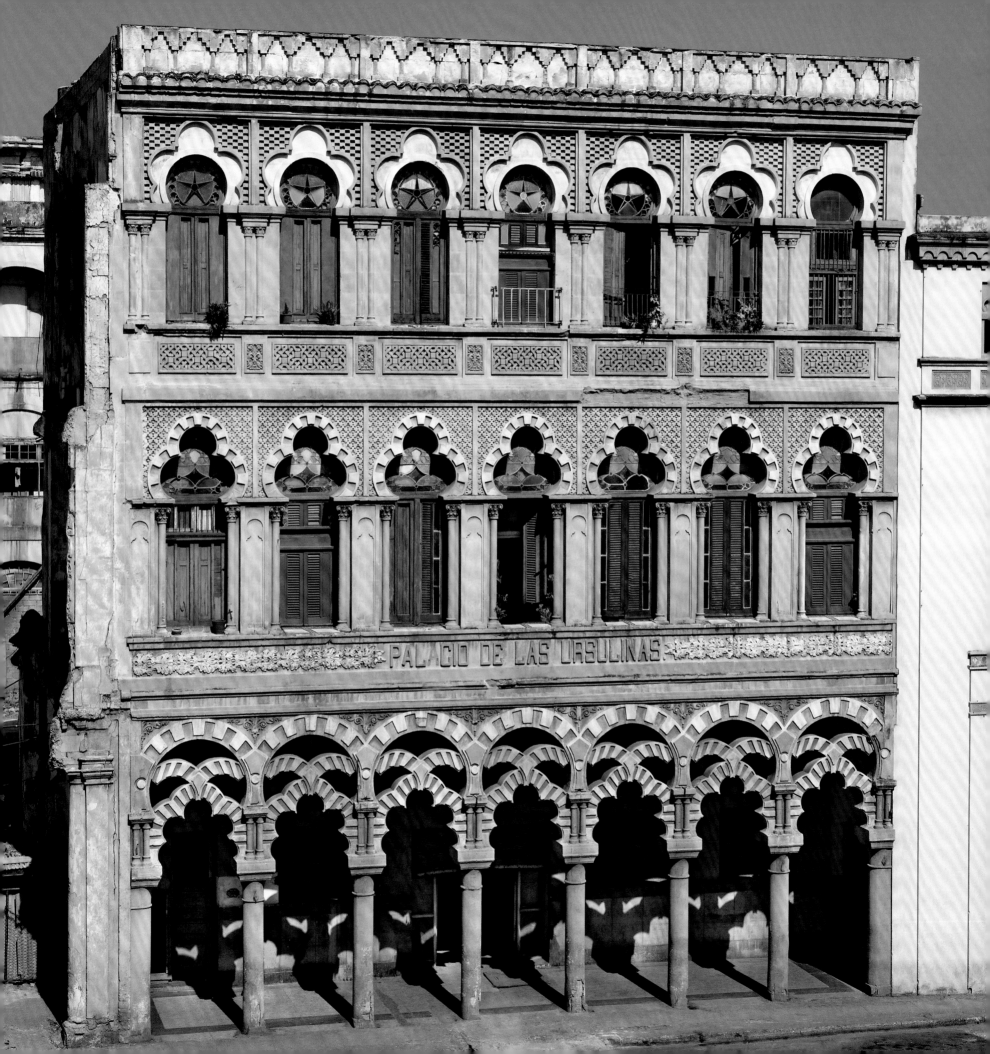

Opposite
The decorative elements of the façade of Palacio de las Ursulinas exemplify the Spanish Arab influence that has endured through four centuries of Cuban architecture.

Right top
Detail of Mudéjar architectural elements.

Right bottom
This Moorish-Spanish domed pavilion is in a private water garden on the edge of El Vedado.

Next spread
Interior detail of the domed pavilion built on an artificial island at the water garden of Carlos Miguel de Céspedes's mansion Villa Miramar. The tiles were brought from La Cartuja in Seville, Spain.

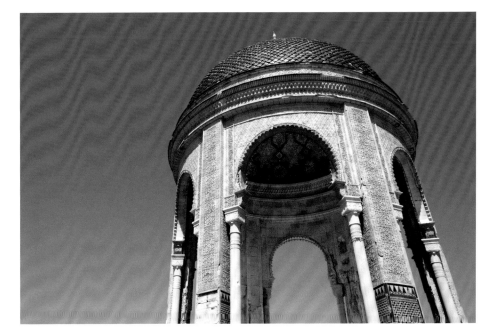

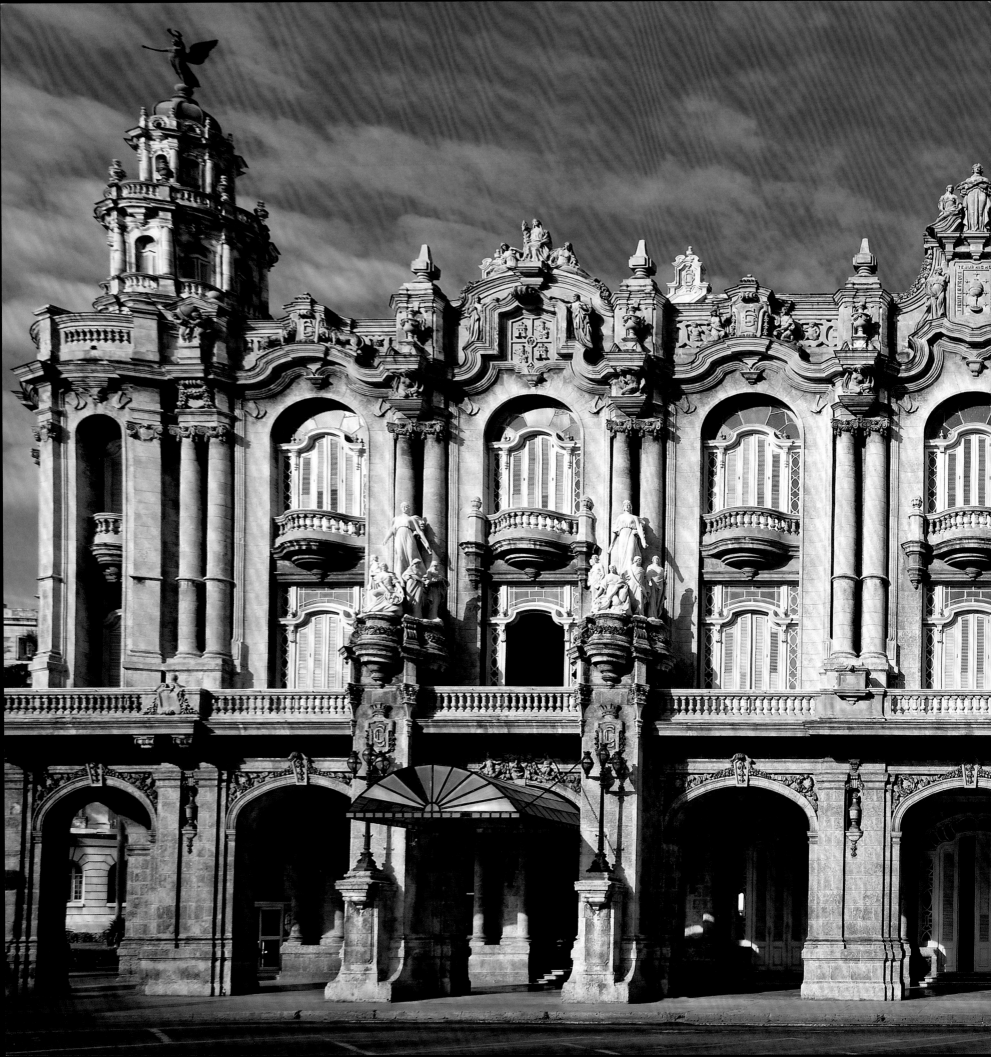

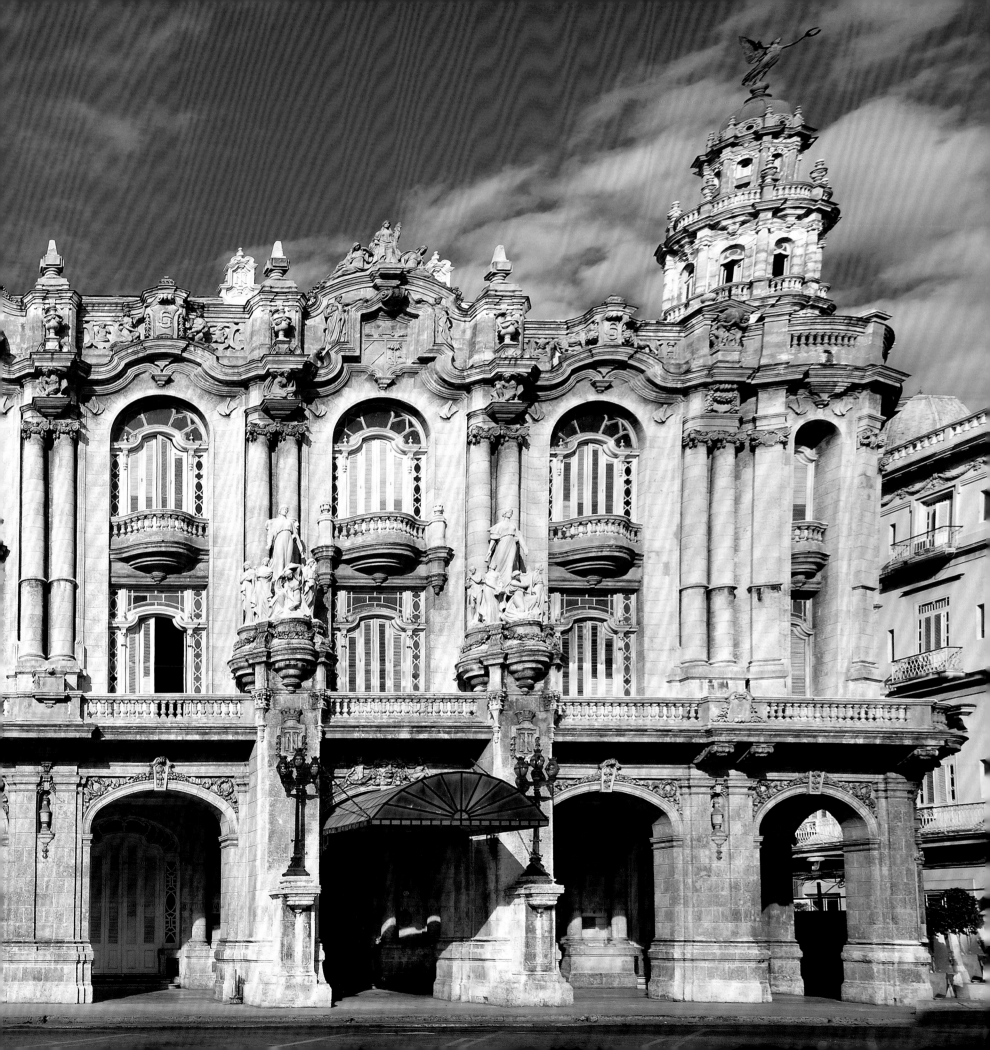

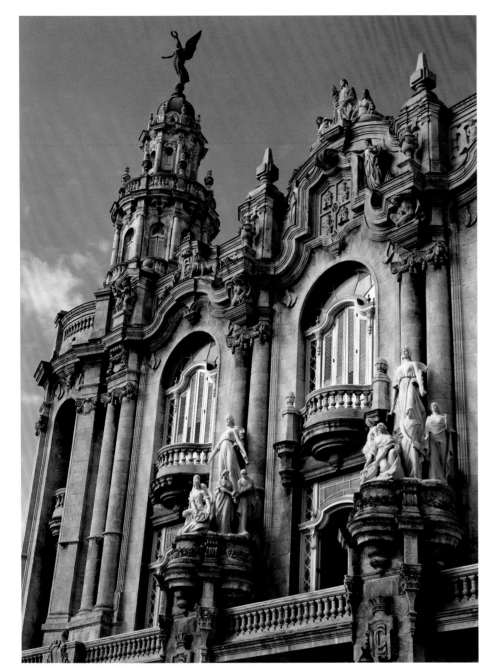

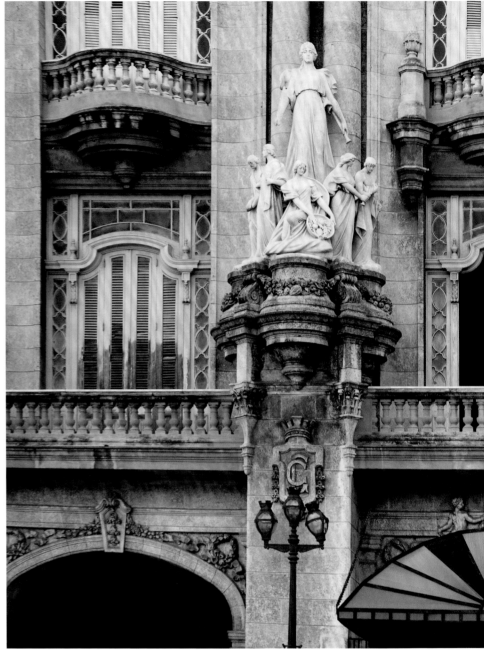

Previous spread
The Cuban Galician Community, an affluent Spanish leisure society, was founded in 1897 in Havana and built this impressive palace, Centro Gallego. Now known as the Gran Teatro de la Habana, the famous Sarah Bernhardt performed here, as well as Arthur Rubinstein and Andrés Segovia.

Above left and center
Details of the elaborate and flamboyant façade of one of Cuba's most important social clubs that was designed by Paul Belau and built in 1915.

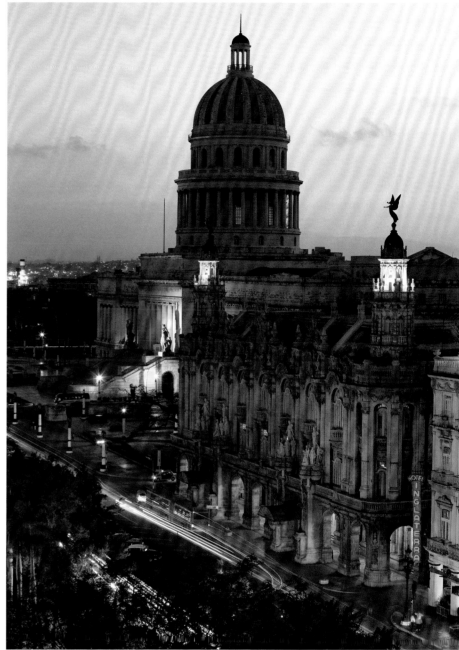

Above
*The Gran Teatro at night with
the towering neoclassical Capitolio
building, which was constructed
in the 1920s, in the background.*

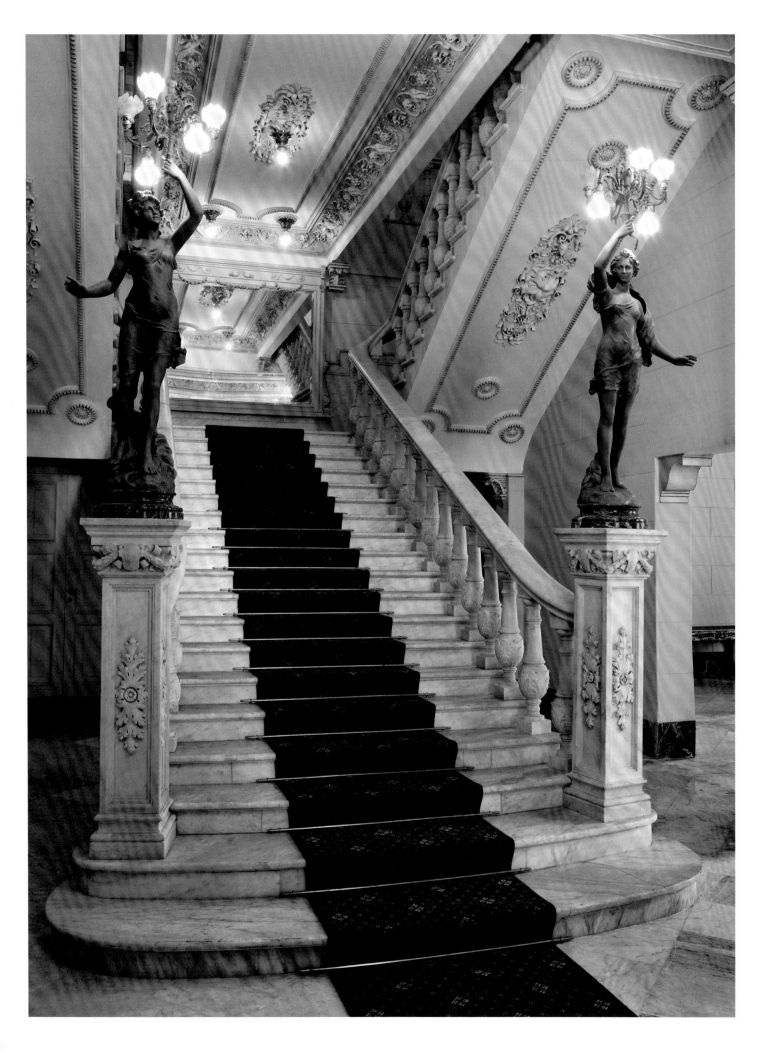

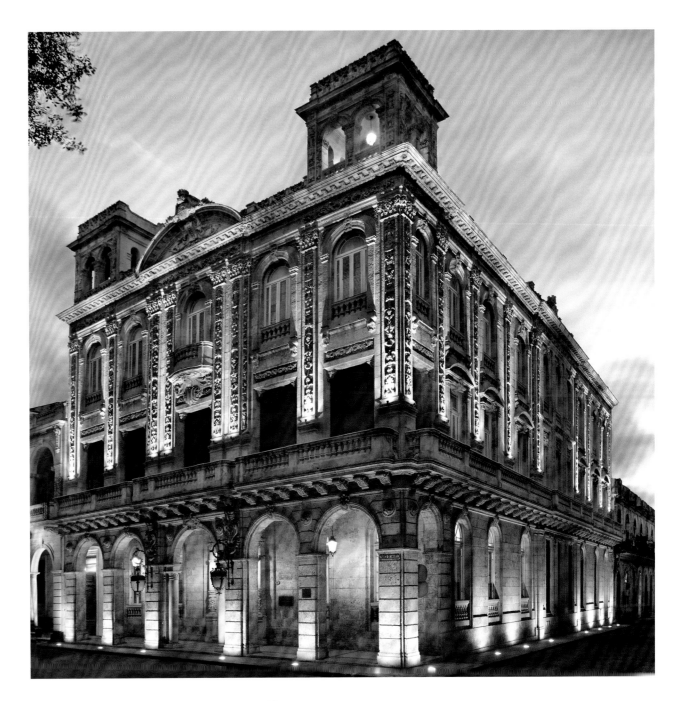

Opposite
*Entrance hall staircase of what was
the Casino Español, built in 1914 on
the prestigious Prado Promenade.*

Next spread
*The grandeur of the second-floor
Grand Salon reminds one more of
a European throne room than the
ballroom it was designed to be.*

Above
*Casino Español's Plateresque-inspired
decoration of the neo-baroque
and Spanish renaissance style was
designed by Luis Dediot.*

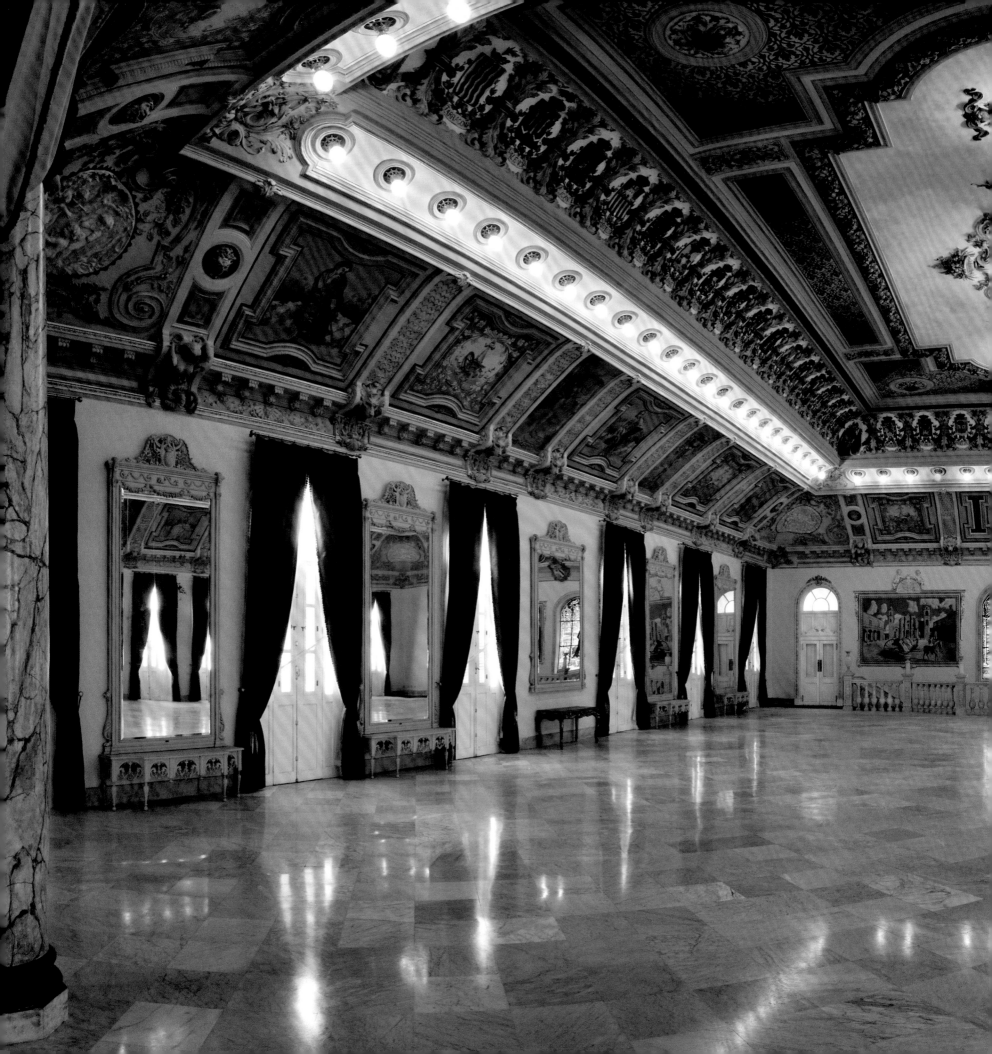

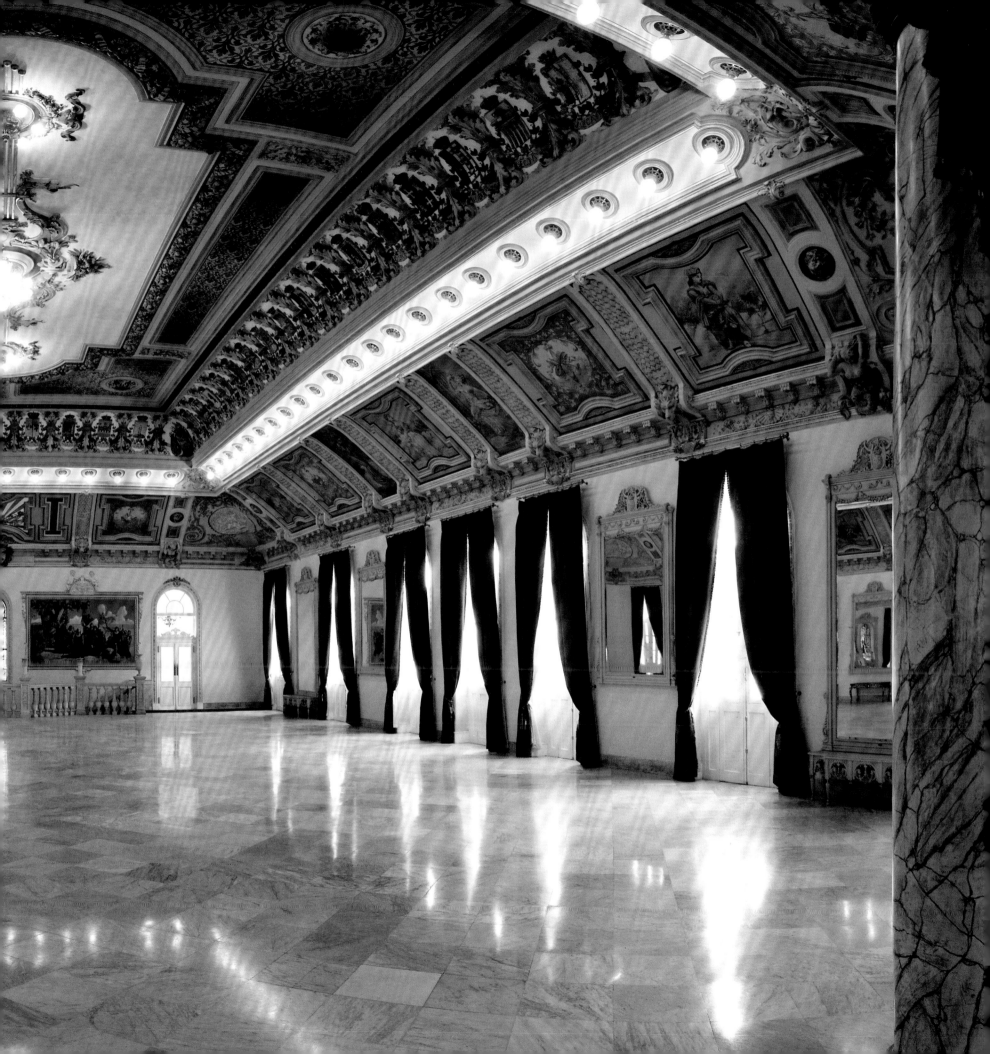

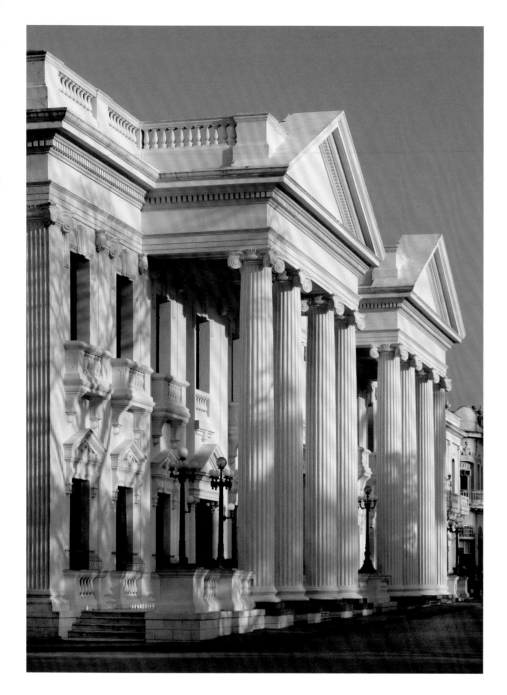

Above
*The Palacio Provincial's imposing
neoclassical façade with Ionic
columns was built in 1922 and faces
Santa Clara's Parque Vidal.*

Opposite
*The late nineteenth-century Hotel
Inglaterra is noted for its grand
neoclassical exterior and lavish,
exotic, Moorish-influenced interior.
The statue of Cuban national hero
José Martí in the foreground was
sculpted in Carrara marble in
Rome by Jose Vilalta y Saavedra
and inaugurated in 1905 by
Generalísimo Máximo Gómez.*

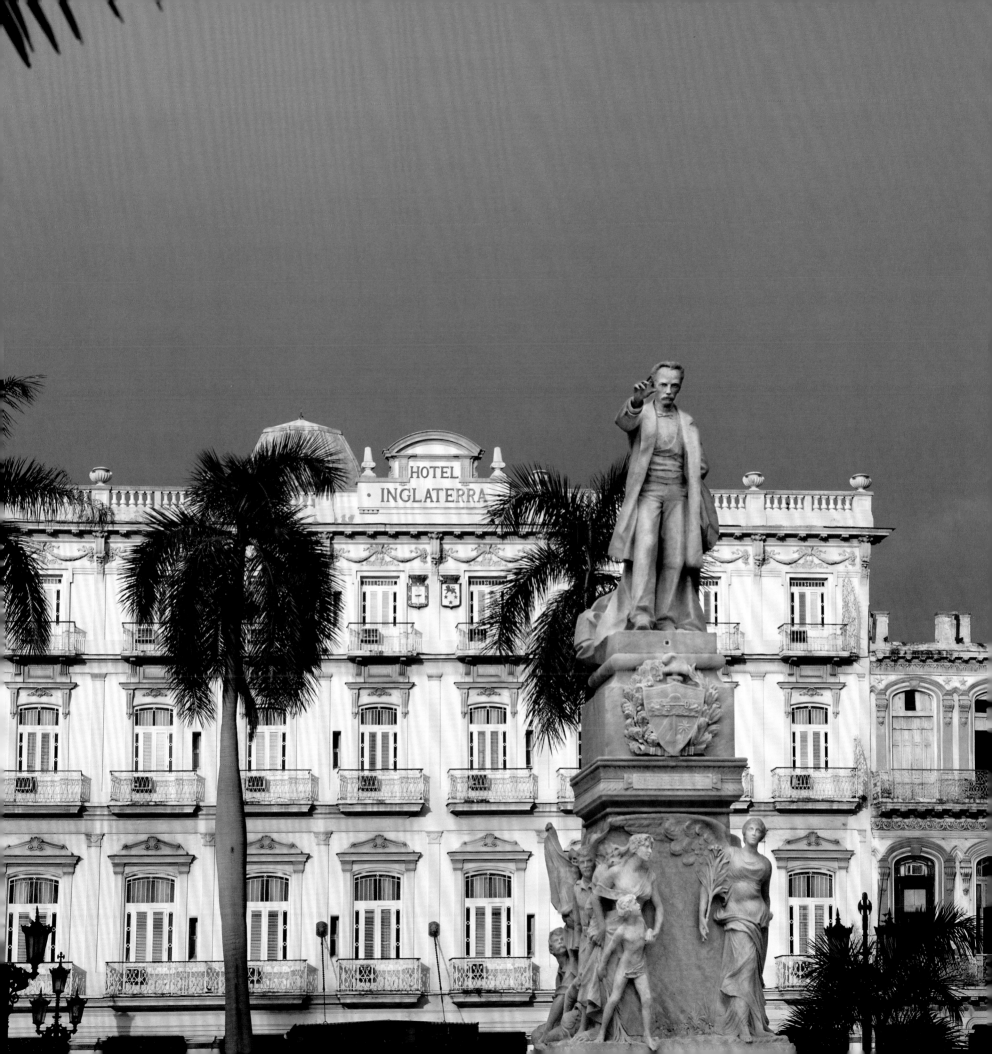

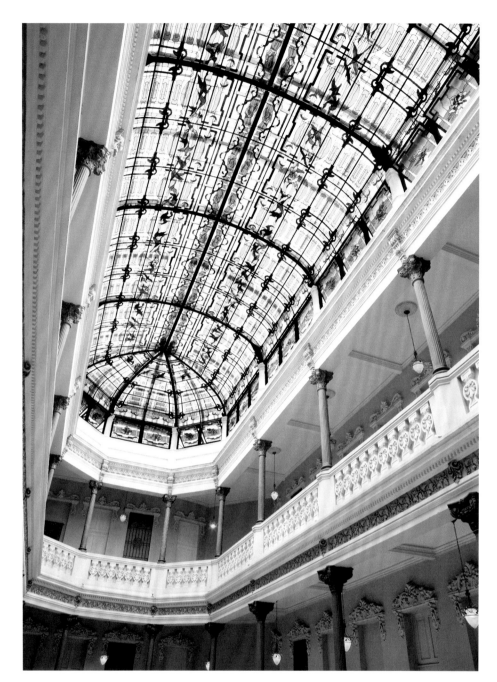

Left
Stained-glass skylight over the atrium and the interior courtyard galleries in what is presently the Hotel Raquel, built in 1908. North American and European glassmakers, including Louis Comfort Tiffany, were commissioned to design and install elaborate stained glass in Cuban mansions.

Opposite left
An art nouveau bar in the atrium.

Opposite right
The lobby, surrounded with Corinthian columns and stained-glass windows, shows the care that architect Naranjo Ferrer took with his design.

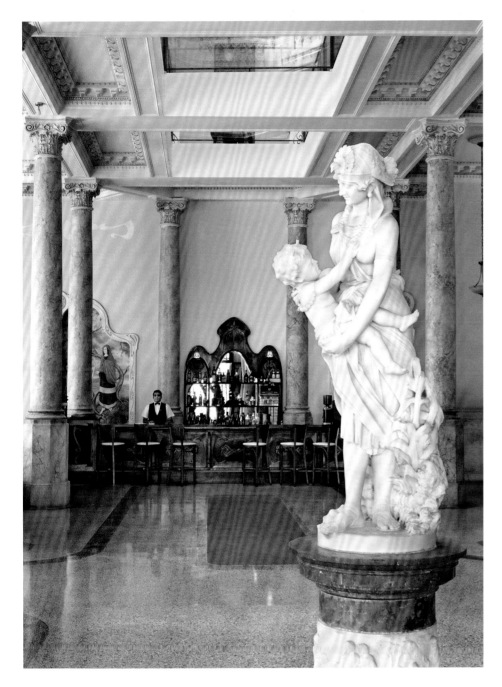
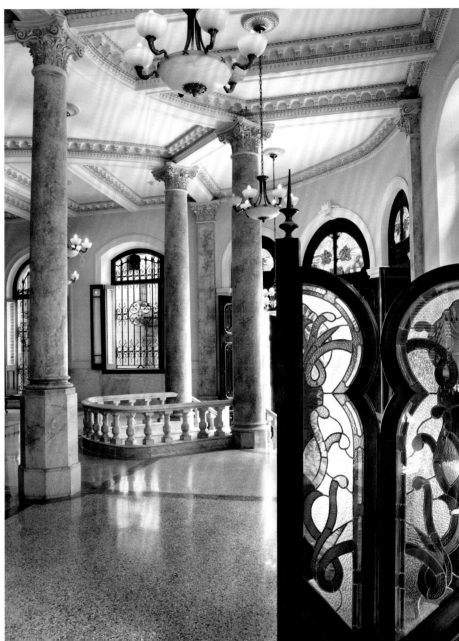

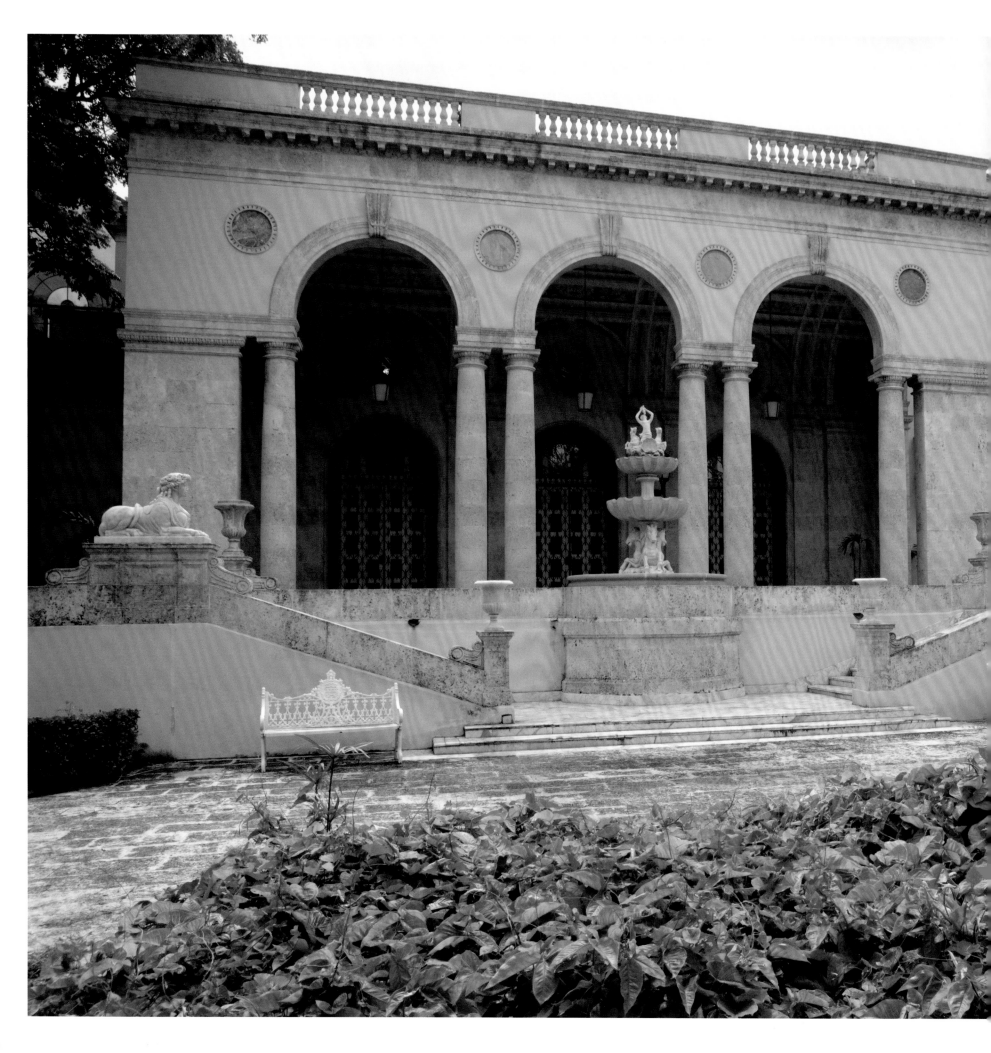

Left
Casa de Marcos Pollack y Carmen Casuso was designed to replicate an Italian renaissance villa and was completed in 1929 in the Cubanaçan district of Havana. The loggia portico has three arches supported by double columns and a richly decorated arched ceiling.

Above
A view of the side of the house and its porte cochere.

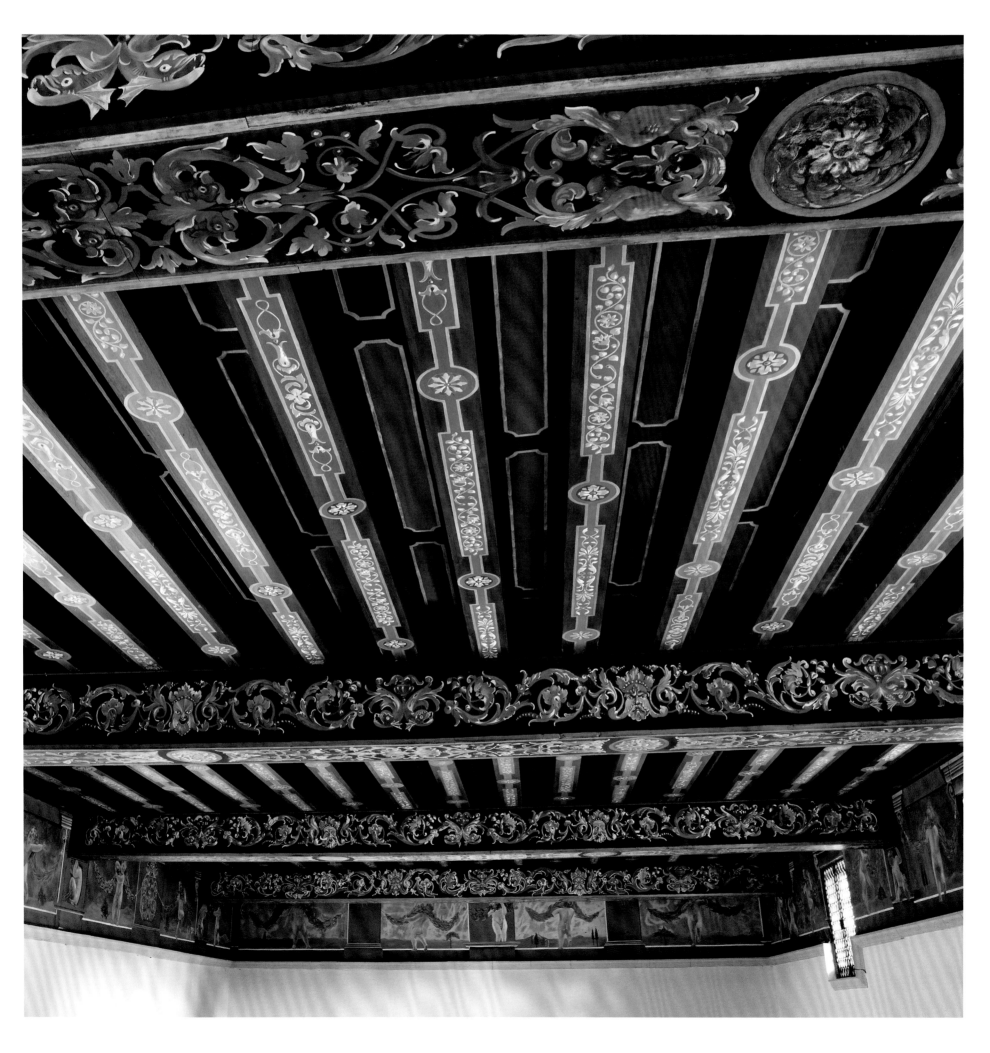

Opposite
The ceiling, wood rafters, and surrounding frieze are all hand-painted and decorate the grand drawing room (sala).

Right
The porticoed gallery of the Mark Pollack house has columns, all sculpted from different colored marble that surround a center courtyard.

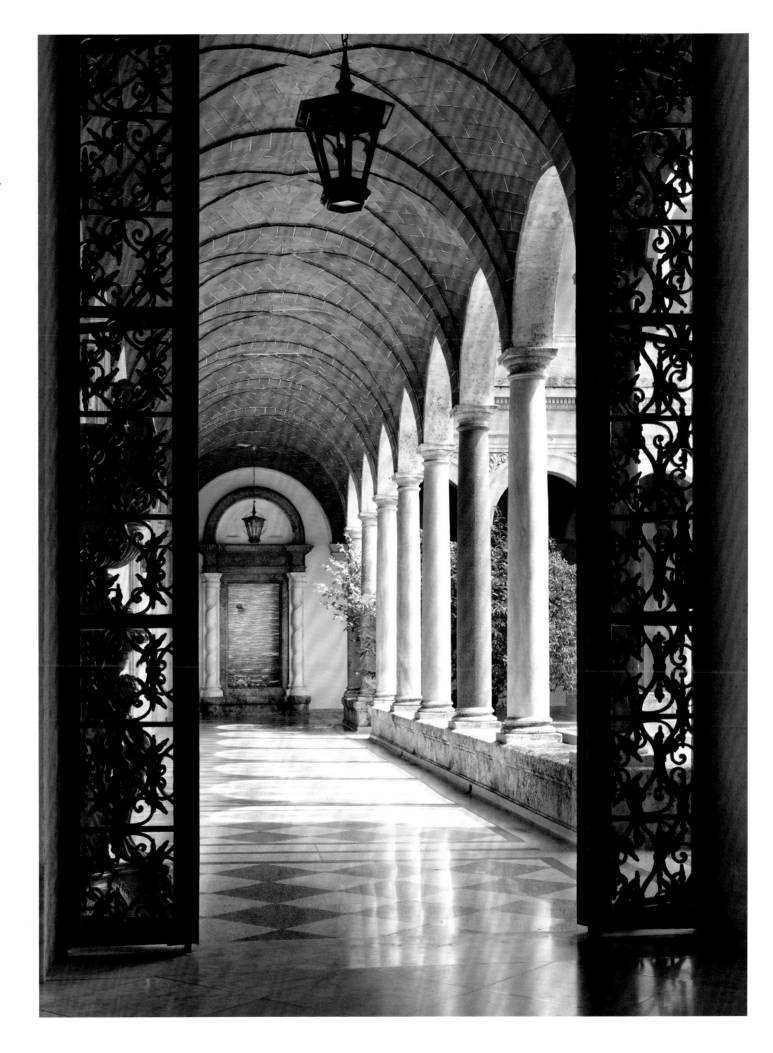

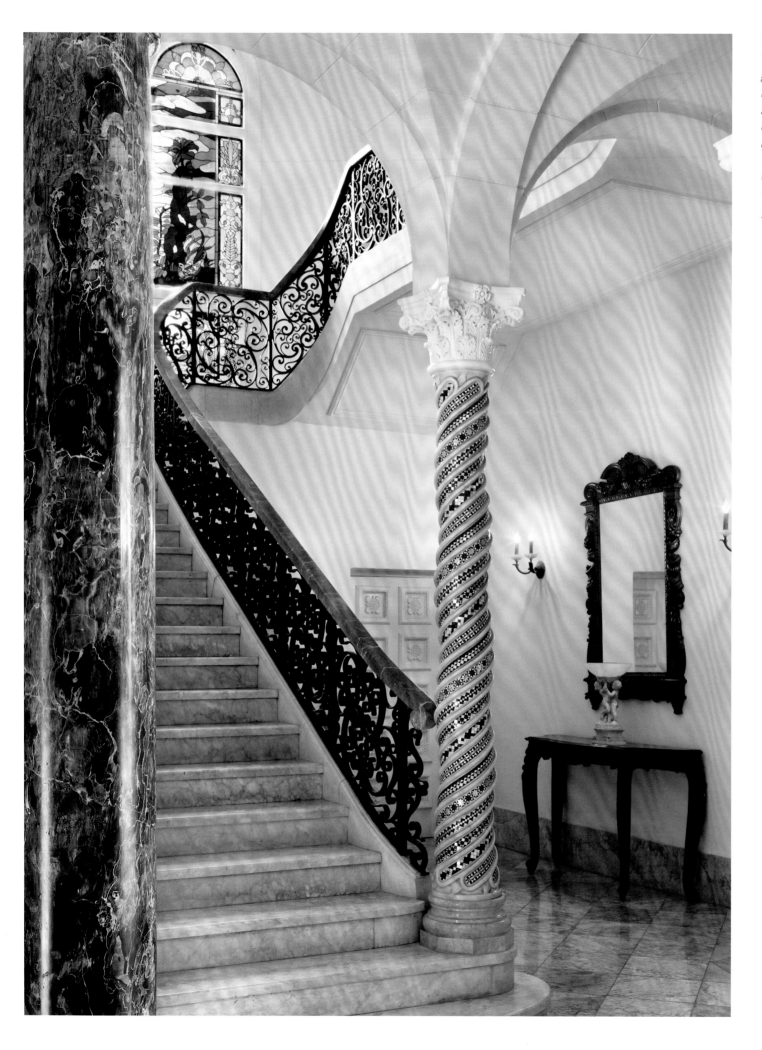

Left
The staircase and stained-glass window of the Pollack house. Notice the bejeweled spiral column, one of the many eclectic architectural elements of the house.

Opposite
The dining area of the Pollack mansion.

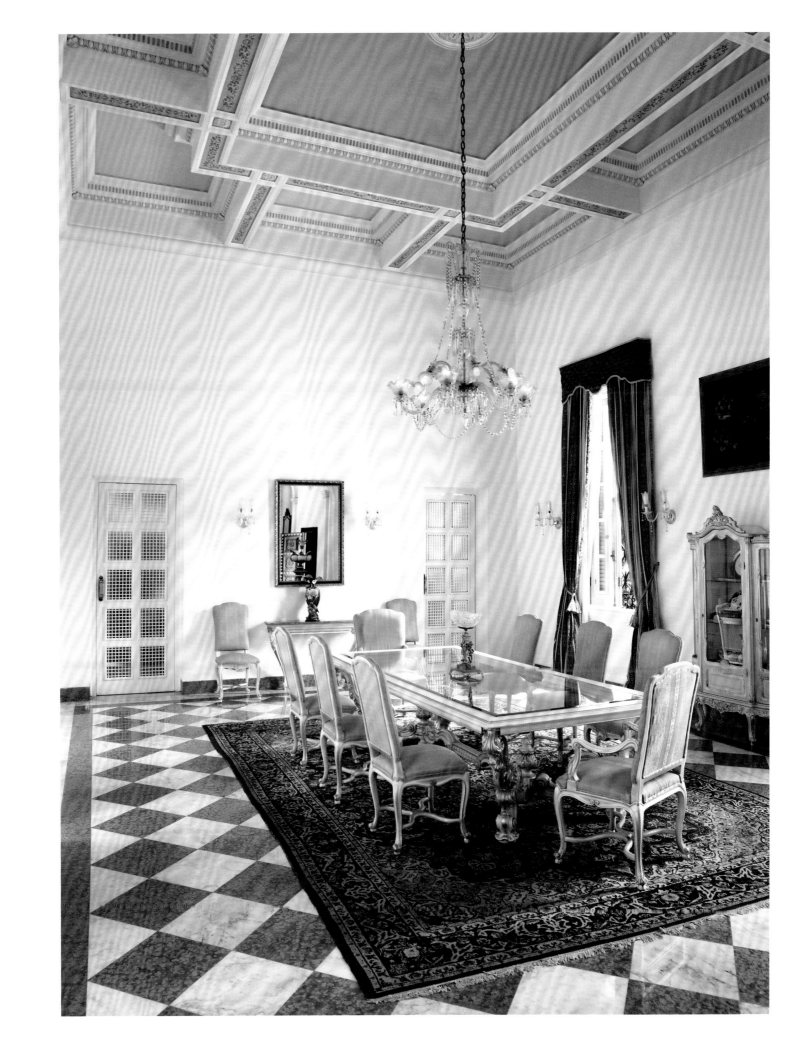

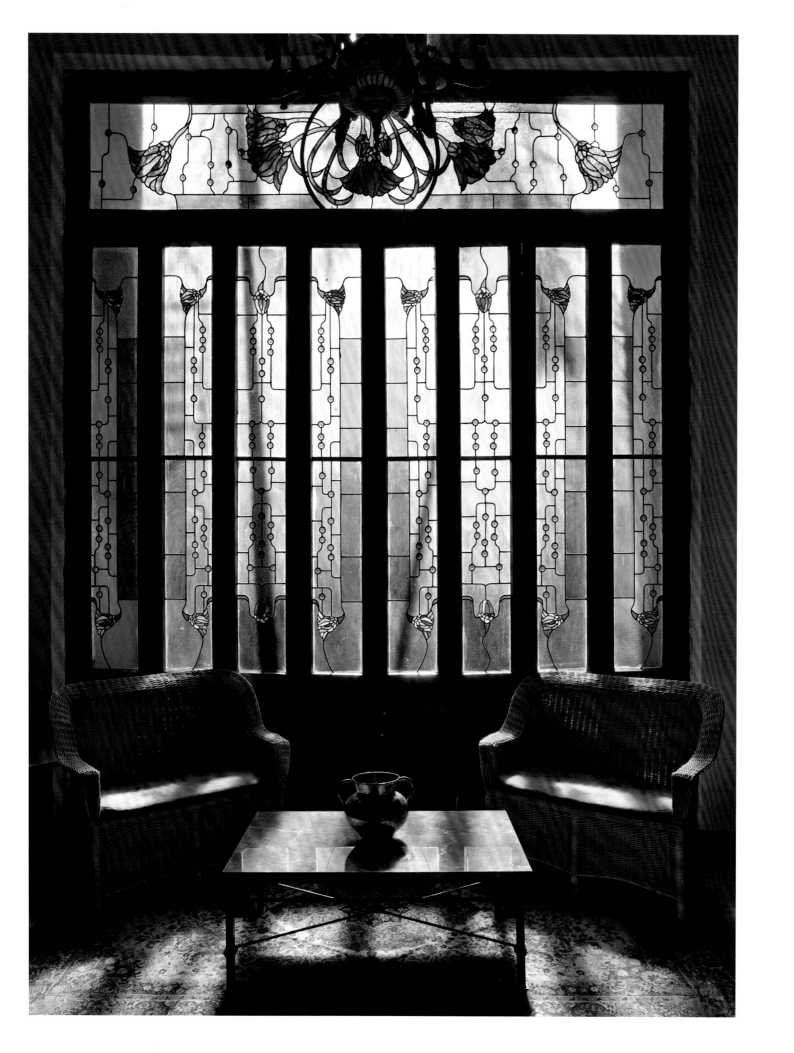

Opposite
One of many art nouveau stained glass windows that can be found in Havana.

Above left
An art nouveau style embellished doorway retains the traditional mahogany plank carved pair of doors.

Above right
Detail of the art nouveau flamingo door motif, probably taken from a contemporaneous publication.

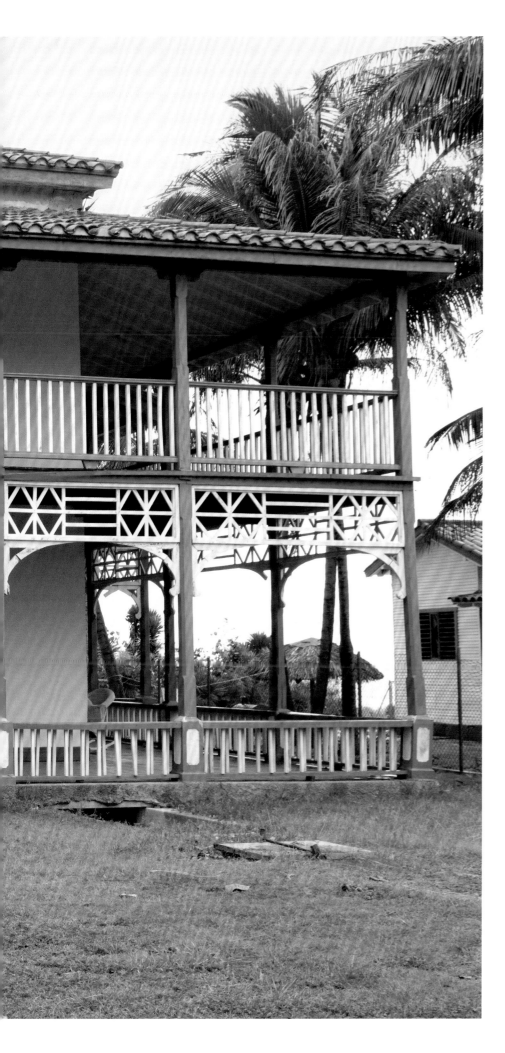

Left
Early twentieth-century chalet beachside home with delicate fretwork and French roof tiles in Varadero.

Next spread
Porch overlooking the Atlantic in Varadero, the largest seaside resort in Cuba today. Wealthy Cubans from Cárdenas and Havana built beach villas here at the turn of the twentieth century.

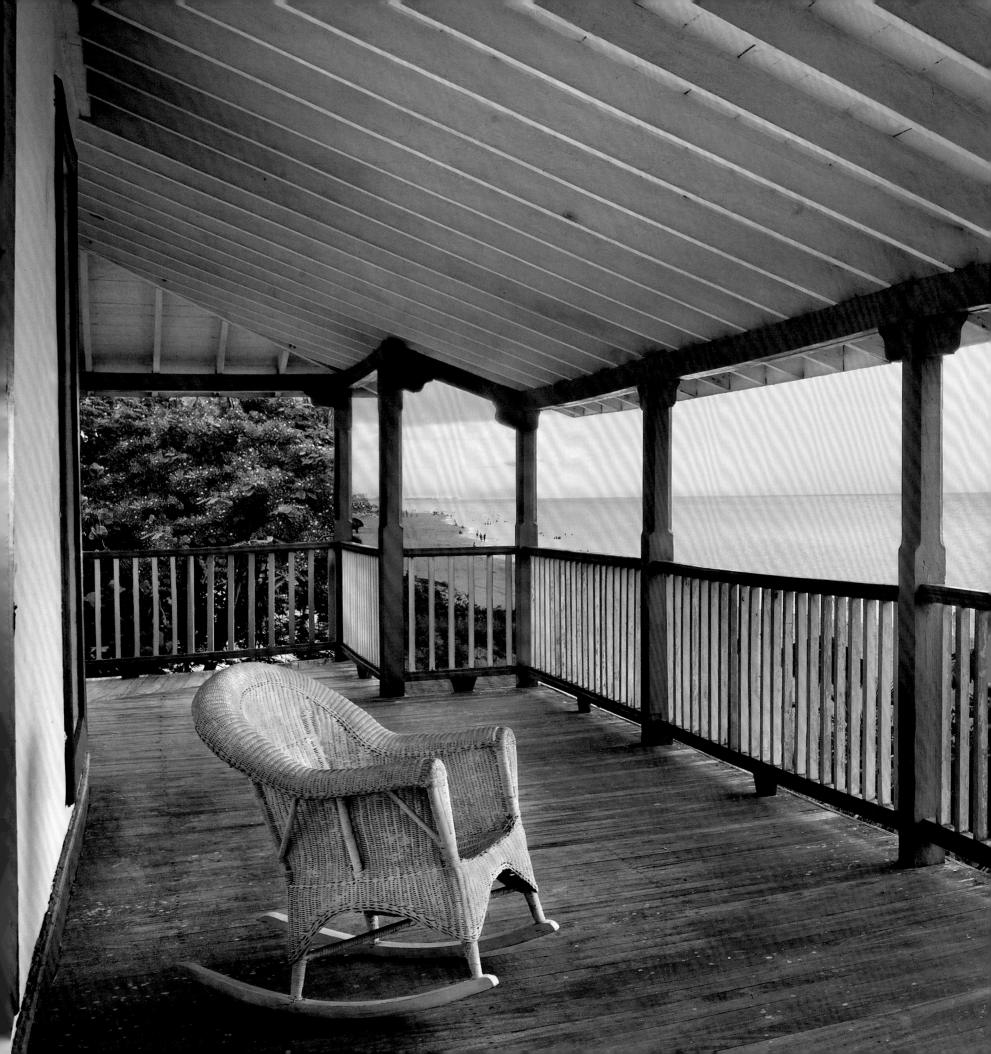

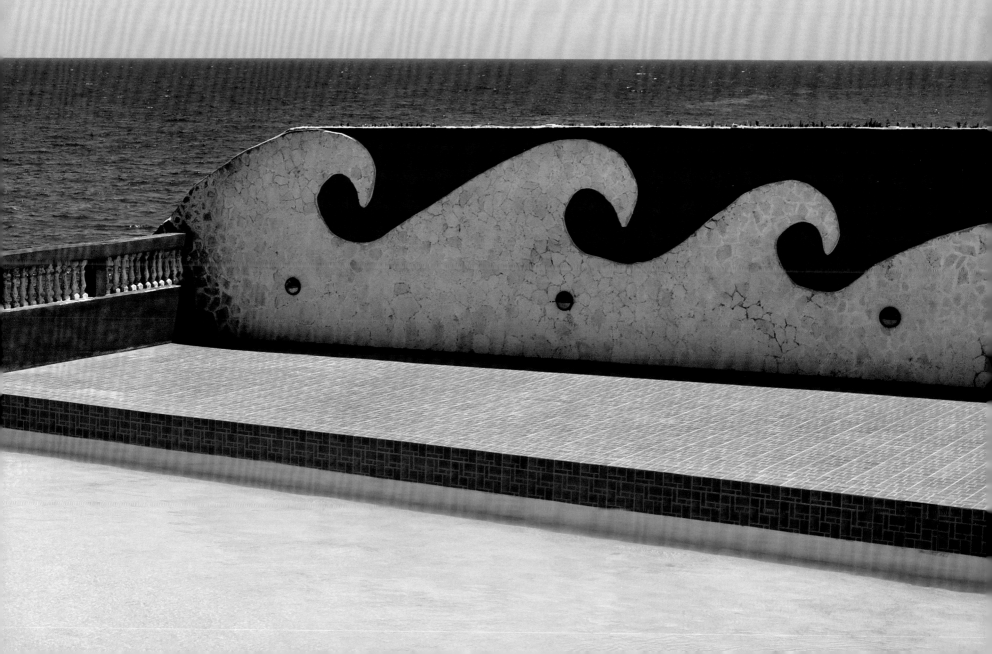

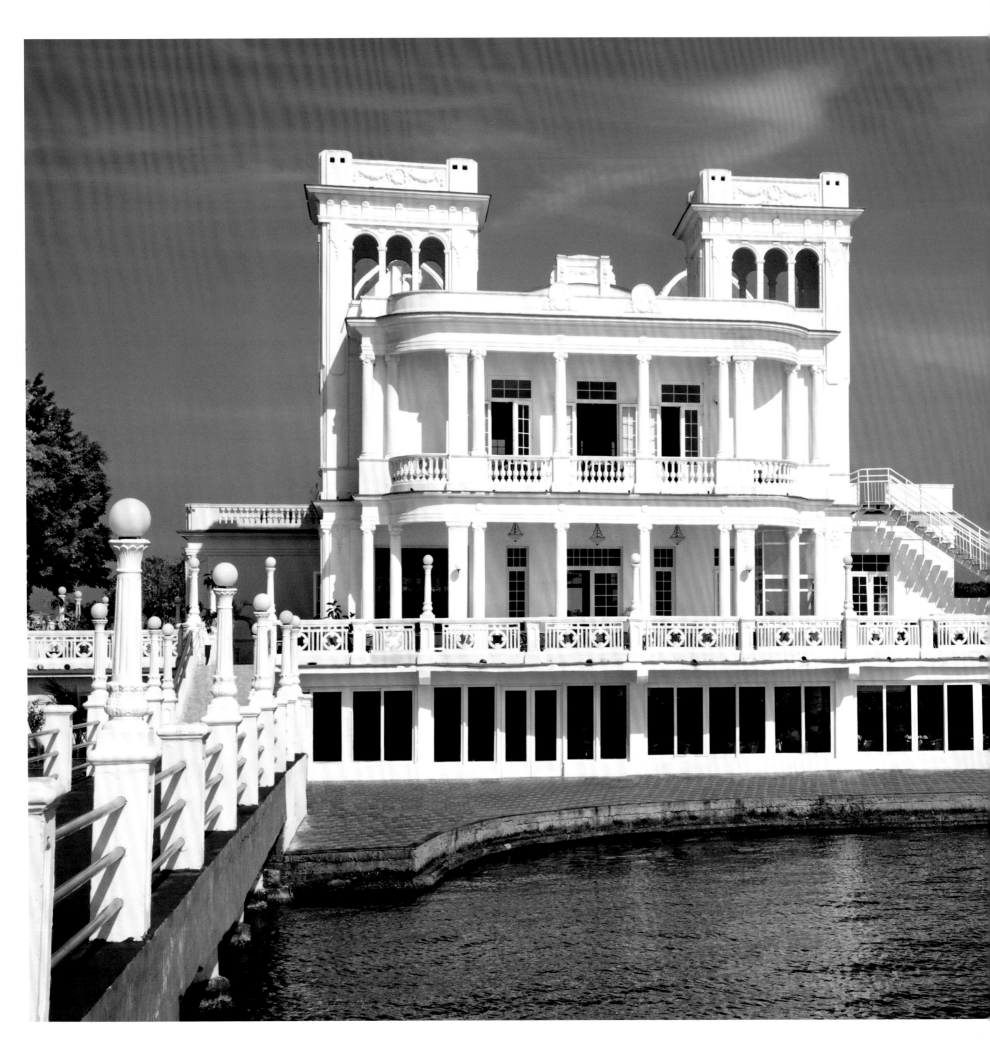

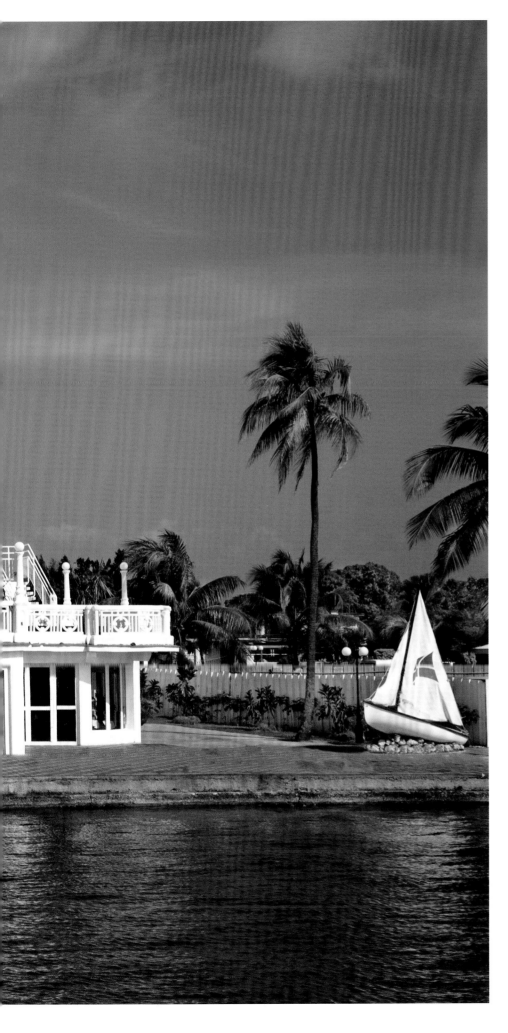

Republican Era and Modernization

The turn of the twentieth century and Cuba's new independence spawned a push for modernity in domestic architecture, and Europe and especially North America were influential to the world-class Cuban school of architecture.

Within the first decade of the twentieth century, the art nouveau style arrived from Europe with Catalan, Viennese, and French versions in overlapping succession. The numerous and very different decorative façade treatments of Havana's Palacio Cueto, built between 1905 and 1908, and the Guasch Palace in Pinar del Río, built between 1909 and 1914, are perfect examples of the modernistic effect these styles produced.

After the War of Independence and the Spanish-American War, Cuba once again found itself under foreign control, now by the United States. Vast swaths of land, predominantly sugarcane fields, gradually reverted to the property of United States corporations. The United Fruit Company was one that purchased Cuban land for a pittance. Additionally, American companies began to invest hundreds of millions of dollars in major Cuban industries.

The positive side to the U.S. investments was that the billions of dollars invested brought the Cuban economy back from the devastation caused by the wars for independence from Spain. The unprecedented fount of capital, popularly named the "dance of the millions" (*danza de los millones*), was responsible for a building boom that lasted from 1910 to 1930 and created new suburbs throughout all of Cuba. These foreign investments in mining, railroads, tobacco, coffee, utilities, and, most of all, in sugar also paid for

massive civic constructions and improved public utilities. The influx of new wealth also brought about a new era of building plush, grand mansions again. New fashions and architectural styles like the art nouveau, Beaux-Arts, and art deco blossomed in cities all over the island.

By World War I, Havana's El Vedado area was favored by wealthier Cubans as the "only chic place to live," and construction of mansions in the eclectic, neoclassical, and Beaux-Arts styles ensued.

In the neighborhood of Vedado, Cuban architect Leonardo Morales designed and built a large residence in 1916 for landowner and banker Pablo González de Mendoza. The monumental Casa de Pablo González de Mendoza is surrounded by large gardens that ensure privacy and contain romantic marble sculptures and fountains. The most famous feature of the "Vedado style," a variation of the neoclassical trend, is the Roman-style pool (baño romano). The first indoor swimming pool to be built in Cuba is reminiscent of a Pompeian impluvium with the wooden Mudéjar ceiling used in colonial architecture.

In terms of domestic architecture, El Vedado's suburban district would rival any quarter in the world's great cities for displays of luxurious homes.

Strict ordinance ensured orderly and coherent development and promoted the completion of a neighborhood of a quality of architecture and planning so far unsurpassed in Havana.[30]

The Beaux-Arts style is derived from the academic teaching of the École des Beaux-Arts, Paris, and is characterized by its formal classical designs and rich decoration. One example is the French classical-revival Palacio de la Condesa de Revilla de Camargo. The two-story palacio was built in 1927 of *capellania* stone, has an entrance hall sculpted from white

Carrara marble, and displays one of the most spectacular staircases in Cuban residential architecture.

Cuba's 1920s Beaux-Arts style fused baroque, classical, Renaissance, and neoclassical architectural and decorative elements. Another example of this popular lavish style that conveyed a message of grandeur is the Casa de Juan de Pedro y Baró. Juan Pedro-Baró lived in Paris, and after a brazen and scandalous love affair he married Catalina Lasa. His house was built in 1926 by Cuban architects Evelio Govantes and Felix Cabarrocas in a Beaux-Arts Italian Renaissance style, and it was the first mansion in Cuba to adopt art deco ornaments and aesthetics, with interiors by the fashionable French designer René Lalique. Casa de Juan de Pedro y Baró was celebrated in its day for its elegance and luxury of its materials, which included sand from the Nile to make the special stucco, Cuban mahogany paneling, French and Italian marbles, and wrought-iron grilles and banisters from Paris. The gardens were laid out by French landscape designer Jean-Claude Nicolas Forestier and featured a hybrid yellow rose that Juan Pedro-Baró had horticulturists develop especially for his bride; it is known in Cuba as the "Catalina" rose.

The invasion of American architecture was most noticeable with the construction of skyscraper-like buildings that were built as high as ten stories. Examples would be the more-than-two-hundred-foot-tall Compañía Cubana de Teléfonos tower, designed in the eclectic taste and built in 1927; the 1923 Hotel Sevilla, designed in the Moorish style; and the Bacardi Building, done in the art deco style and built in 1930. The monumentality of building, first conceived in Cuba centuries before, continued throughout the first half of the twentieth century not only in Havana with the Presidential Palace (Palacio Presidencial) in 1920 and the National Capital (Capitolio Nacional) in 1929, but also with the monumental private mansions and *palacios* throughout the island as well. Two examples in the beginning of the Republican era are Casa de Francesco Pons, built in 1906

with its Corinthian-columned portico, and the residence of Dionisio Velasco, built in 1912. The Velasco mansion has an ornate decorative façade with projecting balconies and modernist architectural details and is today the Spanish Embassy.

Much of the twentieth-century rebuilding from the independence wars also resulted in the development of a new middle class.

The Creole aristocracy of the colonial period had more or less disappeared with the failure of the sugar mills between the Ten Years' War (1868–78) and the last independence war. By the 1950s, not a single sugar plantation still belonged to the family of an original Spanish grantee.[31]

To accommodate an expanding middle and upper middle class, Cuban cities and towns started spreading into suburbs. Lavish single-family residences in the neoclassical, revivalist, and eclectic styles were built in Vista Alegre in Santiago de Cuba, Havana's El Vedado, and many other Cuban suburbs.

The new twentieth-century architecture continued to vary with a wide range of styles that was classified as Cuban eclecticism and was best described in 1929 as:

These buildings were well proportioned, but of a quasi-Greek rigidity. Later we progressed to the Italian Renaissance… After that there were some variants on Louis XVI, and I dare say that from 1914 to 1924 our architecture was a blend of this latter style and Italian Renaissance, in a fusion that was characteristic of our country and produced many distinguished works…. The Spanish Plateresque was introduced circa 1924, and became outrageously modish for a while. Then the Florentine came into vogue, and the California Mission, and finally … Cuban colonial art deco. The recent period has, therefore, spawned a new plethora of styles in the absence of precise time-frames, for at the same

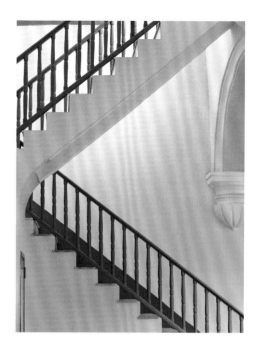

Opening spread
The pool of Casa de Eutimio Falla Bonet, a house designed by Eugenio Batista and built in 1939 overlooking the Caribbean Sea for millionaire philanthropist and conservationist Eutimio Falla Bonet.

Previous spread
One of the many seaside, turn of the twentieth century, elegant villas built by sugar magnates in Cienfuegos.

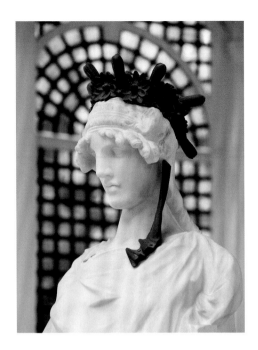

Early twentieth-century statue of Aphrodite in the impluvium of a home in El Vedado.

time as one style came into fashion others that until lately had claimed that honor were still under construction.[32] Cuban cities were becoming modernized and their architectural content was diversified. There were public and private offices and institutions, government buildings, bars, hotels, hospitals, social clubs, and commercial complexes, all designed, developed, and disseminated throughout the island.

By the 1940s the modern architectural movement had shed all traditional reminiscences of the Mudéjar, Romanesque, gothic, and baroque influences Cuba had experienced, and another housing boom resulted from capital investment accumulated after World War II.

Because of the technological advancement of reinforced concrete, apartment buildings started springing up in the late 1940s and through the next decade for the middle classes.

With regard to individual housing and apartment buildings alike, two distinct architectural trends emerged: one, which we may call "modern," embraced new criteria of spatial distribution and functional use, but remained ultimately anodyne and expressionless. The other was more properly "avant-garde," and sought to generate space on the basis of function. It achieved genuine heights of architectural merit by incorporating certain values of our national culture to synthesize a uniquely Cuban architecture.[33]

Modernism came into its glory and peaked in the 1950s. Thousands of Cuban homes were designed in the contemporary fashion in the suburbs of towns and cities throughout the island. Houses in Havana's Miramar and Cubanacán districts illustrate the last phase of Cuban modernism before the Communist Revolution.

In the Miramar district Casa de Eutimio Falla Bonet was designed by architect Eugenio Batista and broke radically

with the traditional grandeur and opulence of Havana's elite. Constructed in 1939, the single-story modernity employs concepts that Batista developed to achieve a style influenced by traditional Cuban colonial architecture but defined by the latest modernism in aesthetic composition. It includes structures designed with porticoes and galleries, planned around courtyards with abundant natural light and ventilation by way of louvered blinds.

Though they are evident tributes to tradition, they are articulated in a novel way. Thanks to its inventive combination of time-honored elements, the villa was to be a guiding example to the creators who renewed Havana's architecture after the Second World War.[34]

The Cubanacán district was originally called Country Club Park and was Havana's equivalent to Beverly Hills. First developed in the 1920s by Alberto Mendóza with winding tree-lined streets and enormous lots, the district housed the most ostentatious and grandiose mansions built by Havana's wealthy classes. In the character of country estates, the United States ambassador's residence was built in this area in 1939 in the twentieth-century neoclassical "garden city" style. Designed and built with a collaboration of American and Cuban architects and builders, the residence has a total of sixty-five rooms and covers more than 31,700 square feet of living space. The first-floor state dining room seats forty people. The second floor has seven bedrooms each with its own loggia from where the grounds can be viewed. The residence is surrounded by seventeen acres of beautiful formal gardens, with fountains, a swimming pool, tennis courts, and an orchard of fruit trees. At the end of a long promenade, overlooking a reflecting pool, is a huge American eagle sculpture. It once stood atop the Monumento del Maine on the Malecón, Havana's ocean promenade. It was placed to commemorate the battleship *Maine,* blown up in Havana Harbor on February 15, 1898, killing 266 of the crew members—the incident that ignited the Spanish-American War.

Another diplomat's home is the Swiss ambassador's residence, originally built for Swiss banker Alfred von Schulthess in the 1950s by Richard Neutra. Considered one of the finest modern villas in Cuba, the Casa de Alfred de Schulthess integrates nature into the architectural concept. The tropical gardens were designed by Brazilian landscaper Roberto Burle Marx and are used to enhance the geometric glass surfaces of the house and connect the interior with the exterior to convey a feeling of transparency and openness.

Today, with the exception of the few *ingenios* and *cafetales* that have been made into government restaurants, all of Cuba's once large sugar and coffee plantation great houses (*haciendas*) lie in ruins, destroyed during the wars of independence as part of the scorched-earth policy carried out by the Mambi (independent) army or by the reorganization of agricultural systems under the communist regime in the last half of the twentieth century. Most of the wealthy homeowners fled Cuba in the 1960s, and their country villas, *palacios*, and mansions were dispensed to government officials or their appointees who live in the lap of luxury behind closed doors and are unavailable for research or photography.

By the 1960s, Cuba's architectural revolution abruptly ended. Following the Communist Revolution, most of the leading architects left the island; in 1965 the School of Architecture closed, signifying the end of Cuba's glorious era of architecture.

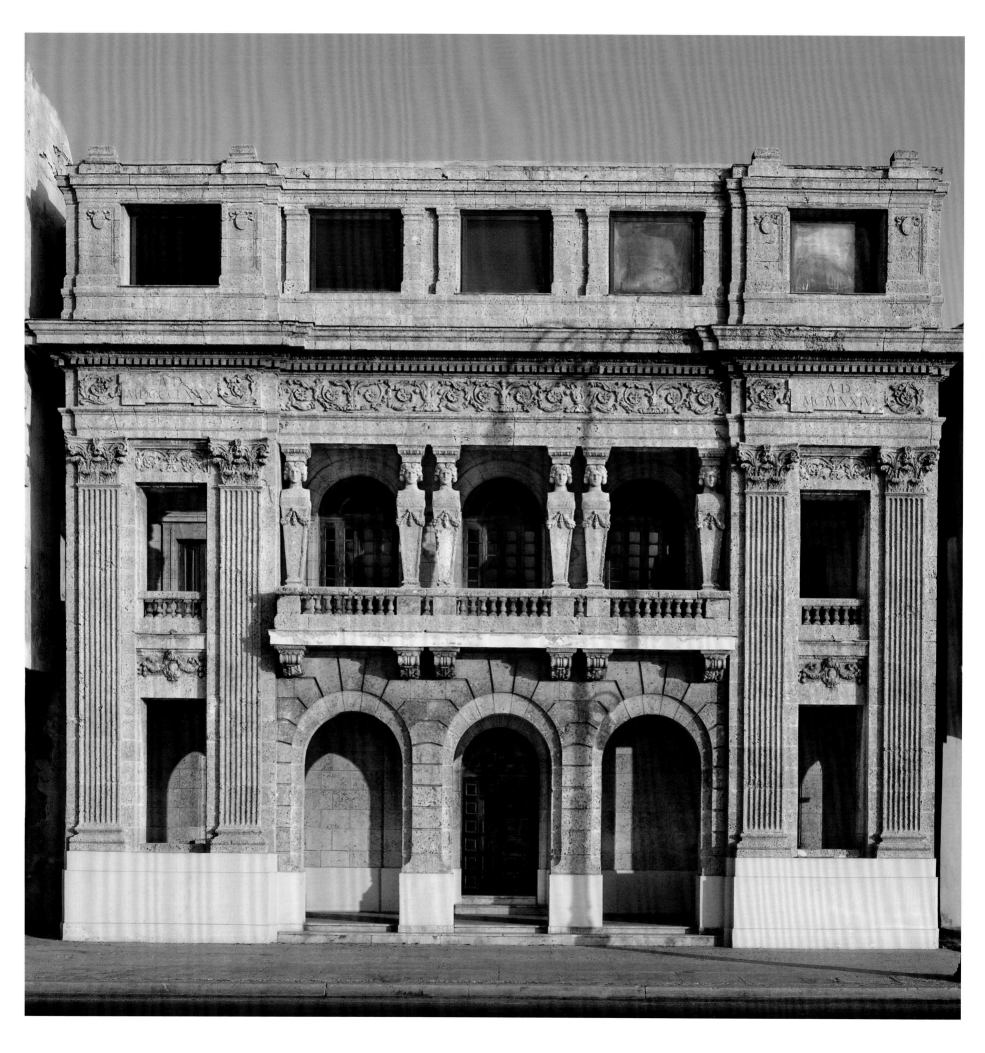

Opposite
One of the more notable twentieth-century buildings constructed in Havana by wealthy merchants and industrialists overlooking the Malecón seafront drive. The three-story façade features a row of caryatids.

Right
Six caryatids support an entablature upon the building's façade along the Malecón, a five mile-wide boulevard overlooking the Caribbean Sea in Havana.

Next spread
A ballroom is lined with vast mirrors (espejos) and is often referred to as the Hall of Mirrors, in Havana's Presidential Palace designed by Paul Belau and Carlos Maruri and built in 1920.

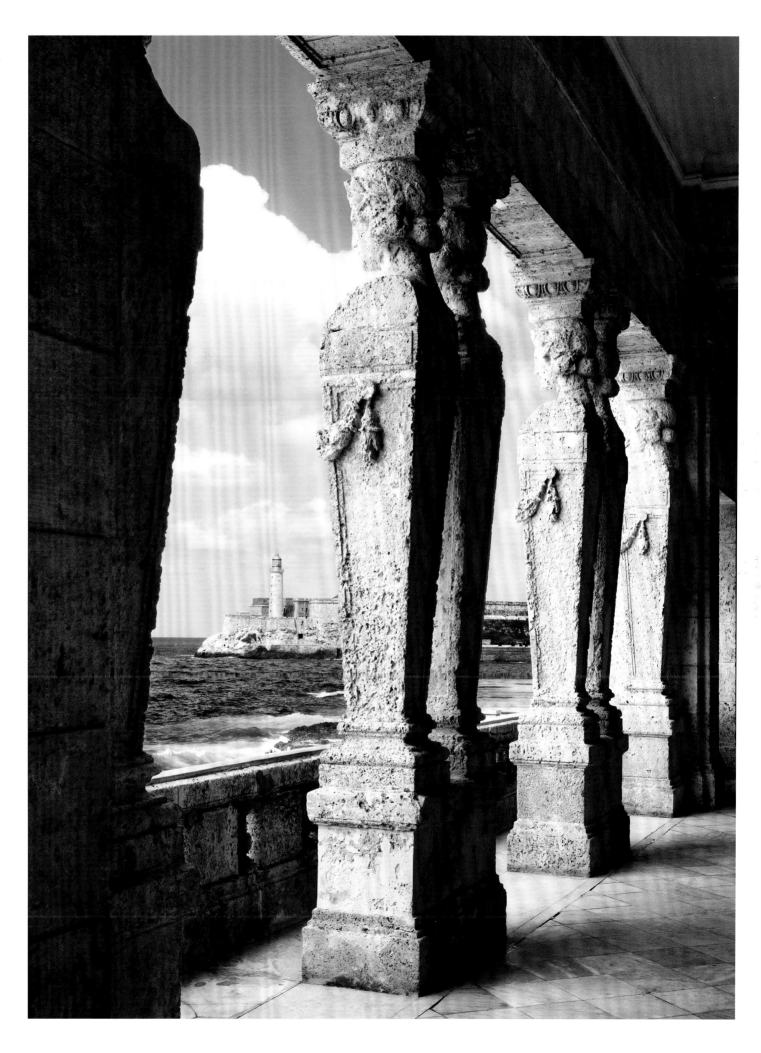

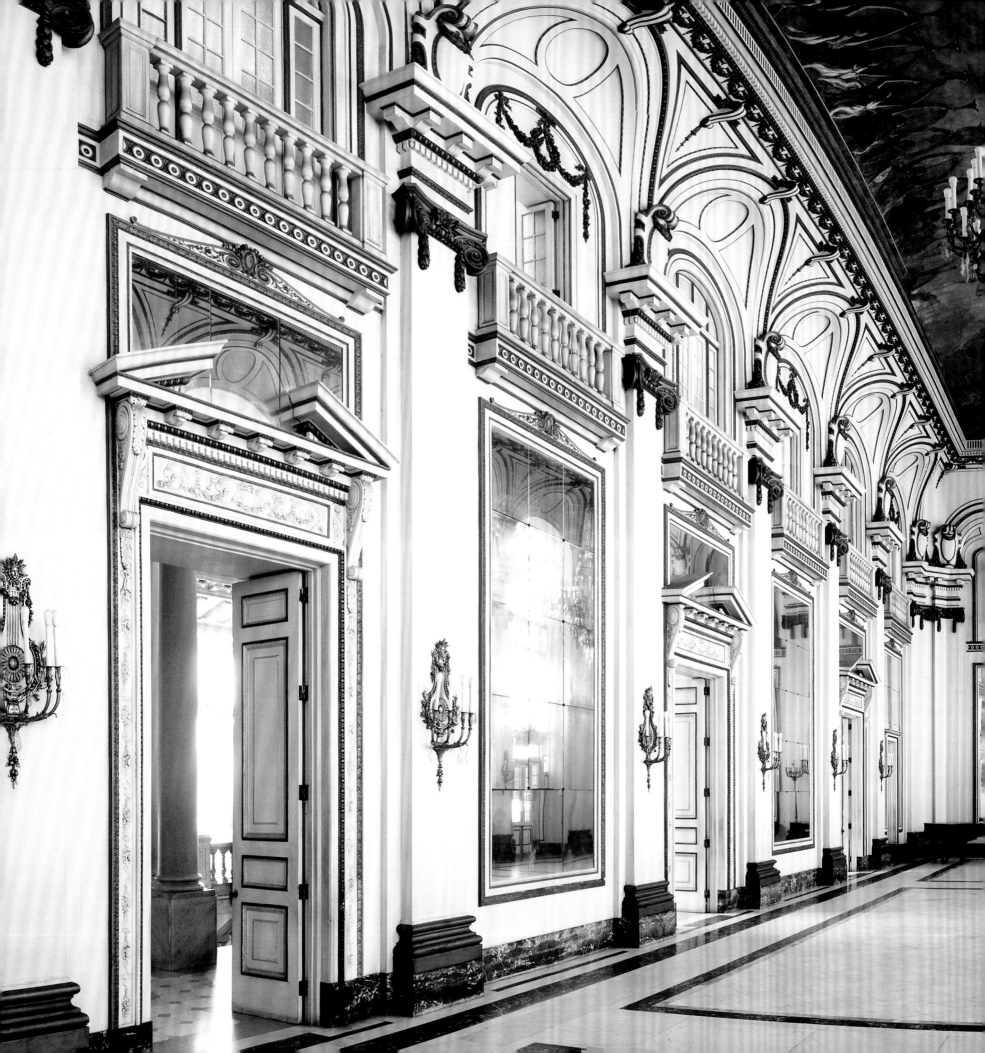

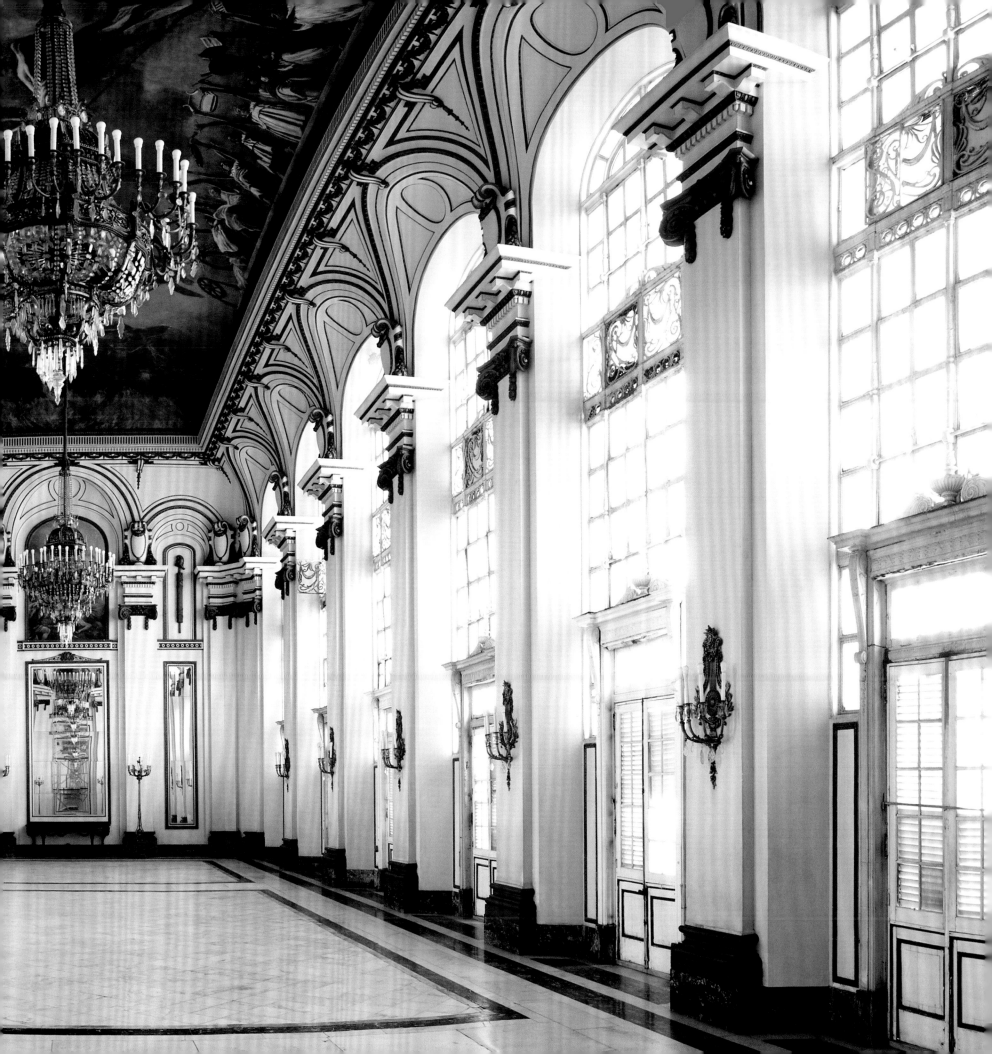

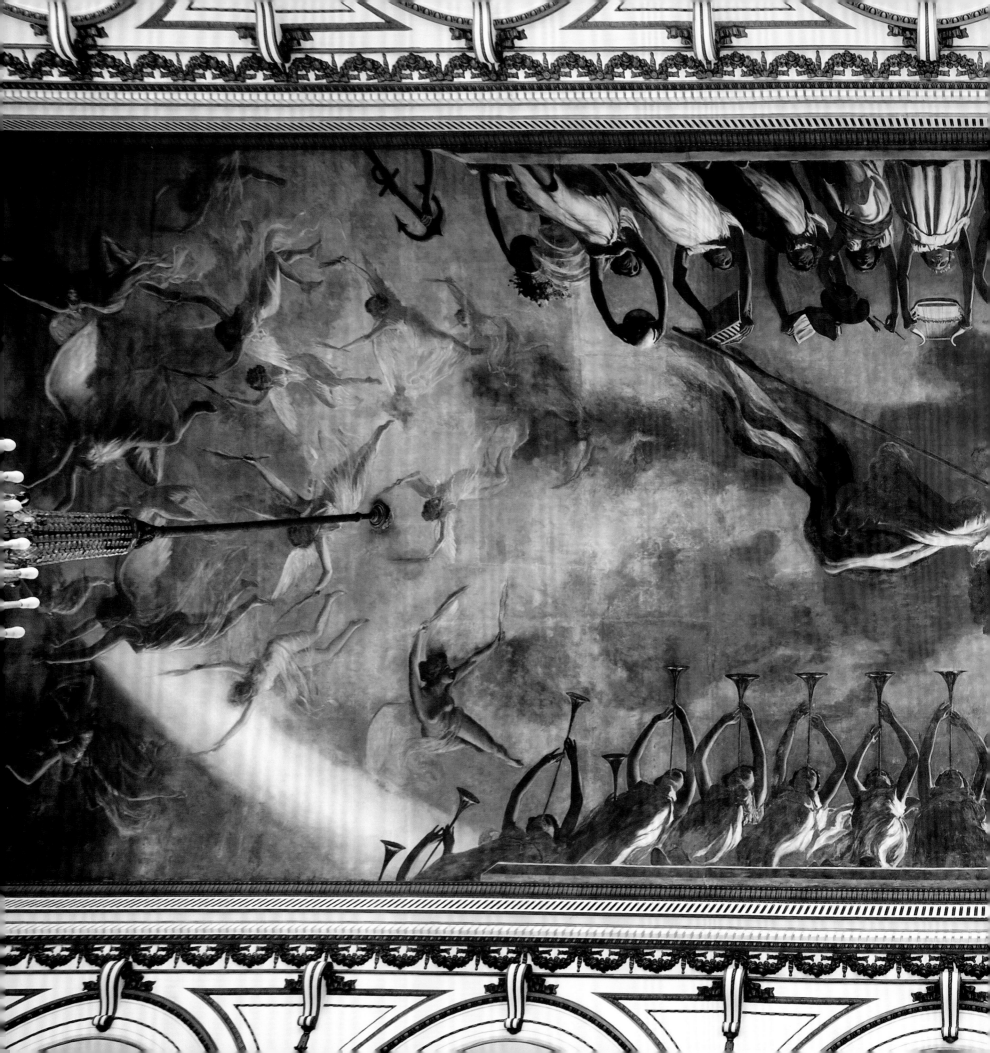

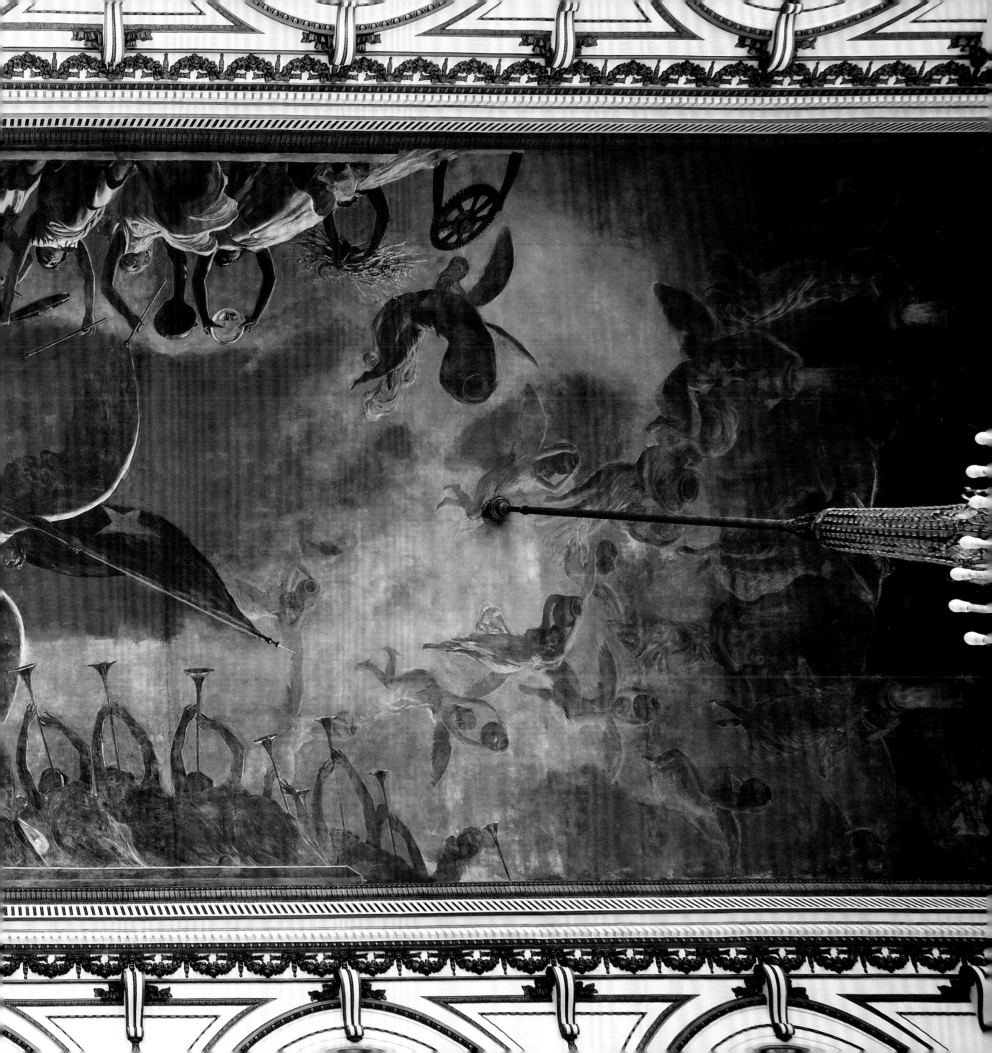

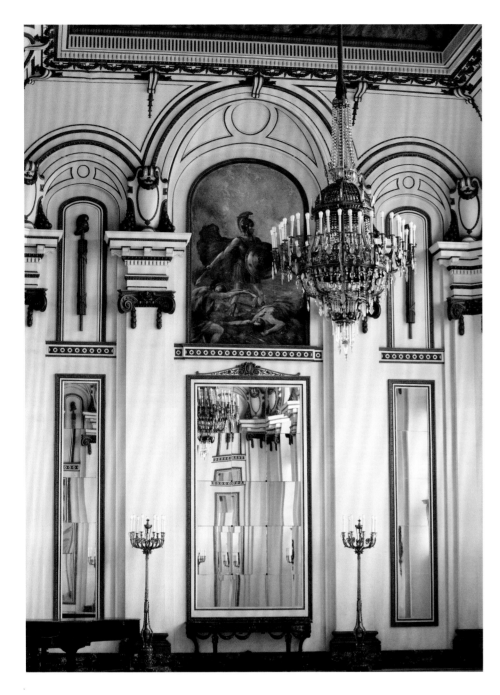

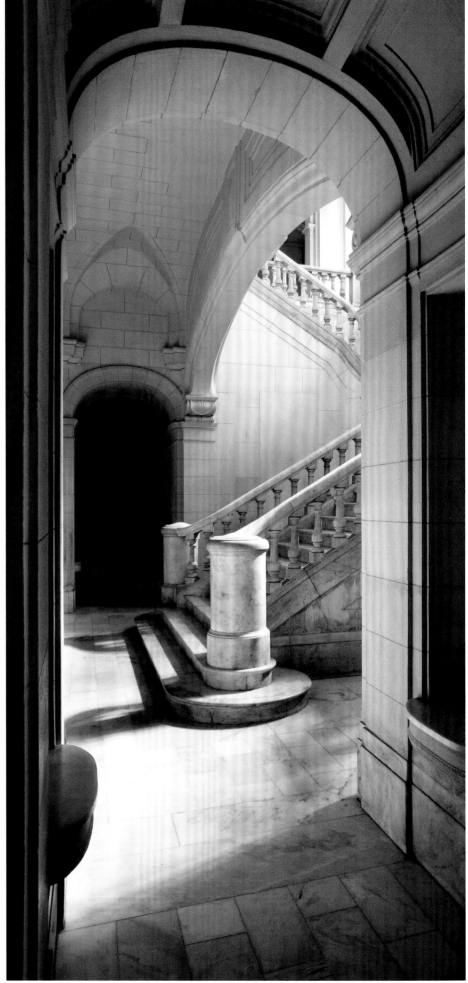

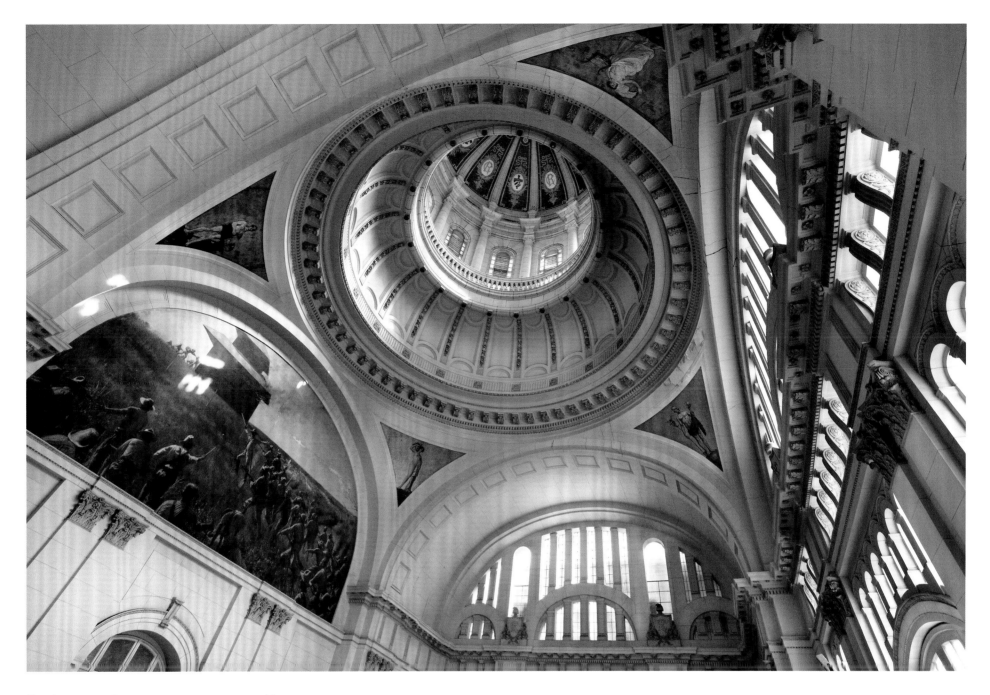

Previous spread
The Hall of Mirrors (Salón de los Espejos) has ceiling frescoes by Cuban artists Armando Menocal and Antonio Rodriguez Morey.

Opposite left
Detail of interior architectural fittings and moldings in the ballroom.

Opposite right
Detail of the marble staircase that still bears bullet holes from an attack in 1957 by revolutionary students on a mission to kill then President Batista.

Above
The classical and highly sophisticated interior design with decorations by Tiffany.

Next spread
The dome above the staircase reflects the grand tradition of Cuba's classical civic buildings and consists of multicolored ceramics. It includes four panels decorated by Mariano Miguel González and Esteban Valderrama against a gold leaf background.

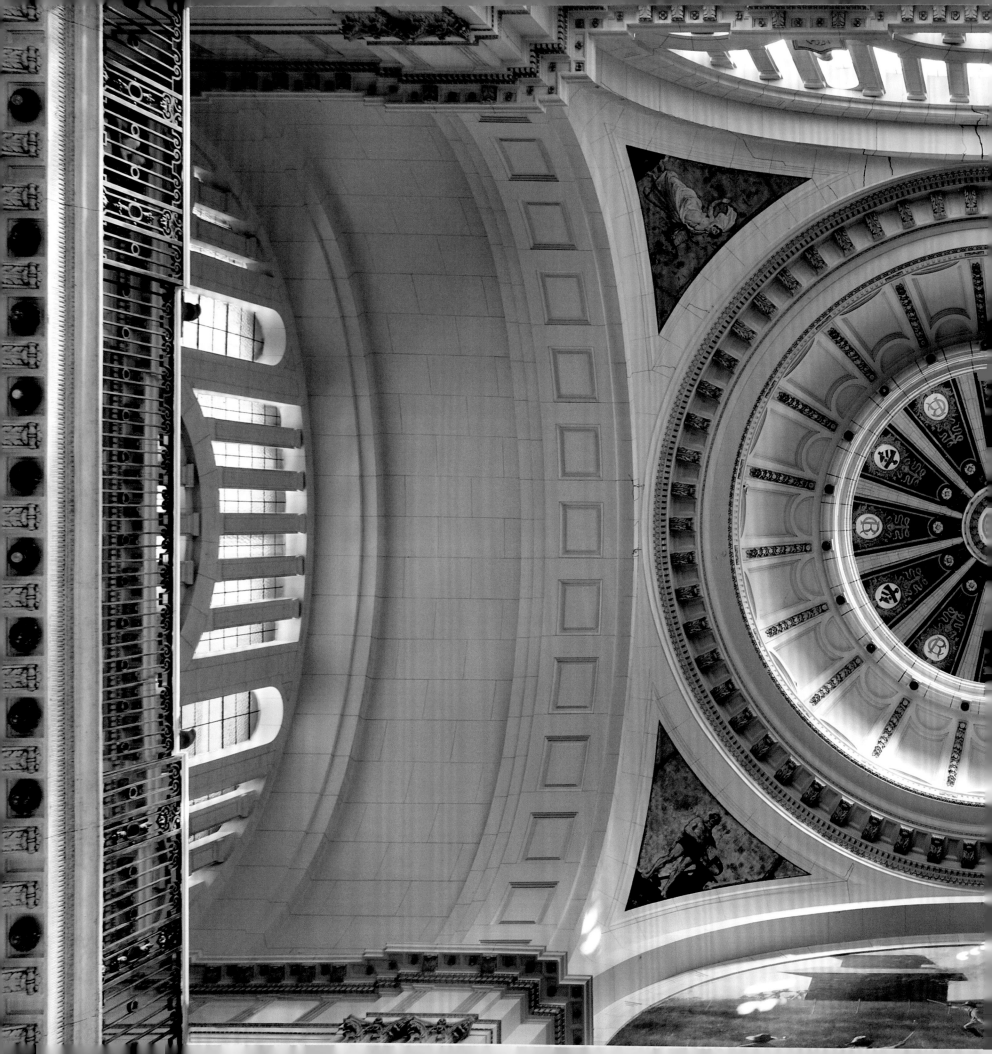

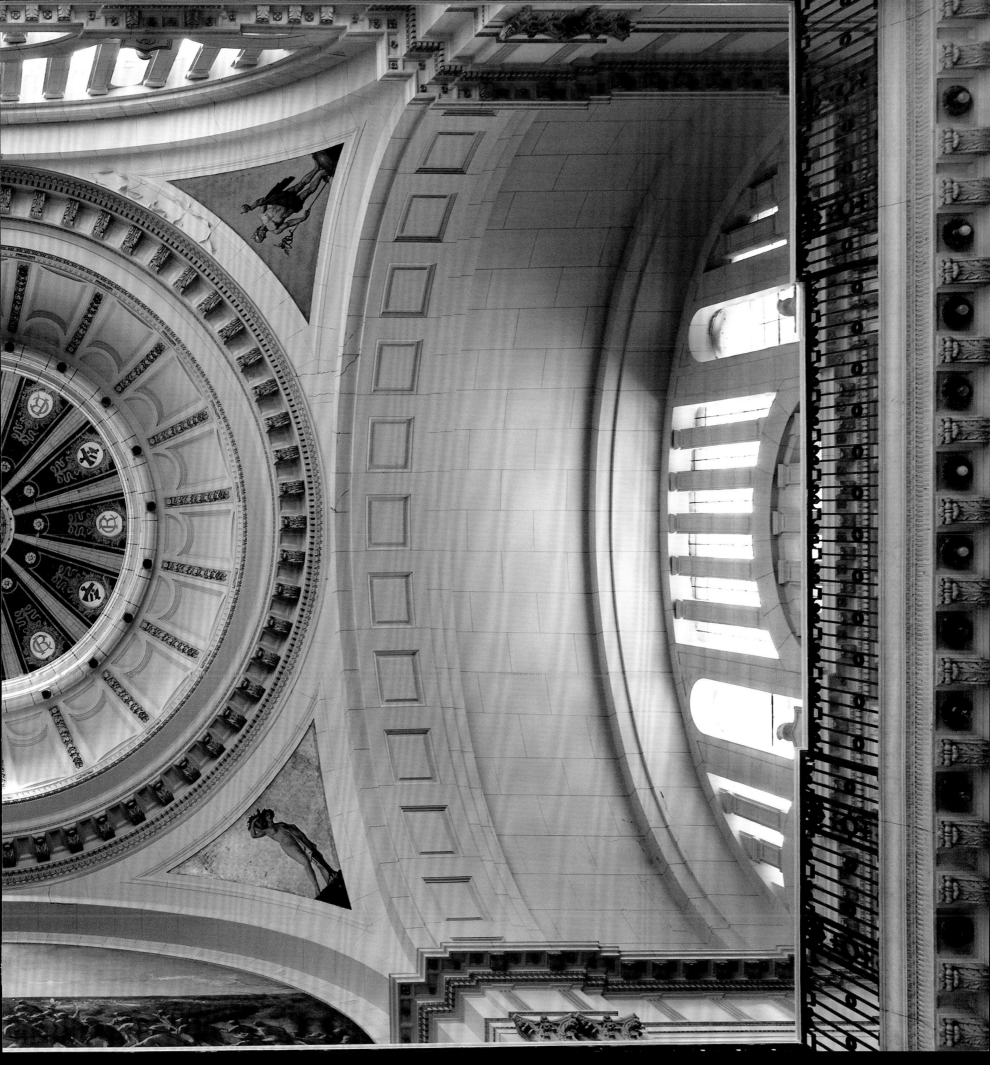

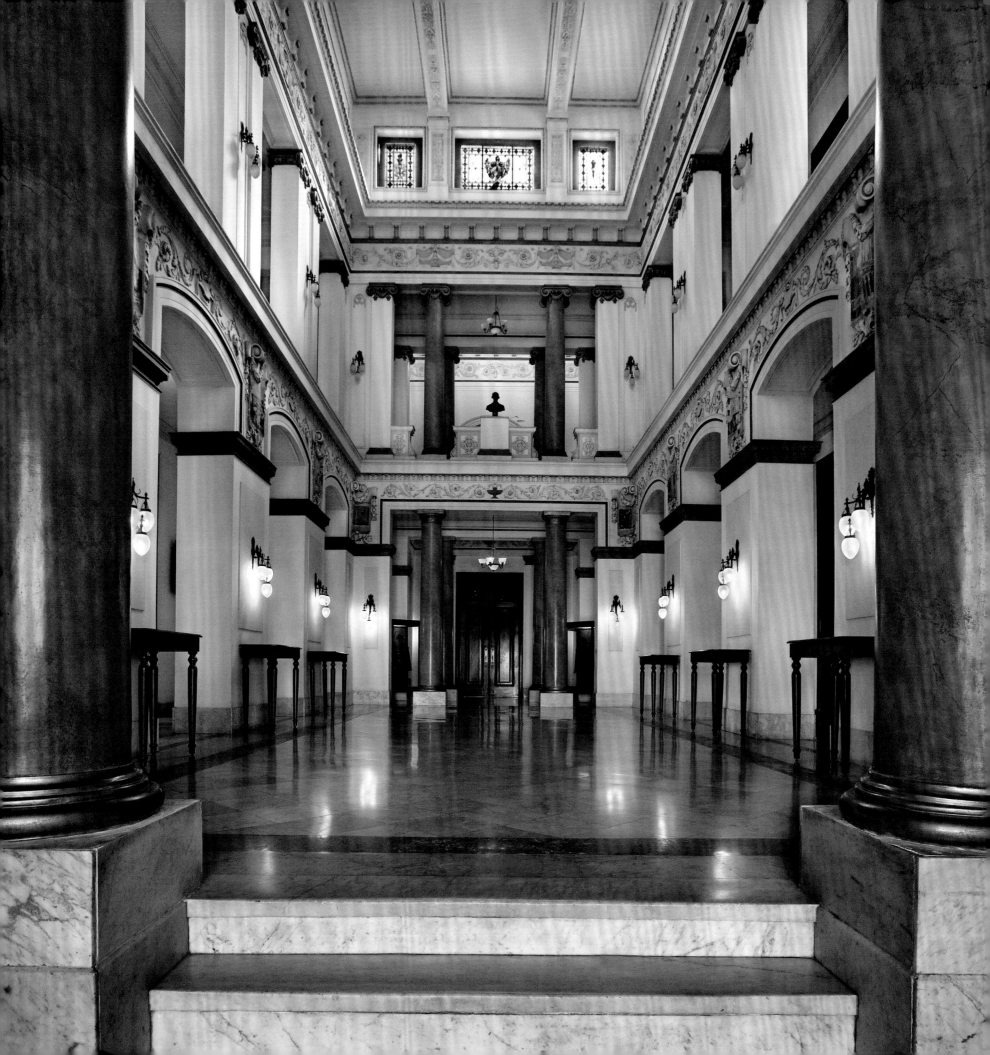

Opposite
A view from the vestibule of the grand hall of Cámara de Representates, *or the Chamber of the House of Representatives, built in 1909.*

Right
A mid-twentieth-century portico exemplifies the architectural tradition of colonnade and portico construction for four hundred fifty years of Cuban history.

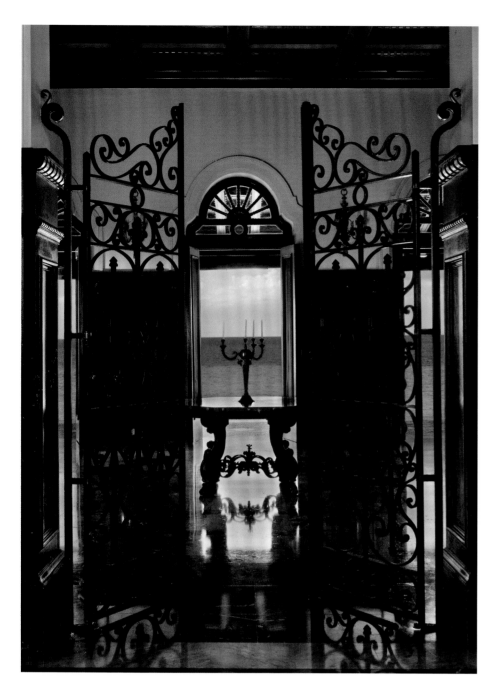

Previous spread
*A beachfront Spanish-style mansion
named Xanadú, built in 1926 by
American millionaire Irénée du Pont
and used as a family vacation home.*

Left
*The entrance to Xanadú, which was
designed by Evelio Govantes and
Félix Cabarrocas.*

Opposite top left
*Xanadú's salon with a seldom
used fireplace.*

Opposite top right
*Carved from Cuban mahogany, the
staircase leads to the upper floors.*

Opposite bottom
*One of the six bedrooms of the house
overlooking the water.*

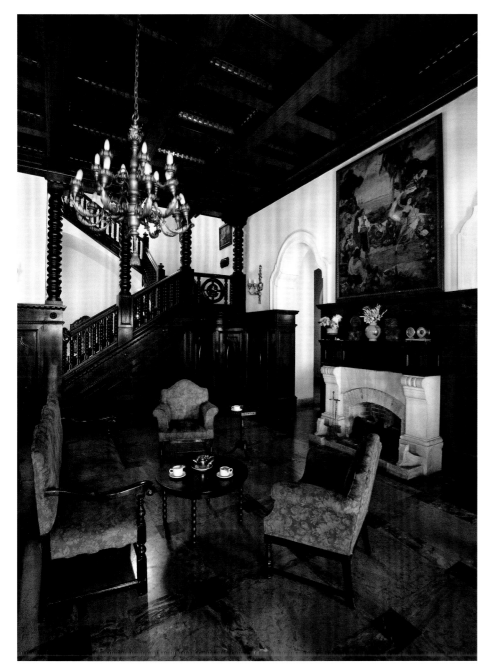
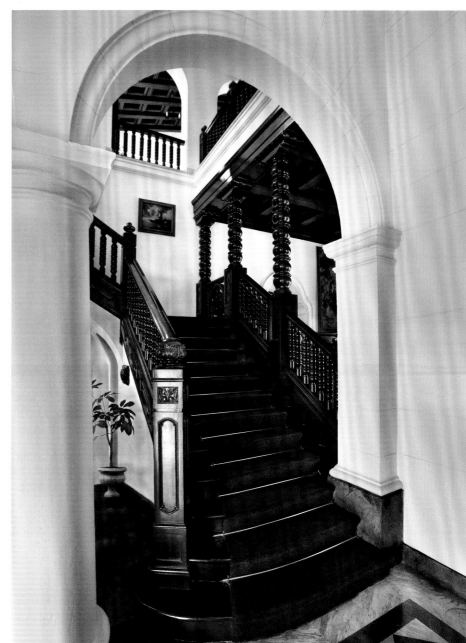
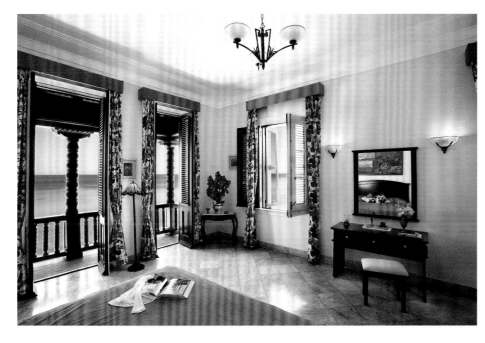

Above
*Xanadú features Moorish balconies
with hand-carved details in mahogany.*

Opposite
*The top floor was once a ballroom,
designed and decorated in an Italian
rococo manner with coffered ceiling
and imported marble floors.*

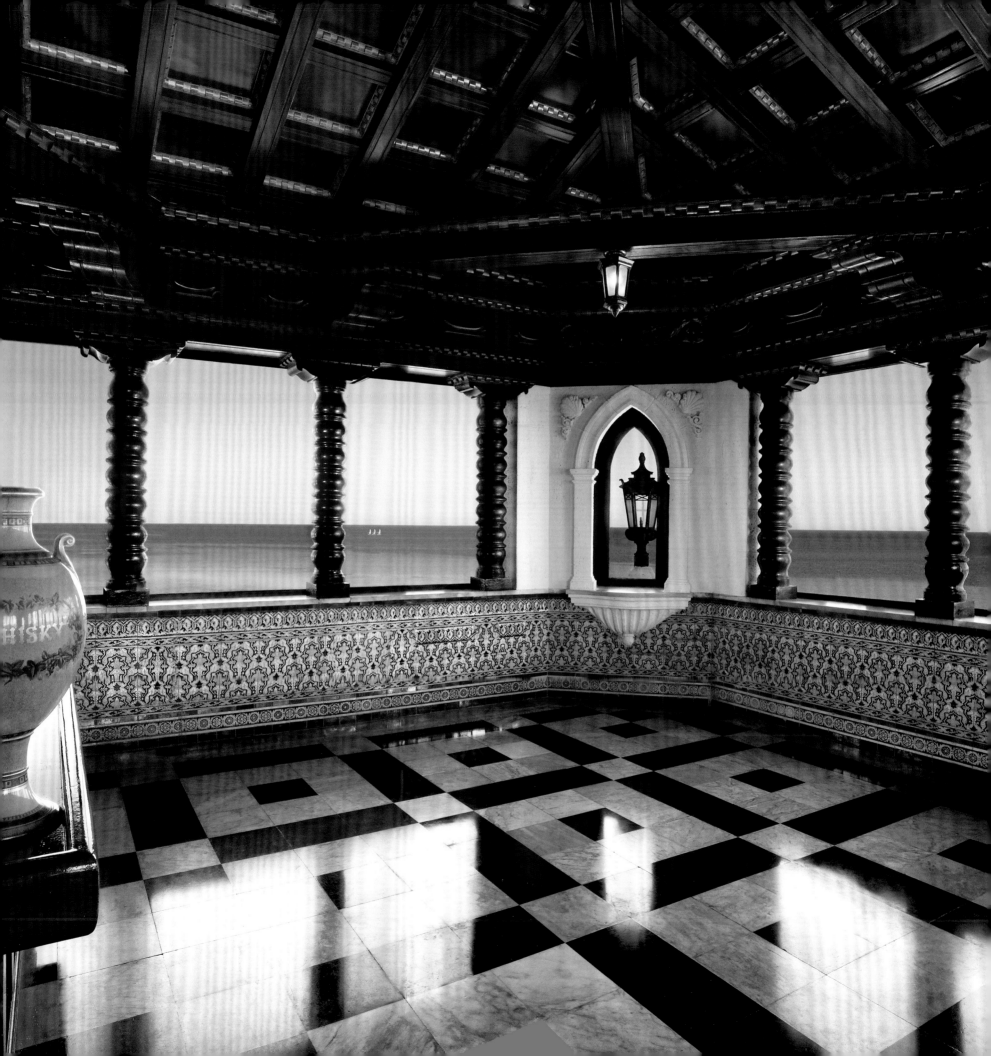

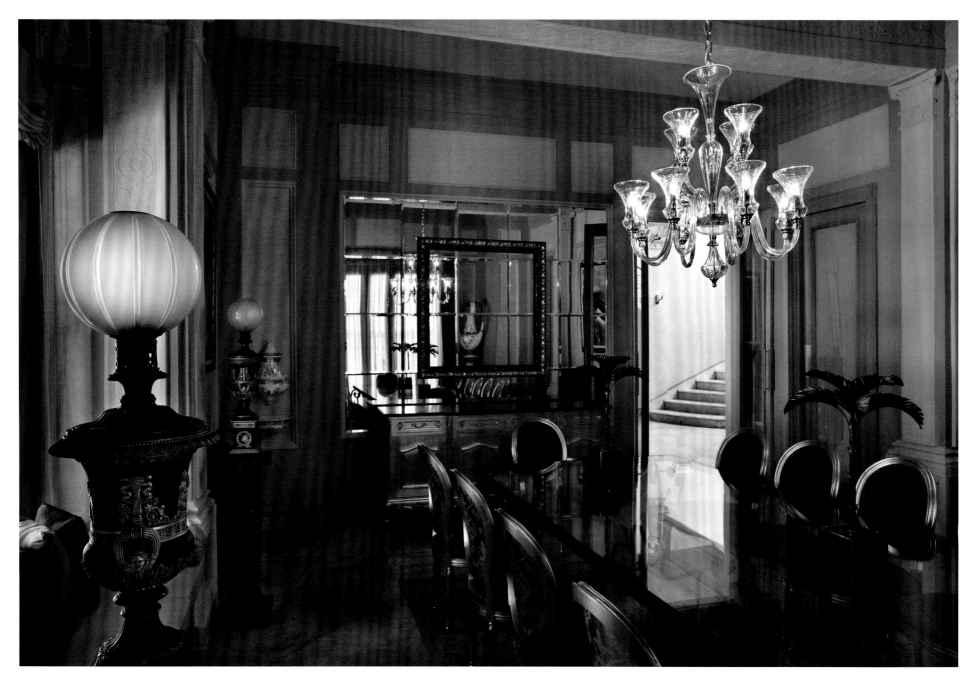

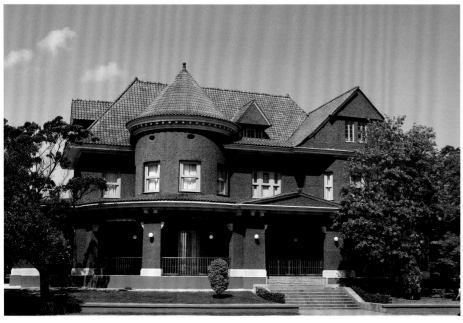

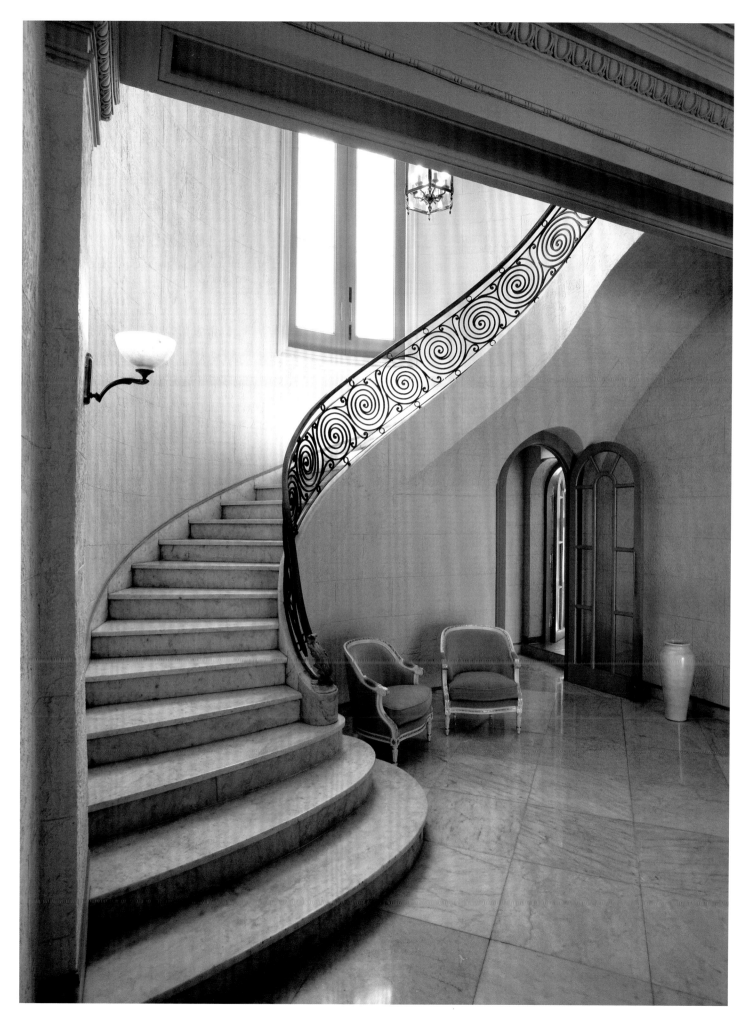

Opposite top
The dining room of Casa de Albertode Armas.

Opposite bottom left
Casa de Albertode Armas was built in 1926 and restored in 2010.

Opposite bottom right
Detail of the third floor's green ceramic tile roof.

Left
The main floor vestibule and staircase, which leads to the second floor's five bedrooms.

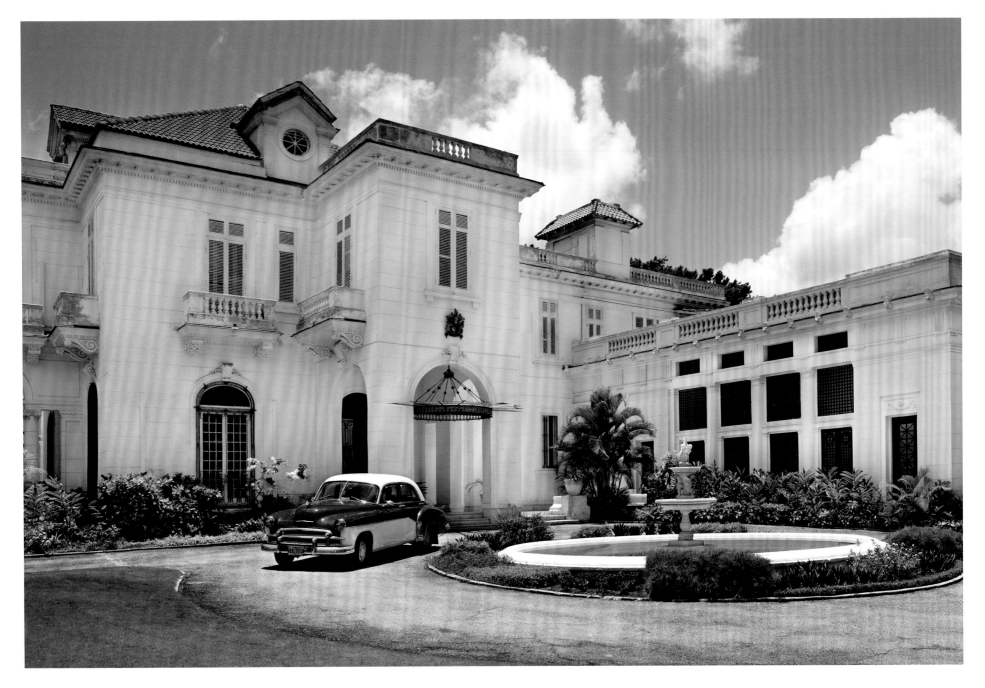

Above
Main façade of Casa de Pablo González de Mendoza, designed by Leonardo Morales and built in the "Vedado Style" in 1916.

Opposite left
The Pompeian-like impluvium was the first indoor swimming pool built in Havana. The large skylight is supported by immense painted wooden beams. During parties the pool was boarded over and used as a dance floor.

Opposite right
A large mirror and latticework frame flank the terrace and antechamber entrance to the pool.

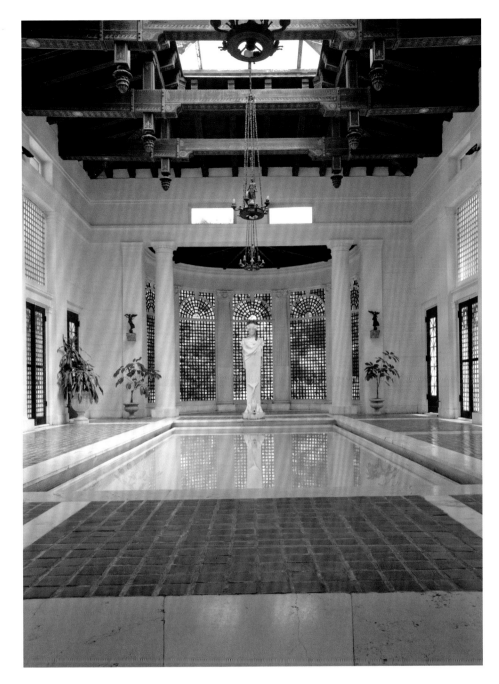

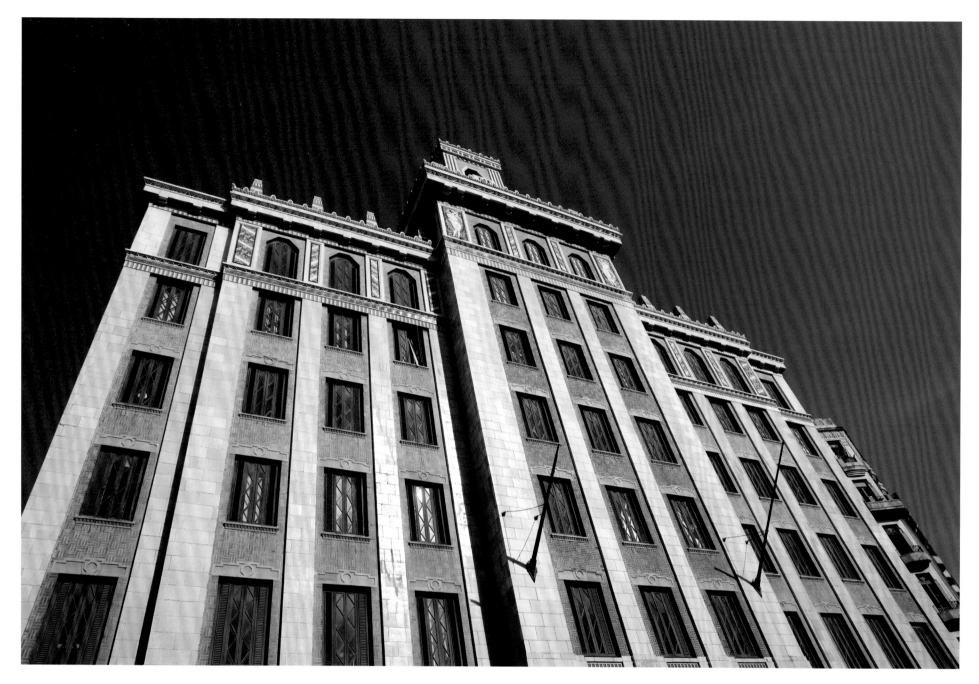

Above
*The modern architectural lines of art
deco distinguish Havana's Bacardi
building, once the headquarters of the
Cuban rum empire.*

Opposite left
*Detail of the glazed colorful terra-
cotta embellishments.*

Opposite right
*The Bacardi emblem, a bat, crowns
the building's spire.*

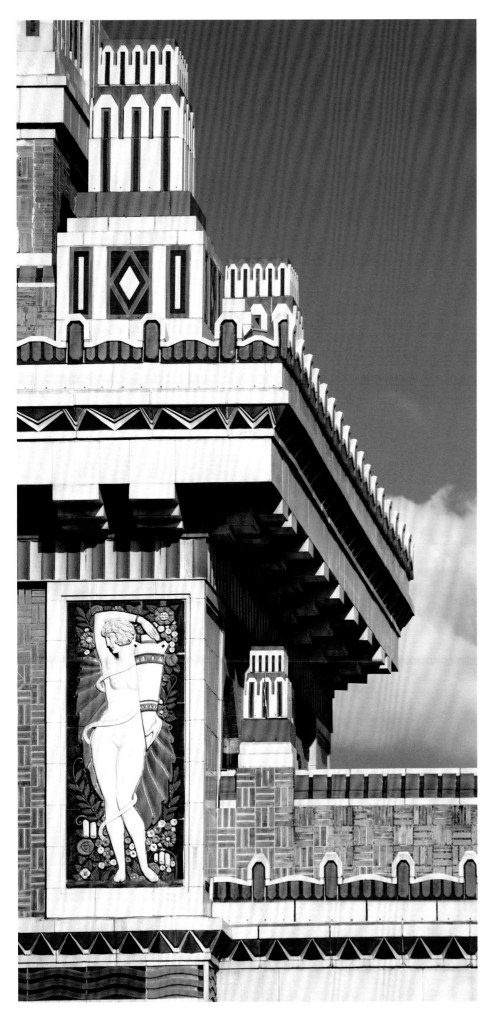
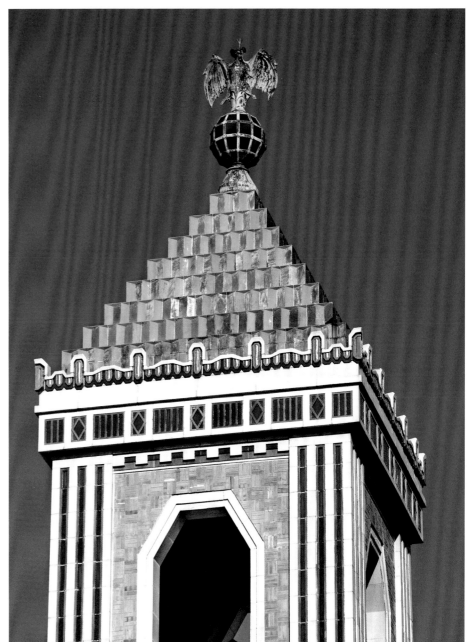

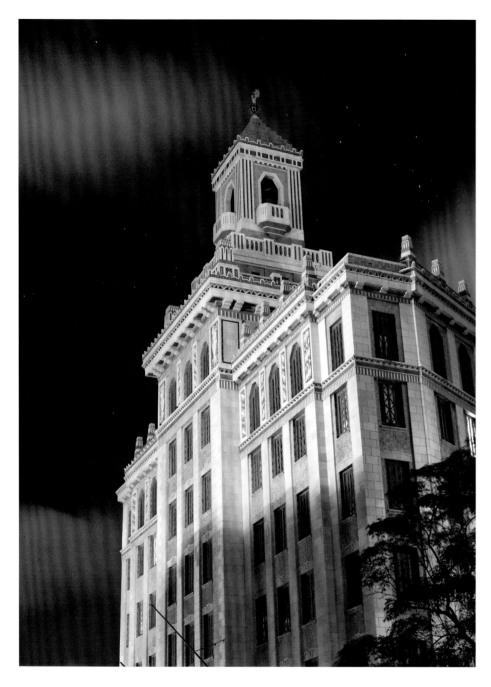

Above
The Bacardi building at dusk, the best example of an art deco commercial building in Cuba.

Opposite
The Bacardi building was designed by Esteban Rodriguez Castells, Rafael Fernández Ruenes, and José Menendez.

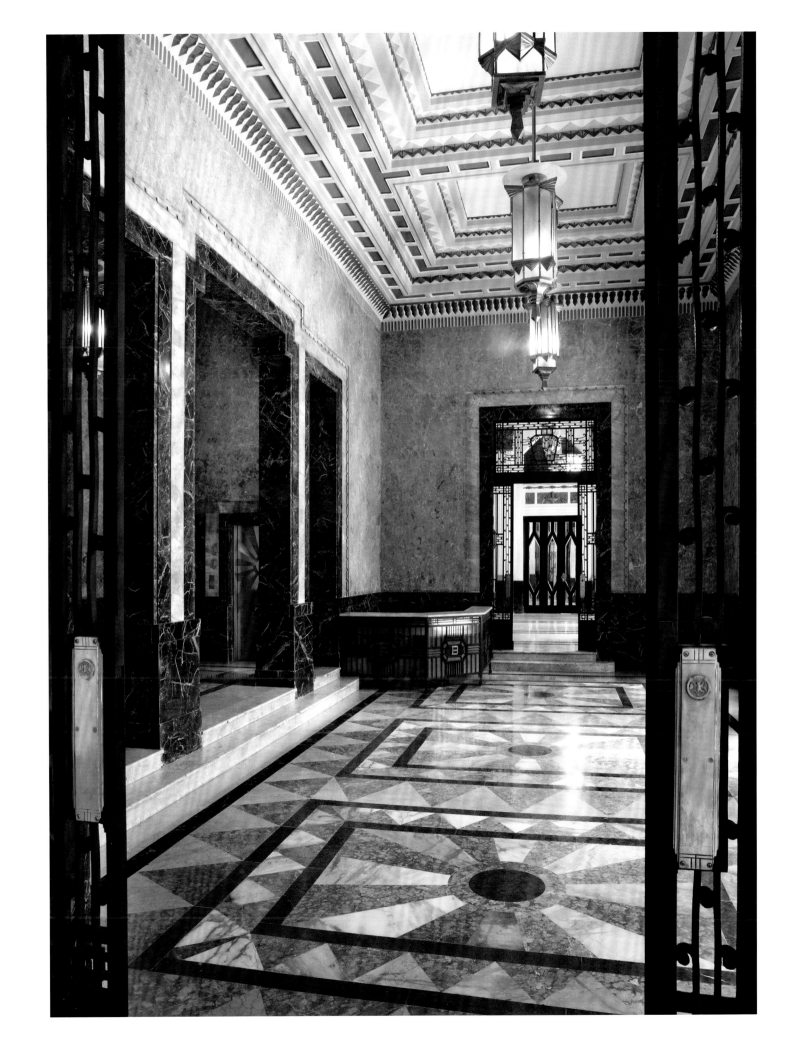

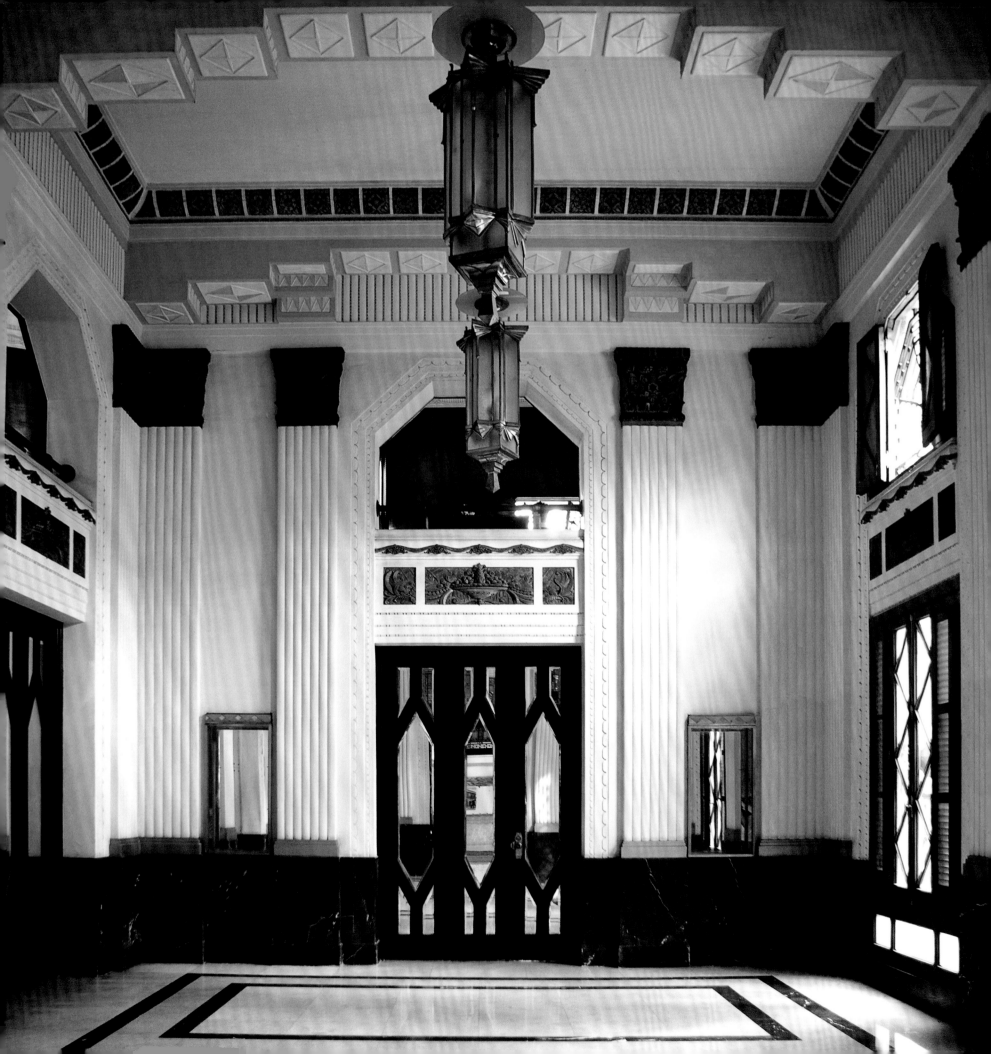

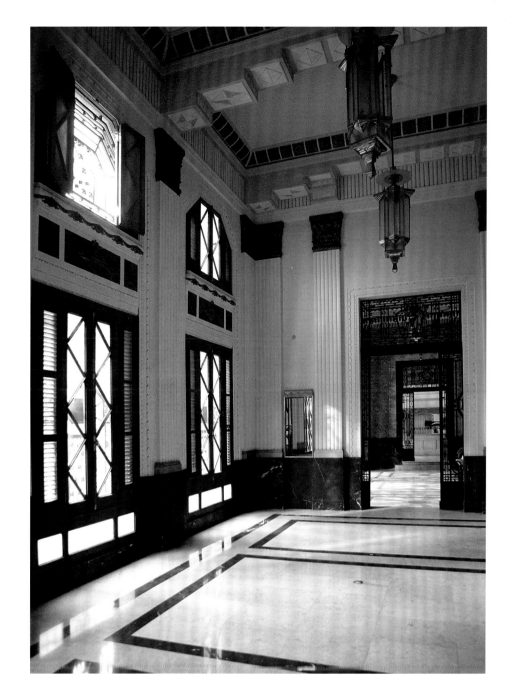

Opposite
The Bacardi building's vestibule, or lobby,
is decorated from floor to ceiling with
multicolored marble that was imported
from various countries in Europe.

Above
Detail of lobby.

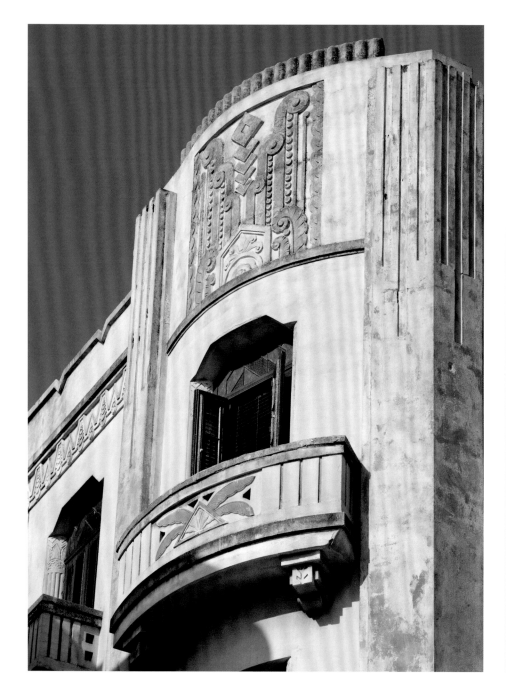

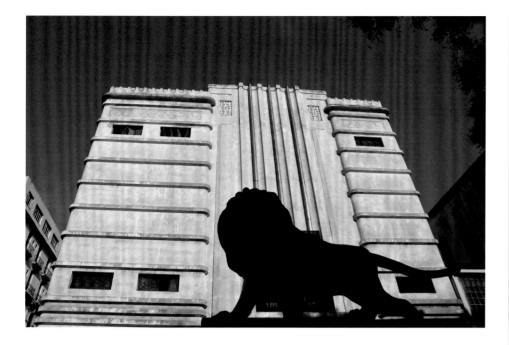

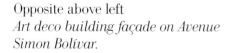

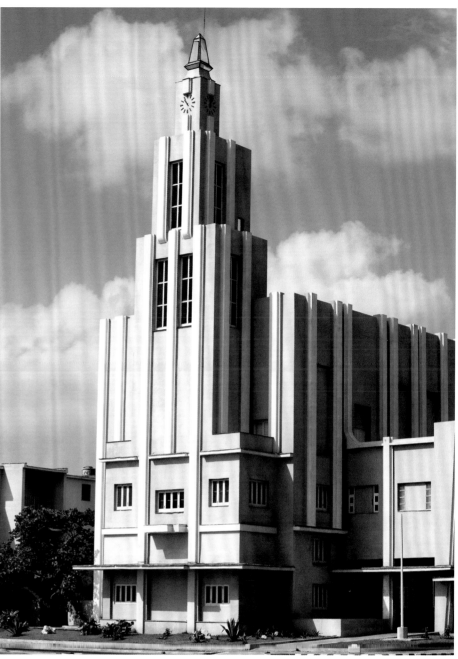

Opposite above left
Art deco building façade on Avenue Simon Bolívar.

Opposite above right
An art deco–designed post office on Obispo Street in Havana.

Above left
The art deco Cine-Teatro Fausto was designed by Saturnino Parajon and built in 1938.

Above bottom left
Theatre interior with archetypal art deco features such as the staircase.

Above right
The Casa de las Américas employs vertical setbacks characteristic of art deco architecture in Cuba.

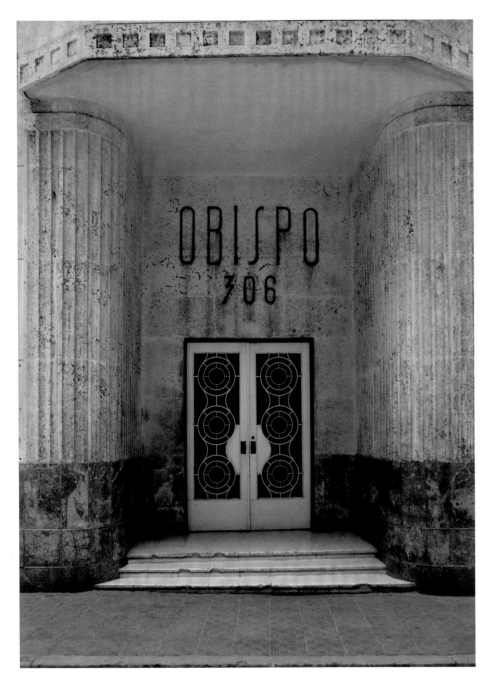

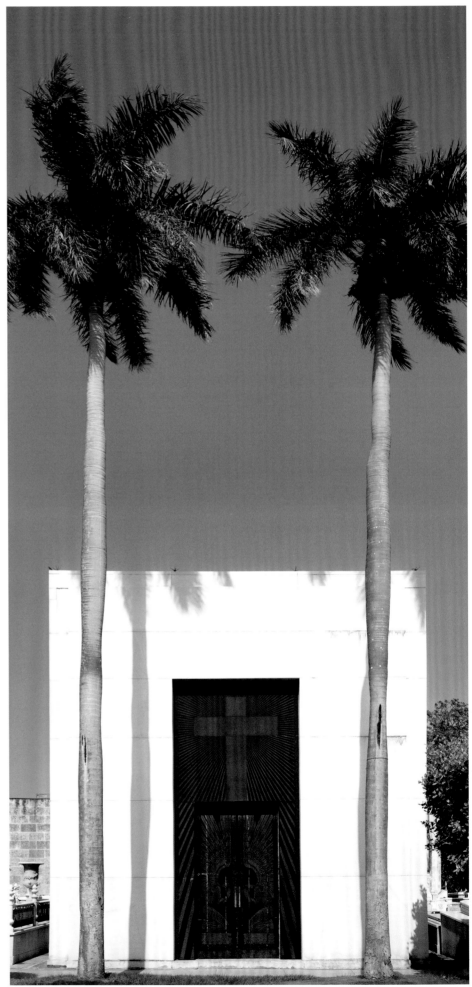

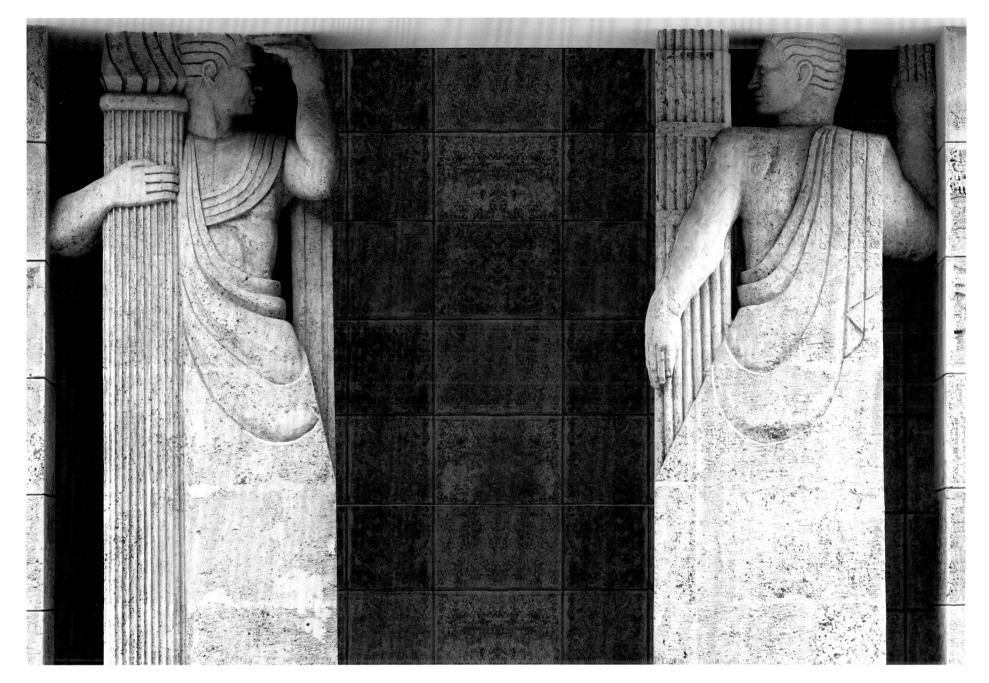

Opposite left
Another art deco building on Obispo Street. The term Art Deco never existed during the lifetime of the movement. It was first used in 1966 on the occasion of the retrospective exhibition held in Paris at the Musée des Art Décoratifs.

Opposite right
The white marble and black granite mausoleum of Catalina Lasa designed by René Lalique in 1936 in Cementerio Cristóbal Colón, which was established in the 1870s.

Above
Art deco sculptured columns on a Havana building.

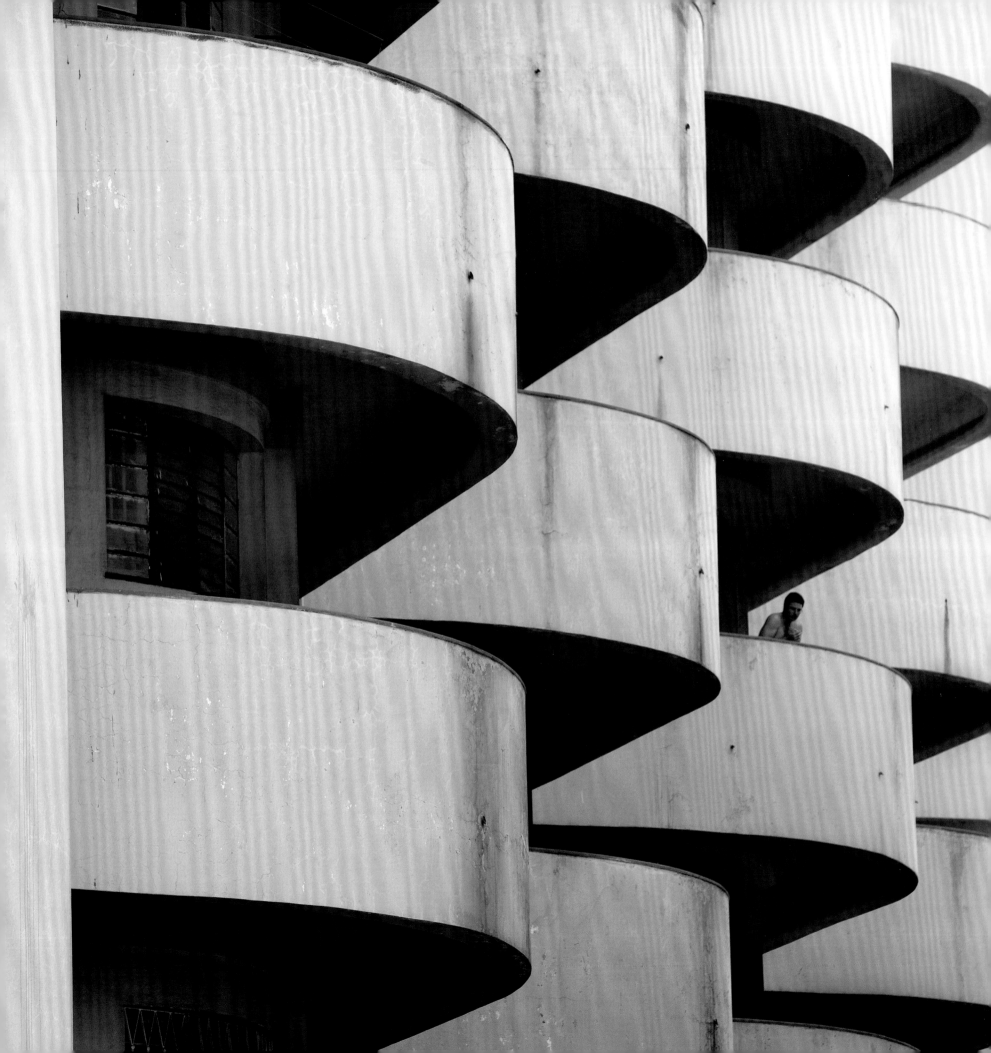

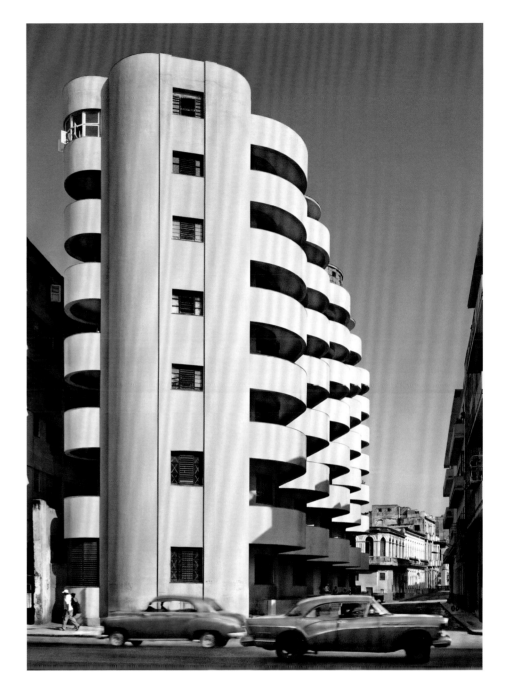

Opposite
*Edificio de Apartamentos Solimar's
wide circular balconies represent ocean
waves and celebrate the sea.*

Above
*The Solimar apartment building
by Manuel Copado, built in 1944,
dominated the central Havana skyline
during the 1940s.*

Previous spread
Built in the neoclassical style, the U.S. Ambassador's residence in Cuba was begun in 1939 and completed in 1942. Because of the absence of formal diplomatic relations with Cuba, the equivalent of an ambassador, the U.S. Chief of Mission of U.S. Interest Section in Cuba presently resides in the house.

Right
Designed by U.S. State Department architects and constructed by Havana-based engineers and builders, the residence covers 31,750 square feet of living space with seven bedrooms, each with its own loggia.

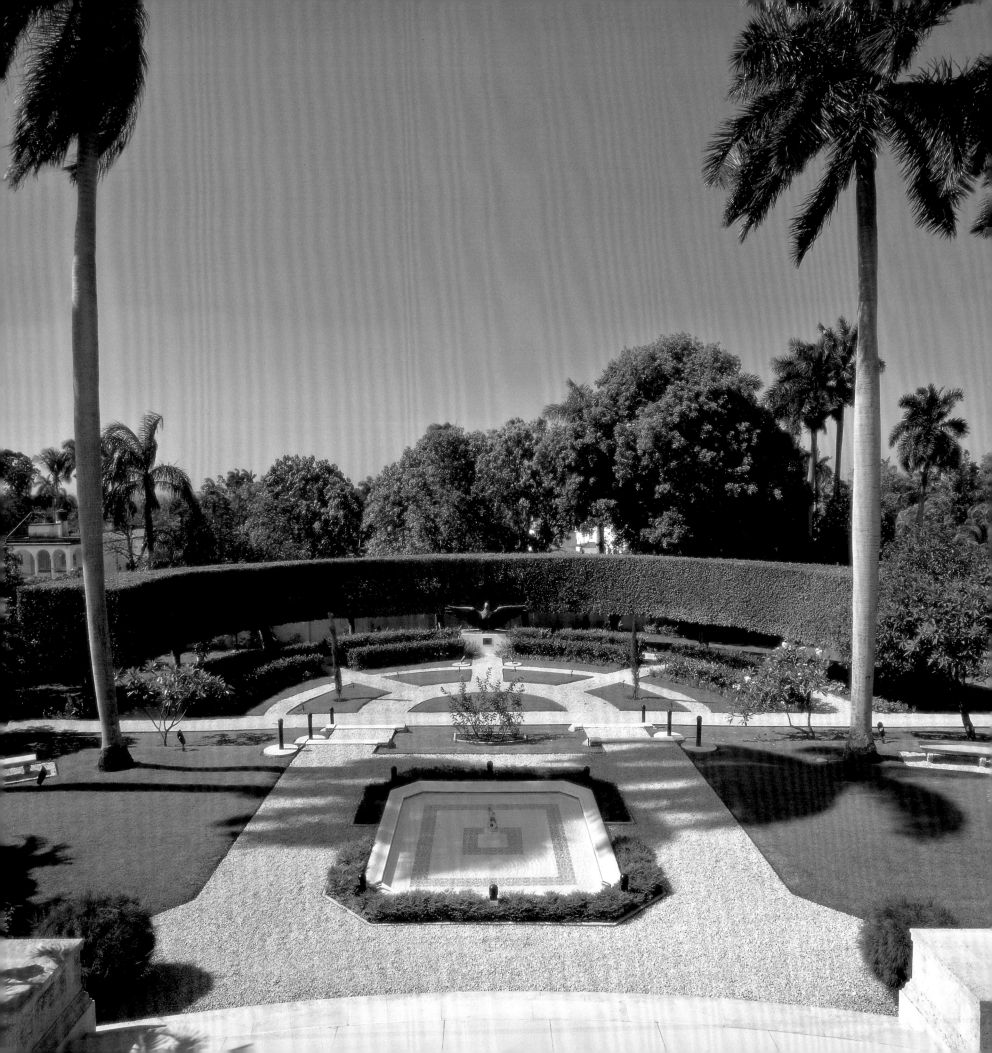

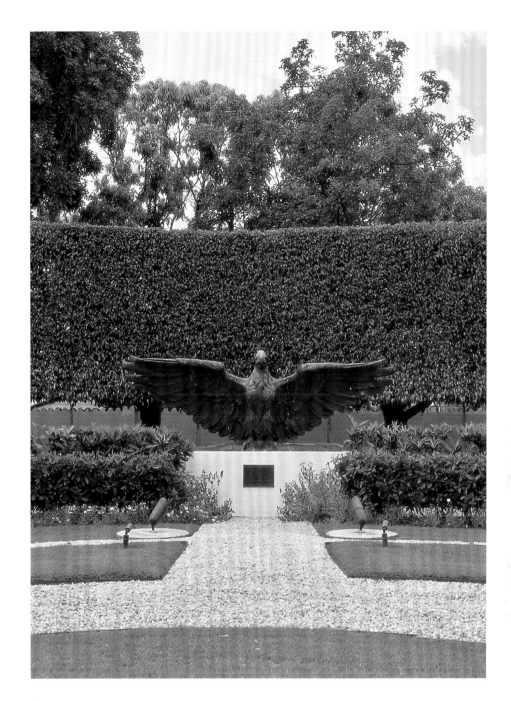

Opposite
A partial view of the five-acre formal gardens and the reflecting pool.

Above
The original brass eagle from the Monument to the Victims of the Maine (restored after its fall in a 1926 hurricane) presides over the formal gardens of the Ambassador's residence.

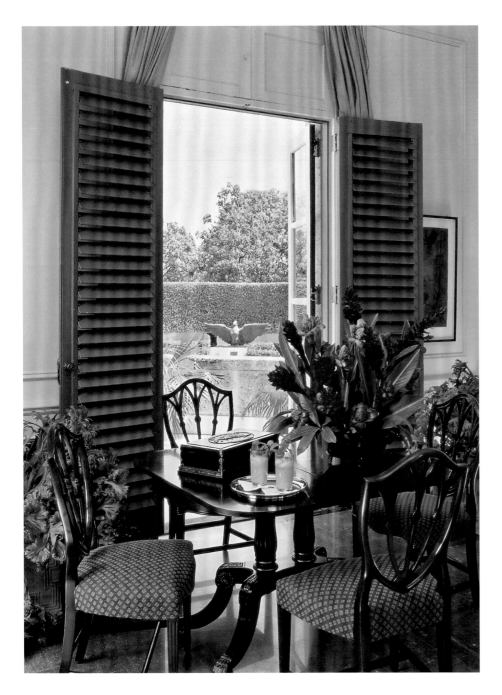

Above
A view from one of the small ground-floor dining areas.

Opposite
The formal state dining room that seats thirty-four at its long elegant table, where over the years many prominent people have dined, including First Lady Bess Truman, Winston Churchill, and Cardinal Spellman.

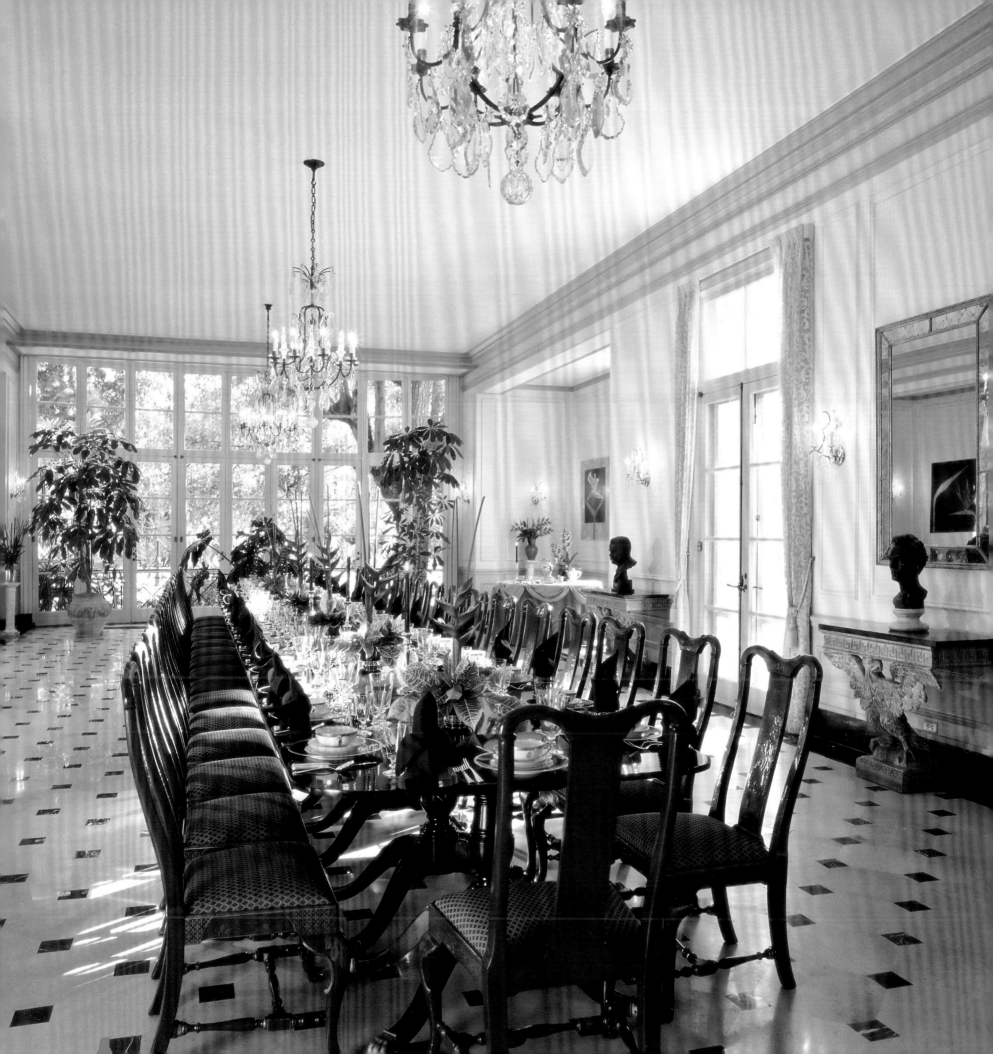

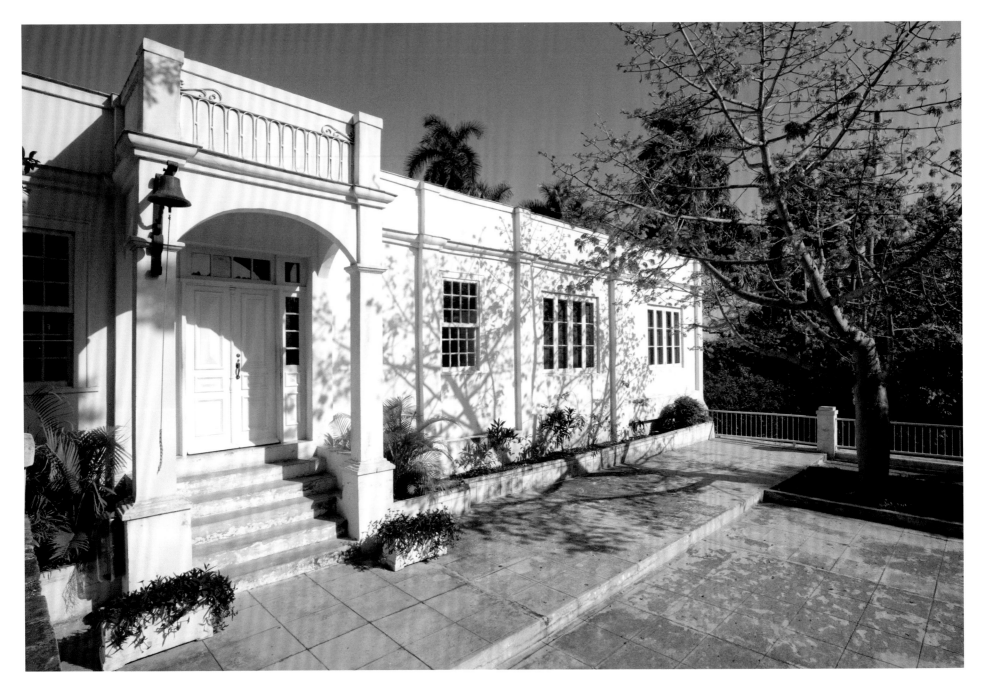

Above
*Ernest Hemingway moved to Cuba in
1939 and spent twenty-one years at
Finca Vigia, or Lookout Farm, which
was originally built in 1887 in the
suburb of San Francisco de Paula,
approximately ten miles southeast
of Havana.*

Opposite top and bottom
*Two views of the same living area
preserved in its original state. Finca
Vigia's interiors have been kept
as they were found in 1960 when
Hemingway left Cuba.*

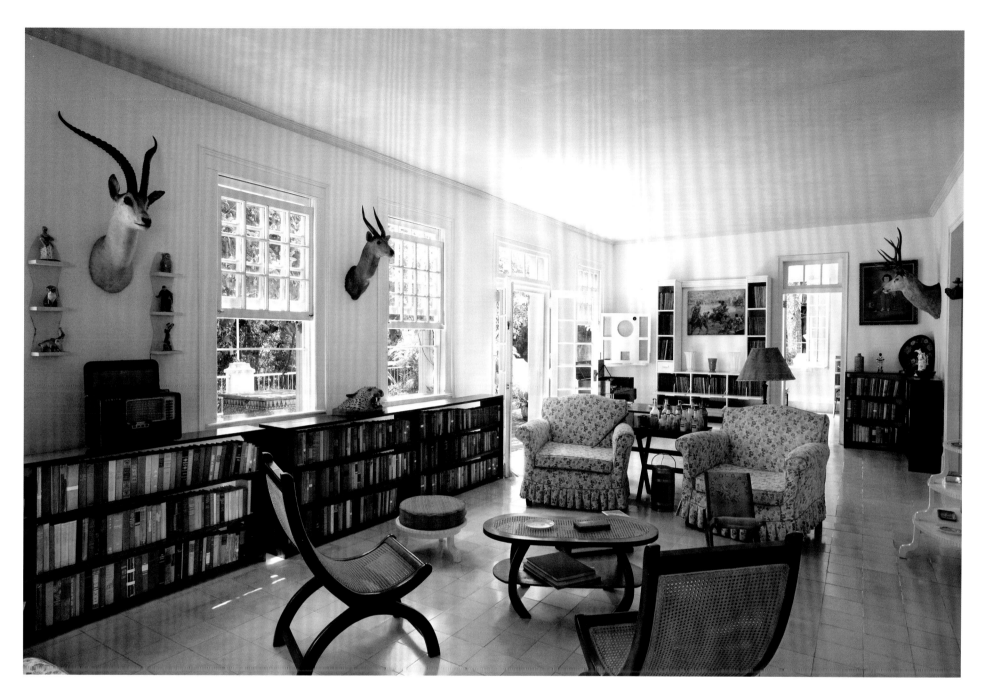

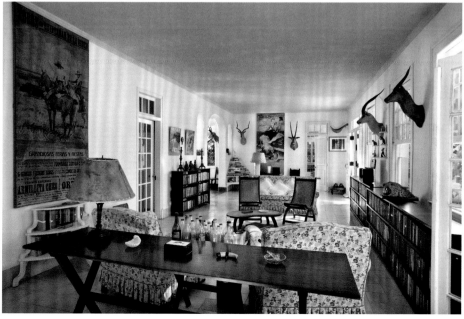

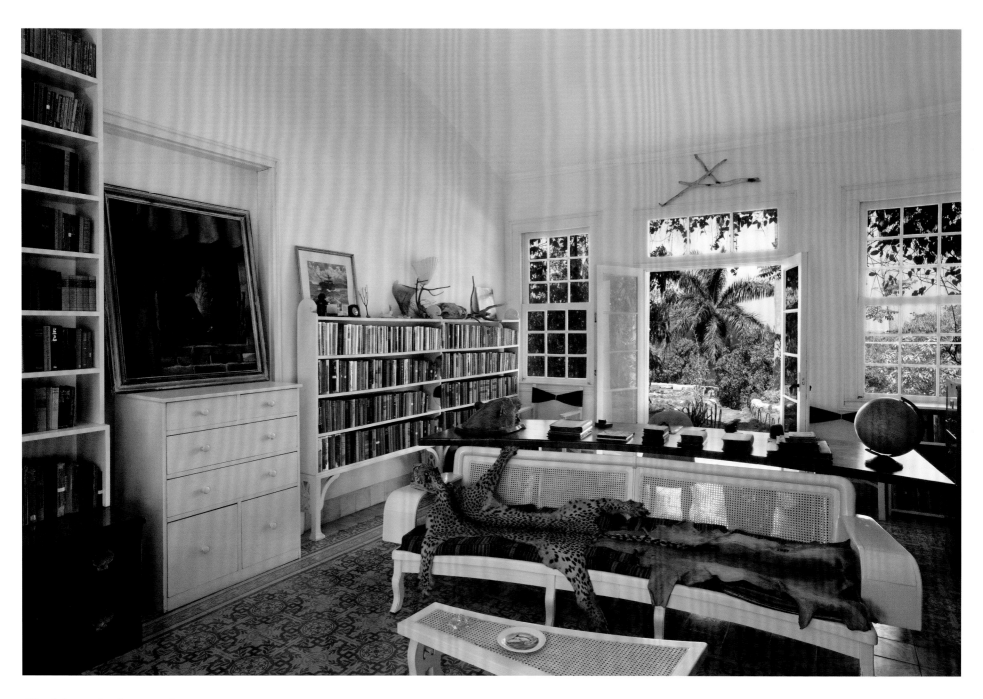

*All of the author's possessions,
including more than ten thousand
books, have been preserved.*

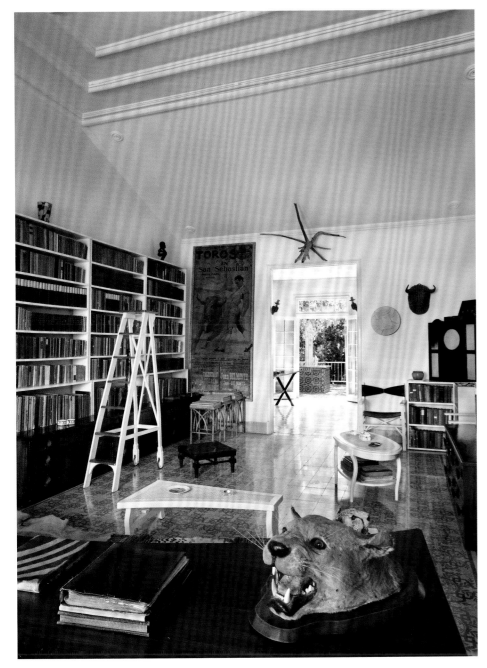

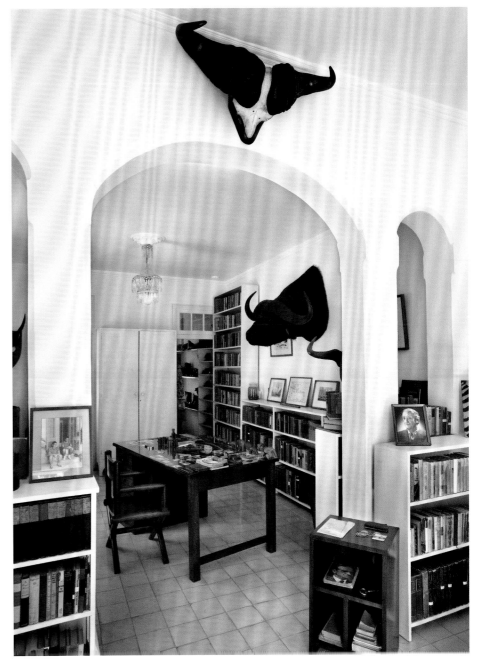

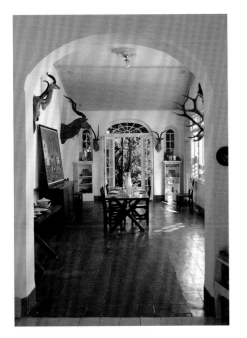

Above left
A view from Hemingway's large mahogany plank writing desk through the library. Here he wrote The Old Man and the Sea, A Movable Feast, *and* Islands in the Stream.

Above right
Another small writing alcove off one of the three bedrooms.

Below left
The dining area off the kitchen area.

Below right
A detail of the magnificent library and locally made library ladder.

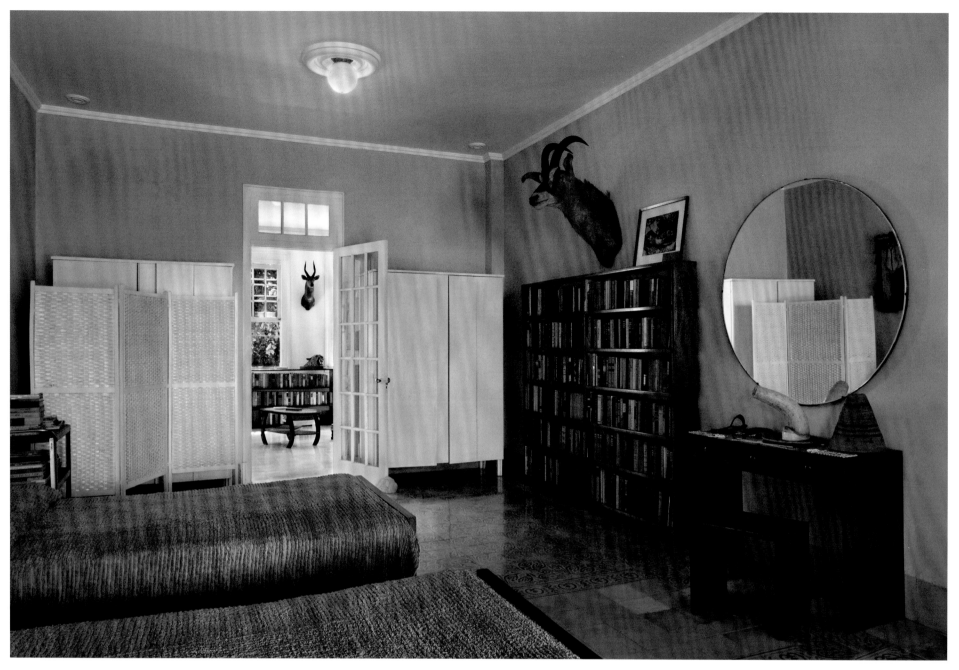

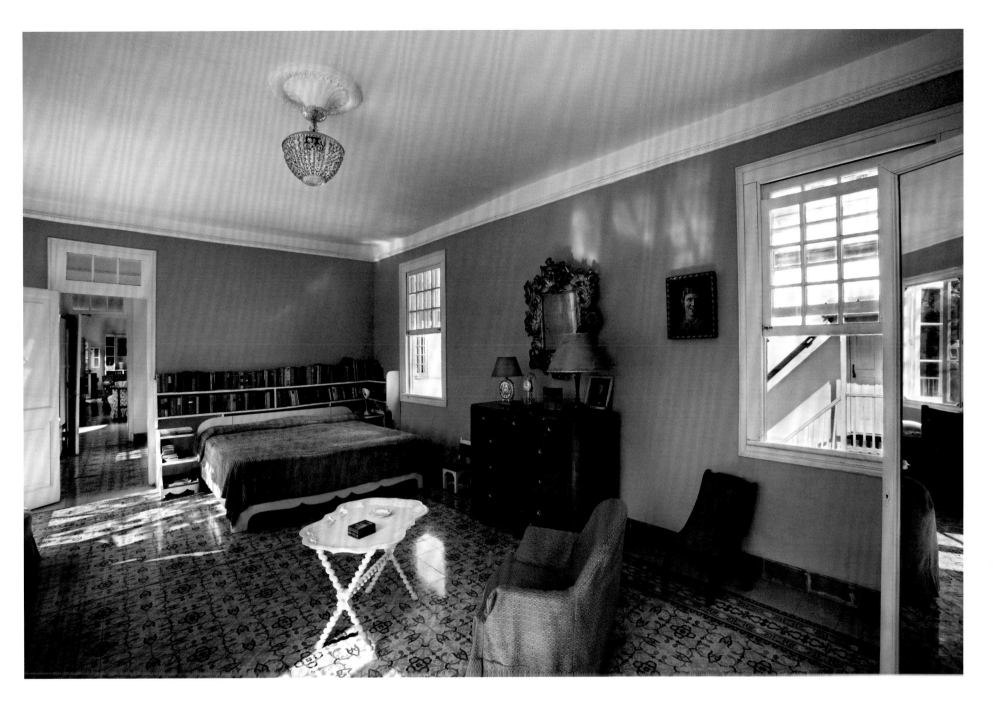

Opposite top
*One of the bedrooms directly off the
living area.*

Opposite bottom
*Bullfighting memorabilia from
Hemingway's collection of paintings
by Miró and Klee decorate the house.*

Above
Finca Vigia's master bedroom.

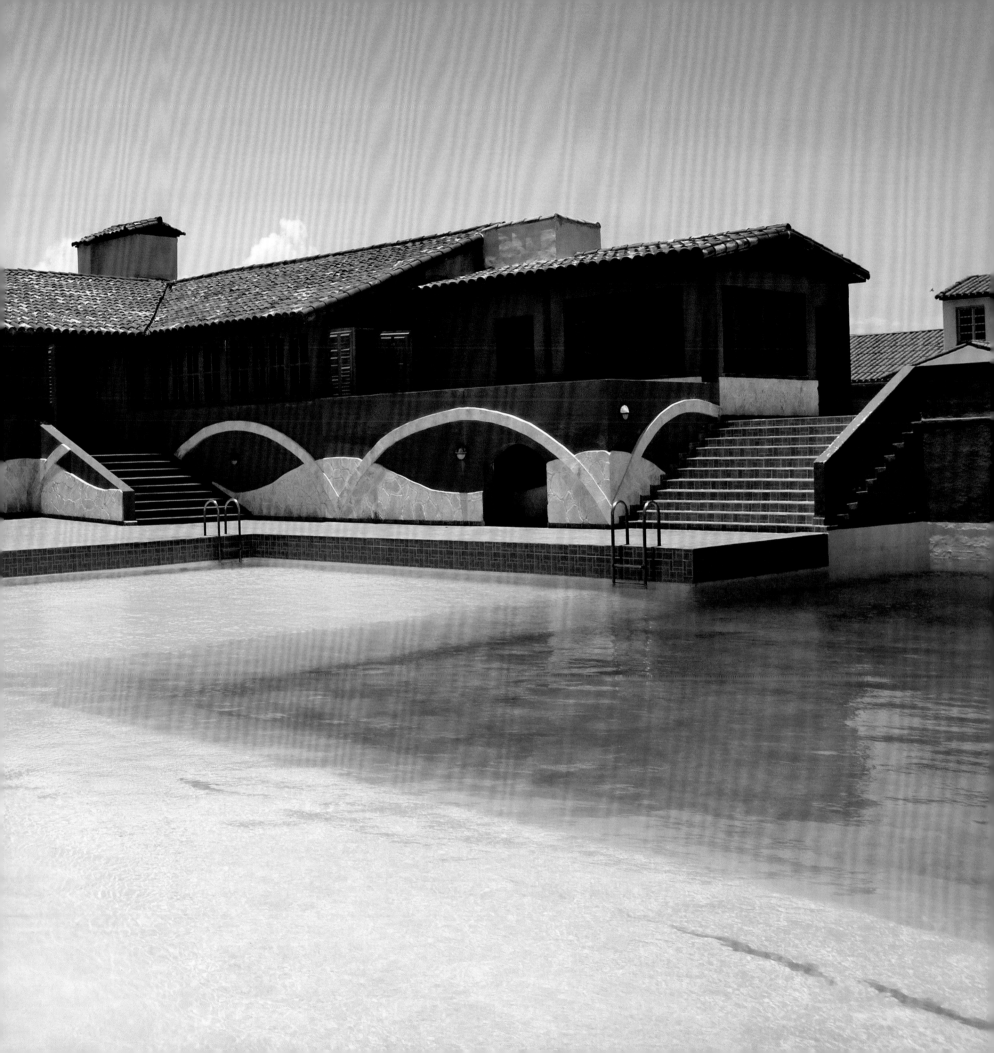

Previous spread
*The rear of the Casa de Eutimio Falla
Bonet, designed by Eugenio Batista in
the late 1930s.*

Above left
*Bar at the Bonet house with a mural
painted and signed by architect
Eugenio Batista.*

Above right
*Detail of the hallway of the Bonet
house, which leads from the front
door directly through the house
to the rear patio overlooking the
Caribbean Sea.*

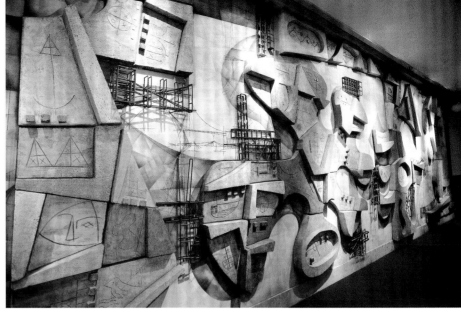

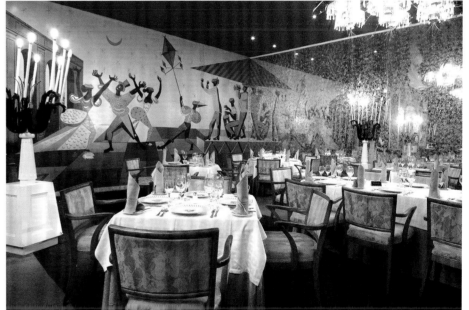

Above
The original architectural fixtures and elements have been preserved in the Hotel Habana Riviera.

Above top right
A sculpture relief by Cuban artist Rolando López Dirube at the entrance to Riviera's former casino.

Above bottom right
The Riviera's L'Aigeon restaurant has conserved the original lamps, chandeliers, and wall mural A Cuban Mardi Gras by Spanish artist Hipólito Hidalgo de Caviedes.

Next spread
The Riviera was built in 1957 and became one of the symbols of modern architecture in Havana.

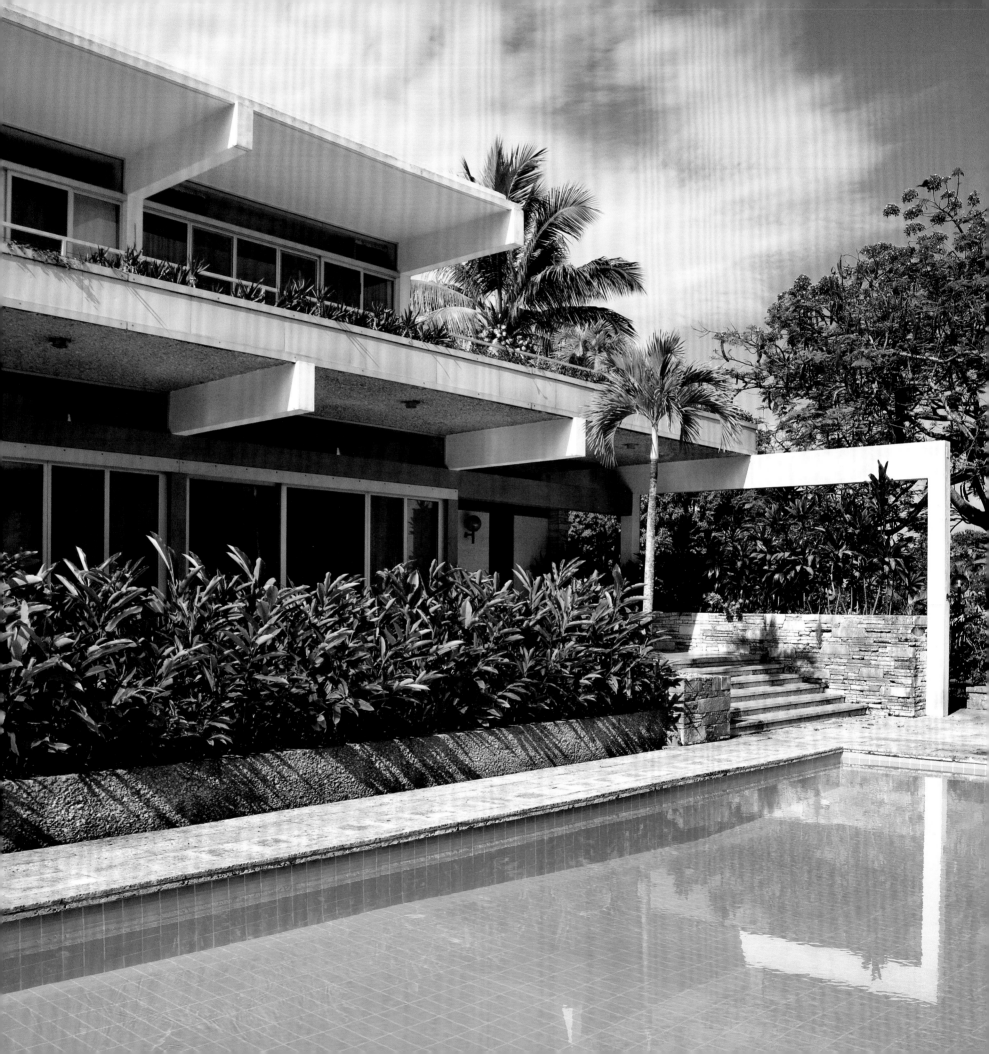

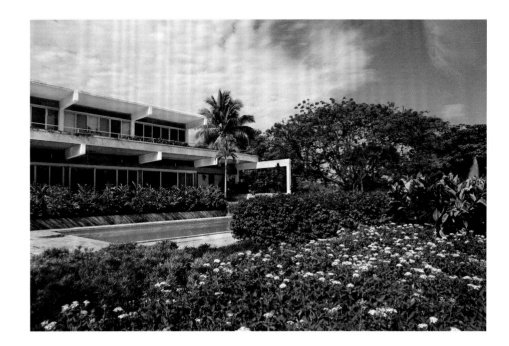

Opposite and above
Casa de Alfred von Schulthess was designed by internationally renowned modernist architect Richard Neutra in collaboration with the Cuban firm of Alvarez y Gutierrez and built in the Country Club Park area (now called Cubanacán) in 1956. The gardens were designed by Brazilian landscaper Roberto Burle Marx.

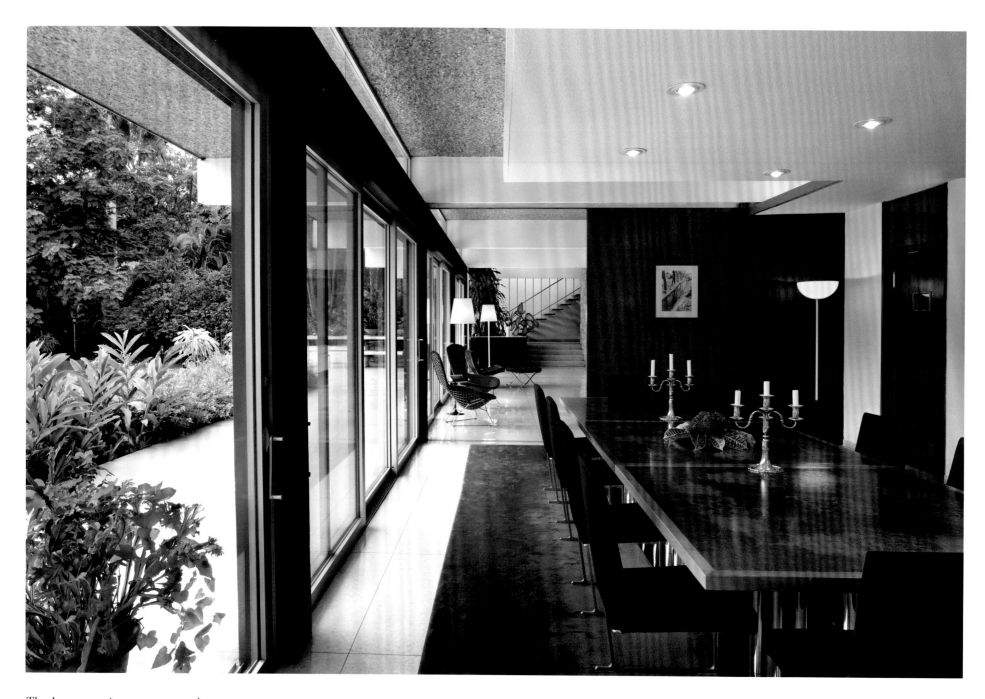

*The large continuous space where
the dining room, bar, living area, and
hallway are successively located.*

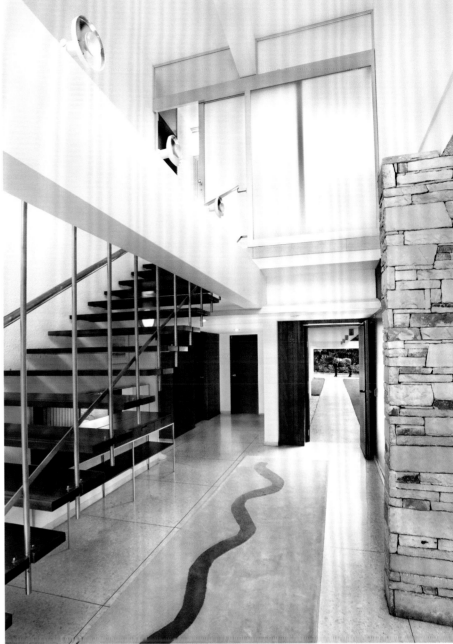

Above left
*The house is filled with furniture
from the period such as Barcelona
chairs by Mies van der Rohe, the
Wassily chair by Marcel Breuer,
and a Corbusier lounge chair.*

Above right
*Entrance hall and a staircase that
leads to the second-floor bedrooms.*

Next spread
*The concrete-and-glass design stresses
clarity of form and function with a
blend of art, landscape, and practical
comfort.*

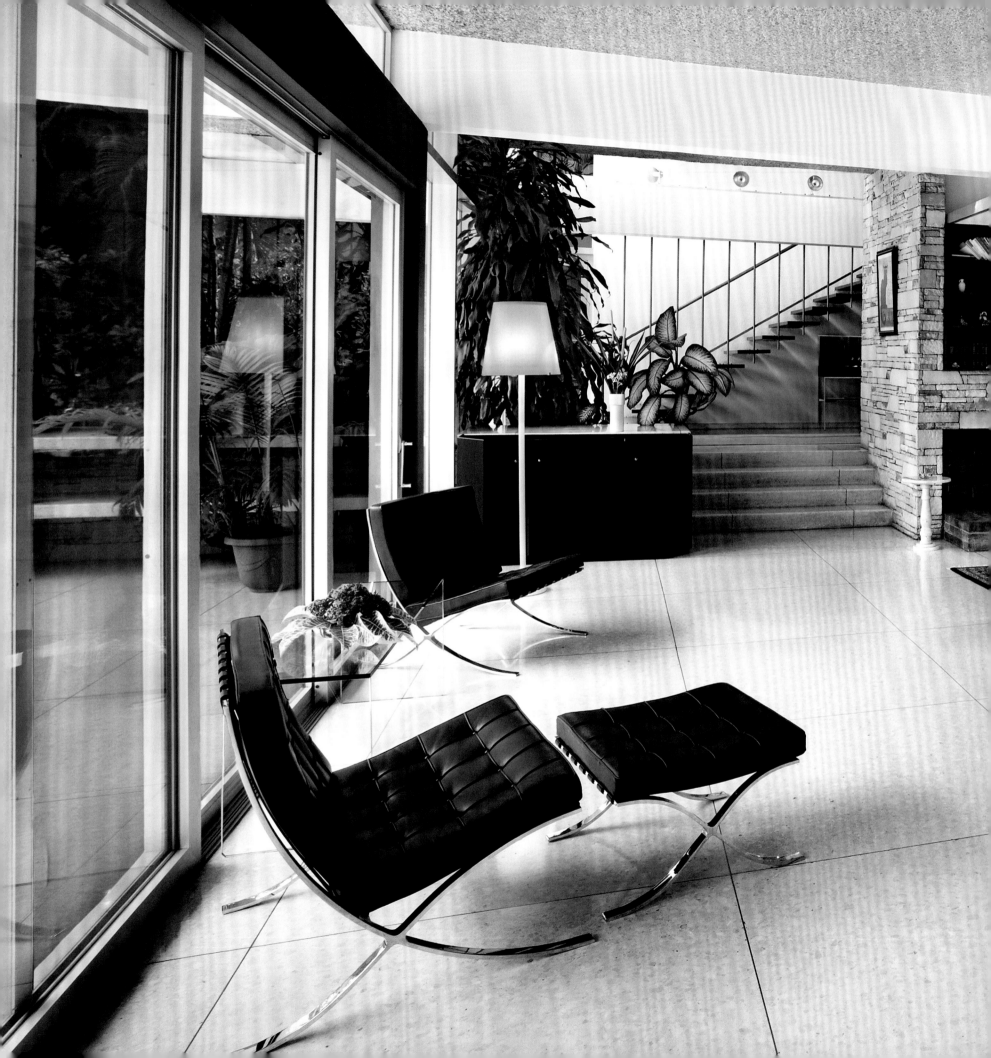

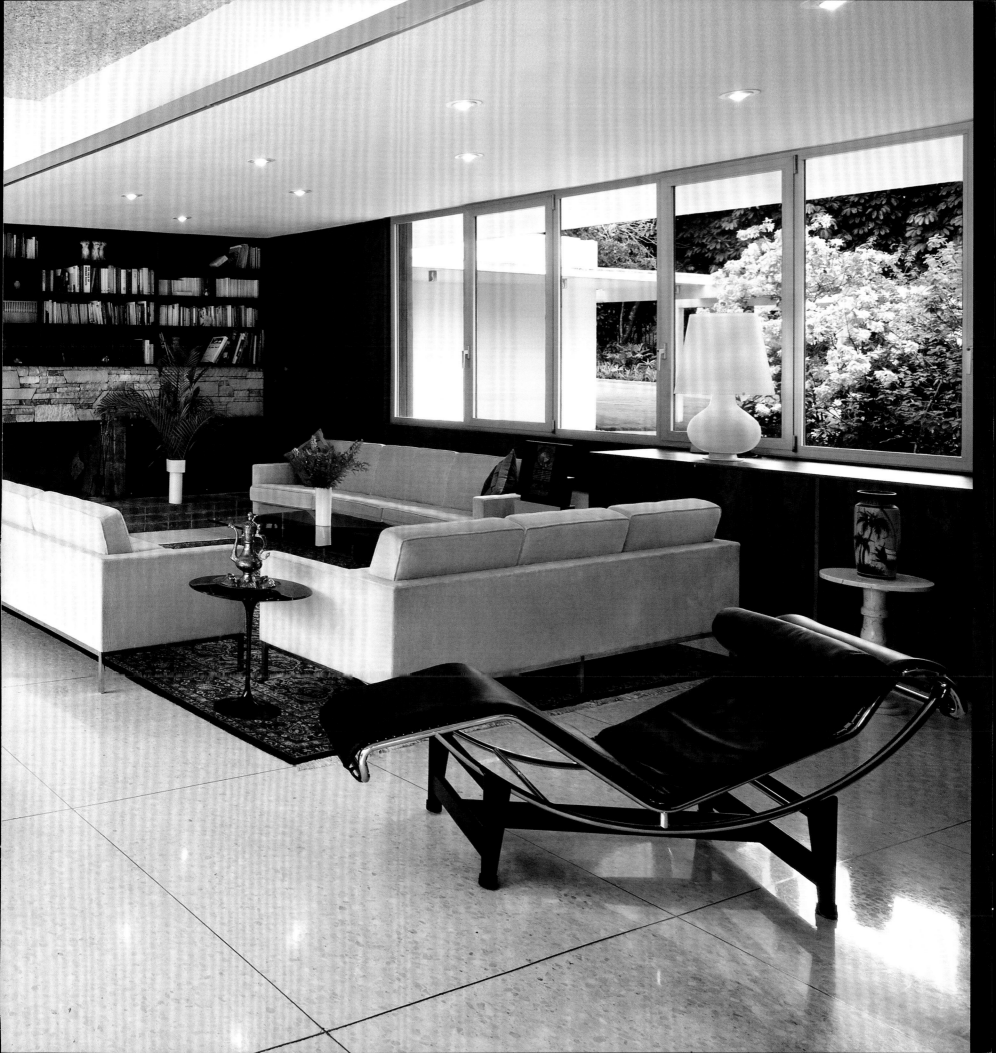

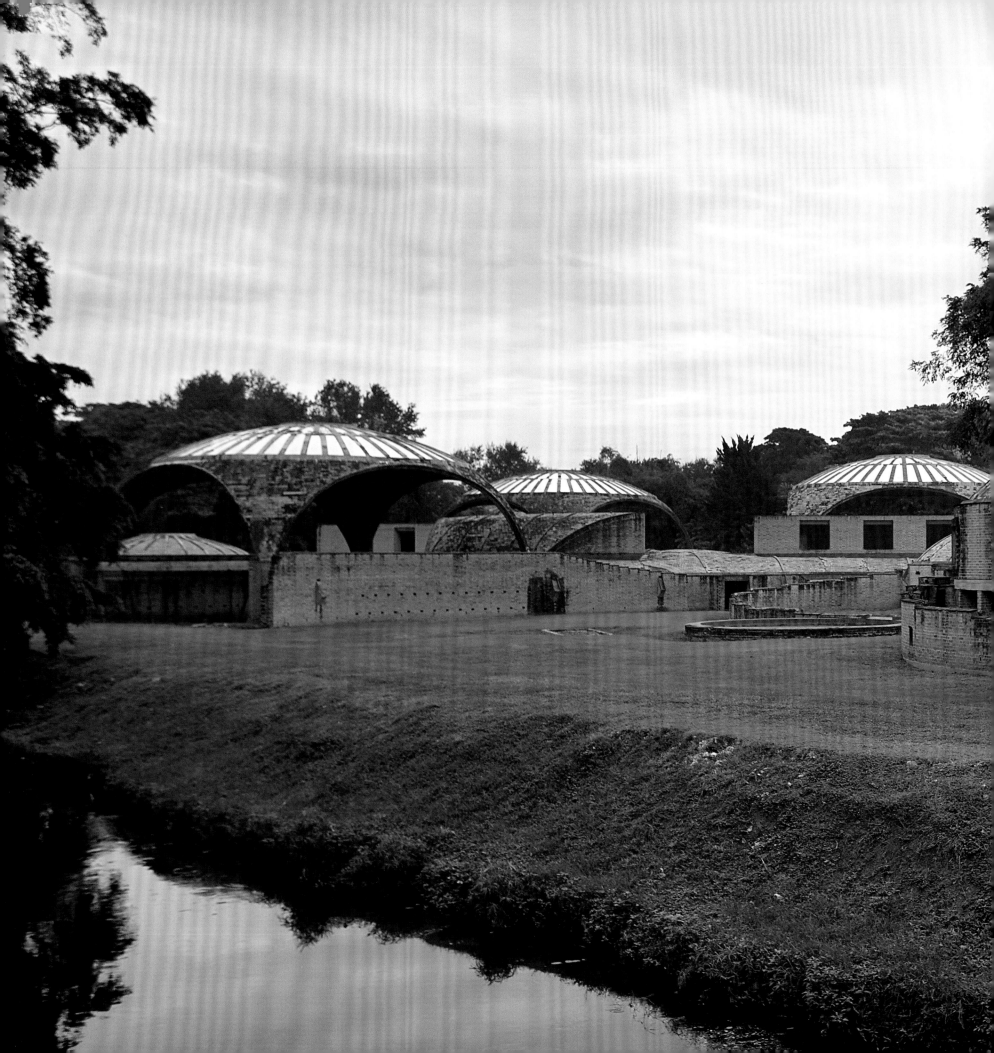

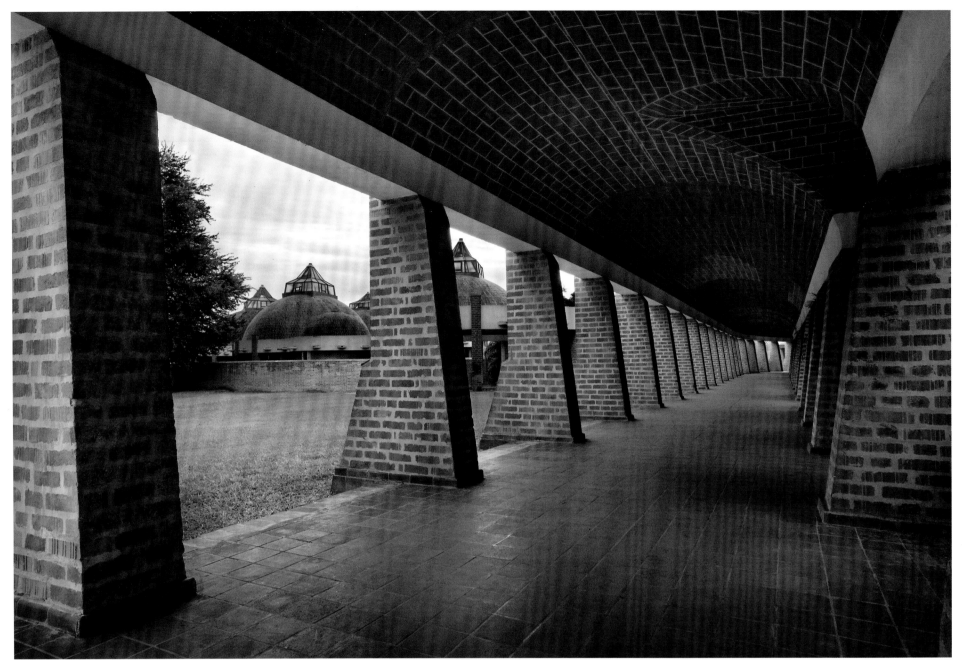

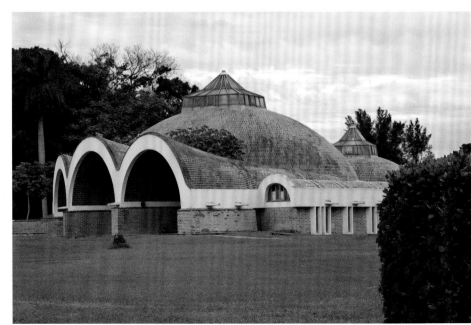

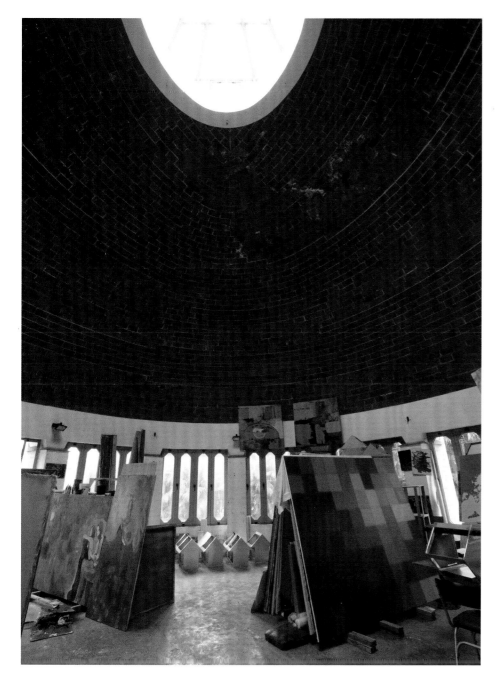

Previous spread
Cuba's National Art Schools, Escuelas
Nacionales de Arté, *was built in the
early 1960s. The Cuban architect
Ricardo Porro led the project and
collaborated with two Italian
architects, Roberto Gottardi and
Vittorio Goratti.*

Opposite top
*Traditional and relatively inexpensive
construction materials such as
brick and earthenware slabs were
used throughout.*

Opposite bottom
*The lead architect of the school,
Ricardo Porro, applied an aesthetic
of sensualism to the design, making
the painting studios representative of
female breasts. In a recent interview
in Paris, he said, "In those days
anything and everything seemed
possible."*

Above left
*The interior of one of the school's
painting studio.*

Above
*One of the school's many hallways
shows a construction design
reminiscent of Catalonian brick
vaults, which minimized the use of
steel and concrete.*

Next spread
*The three-thousand-capacity stadium
designed by Octavio Buigas and
built in 1960 at Parque Deportivo
José Martí.*

Acknowledgments

Cuba is home to one of the world's greatest collections of architecture, spanning more than four centuries. When I first visited the island in the 1990s and experienced the array of amazing architecture, I coined the phrase "preservation by neglect." I was happy to see that there were no McDonald's, Dunkin' Donuts, strip malls, or insensitive development. The cities were beautiful but deteriorating and in need of restoration. Since then I have seen tremendous changes in Cuba regarding the preservation of historically significant architecture. I've traveled the island from Pinar del Río in the west to Santiago de Cuba in the east and met the curators, historians, conservators, and custodians of Cuba's material culture. They continue to identify, research, and restore their valuable cultural essence or Cubanidad, Cuba's architectural heritage.

This trove of historically significant ecclesiastical, military, civil, and government buildings displays a wide variation of styles and fashions. Most impressive is the domestic architecture—the palaces, mansions, and castles built for the sugar wealth that dominated the island, particularly during the colonial era.

Working in Cuba, as on any Caribbean island, has both its pros and cons. The most obvious pro was being able to work with and among the Cuban people. Never in my forty years of traveling throughout the Caribbean have I met a more friendly, gracious, and hospitable culture. The Cubans I worked with were industrious, resourceful, genuinely interested in our project, and generously shared their homes, knowledge, and resources.

Of course, as with any book project, there were difficulties. When in Cuba, my major obstacle was gaining access to what are historically significant private homes, which have in the last half century become "protocol houses" (villas that now serve as homes for VIPs and foreign dignitaries during their visits to Cuba) or government offices. One incident that stands out was being denied permission to

photograph an exterior staircase at the Palacio de Domingo Aldama, considered by many architectural historians to be the quintessential nineteenth-century palacio in Havana. Today it is ironically the headquarters of the Institute of the History of the Communist Movement and the Socialist Revolution and therefore strictly off-limits to foreigners.

With that said, I do want to most sincerely thank Eusebio Leal Spengler, Historiador de la Ciudad de la Habana, who heads a carefully planned program of preservation in old Havana and was instrumental in my gaining entry to most of the historical and culturally important buildings throughout Cuba. Without his help, this book would not have been possible. Secondly I would like to acknowledge and thank Maria de Lourdes (Luly) Duke, whose not-for-profit organization Fundación Amistad enabled my research and photography team and me to travel to Cuba legally, flying from Miami to Havana, something that any and all Americans should be free to do.

This book has been in the making for over ten years and the list of people and institutions who have contributed is very long. They include:

Jenny Alcebo
Celene Valcálcer Almagro
Alina Ochoa Aloma
Dr. Patricia Rodriguez Aloma
José Rodríquez Barreras
Osmel Ruiz Barrios
Gloria Berbena
Martica Castellano Bosch
Argel Calcines
José Fábregas Carballo
Mr. Norberto Carpio
Andy Connors
Thomas Connors
Thomas Cooper
Juana Isabel Cabrera Daciela

Fray Agustin Ibarra Diaz
Jonathan D. Farrar
Hendy Fernandez
Carmen Rodriguez Ferrer
Gloria Álvarez Frigola
Margarita Suárez García
Barbara Cameron Gregg
Ruth Grossenbache
Mr. Herman Van Hoff
Ms. Milagros Díaz Huerta
José Linares
Arch. Reynaldo Mendoza,
Ambassador Dianna Melrose
Juan Luis Morales Menocal
Irán Millan
Mr. Edel Morales
Lourdes Nunez
Katia Varela Ordas
Victor Echenaguria Pena
Gema Perez
Ricárdo Porro
Yolanda Wood Pujois
Ambassador Jean-Claude Richard
Ms. Ada Rosa Alfonso Rosales
Dr. Margarita Ruiz
Dr. Alicia García Santana
Dr. Isabel Rigol Savio
Raida Mara Suárez
Severino Rodriguez Valdes
Dr. Ercilio Vento
Lic. Lizania Alonso Villar
Ulla Van Zeller

To my photographer, Brent Winebrenner, goes my sincerest gratitude for his patience and professional talent. His work discerns the essence of Cuba's architecture and interiors with available lighting that accentuates the depth and ambience hidden in every image.

Also thanks to Dee Dee DeGelia for the strength of her post-production imagery work. I want to also thank Karolina Stefanski for all the research work she was able to do, especially in Cuban baroque and Spanish plateresque, and Gene Wilkins for overseeing the offices of Michael Connors International during my long absences in Cuba.

Special thanks to Rizzoli editor-in-chief Charles Miers for having the vision to recognize the hidden beauty of Cuba, my editor, Ellen Cohen, for sticking it out and allowing me to express my vision, and the designers Massimo Vignelli and Beatriz Cifuentes-Caballero, whose dedication to design excellence assured an impeccable result.

Finally, I would like to express my gratitude to the Cuban people. Their island hospitality was beyond anything I could have imagined, and I can only hope that this book will somehow bring the people of Cuba and the people of the United States one step closer.

Correos y Telégrafos

Notes

1 Doris Kindersley, *Cuba* (London: Penguin Co., 2002), p. 210.

2 Toby Lester, *The Fourth Part of the World: The Race to the Ends of the Earth, and the Epic Story of the Map That Gave America Its Name* (New York: Simon & Schuster, Inc., 2009), pp. 262–63.

3 Ibid, p. 263.

4 Alec Waugh, *A Family of Islands* (New York: Doubleday & Company, Inc., 1964), p. 3.

5 W. Adolphe Roberts, *The French in the West Indies* (New York: The Bobbs-Merrill Company, 1942), p. 13.

6 Eric Williams, *From Columbus to Castro: The History of the Caribbean, 1492–1969* (New York: Vintage Books, 1984), p. 72.

7 John Alexander Exquemelin, *The Buccaneers of America* (1684: Reprint, London: Swan Sonnenscheis & Co., 1893).

8 Ibid, ix.

9 Louis Hanke, *Bartolomé De Las Casas and The Spanish Empire in America: Four Centuries of Misunderstanding*, Vol. 97, No. 1 (American Philosophical Society, 1953), pp. 26–30.

10 Michael Connors, *Caribbean Houses; History, Style and Architecture* (New York: Rizzoli International Publications, Inc., 2009), p. 66.

11 Rachel Carley, *Cuba: 400 Years of Architectural Heritage* (New York: Whitney Library of Design, 2000), pp. 53–55.

12 Fernando Marias, *The Dictionary of Art*, Vol. 29 (New York: Grove, 1996), p. 264.

13 María Luisa Lobo Montalvo, *Havana: History and Architecture of a Romantic City* (New York: Monacelli Press, 2000), p. 45.

14 Leopold Castedo, *A History of Latin American Art and Architecture: From Pre-Columbian Times to the Present* (New York: Frederick A. Praeger, Inc., 1969), pp. 144–45.

15 Eric Deschodt, *The Cigar* (Paris: Editions du Regard, 1996), p. 17.

16 Ibid, p. 42.

17 Hector Rivero Borrell et al., *The Grandeur of Viceregal Mexico: Treasures from the Museo Franz Mayer* (Texas: University of Texas Press, 2002), p. 32.

18 Hugh Thomas, *Cuba or The Pursuit of Freedom* (New York: Da Capo Press, Inc., 1971), p. 128.

19 Richard Golt, *Cuba: A New History* (New Haven: Yale University Press, 2004), p. 37.

20 John E. Willis, Jr., *1688: A Global History* (New York: W.W. Norton, 2001), pp. 49–50.

21 Eric Williams, *From Columbus to Castro: The History of the Caribbean 1492–1969* (New York: Vintage Books, 1970), p. 144.

22 Hector Rivero Borrell et al., *The Grandeur of Viceregal Mexico: Treasures from the Museo Franz Mayer* (The Museum of Fine Arts, Houston, Museo Franz Mayer, Mexico, 2002), p. 25.

23 Javier Rivera, *The Dictionary of Art*, Vol. 29 (New York: Grove, 1996), p. 269.

24 Xavier Galmiche, *Havana: Districts of Light* (Paris: Vilo Publishing, 2001), p. 9.

25 María Luisa Lobo Montalvo, *Havana: History and Architecture of a Romantic City* (New York: Monacelli Press, 2000), p. 72.

26 Sherry Johnson, *The Social Transformation of Eighteenth-Century Cuba* (Florida: University Press of Florida, 2001), p. 10.

27 Eric Williams, *From Columbus to Castro: The History of the Caribbean 1492–1969* (New York: Vintage Books, 1970), pp. 365–66.

28 María Luisa Lobo Montalvo, *Havana: History and Architecture of a Romantic City* (New York: Monacelli Press, 2000), p. 134.

29 Isadora Duncan, *My Life* (New York: Liveright, 1927), pp. 329–30.

30 Maria Elena Martin Zequeira, Eduardo Luis Rodriguez Fernández, *La Havana: Guia de Arquitectura* (Madrid: Agencia Española de Cooperación Internacional, 1998), p. 184.

31 Rachel Carley, *Cuba: 400 Years of Architectural Heritage* (New York: Whitney Library of Design, 2000), p. 131.

32 Leonardo Morales, "La arquitectura en Cuba de 1898 a 1929," *El Arquitecto*, 1929, No. 38, pp. 423–31.

33 María Luisa Lobo Montalvo, *Havana: History and Architecture of a Romantic City* (New York: Monacelli Press, 2000), p. 263.

34 Rachel Carley, *Cuba: 400 Years of Architectural Heritage* (New York: Whitney Library of Design, 2000).

First published in the United States of America in 2011
By Rizzoli International Publications, Inc.
300 Park Avenue South, New York, NY 10010
www.rizzoliusa.com

Designed by Massimo Vignelli
Associate Designer: Beatriz Cifuentes-Caballero

Rizzoli Editor: Ellen R. Cohen

ISBN: 978-0-8478-3567-6
Library of Congress Control Number: 2011932183

Copyright © 2011 Michael Connors

Printed in China

2011 2012 2013 2014 2015 / 10 9 8 7 6 5 4 3 2 1

All photographs by Brent Winebrenner except for the following:

Bibliothèque Nationale de France: 26–27; Bruce Buck and courtesy of Condé Nast Publications: 284–85, 287, 288, 289, 290, 291; Colección de la Fototeca Histórica de la Oficina del Historiador de la Ciudad de la Habana: 94–95; 99 (middle/bottom); 100 (both); Andreas Kornfeld: 65, 151; Vanessa Rogers: 28, 39, 51 (top/bottom), 76, 77, 134, 138 (top right), 139, 142, 143 (both), 146 (right), 147, 149, 169, 191, 192, 193, 194 (all), 195, 197, 198, 207, 276, 277, 301 (all); DeeDee deGelia: 14-15, 45 (right), 295 (lower right)